Praise for
Frances and Joseph Gies

CATHEDRAL, FORGE, AND WATERWHEEL

"The authors ... demonstrate not only their remarkable well-informed and articulate mastery of technical detail but also their command of the historiographical issues that continue to enliven this field of study." —*Historian*

"In their latest medieval study, the Gieses explode the myth that the Middle Ages were unconcerned with the empirical and demonstrate that the Renaissance itself was the outcome of gradual progress made over the previous thousand years. . . . A mine of information." —*Kirkus Reviews*

LIFE IN A MEDIEVAL VILLAGE

"What marks [*Life in a Medieval Village*] is its lucidity and the vividness of its imaginative reconstruction of the past—the detail of its pictures of peasant homes, peasant diet, parish politics, and peasant religion." —*New York Review of Books*

"Extremely detailed research takes up in turn food, clothing, farm tools, marriage customs, prayer, games—in short, all conceivable threads in the fabric of village life. . . . The simple and logical organization of the material—together with the lively illustrations taken from manuscript illumination, woodcuts, tapestry—makes *Life in a Medieval Village* a good introduction to the history of this period." —*Los Angeles Times*

WOMEN IN THE MIDDLE AGES

"A reliable survey of the real and varied roles played by women in the medieval period. . . . Highly recommended."　　—*Choice*

LIFE IN A MEDIEVAL CASTLE

"Joseph and Frances Gies offer a book that helps set the record straight—and keeps the romance too. . . . The authors allow medieval man and woman to speak for themselves through selections from past journals, songs, even account books."

　　　　　　　　　　　　　　　　　　　　　　　—*Time*

A MEDIEVAL FAMILY

A MEDIEVAL FAMILY

The Pastons of Fifteenth-Century England

FRANCES AND JOSEPH GIES

HarperPerennial
A Division of HarperCollinsPublishers

A hardcover edition of this book was published in 1998 by HarperCollins Publishers.

HarperCollins books may be purchased for educational, business, or sales promotional use. For information please write: Special Markets Department, HarperCollins Publishers, Inc., 10 East 53rd Street, New York, NY 10022.

First HarperPerennial edition published 1999.

Designed by Elliott Beard

The Library of Congress has catalogued the hardcover edition as follows:

Gies, Frances.
 A medieval family : the Pastons of fifteenth-century England / Frances and Joseph Gies. —1st ed.
 p. cm.
 Includes bibliographical references and index.
 ISBN 0-06-017264-9
 1. Paston letters. 2. Great Britain—History—Wars of the Roses, 1455–1485.
 3. England—Social life and customs—1066–1485.
 4. Manuscripts, Medieval—England—Norfolk.
 5. Middle class—England—History—Sources.
 6. Family—England—History—Sources.
 7. Fastolf, John, Sir, 1378–1459. 8. Paston family—Correspondence. 9. Fifteenth century.
 I. Gies, Joseph. II. Title.
DA240.G54 1998
942.04—dc21 97-49169

ISBN 0-06-093055-1 (pbk.)

99 00 01 02 03 ❖/RRD 10 9 8 7 6 5 4 3 2 1

To Fitz

Contents

Maps

Illustrations

Acknowledgments

This book was researched principally at the Harlan Hatcher Graduate Library of the University of Michigan.

We gratefully acknowledge the assistance of Dr. Patricia McCune of the University of Michigan, who read the manuscript and made helpful suggestions. We also thank the Department of Manuscripts of the British Library and the Norfolk Museums Service, especially Bill Milligan and the late Dr. Sue Margeson of the Castle Museum in Norwich.

A
MEDIEVAL
FAMILY

Chapter 1

THE LETTERS

he Paston Letters, written by a fifteenth-century family of the Norfolk landed gentry, their friends, and their associates, comprise more than a thousand letters and documents. Dealing with family and domestic problems, litigation and business affairs, they have no literary pretensions and only peripheral political significance. Their value to historians lies in the family's very ordinariness and the letters' consequent wealth of information about manners, morals, lifestyle, and attitudes in the late Middle Ages. Their existence itself reflects the increasing literacy of the gentry, as well as the troubled times that separated family members and imposed written communication.

The Paston archive first came to public notice in 1787 when a Norfolk gentleman named John Fenn, a

member of the enthusiastic class of amateur historian-archaeologists known as antiquarians, published two volumes under the cumbersome title *Original Letters, Written During the Reigns of Henry VI, Edward IV, and Richard III, By Various Persons of Rank and Consequence*. The title was misleading. Most of the correspondence was not that of "persons of rank and consequence" but of three generations of the Paston family and their compatriots, persons of only middling rank and consequence.

The publication was greeted by an accolade from Horace Walpole, earl of Orford, himself a famous composer of letters, which gave it an immediate boost. Walpole's appreciation was principally for the occasional letters of the "persons of rank": "Lord Rivers, Lord Hastings, the Earl of Warwick. . . . What antiquary would be answering a letter from a living Countess when he may read one from Eleanor Mowbray, Duchess of Norfolk?"[1] On the other hand, Hannah More, a prominent bluestocking, deplored the letters' want of elegance and their "barbarous style." She concluded that they might be of some use as a historical resource but that "as letters they have little merit."[2]

Mrs. More's (privately expressed) opinion was not generally shared, and the book was a success in court and literary circles, resulting in Fenn's being knighted by King George III. The first two volumes were followed by a third and fourth in 1789, while a fifth, left ready for publication by Fenn at his death in 1794, was published by his nephew William Frere in 1823.

The Fenn edition, like subsequent versions of the Paston Letters, was limited in time frame to the fifteenth century though the family's correspondence, after a break, continued through the seventeenth century. It is the letters and documents of the fifteenth century, by presenting a coherent record of three generations of the family, that constitute an incomparable resource for the social history of the time and a record of a pivotal class of the late Middle Ages. Sandwiched between the nobility—a few score

families, most of them very wealthy—and the upper (yeoman) tier of the peasant masses, the English gentry numbered only about a thousand households, filling the professions, especially the law, and owning enough property to ensure a decent standard of living.

But the Pastons are more than a microcosm of a class: they are individuals with personalities and stories that are accessible to us, once the obstacle imposed by language has been overcome. With the exception of a few in French or Latin, the letters are written in a language somewhere between the Middle English of Chaucer (d.1400) and the Early Modern English of Shakespeare; in fact, they present, in addition to the raw material of social history, a record of an important stage in the history of the English language, just before and just after the introduction of printing. Geographically, the Paston idiom is located in the East Midlands. North, South, and Midland English differed on a scale that made Northern speech difficult for Southern speakers to understand; Midlanders understood both.[3] East Midland speech, used by Court and government circles and by the Justices of Assize, was in the process of becoming modern English.[4] In its transitional fifteenth-century state, it presents difficulties for the modern reader in vocabulary, grammar, and spelling. Some words have since passed out of the language; others have changed their meaning; old verb and pronoun forms persist; word order is confusing.*

Spelling, however, is the greatest obstacle, differing not only

*The printed editions of the letters, while preserving the language and spelling of the originals, have added punctuation. The original letters are for the most part without punctuation, except for an occasional slash (/), a double slash for a sharper break, or, rarely, a period. A few writers divided their letters into paragraphs or prefaced new subjects with "Item."

from the modern but from letter to letter, within a letter, or even within a sentence. Evidently English readers of John Fenn's day were closer to Middle English than we are today; few modern readers would have the patience to read the Paston letters in their original form. In this book the prose is "translated" for the sake of intelligibility without, so far as possible, sacrificing contemporary flavor. For example, Margaret Paston's letter to her husband John, about a possible marriage for his sister, Elizabeth, reads in the original:

Right worshipfull hosbond, I recommawnd me to yow, praying yow to wete that I spak yistirday with my suster, and she told me that she was sory that she myght not speke with yow or ye yede; and she desyrith if itt pleased yow, that ye shuld yeve the jantylman that ye know of seche langage as he myght fele by yow that ye wull be wele willyng to the mater that ye know of; for she told me that he hath seyd befor this tym that he conseyvid that ye have sett but lytil therby, wherefor she prayth yow that ye woll be here gode brother, and that ye myght have a full answer at this tym whedder it shall be ya or nay. For her moder hath seyd to her syth that ye redyn hens that she hath no fantesy therinne, but that it shall com to a jape, and seyth to her that ther is gode grafte in dawbyng, and hath seche langage to her that she thynkyt right strange, and so that she is right wery therof, wherefor she desyrith the rather to have a full conclusyon therinne. She seyth her full trost is in yow, and as ye do therinne, she woll agre her therto.[5] (See illustration on page 5)

Translation:

Right worshipful husband, I recommend myself to you, praying you to know that I spoke yesterday with my sister [-in-

Letter from Margaret Paston to her husband, John, 30 January, probably 1453, asking his help in finding a husband for his sister, Elizabeth. *(British Library, MS. Add. 36888, f.91)*

law], and she told me that she was sorry that she could not speak with you before you went; and she desires, if it please you, that you should give the gentleman that you know of such an answer that he might feel that you will be favorable to the matter that you know of; for she told me that he has said previously that he thought that you have set but little importance by it, wherefore she prays you that you will be her good brother, and that you might have a full answer at this time whether it shall be yes or no. For her mother has said to her since you rode hence that it shall come to a joke; and says to her that there is good art in putting on makeup; and has language to her that she thinks very strange, so that she is very weary thereof, wherefore she desires rather to have a full conclusion of it. She says her full trust is in you, and whatever you decide to do, she will agree to it.

Numerals in the letters are almost exclusively Roman, although Hindu-Arabic notation had long been introduced in Europe. (For clarity's sake, this book writes out the numbers, or substitutes Arabic for Roman.) The Pastons probably employed the counting board (a version of the abacus) for their computations. Margaret makes a reference to John's "board," which, along with his coffers, required space "to go and sit beside."[6] The monetary system, inherited from the Romans, was universal in medieval Europe and preserved in England until the 1970s: in Latin, *libri, solidi,* and *denarii,* in English, pounds, shillings, and pence; twelve pence to a shilling and twenty shillings to a pound. Counting by dozens and scores of dozens apparently seemed natural to the Middle Ages. In the Paston Letters, pounds are expressed by the abbreviation *li.* (for *libri,* as for example, "xx *li.*") for which this book substitutes the word "pounds" or the modern pound sign (£); the abbreviations for shillings and pence are the same as in predecimal Britain: s. for shillings, and d. (*denarii*)

for pence. In England another often-used unit was the mark, which equaled two-thirds of a pound, a relationship confusing to a modern observer but giving no trouble to the Pastons, who switched back and forth between pounds and marks with casual dexterity.

The one basic, universal coin circulated throughout medieval Europe was the silver penny. In England there were multiples, 4d. and 2d. coins (groats and half-groats), and fractions, half- and quarter-pennies, but there were no large silver coins. The pound and the shilling, as well as the mark, were only "moneys of account," used for convenience in dealing with large amounts but not existing as actual coins. There was no paper money. A few English gold coins existed: the noble, worth a third of a pound, and the half- and quarter-noble. In 1464 the old noble was renamed the "angel," and the new noble, also called the "royal," became a half-pound.

The Paston collection reflects the growth of literacy in the late Middle Ages, as well as the emergence of English as a written language. But the letters also indicate that writing was hard work, which often devolved on servants, secretaries, and amanu- enses. Several smaller English collections survive from the same period, notably those of the Celys, the Plumptons, and the Stonors.[7]

Many of the male Pastons' letters are in the hand of the sender; some were dictated to or even composed by clerks and usually but not always signed by the sender. Most of the women's letters are dictated, implying that though the women could read, they were not proficient at writing or at least found it a chore.

The correspondence among Paston family members consists mostly of originals; letters sent to persons outside the family exist in drafts or in copies—"doubles," as Sir John Fastolf, a leading

figure in the Paston story, called them, directing his clerks to make and keep them. [8]

The survival of the large Paston archive owes something to luck. However, the content of the letters at least partially explains why the family took such pains to preserve them: much of the substance has to do with the ferocious disputes over property that constituted a large part of the activity of gentry and nobility in the fifteenth century. The first John Paston (designated in this book as John Paston I, or simply John Paston) was a lawyer by profession and through the last several years of his life engaged in the most bitterly fought of all the Paston battles, that over the estate of Sir John Fastolf.

John Paston's wife Margaret, one of the central figures in the correspondence, recalled the value that her late husband attached to the written document when she counseled her eldest son, "Keep wisely your writings that are of charge [important], that they come not into the hands of those that may hurt you hereafter. Your father, whom God assoil [pardon], in his troubled season set more [store] by his writings and evidence than he did by any of his movable goods. Remember that if they were taken from you, you could never get any more such as they are."[9]

Second only to land dealings as a theme of the letters are family affairs: marriage prospects and arrangements, visits, the discipline of children being educated away from home, pregnancies, sickness, death. Letters became of paramount importance as families of the gentry were geographically separated, the daughters marrying and joining their husbands, the sons going off to train for careers in law, service to lords, or in the Church. Family feeling extended to uncles, cousins, and in-laws—the last customarily referred to simply as "brother," "sister," "mother," or "father" and in many ways treated as blood relations. Stretching the custom further, friends were often addressed as "cousin" even when there was no question of kinship. (John's letters to his

wife were usually addressed "to my cousin Margaret Paston," though she was certainly no blood relation.) Sometimes, indeed, it is difficult to distinguish between real and courtesy cousins, so complex were relationships thanks to shortened life spans and frequent remarriages. Sir John Fastolf's mother was married three times, his wife twice; no wonder everyone seemed to be his cousin. One historian comments, "I am inclined to believe that everybody who was anybody in England in the late middle ages, and especially those 'at court,' had kinships or alliances of one degree or another with everyone else."[10]

However extended and sometimes artificial the compass of relationship, family feeling was genuine and strong. F. R. H. DuBoulay describes it as "an eagerness for letters and news from distant members every bit as ardent as that displayed among Victorian families."[11] Many letters include the phrase "I think it long ere I heard from you." For a woman like Margaret Paston to provide the nexus of communication for husband, children, kinsmen, and friends was natural.

The letters' salutations, not written on a separate line but as part of the opening sentence, follow accepted formulas but reflect the relative status of the writers. Equals address each other simply: "Right worshipful sir," "Trusty and well-beloved," or sometimes merely "Sir." In addressing Margaret, as children to mother, her sons show deference, employing such elaborations as "Most worshipful and my right special good mother, as humbly as I can, I recommend me unto you, beseeching you of your blessing." Their father receives a similar submissive greeting, particularly when the son who is writing is out of favor with him: "Right worshipful sir, in the most lowly wise, I commend myself to your good fatherhood, beseeching you of your blessing." Margaret's letters to her husband begin "Right worshipful husband, I recommend me to you, desiring heartily to hear of your welfare." Servants' letters often open with "Please your worship-

ful mastership to know," or "Right worshipful and my most reverend master, I recommend myself unto your good mastership," or once, when a special favor is asked, "Right worshipful master, I recommend me unto your mastership, and I thank your mastership that it pleased your mastership to send me word again of my letter." John's letters to Margaret, on the other hand, begin with a businesslike "I recommend me to you," those to his sons often with the curt "Sir."

Margaret usually accorded her sons the desired blessing, even when (as was often the case) she had fault to find. On one occasion she chided her eldest son for not asking for it.[12] The religious expressions so regularly used at the closing of the letters— "I beseech Almighty God keep you"; "I pray to Our Lady, help us, and her blessed Son, who have you in His holy keeping"; "The holy Trinity keep you"—have a ritualistic ring, as do the words "whom God assoil," or a similar formula, whenever a dead friend or relative is mentioned.* Yet the sincerity behind these phrases is attested to by much behavior: substantial donations to churches and monastic institutions; the pilgrimages to Walsingham, Canterbury, and Compostela; the adherence to Church rulings even when these are adverse. Wills express a strong concern for life after death, though disregard of provisions for prayers for the souls of the dead demonstrates the conflict between religion and material interest. "Concern for the dead did not lead [the Pastons] to neglect the living, in fact the reverse," says Colin Richmond.[13]

In addition to property matters and family news, the letters often deal with questions of minor but immediate practical concern: items to be purchased in London, caps for the children, a yard of broadcloth for a hood, a clock needing repair, a student's

*In one case a modern editor uses the absence of the formula, showing that the person mentioned was still alive, to date a letter.[14]

threadbare gown to be "raised" (the nap brushed up), linen sent to London to be made into shirts. Sometimes these errands are the main burden of a letter; more often they are tacked on to more important news. Margaret Paston, especially, often concludes a letter that reports a threat to family property or a visitation of the plague with a request to husband or son for a jar of mustard or a measure of cloth for a gown. A letter in which she warns her second son about a threatened lawsuit concludes with instructions to buy her "a sugar loaf, and dates, and almonds" with money she has entrusted to the messenger, adding that if the total comes to more, "when you come home I shall pay you."[15]

Finally, the letters contain "tidings"—the news of the day, usually forwarded from London to Norfolk, occasionally in the opposite direction. "As for tidings here . . . the duke of Burgundy is still besieging Neuss."[16] "We had tidings here that the Scots will come into England within seven days, to rescue these three castles."[17] "As for tidings here, I trow you have heard . . . how the earl of Oxford landed . . . in Essex the 28th day of May, save he tarried not long."[18]

In a few instances the tidings are the only accounts—eyewitness or secondhand—of historical events, as in the letter from Paston friend and agent William Lomnor to John Paston describing the murder of the duke of Suffolk,[19] or Sir John Fastolf's servant John Payn's letter, also to John Paston, telling the story of his own unwilling involvement in Jack Cade's Rebellion.[20]

Others besides Hannah More have found the style of the letters generally lacking in elegance. Their purpose was not literary but informational; most of the writing is simple and direct, if sometimes marred by repetition, ambiguity, and legalese ("the said lord of Clarence," "the said earl of Oxford"). But the language is usually clear enough, often forceful and colorful, sometimes neatly turned, and occasionally livened by figures of speech. Margaret writes, "We beat the bushes and have the loss

and the disworship and other men have the birds"[21] and "Men cut large thongs here of other men's leather.[22] She quotes an enemy as saying "The duke of Suffolk is able to keep daily in his house more men that Daubeney has hairs on his head."[23] Her eldest son, Sir John, complains of a man who is quitting his service, "I have kept him these three years to play St. George and Robin Hood and the Sheriff of Nottingham."[24] Or her second son writes Sir John, in Parliament, "I pray God send the Holy Ghost among you in the Parliament House, and rather the Devil, we say, than you should grant any more taxes."[25] Occasionally the correspondents put in a proverb: "Judas sleepeth not,"[26] "Who cometh first to the mill, first must grind,"[27] "Wrath said never well,"[28] "Haste rues."[29]

There are telling vignettes: the deathbed of John Paston's father, with his mother, Agnes, praying at the foot of the bed and John, the dissatisfied heir, angrily pacing the room;[30] Agnes challenged by hostile villagers in the parish church;[31] a confrontation at the manor gate of Oxnead between a claimant to the property and John's brother Edmund;[32] a street fight in Norwich;[33] a pathetic train of peasants whose cattle have been seized, following their animals as they are led away.[34]

Sometimes the letters are eloquent. One such, from Paston bailiff Richard Calle to Margery Paston, with whom he had contracted a clandestine marriage, is often included in anthologies of love letters.[35]

One reason for the existence as well as the survival of the Paston Letters is the spread of paper manufacture, which reached Moorish Spain from China in the twelfth century and England by the fifteenth. Parchment was still used for many legal documents, but all the Paston letters are on paper. Fabricated entirely from rags, medieval paper was of excellent quality, capable of lasting through the centuries and cheap enough to be liberally used by

the gentry (though they were thrifty with it). It came in sheets of several different sizes, frequently about 17 by 11 inches. The Pastons and their correspondents wrote across the shorter side and when they were finished cut off the remainder of the sheet. The result was usually a page about 11 inches wide and 4 or 5 inches deep, sometimes little more than a strip. The handwriting that filled the paper was small, with lines well spaced and neatly horizontal. The ink was a reddish-brown, which has now faded into sepia. Each letter was folded laterally in the middle, or sometimes twice, into thirds, and then into a small packet, which was secured by thread or narrow paper tape and then sealed with wax. The address was written on the outside—"To my right worshipful husband, John Paston, be this letter delivered in haste"; "To my right worshipful mother, Agnes Paston"; "To my master Sir John Paston in Fleet Street"—and the letter confided to a messenger.

A man on horseback might cover the 114 miles from Norwich to London in four days, as Sir John Paston indicates in a letter of 16 April 1473, to his brother John III: "I wrote you a letter [dated 12 April] you should have at Norwich this day or else tomorrow in the morning."[36] Often the messenger was identified as the bearer of further information that could be delivered orally. "If it please you to enquire of Simon, bringer of this letter, he shall inform you of [Lady Felbrigg's] language," wrote James Gloys, the Paston family chaplain, to John Paston;[37] a Paston agent wrote, "Pynchamour shall tell you by mouth more than I have leisure to write to you";[38] and, Margaret to John, "Pecock shall tell you by mouth of more things than I may write to you at this time."[39] But occasionally the messenger was judged not capable of communication. Paston agent William Barker wrote asking Margaret for instructions in a land matter, specifying that she answer in writing, "for I trust not well the report of the bringer hereof for his simpleness and dullness of wit."[40]

Often messengers were servants, but anyone who was on the road might be pressed into service. There were also some professional messengers. John Paston, in London, sent Margaret a letter by "a common carrier, [who] was at Norwich on Saturday and brought me letters from other men," and he reproached her that her servants did not "inquire diligently after the coming of carriers."[41] On one occasion he sent Margaret a letter by a goldsmith,[42] on another by "a priest of St. Gregory's parish of Norwich,"[43] on still another by "a man of St. Michael's parish."[44] Margaret dispatched one letter by "Chitock's son that is an apprentice in London."[45]

Trustworthy carriers could not always be found. Margaret apologized for slowness in replying to John because "I could get no messenger to London unless I would have sent by the sheriff's men; and I know neither their master nor them, nor whether they were well-willing to you, and therefore methought it better not to send a letter by them."[46]

Letters were sometimes not delivered or were lost en route. John Paston III wrote his father explaining, "So God help me, I sent you a letter to London soon after Candlemas, by a man of my lord's [the duke of Norfolk], and he forgot to deliver it to you, and so he brought the letter to me again, and since that time I could get no messenger till now."[47] His older brother sent a confidential letter by Paston employee William Worcester, who was apparently attacked and robbed, leaving Sir John concerned about the letter: "I do not want that letter to be seen by some folks; wherefore I pray you take good heed how [it] comes to your hands, whole or [the seal] broken."[48]

Sending money was a special problem. John Paston once asked Margaret to send him some in London, suggesting that an amount in gold coins might "come up safely" with two of their agents, or "peradventure some trusty carrier" who might have it "trussed in some fardel [package]," not letting the carrier know that it was money, "but some other cloth or vestment of silk or

thing of worth."⁴⁹ Similarly, their youngest son, William III, sent "four gold nobles" in a box "as though it were evidence [documents]," since the messenger was leaving his employ and "I would not he knew so much of my counsel."⁵⁰ Another strategy was a version of a common medieval technique, borrowing money in one place to be repaid in another. Thus Margaret, asking John III to buy her a cask of malmsey in London but afraid to entrust the money to a messenger, suggested that he borrow it "from Townshend or Playter," two Norfolk men in London, "or some other good countryman," and when they came to Norwich "I will repay them."⁵¹ Margaret's aunt, needing to pay twenty marks to a man in London, asked John to borrow the sum and pay it for her; meanwhile she would deliver the amount in gold to Margaret "for you to have on your coming home, for she dare not adventure her money to be brought up to London."⁵²

The messenger had to be paid extra if he made the trip solely to carry a letter or if he had to wait for it. Richard Calle notified Margaret that John expected her to "allow the bearer hereof for his costs, inasmuch as he comes hither for that matter and no other."⁵³ John's brother Clement wrote him from London, concluding, "You must pay [the messenger] for his labor, for he tarried all night in this town for this letter."⁵⁴

Third parties were sometimes asked to forward letters: writing to his brother, who might have gone to Calais to join the English garrison there, John Paston III addressed the letter, "This bill be delivered to Thomas Green, good man [host] of the George [Inn] by Paul's Wharf, or to his wife, to send to Sir John Paston, wherever he is, at Calais, London, or other place."⁵⁵ Or Paston agent Thomas Playter to John Paston I: "To John Paston the older in haste, and if he be not at London then to be delivered to Clement Paston in haste."⁵⁶ Or Margaret to John: "To my right well beloved brother Clement Paston, for to deliver to his brother John, in haste."⁵⁷

Letters are dated at the end rather than the beginning. Sometimes the dating is meaningful only to the addressee: "the Friday next after I departed from you." Occasionally it is by the day of the month—"Written the xxii day of January"—more often in relation to the nearest saint's day or other Church feast— "Written in haste at Norwich on the Wednesday next after St. Simon and Jude." The year is often omitted; when included, it is by abbreviated reference to the reigning monarch: "anno xxxiiii Regis Henrici VI (thirty-fourth year of the reign of Henry VI); "anno E. iiii xviii" (eighteenth year of the reign of Edward IV).

The unrest and disorders of the period—the closing chapters of the Hundred Years War and the Wars of the Roses—are manifested in the letters. The first, few in number, date from the period of English military success, 1415–1429, ending with the appearance of Joan of Arc at Orléans. English defeats, the defection of England's ally, Burgundy, and the ten-year truce of 1435–1445 followed; resumption of the war found the English on the defensive until final defeat at Castillon in 1453. The developing catastrophe provoked popular dissatisfaction, which combined with the mental illness of King Henry VI and the rivalries of the great English nobles to bring on the strange series of conflicts known as the Wars of the Roses.

This romantic title was conferred by Sir Walter Scott three hundred years later, in reference to the red and white roses sometimes used as insignia by partisans respectively of Lancaster and York. In 1460 the duke of York was killed attempting to make good his claim to the crown, but his son Edward succeeded in vindicating the claim with battlefield victories over the rival Lancastrian party, with the aid of the brilliant, ambitious earl of Warwick ("the Kingmaker"). As Edward IV, the new king survived several vicissitudes, a falling-out with Warwick, captivity, exile, and triumphant return. He was succeeded by his brother,

Richard III, who usurped the throne from his nephew, one of the two young princes who disappeared into the Tower, never to be seen again. In 1485, Richard was in turn defeated and slain in battle by the Tudor-Lancastrian earl of Richmond, who assumed the throne as Henry VII (d. 1509). The last of the medieval Paston letters date from his reign.

Thus, although the direct political significance of the letters is limited, they supply insights into the atmosphere of a stormy era. The Paston family's legal and extralegal adventures provide revealing detail about the rough and rapacious character of the English nobility and gentry in both their endless property contentions and their readiness to resort to violence, so conspicuous a factor in the Wars of the Roses.

The Pastons' position in the Wars mirrors that of much of their class. They were neither Lancastrian nor Yorkist by tradition or conviction but were drawn into one camp or the other by the combination of their own private interests and the posture of whatever great noble—duke of Norfolk, earl of Oxford, Lord Scales, Lord Hastings—they depended on at the moment for patronage. In the course of the Wars, the Pastons received summonses from both sides to serve; they evidently declined to heed those from Lancastrian Henry VI in 1459 and Yorkist Richard III in 1485, while acceding to those from the Lancastrian earl of Oxford in 1471 and Yorkist Edward IV in 1475. John Paston III was wounded by a Yorkist arrow at the battle of Barnet in 1471 and lived to be knighted on the battlefield of Stoke in 1487 by Tudor-Lancastrian Henry VII. In part, the Paston men survived the Wars because they were gentry rather than nobility; while their social betters were commonly hunted down and beheaded after losing a battle, Sir John Paston and John Paston III successfully sued for pardon after fighting on the losing side at Barnet.

Recent historians differ over whether in England the fifteenth century was more lawless than its predecessors, but it seems clear

that the mental infirmity of Henry VI and English disappoint-
ment and bitterness over the loss of the Hundred Years War con-
tributed to a weakness on the part of the central government that
dangerously augmented the power of local magnates. K. B.
McFarlane has pointed out how the operation of primogeniture
reinforced the natural mortality of the fifteenth century to extin-
guish many noble lineages. The survivors became the enormously
wealthy earls and dukes whom Sir John Fortescue, contemporary
authority on the judicial system, called the "overmighty subjects"
of the era.[58] In the Pastons' region of East Anglia, three of these
dominated: the Mowbray (later Howard) dukes of Norfolk, the
de la Pole dukes of Suffolk, and the de Vere earls of Oxford.

The instrument of power of the great lord was the retinue, its
core made up of armed men fed, lodged, and paid by the lord. To
it could be added a following of numerous officials, tenants, and
servitors of varying degrees, making up the lord's "affinity."
Young John Paston III served for several years in the affinity of
the duke of Norfolk. The total number of followers wearing a
lord's colors and eating from his kitchen provided an index of his
status. Some historians have given the name "bastard feudalism"
to the fifteenth-century system that rewarded the lord's followers
with indentures—money contracts—rather than the land grants
of feudalism. The term has been criticized but nevertheless found
useful. Contemporary vocabulary referred to "livery and mainte-
nance," livery meaning clothing bearing the lord's badge and col-
ors and maintenance meaning support in the law courts, often
through corruption of officials. "Livery and maintenance" pro-
voked widespread protest, but the weak royal power did not
serve to curb the abuse.[59]

Besides the followers that the lord retained as salaried ser-
vants or through indentures, he exchanged a variety of mutually
beneficial services with members of the local gentry. As "good
lord" to a Paston, a duke of Norfolk or earl of Oxford could

influence his client's case in or out of court, while the client could return the favor in certain cases where the lord did not care to be involved personally. The earl of Oxford requested that John Paston I "labor"—influence—a jury in favor of a tenant who was being sued by a Norwich tradesman, direct action in such a cause being beneath the dignity of an earl.[60] In the important area of courtship and marriage, a Paston might ask the earl of Oxford for a good word with the lady's uncle or knightly parent; reciprocally, the earl might ask John Paston I to do the same in respect to the courtship of a Norfolk lady by a favorite Oxford retainer.[61]

That such a mutual relationship between greater and lesser members of the elite was of outstanding importance is emphasized again and again in the Paston Letters, which show the Paston men repeatedly counting on the "good lordship" of a powerful noble whom they in turn serve in many small ways as "well-willers." "For those who wished to rise in the world, good lordship was essential," concluded McFarlane.[62]

Lordship involved both fear and love. Margaret Paston once wrote her son John III, "For God's sake, in this unstable world, labor earnestly your matters that they may have some good conclusion, and that shall make your enemies fear you, else they shall keep you low and in trouble."[63] Paston agent John Russe addressed John Paston I in a similar vein: "Sir, I pray God bring you once to reign among your countrymen in love and to be dreaded."[64] A modern historian comments, "Like God himself, a lord should rule his people with a loving authority which would call forth their dread—the awe and respect due to legitimate authority—but also their love."[65]

The vocabulary of the letters reflects the social realities. The Pastons appealed to their superiors' "good lordship"; their own servants appealed to the Pastons' "mastership" or, in Margaret's case, "mistress-ship," the terms implying not only power but

obligation and responsibility. Influencing one's lord or master was a constant necessity—"laboring" them, or "moving" them to take some action; it was necessary to "common" (commune) with them. The support of one's friends was imperative—one's "well-willers," those who were "well-willing" toward one—as was respect, "worship," opposed to loss of respect, "diswor-ship." Another constantly repeated word descriptive of the eco-nomic life of the gentry, whose income came mostly from rents, was "livelode" or "lyflode" (the nearest modern equivalent is "livelihood"), meaning both the rents and the property that yielded them.

Little is known about what happened to the Paston collection between the fifteenth and eighteenth centuries. At some point, probably late in the sixteenth century, an anonymous antiquar-ian examined the fifteenth-century documents and made explanatory annotations: "A letter to Sir J. Paston from his mother"; "From his brother Sir John Paston, knight"; "It appeareth by this letter that Sir John Fastolf was of kindred to John Paston"; "The Lord Scales is now friend to Sir J. Paston." Some part of the collection was sold early in the eighteenth cen-tury, when the Pastons were in financial straits. In 1735 a large part of the archive passed into the hands of a clergyman named Francis Blomefield, who was engaged in writing a history of the county of Norfolk and was given access to papers in a storage room of the Paston family seat at Oxnead. Blomefield sifted through the documents and was prepared, according to his own account, to burn those relating "to family affairs only"— "though I must own 'tis pity"—preserving those that were "of good consequence in history." He destroyed accounts, court rolls, estate surveys, and deeds, but fortunately, contrary to his stated intention, kept much that pertained to "family affairs" and was not of great historical significance. The resulting collec-

tion was sold and resold, finally in 1775 ending in the hands of John Fenn, whose publication brought the letters to their first public light.[66]

After publication, the original manuscripts disappeared, to reappear, in the words of modern editor Norman Davis, "in a strange piecemeal way." The manuscripts of Fenn's first two volumes vanished from the royal library sometime after their presentation to King George III; the manuscripts of the other three volumes also disappeared for some years before rediscovery in the possession of relatives of Fenn. The king's set of originals finally turned up in the hands of another family, who kept them until 1933, when they were finally purchased for the British Museum, now the British Museum and Library, which eventually acquired most of the collection. A few letters are in the Bodleian Library; others at Magdalen College, Oxford; the Pierpont Morgan Library; and Pembroke College, Cambridge.[67]

In the 1870s, James Gairdner published a three-volume edition, expanded to six volumes in the 1890s, and reedited by Gairdner, with newly discovered material, in 1904. This remained the standard edition until 1971–1976, when Norman Davis, a linguistics scholar, produced a new version in two massive volumes, including letters not available to Gairdner and omitting certain documents of peripheral interest. Davis's intensive study of the handwriting resulted in corrections in the dating and authorship of several important letters, and the Davis edition is now accepted by scholars as standard.

What follows is based on the published texts of Davis and Gairdner and other appropriate sources. It is the story of the Paston family in their rise from modest beginnings to a solid position in the affluent gentry, told as much as possible through their own words, a piece of English medieval history that amounts to a sort of nonfiction historical novel.

PASTON FAMILY TREE

Clement m. Beatrice Somerton
d. 1419

William m. Agnes Berry 1420
1378–1444 | d. 1479

John I m. Margaret Mautby c. 1440 Edmund I Elizabeth 1429–1488 m. William II 1436–1496 Clement
1421–1466 c.1420–1484 1425–1449 (1) Robert Poynings m. Lady Anne Beaufort, 1442–1468
 (2) Sir George Browne 2 daughters

John II John III m. Margery Brews 1477 Margery Edmund II Anne Walter William III
(Sir John) 1444–1503 | c.1460–1495 c. 1448–1482 c. 1450–1503 1455–c.1495 c. 1456–1479 1459–c.1503
1442–1479 m. Richard twice m., m. William
illegitimate Calle 1469 no surviving Yelverton 1477
daughter issue

William IV m. Bridget Heydon c. 1490
1479–1554
ancestor of the later Pastons

Chapter 2

THE FAMILY

wo conflicting—in fact, sharply contrasting—versions of the Paston family's early history exist, but one matter is undisputed: their origin in the village of Paston, on the North Sea coast in northeastern Norfolk. In the first decades of the fifteenth century they expanded their activities into the larger world of the provincial capital, Norwich, and its neighboring port of Yarmouth; in the 1420s their orbit grew to include rich, populous London, center of power and wealth.

One account of the Pastons' genealogy, written by a hostile contemporary probably between 1458 and 1460, is a document titled "A Remembraunce of the wurshypfull Kyn and Auncetrye of Paston, borne in Paston in Gemyngham Soken," of which the original manuscript was unfortunately lost in the nineteenth century.[1] The other was advanced in a certificate

23

issued in 1466 in the name of King Edward IV.[2] According to the first version, the Pastons were Norfolk peasants, with servile origins on at least one side of the family, striving to rise above their proper station in society. According to the second, aristocratic Norman blood flowed in Paston veins; they had for centuries held title as lords of manors, had intermarried with the nobility, and were related to "many of the worshipfullest" in England.

The "Remembrauce" describes Clement Paston (d. 1419) as "a good plain husbandman [who] lived upon his land that he had in Paston and kept thereon a plow all times in the year, and sometimes in the barley-sowing, two plows," walking behind the plow himself summer and winter and riding to the mill "on bare horseback with his corn [grain] under him, and [he] brought home meal again under him. And also drove his cart with divers corns to Winterton [fifteen miles south on the coast] to sell, as a good husbandman ought to do." He held 100 or 120 acres "at most" in Paston, and much of it "bond land [land owing the obligations of villein or serf] belonging to Gimingham Hall manor. . . . He held no other manors or land there nor in any other place." Clement married Beatrice, sister of Geoffrey Somerton, "whose true surname was Goneld." According to the "Remembrauce," both Beatrice and Geoffrey were villeins, despite which Geoffrey became an attorney and accumulated enough "pence and halfpence" to "build a fair chapel at Somerton" and to send Clement's son William to school and then to London to study law.

Here we come onto firm ground; other sources confirm that William Paston enjoyed an eminently successful law career. The "Remembrauce" credits him with being "a right cunning [knowledgeable] man" in his profession and states that he rose first to the distinction of serjeant-at-law and then to that of justice of the peace, an important office filled by appointment of the king.

The "Remembraunce" resumes: "And he purchased much land in Paston . . . [and] has a seigneury [lordship] in Paston, but no manor house." But William's son John, the writer complained, "claims a manor there, to the great loss of the Duchy of Lancaster." Gimingham was a part of that duchy, which belonged to the Crown. The tone of the "Remembraunce" shifts from approval for Clement Paston to disapproval for his ambitious descendants.[3]

In contrast, the royal certificate of 1466 stated that the Pastons' "first ancestor, Wulstan, came out of France, together with Sir William Glanville, his kinsman, who afterward founded the priory of Bromholm," near Paston. The coat of arms of Wulstan's son Wulstan was described ("gold flowered azure"), and those of sons Ralph and Robert, and of Robert's sons, the elder of whom married Glanville's daughter. Furthermore, the Pastons and their ancestors had "since time out of mind" held a manorial court and lordship in Paston and had had "many and sundry bondmen" and all the privileges of lords: "homage . . . wardship, and relief." They had been trusted associates and executors of many other lords; "their ancestors had, in old time and of late time, married with worshipful gentlemen"; and they were "lineally descended of right noble and worshipful blood, and of great lords, once living in this our realm of England." Their ancestors had "had license to have a chaplain and have divine service" in their houses and had also "given livelihood to houses of religion, to be prayed for."[4] A seventeenth-century elaboration of this document implied that the "first ancestor, Wulstan" lent his surname to the village of Paston, rather than taking his name from it.[5]

Which account of the Pastons' history is truer? Families of the gentry both rose and fell (more often, according to McFarlane, falling from the nobility than rising from the peasantry).[6] Given the conditions of record keeping, proof of ancestry

was difficult to establish. Only about a fifth of the English gentry of 1500 could trace their ancestry back to landed families of their counties two hundred years earlier.[7] Yet the import of the question was more than a matter of snobbery, though snobbery played a role. Property ownership and legal status were involved. Twice Paston lands were seized on the pretext that the family were "bondmen" of the king—serfs of the manor of Gimingham, part of the king's duchy of Lancaster—and Clement's grandson John was imprisoned on that claim. Only with the publication of the royal certificate affirming their status as free men and gentlemen did the Pastons establish themselves on unshakable ground as members of the gentry.

Ironically, the ancient distinction between free and servile had by this time lost nearly all its significance within the peasant community, whose leaders and wealthiest members might technically be villeins. The labor services that had most clearly defined servile status had nearly all been commuted to money payments. But in relations between the world of gentry and nobility and that of the peasants, the distinction remained important and could be used for purposes of legal harassment, since it was not always easy to determine. The test of unfreedom usually was a written record of a servile obligation paid or performed by an ancestor. One such servile duty was attendance at a lord's manorial court. Surviving court rolls of Gimingham list neither Pastons nor Somertons among the servile tenants attending. In the thirteenth century the neighboring village of Bacton listed a William Paston as a villein and an Edmund Paston as free; whether either of them was Clement's ancestor cannot be ascertained. Similarly, certain early deeds, which the Pastons cited as proof of their noble descent, list "de Pastons" who may or may not have been ancestors of the later family.[8]

The first document clearly connected with them, dated 1341, is an agreement involving a Clement de Paston and his son

William that tells nothing about their status.[9] The later Clement of the "Remembraunce," who died in 1419, is the first Paston about whom we have clear independent knowledge, in the form of his will. In it he made several modest bequests: to the vicar of the parish church of St. Margaret at Paston "for my tithes and other things owed to him if they are not paid," seven pounds of wax "for the lights before the image of St. Margaret" in that church and a small sum for repairs to the church; small bequests to the vicar of the church of Bacton and to two other churches in nearby villages, and the sum of six shillings eightpence to the prior and convent of Bromholm. The residue went to his sister Margery and his son William, to "pay his debts, amend any extortions and injuries, if he has perpetrated them, and make true restitution. . . . What remains they shall spend on works of charity and piety" for his soul, that of Beatrice his wife, and the souls of his deceased parents, his benefactors, and "all deceased believers." He was to be buried in the parish church in Paston, "between the south door and the tomb of his wife Beatrice."[10]

Clement's brother-in-law, Geoffrey Somerton (d. 1416), is similarly the first member of the Somerton family about whom there is solid information. By the 1370s, Geoffrey had already expanded his sphere of activity beyond the confines of the village to become a leading member of the Norfolk community. His name appears in public records then and in the 1380s as an attorney and as justice of the peace for Yarmouth. Further contradicting the imputation of servile origin, he served four times in Parliament. Having achieved success, and being himself childless, Geoffrey promoted the career of his sister Beatrice's son William, whom he not unnaturally steered toward the law.[11]

A less glamorous profession than the military, the law provided a more secure means of upward mobility. "It is difficult to underestimate the continuous social advancement of lawyers and their ability to break into the upper ranks of society," writes

M. M. Postan.[12] Lawyers filled official posts, acted as judges, served on baronial councils and in the royal Exchequer, and played an indispensable role in the property transactions of the wealthy and noble. The lawyers, and more broadly the gentry to which they usually belonged, were the movers and shakers of social, economic, and political life. In Colin Richmond's words, they were the "men who managed things," who were "councillors of many masters, kings not excluded," whose "loyalties were never predetermined because they owed them everywhere; they were their own men because they were everyone else's."[13] Agnes Paston, one of the principal figures in the Letters, wrote cogently to one of her sons: "I . . . advise you to think once a day of your father's counsel to learn the law, for he said many times that whosoever should dwell at Paston should have need to know how to defend himself."[14]

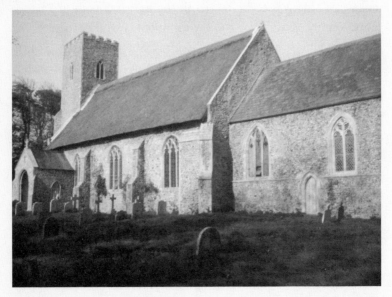

The parish church of St. Margaret's, Paston, where Clement Paston was buried "between the south door and the tomb of his wife Beatrice."

Thus whatever the Pastons had been in earlier times, it seems to have been the marriage of Clement Paston to Beatrice Somerton that launched their rise in the fourteenth and fifteenth centuries. From the upper stratum of the peasantry—beginning to be called "yeomen"—they ascended to the gentry: knights, squires, and country landlords, socially equivalent to the merchants of the towns. The Pastons were by no means the first to make the climb, nor the first to be resented for making it.

William Paston's ability and character undoubtedly contributed to the family's advancement. His rise to the rank of serjeant-at-law, equivalent to the status of knight, permitted him to practice in the Court of Common Pleas, the busiest of London's courts.[15] In time he was appointed a justice in the same court. Shrewd, ambitious, perhaps unscrupulous, respected as a lawyer and formidable as a judge, he forged connections with magnates such as the Mowbrays, dukes of Norfolk, and wealthy Sir John Fastolf. William served as executor and "feoffee" to many important landowners. This last office was a clever invention of fourteenth-century lawyers that permitted a propertied client to grant lands to trusted friends—his feoffees—to hold during his lifetime, while he kept the use of them, and to dispose of according to his instructions after his death. Known as "use," the device protected an estate against inheritance laws, forfeiture for treason, and claims of wardship over the heir.[16] William served at various times as steward to the duke of Norfolk and the bishop of Norwich.[17] To add to what he had inherited from his father, he purchased land in and around Paston as well as in more distant parts of the county. Often the sellers were widows, and more than once the records suggest that they were exploited.

For gentry, nobility, and peasants alike, land was the principal sustenance. It "did not sink like venturing ships nor default like debtors; it could easily be sold or mortgaged or leased if cash were needed, and it could produce at least a steady and often a

satisfactory income," says DuBoulay.[18] The Pastons, like many medieval landowners, farmed out some of their estates to entrepreneurs who paid a flat fee, or "farm," and collected the revenues. Rents were by now paid mostly in cash, though the Pastons took certain products to market themselves, especially wool and malt, the essential ingredient in ale, the universal English drink.

Land was the source not only of income but also of prestige and power. To establish his "lordship" in Paston and his authority over his neighbors, William sought to consolidate his scattered holdings and improve his status by strategic exchanges: he traded two free holdings in Paston and neighboring Edingthorpe with the duchy of Lancaster for two unfree holdings in the same villages simply in order to acquire bond tenants, a requisite of lordship.[19] He also made his first moves to establish the "manor place" that the "Remembraunce" said he lacked. He planned the construction of a large house, with "parlor and chapel," and obtained a license to enclose a road that ran to the south of the house, between it and the parish church, walling it up and building a new road on the north side of the house. This undertaking was fated to cause no little trouble with his neighbors.[20]

William took an even more momentous step in 1420 when, at the age of forty-two, a year after the death of his father, Clement, he married Agnes Berry. Agnes was the young (perhaps eighteen-year-old) daughter of Sir Edmund Berry, a Hertfordshire knight, whose only other child was a younger daughter. Consequently she brought three valuable if scattered manors: Marlingford, in Norfolk, west of Norwich (inherited from her maternal grandmother); Stanstead, in Suffolk; and Horwellbury, her father's home in Hertfordshire, which she inherited after his death in 1433. These constituted a worthwhile accrual to the expanding Paston estates, though their possession was qualified

by the fact that they were Agnes's for life, and as it turned out, she lived to a ripe old age.

Furthermore, the late Middle Ages had added an improvement in a wife's part of the marriage settlement in the form of the "jointure," land provided by the husband's family and held jointly by the husband and wife during their lifetimes, afterward by the survivor. Agnes's jointure was Oxnead, southwest of Paston, a property purchased by William a year before the marriage. Agnes also received a dower, a much older form of marriage contribution from the groom to the bride, designed to support a widow. Agnes's dower was substantial, including Paston itself and other nearby lands that William had acquired. All these properties remained in Agnes's hands from William's death in 1444 to her own in 1479, when they became a fruitful source of conflict among her heirs.

The only surviving letter between Agnes and William concerns the approaching marriage of their eldest son, written or dictated by Agnes in a brisk and businesslike tone, incidentally asking William to buy her some gold embroidery thread and reporting that "your stews [fishponds] do well."[21] References to her husband in Agnes's other letters show that her attitude toward William was respectful and that above all she shared his acquisitive nature and combative temperament. By the time of William's death, Agnes had borne six children. Five lived to adulthood, and three played important roles in the family history.

Chapter 3

JUDGE WILLIAM
AND HIS CHILDREN

1421–1444

he children of William and Agnes who survived to adulthood were born over a span of twenty-one years: John in 1421, the year that his father became a serjeant-at-law; Edmund in 1425; Elizabeth in 1429, the year that William became a justice in the Court of Common Pleas; William II in 1436; and finally Clement in 1442. The fact that Agnes bore a fifth son, Henry, who died in infancy is known only from a reference in one of Margaret's letters to John's having had a "brother Harry."

The first decade of the marriage, before William became a judge, saw him involved in several of the kind of violent legal battles typical among the gentry. In a letter of 1426, he prayed that "the Holy Trinity deliver me of my three adversaries."[1] The first of these was one of the widows whom William may have

exploited, a Norwich woman named Juliane Herberd who had inherited a modest piece of property in Little Plumstead, east of Norwich, a messuage (house and yard), nineteen acres of arable land, and seven acres of heath. At some point around 1400, William had offered her an insufficient price for her land, at the same time, she claimed, taking possession of all her deeds and documents. When she protested, he caused her to be imprisoned, first in Fleet Prison in London, just outside the city walls, and later in the "pit" of Norwich Castle. There, according to her complaint, she was fettered, given only "a pint of milk in ten days and ten nights and a farthing loaf," and "the brain [struck] out of her head." Furthermore, William pocketed the income from the property, "thirty shillings a year and more."[2]

Court records give Juliane's plaint but not William's reply or the court's decision. In 1426, when she was still pursuing him with "slander," he wrote, "I have nought trespassed against [her], God knows, and yet I am foully and noisingly vexed . . . to my great unease."[3] Perhaps the widow exaggerated William's persecution but yet had some justice on her side. In the end, William did not get the land, and Juliane pursued her case against him for another fourteen years without result.[4]

The second of his adversaries was a "cursed bishop," a dubious cleric named John Wortes who claimed the office of prior of Bromholm and even asserted that he himself was a Paston. William, as lawyer for the incumbent prior, brought an action against Wortes, who escaped abroad, inveigled support in Rome, and got a judgment against William, who was fined and excommunicated.[5]

The third adversary was Walter Aslak, a veteran of the Hundred Years War who had influential friends and who claimed the "advowson"—the right to appoint a clergyman—of Sprowston church. Aslak's possession of the manor of Sprowston was not in question, but William Paston, acting for the prior of

Norwich Cathedral Priory, claimed that the priory had held the advowson of the church for thirty years before the Aslaks acquired the manor, and the priory had never surrendered it. Apparently William won his case, but the sequel demonstrated a shortcoming of medieval law: the difficulty of enforcing legal decisions and hence the need for arbitration. Walter Aslak attacked William and "his clerks and his servants" by posting bills on the gates of Norwich and of two of its churches that threatened those who had participated in the suit with "menaces of death and dismembering." Some of the threats—in verse— included the Latin words "et cetera," implying that even more fearful reprisals were contemplated. William demanded "surety of the peace"—a promise by Aslak to refrain from violence—and simultaneously sued him for trespass. Sir Thomas Erpingham, justice of the peace, drew a promise from Aslak to keep the peace and proposed arbitration of the suit for trespass. William accepted the promise but pursued the suit, which he then advanced, according to Aslak, by bribing a jury that he managed to empanel in the dead of night and which repaid him with a handsome award of £120 in damages. In cases of trespass the losing defendant was jailed until he paid a fine to the king and damages to the plaintiff; Aslak thus wound up in prison while William was merely obligated to buy dinner for the jurors.

Aslak, however, was not finished. He secured the support of the duke of Norfolk, got himself released from prison, and submitted a petition to Parliament. William called on the Exchequer to make his enemy pay the still outstanding damages, but the duke of Norfolk now became "heavy lord to the said William," according to William, whose servants had to go about "in dread and fear intolerable to be slain and murdered" by the duke's bullies. Three more unsuccessful attempts to arbitrate the dispute finally led to a settlement imposed by the duke in 1428: William was ordered to pay £50 in return for Aslak's withdrawal of his complaints.[6]

His accession to judgeship brought William power, prestige, and some peace of mind. In the 1430s he became involved in a more substantive but nonviolent legal clash, destined to last through many decades. The manor of East Beckham, some ten miles northwest of Paston, had been purchased in 1379 by the Winters, another parvenu family with a history very similar to that of the Pastons. William Winter was a peasant's son who studied law, grew rich through service to the great, and bought land. When he died in 1409, his will directed that the income from East Beckham be reserved to subsidize prayers for his soul and that of his wife, at Town Barningham church, and for alms in their names. His son John Winter could not inherit the manor until he had fulfilled these conditions.[7] Such endowments, known as "chantries" (masses might be either said or sung), required royal licenses, which cost money, and also a source of permanent revenue. Common in the wills of nobility and affluent gentry, chantries reflected the new concern with purgatory and the urgency of avoiding its pains and often supplied a yardstick for the status of the deceased.[8]

They were not always honored. John Winter died in 1414 without having complied with the provisions of his father's will, and East Beckham was sold to William Mariot, operator of a fishing fleet in nearby Cromer. After Mariot's death by drowning in 1434, William Paston made arrangements with the widow to buy the estate. The sole surviving Winter responded by seizing and occupying it. Suit and countersuit followed, and after the widow's death her son transferred his allegiance to the Winters and occupied East Beckham himself. More litigation followed, and Judge William seemed to be triumphing, but the story was far from ended.[9]

While Judge William's legal career prospered and his land-holdings continued to grow, his eldest son, John, completed his education, probably starting at a grammar school in Norwich

and then, in his middle teens, going on to Trinity Hall, Cambridge, which taught civil and canon law. But for a career in secular law, the Inns of Court in London remained the preeminent training school. In the fourteenth century, lawyers from the provinces had found it convenient to band together, rent a house in the neighborhood of the Royal Courts of Justice at Westminster, hire cooks and servants, and be assured of lodging and dinner. Some of these arrangements turned into "inns"—Lincoln's Inn, Gray's Inn—and in the fifteenth century took on an educational function as aspiring young men flocked to them to learn practical law from their elders.[10] By the time John Paston arrived in London, some four hundred lawyers were teaching two or three hundred students by precept and example, as they argued the cases that came to the four great central courts, King's Bench, the Court of Common Pleas, Chancery, and the Exchequer. These "Westminster lawyers" were the elite of the profession, enjoying both the exclusive privilege of practice in the central royal courts and prestigious positions in many of the provincial courts.[11]

Teaching at the Inns of Court went beyond mere legal knowledge and techniques to include the social skills and code of conduct that students needed for success. As a result, according to Sir John Fortescue, "knights, barons . . . other magnates, and the nobles of the realm place their sons in these inns," not to learn law, but to acquire "all the manners that the nobles learn," and "for the sake of the acquisition of virtue, and the discouragement of vice."[12]

The court term occupied less than half the year, making the law an especially attractive career for young gentlemen seeking wealth and prestige. But for a man like John Paston, the important thing was a mastery of the law that would enable him "to know how to defend himself" as a landowner. As an addition to his education, when he was eighteen, John also served for a time

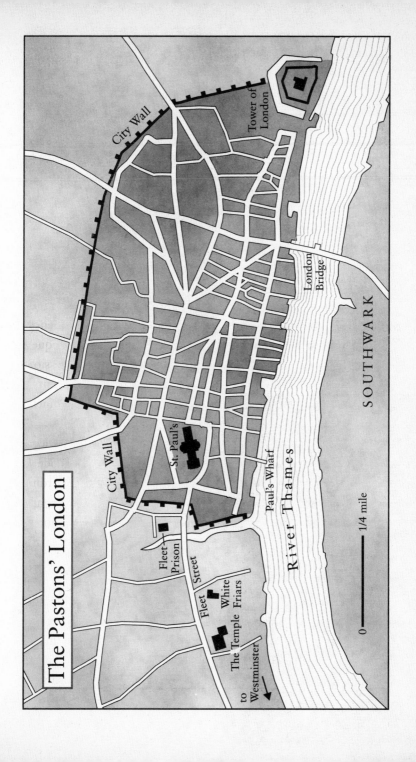

The Pastons' London

City Wall

Tower of London

City Wall

St. Paul's

Fleet Prison

Fleet Street

White Friars

The Temple

to Westminster

Paul's Wharf

London Bridge

River Thames

SOUTHWARK

0 — 1/4 mile

Two of the four great central courts of England in the fifteenth century.

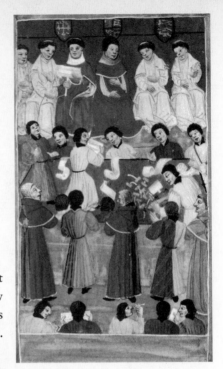

The Court of Chancery, judges at top, clerks immediately below recording the proceedings, lawyers and petitioners at bottom.

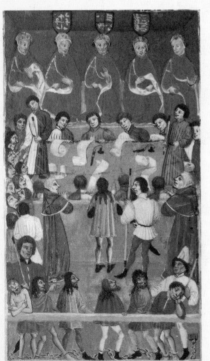

Court of King's Bench, with criminals in chains at bar below. *(The Masters of the Bench of the Inner Temple. Photo: ET Archive. Inner Temple Library MS. 188)*

as yeoman of the royal stable in the household of the young Henry VI.

Judge William had waited until he was forty-two to find a suitable bride; in about 1440, John found one while still a student at Cambridge—or one was found for him. Margaret Mautby, whose age was somewhere between twelve and eighteen, was, like Agnes Berry, an heiress, but she was even more of a prize. The only child of John Mautby, Esquire, with an inheritance conveniently located in relation to the Pastons' lands, she belonged to an old, large, and well-connected Norfolk family. Her father, who had died in 1433, was a cousin of Sir John Fastolf, a great landed proprietor of the region. Her mother, Margery Berney, also came from a family prominent among the Norfolk gentry. After the death of Margaret's father, his widow had married Ralph Garneys, of aristocratic Anglo-Norman descent. Mautbys, Berneys, and Garneys brought the Pastons not only status but a host of connections among the elite of Norfolk.

No record of the marriage negotiations survives. Associations between the Pastons and the Mautbys had gone back several years. Judge William had served as a feoffee of John Mautby's father and probably of John Mautby himself. More significantly for the future, he had for several years acted as legal adviser to Sir John Fastolf, whose brother-in-law, Sir John Radcliff, held Margaret's "wardship"—legal guardianship—with the privilege of arranging her marriage. The compact between Margaret and John Paston was probably worked out between Judge William and Radcliff, with Fastolf as intermediary.[13]

The first meeting between the two principals took place at Reedham, Margaret's mother's family seat. From Paston, Agnes wrote Judge William describing the occasion:

> Blessed be God I send you good tidings of the coming, and the bringing home, of the gentlewoman that you know of

from Reedham this same night. . . . And as for the first
acquaintance between John Paston and the said gentle-
woman, she made him gentle cheer in gentle wise, and said
he was truly your son. And so I hope there shall need no
great treaty [negotiation] between them. The parson of
Stockton told me if you would buy her a gown, her mother
would give thereto a goodly fur. The gown needs to be
bought; and of color it would be a goodly blue, or else a
bright sanguine.[14]

The marriage of John and Margaret brought the Pastons
property with a revenue that Judge William estimated at £150 a
year.* Like Agnes's inheritance, Margaret's was encumbered by
family claims and obligations to Margaret's mother and grand-
mother and to her uncles. Nevertheless, John had made an excel-
lent match and one that proved successful on the personal level.
The two young people liked each other, and further acquaintance
turned liking to love. Though John's infrequent letters to
Margaret were brief and businesslike, hers to him, much more
frequent, were affectionate, solicitous, and warm. In December
1441, during her first pregnancy, she wrote from Oxnead, where
she was staying with Agnes, to John at the Inner Temple in
London, "desiring heartily to hear of your welfare" and thanking
him for a gift he had sent.

The chief purpose of her letter was to remind him of a gown,
"cloth of musterdevillers" (gray wool), that he had been commis-
sioned to buy for her, "for I have no gown to wear this winter
but my black and my green . . . and that is so cumbrous that I am

*Christopher Dyer (*Standards of Living in the Later Middle Ages*,
Cambridge, 1989, p. 19) suggests a minimum of £10 a year "and often
much more" as the income of a fifteenth-century gentleman.

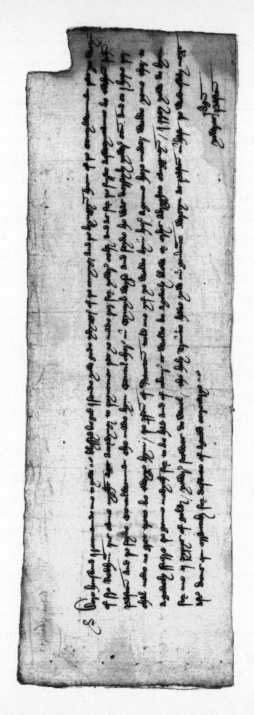

Letter from Agnes Paston to her husband, William, 20 April, probably 1440, describing the first meeting of their son John and his future wife Margaret. (*British Library, MS. Add. 43488, f.4*)

weary to wear it." She reminded him that she had also asked for a "girdle," a belt to fasten the gown, to suit her pregnant state,

for I have waxed so slender [irony] that I may not be girt in any girdle that I have but of one. Elizabeth Peverel [evidently the midwife] has lain sick fifteen or sixteen weeks with the sciatica but she sent my mother [-in-law] word by Kate that she would come here when God sends my time, though she should be wheeled in a barrow.

John Damme [a Paston associate] was here, and my mother discovered me to him [revealed her pregnancy], and he said by his troth that he was not gladder of anything that he heard this twelvemonth than he was thereof.

I may no longer live by my craft [hide my pregnancy]; I am discovered of all men that see. . . . I pray you that you will wear the ring with the image of St. Margaret [patron saint of pregnant women] that I sent you for a remembrance, till you come home; you have left me such a remembrance that makes me think upon you both day and night when I would sleep.[15]

The first child, a son, was born in 1442—the same year as Agnes's youngest, Clement; the following year Margaret was pregnant again, writing, once more from Oxnead, to John in London, full of concern for his health; he had had a "great disease," a "sore."

My mother [Agnes] promised another image of wax of your weight to the shrine of Our Lady at Walsingham, and she sent four nobles [gold coins] to the four Orders of Friars at Norwich to pray for you, and I have promised to go on pilgrimage to Walsingham and to St. Leonard's [Priory, Norwich] for you. By my troth, I never had so heavy a sea-

son from the time that I knew of your sickness until I knew of your amending, and still my heart is in no great ease, nor shall be, till I know that you be very hale.

She begged him to write, and to come home when he could.

I would [rather have you] than have a gown, though it were of scarlet. . . . I hope you should be kept as tenderly here as you are in London. I may not have leisure to write half a quarter as much as I should say to you if I might speak with you. . . . Almighty God have you in his keeping and send you health.

And in a postscript she concluded, "Your son fares well, blessed be God."[16]

The second son was born in 1444. Both boys were named John, an oddity that historians have struggled to explain. Probably at least one of them was named for a godfather. How did the family differentiate between them? Barbara Hanawalt, who found a number of such shared names among late-medieval Londoners, suggested that they were usually called "major" and "minor."[17] In the Letters, the Paston brothers became distinguished, not very long after they began to participate in the family correspondence, by the knighting of the older John. The younger John was also eventually knighted, but not until several years after his brother's death. In the addresses and signatures of the letters, the father is "John Paston, Esquire" or "John Paston the oldest"; the older son "Sir John Paston"; and the younger one "John Paston the youngest," "John Paston the younger," or plain "John Paston." In one letter from Margaret, all three John Pastons are involved, without any special identification: it is addressed to her husband, John Paston, telling him about a letter that she had received "from John Paston" (Sir John), suggesting that "John

Paston" (John the younger) search for some documents.[18] To the addressee, there was no confusion; he knew his older son was in London, the younger at home in Norwich. What they called each other when they were all together, one can only speculate. In this book we refer to the father as "John," or "John I," and the sons as "John II," or "Sir John," and "John III."

The pool from which fifteenth-century Norfolk parents chose first names was in any case not large. The male Pastons over four generations were William, John, Clement, Edmund, and Walter; the females Margaret or Margery, Anne, and Elizabeth.

In 1442, Judge William drew up his will, after John's marriage and before the birth that year of John's first son, but he did not finally date it until 21 January 1444. In preparing it he confronted a dilemma of many medieval fathers. The reigning system of primogeniture was designed to preserve continuity in one main branch of the family and protect the integrity of the estate identified with that branch. Two factors threatened the principle. First was the wife's jointure and dower, sources of her income in widowhood, and those of the daughters-in-law; all these properties reverted to the principal heir only on the women's deaths. Second was the father's natural desire to provide for his other children, with lands for the sons and dowries for the daughters.

Judge William's will had to make provision for his widow, Agnes, and his five children, the oldest of whom, John, had a wife and a growing family. To his widow, William assigned her jointure, Oxnead; her inherited properties of Marlingford, Stanstead, and Horwellbury; and Cromer, Paston, and the other adjacent properties that had been her dower. To principal heir John he left the manor of Gresham, which William had purchased and provided as Margaret's jointure at the time of the marriage. He further stipulated that, upon Agnes's death, John was to get Oxnead.

To John's younger brothers, Edmund, then eighteen, William, seven, and Clement, two, he left several small manors whose income would maintain them until they reached majority and would provide for their education, Edmund's and William's in the law, Clement's at grammar school. Fifteen-year-old Elizabeth was also to be maintained out of Clement's inheritance. She was to have two hundred pounds for her marriage, provided that she married in accordance with the advice of Agnes and William's other executors. Her husband must be "of equal age," "sufficient status," and "sound lineage" and must supply a jointure of land with an income of "not less than forty pounds per year." The remainder of the income from these manors was to go for masses and pious works for William's soul.[19]

These provisions, upon later review, left him unsatisfied—at least according to Agnes, writing twenty-two years later (September 1466), when she made her own will, by which time she had become alienated from the main branch of the family. William's "last sickness took him" in London, where he was staying with Agnes and daughter Elizabeth. Agnes described his deathbed scene, and events preceding and following it, in graphic detail. She claimed that William had "divers times rehearsed" to her that "the livelihood which he had assigned to his two youngest, William and Clement, was so little that they might not live thereon, without that they should hold the plow by the tail"—in other words, till the land. Consequently, on his deathbed he assigned several properties as yet left unmentioned, which would otherwise have accrued to John Paston, the principal heir. These were Sporle, Beckham, and Swainsthorp. Part of the income of Swainsthorp, William decided, should go for a perpetual chantry, to pay "the monk that . . . sings the mass of the Holy Ghost in Our Lady Chapel in Norwich [Cathedral Priory]" where William "purposed to lay his body"—specifically "four pence a day, to sing and pray for his soul and mine," recalled

Agnes, "and all the souls that he and I have had any good of or are beholden to pray for."

In August of 1444, she continued, "my said husband lying sick in his bed, in the presence of John Paston, his son and mine, John Bacton, John Damme, and of me, declared his will touching certain of his children and me." To John he explained, "I will not give so much to one [meaning John] that the remnant have too little to live on."[20] The decision did not sit well with John; now much of the estate he regarded as properly his was placed instead in the hands of others, for an indefinite future. John's concern was not wholly selfish; he had a wife and child, or children, to support.

But William was determined. Feeling death draw close, and lamenting his "sin of sloth" in not sooner revising his will, he told Agnes (still according to her later report), "Whatsoever becomes of me, dame, I want you to know my will." He then reiterated his desire to leave sufficient land to William and Clement and to have his perpetual mass. In a word, according to Agnes, William made a final oral will transferring certain property from John to his younger brothers and to the Church.[21]

William died on Thursday, 14 August 1444, "betwixt eleven and twelve of the clock." The following day, Agnes sent for John and the executors, who were in Norwich.

And on the Wednesday after came John Paston, etc. And on the Friday, John Paston, John Damme, and I went into the chamber, and they desired of me to see the will. I let them see it. And John Damme read it, and when he had read it [aloud], John Paston walked up and down in the chamber. John Damme and I knelt at the foot of the bed.[22]

After the reading of the written will, Agnes "opined and declared to John Paston and all the other executors of my husband" what William had told her on his deathbed about the

bequests to William and Clement and the perpetual chantry, "desiring them to have performed it. And the said John Paston would in no wise agree thereto, saying that by the law the said manors should be his, inasmuch as my husband made no will of them in writing, and [John] got the deeds out of my possession . . . without my knowledge."

Furthermore, Agnes said, John tried to induce her to alter the written will, to add the manors of Sporle and Swainsthorp to his own bequest. John Damme, sympathetic to him, apparently was delegated to suggest this action to Agnes, but she told the other executor, William Bacton, that she "could not find it in my heart to set in the will what I knew well was the contrary. And he said he would not counsel me thereto."[23]

A shadow of doubt is cast on the details of Agnes's story by testimony from her daughter Elizabeth in a letter of 1485 addressed to John Paston III. During her father's last sickness "and until he was deceased," he was in London. John I was in Norfolk and did not come to London until William was dead. In other words, the deathbed quarrel between father and son so circumstantially reported by Agnes must have taken place, if at all, at some earlier time. This letter, however, exists only in a draft in John III's handwriting, made at a time when he was involved in litigation with his uncle William II, when it was in his interest to discredit Agnes's account.[24]

The principal facts remain clear enough, however: Judge William breathed his last on 14 August 1444, the executors were sent for, and conflict arose over Agnes's report of the changes the judge had made orally to John's disadvantage.

Besides the landed property, there was another prize sufficient to provoke contest, a "treasure" of money and plate deposited in the Cathedral Priory of Norwich by Judge William to guarantee his perpetual chantry. According to Agnes, John now went to the abbey and laid hold of the treasure,

unknown to the prior or any other person of the said abbey, and without my knowledge and assent, or that of any of the executors, bore it away, keeping it still against my will and all the other executors' wills, neither restoring the said William and Clement to the foresaid land nor recompensing them from my husband's treasure and ordaining for my husband's soul in having his perpetual mass according to his will.[25]

Agnes's account condensed and foreshortened what actually happened to the treasure. As the story was told in 1487 by the prior, the treasure remained in the priory's keeping for some time, while Agnes and John argued about the financing of the chantry. When Agnes stood firm in her demand that it be paid from the income of Swainsthorp, John peremptorily settled the argument by removing the treasure. "And," the prior complained, "after that deed done, there was no more money given us, either to keep the said obit [the yearly commemoration of the death], nor to pray for the soul of the said William," except that Agnes paid something every year out of her own pocket, "to remember the soul." After her death, "this many years nothing has been given us, notwithstanding [the fact that] of our own devotion we have rehearsed his name in our prayer roll every Sunday."[26]

John kept Sporle, Swainsthorp, Beckham, and the treasure, and Agnes nourished anger and resentment to the end of her life.

Thus with the best of intentions, seeking only to provide for all his children, his own soul, and that of his wife, Judge William created a rift in the family that lasted for decades and endangered the Paston fortunes.

Chapter 4

LAND DISPUTES AND THE SIEGE OF GRESHAM

1444–1450

oss of Judge William's prestige and personality inevitably slowed the Pastons' upward climb. Projects that he had initiated foundered or slackened, yet they were by no means abandoned.

One enterprise carried on by the surviving family was William's plan to enlarge the house at Paston and convert it into a true manor house, appropriate to the claim of lordship. The judge had made detailed plans. In February 1445, six months after his death, Agnes wrote her son Edmund at Clifford's Inn, another of the London Inns of Court:

> Find out from your brother John how many joists will serve the parlor and chapel at Paston, and what length they must be, and what breadth and thickness . . . for your father's wish was . . .

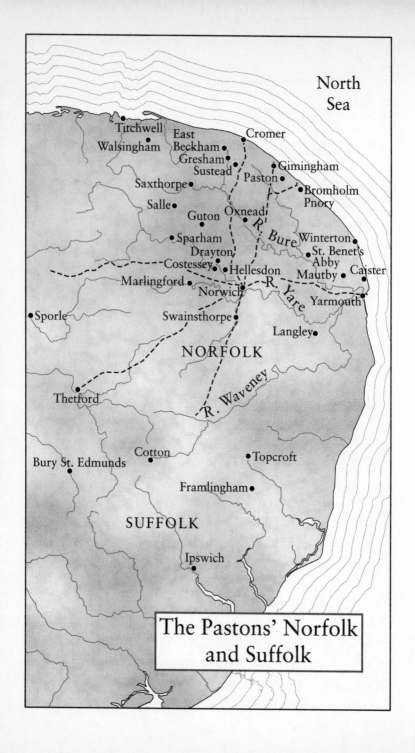

The Pastons' Norfolk and Suffolk

that they should be nine inches one way and seven another way. And purvey therefore that they may be squared there and sent here, for none such can be had in this country.[1]

Judge William had already been granted the license to close off the road to the south of the house and build a new one on the north. The new house stood just north of the parish church. The previous Lent, William had reached an agreement with the vicar, William Pope, to establish the boundaries between the two properties and had planted "dools" [boundary stakes] to mark them. But after William's death, Agnes wrote, the vicar "pulled up the dools, and says he will make a ditch from the corner of his [existing wall] right over the way to the new ditch of the great close."[2]

At dispute was a half acre of land, but there was another problem. The closing off of the old road aroused strong feelings in the Paston villagers. In erecting a wall to block it, the Pastons also blocked the path of the processional around the church, a feature of the service; "the procession was stopped in," one Paston dweller complained to Agnes.[3] The vicar negotiated a new boundary settlement with the Pastons in 1447, but the villagers continued to object, and not only in words.[4] Four years later Agnes reported conflict over the new wall she was having built:

On Thursday the wall was made a yard high, and a good while before evening, it rained so hard that they were fain to cover the wall and leave work. And this water is fallen so sore that it stands under the wall a foot deep toward Ball's [a neighbor's] land. And on Friday after communion, some person came churchward and shoved down all that was thereon, and trod on the wall and broke some [of it] and went over; but I cannot yet know who it was. And Warin King's wife, as she went over the stile, cursed Ball [who had agreed to the arrangement] and said that he had given away the road. . . .

And after, [Warin] King's folk and others came and cried to Agnes Ball, saying to her the same. Yestereven when I would go to my bed, the vicar said that Warin King and Warin Herman, between mass and matins, took Sir Robert [the curate; "Sir" was a courtesy title for priests] into the vestry and bade him say to me, verily the wall should [be] down again. And [at the time] when the vicar told me, I knew no word thereof, nor yet do by Sir Robert, for he says he was loath to make any strife.[5]

A tense little drama was enacted one Sunday in the parish church when the villagers challenged the lady of the manor. Agnes described the episode to John in her usual vigorous style:

On the Sunday before St. Edmund, after evensong, Agnes Ball came to me to my closet [pew] and bade me good even, and Clement Spicer with her. And I asked him what he wanted. And he asked me why I had stopped up the king's way [public thoroughfare], and I said to him I stopped no way but my own.

The argument attracted attention.

Warin Herman leaned over the partition and listened to what we said, and said that the change was a ruly [regrettable] change, for the town was undone thereby and is the worse by £100. And I told him it was no courtesy to mix himself in a matter unless he were called to counsel [asked to give advice]; and . . . he said the stopping of the road should cost me 20 nobles and that it should be pulled down again. And I let him know that whoever pulls it down shall pay for it. Also he said that it was well done that I set men to work to owl [work at night] while I was here, but in the end I shall suffer my cost.

Warin Herman then accused Agnes of carrying away his hay at Walsham, and she replied that "it was my own ground, and that I would hold it for my own, and he bade me take four acres and go no further. And then shortly he departed from me in the churchyard."[6]

The churchyard, where the lady of the manor could not avoid the villagers, was the scene of other confrontations. Agnes reported to John that on one occasion the same Warin Herman

> after evensong said openly in the churchyard that he knew well that if the wall were put down, though he were a hundred miles from Paston . . . I would say he did it, and he should bear the blame, saying, "Tell it here how so will, though it would cost me 20 nobles, it shall be put down again." And the said Warin's wife with a loud voice said, "All the devils of hell draw her soul to hell for the road that she has made."[7]

There was some justice in the villagers' complaints, as Agnes herself half admitted. She quoted "a certain man" as accusing her of enclosing more than the perch of breadth that her patent had stipulated, and "a thrifty [respectable] woman" as declaring that "at one time the men of [the village of] Paston would not have suffered that."[8] When the charge was brought against her in the Gimingham court by Warin Herman, Agnes made no denial. She was fined sixpence, the standard amount for a trespass. But guilty or not guilty, Agnes stubbornly refused to pay and apparently got away with it; ten years later Warin Herman was still vainly urging the Gimingham court to collect the fine by distraint—the seizure of property to enforce the collection of private debts.[9]

While their trouble with the Paston villagers simmered, the family found itself embattled simultaneously on three other fronts, at

Oxnead, East Beckham, and Gresham, three valuable properties that came under assault from different quarters.

Oxnead was Agnes's jointure. Situated on the river Bure, it boasted a moated manor house. There William had also diverted a road, but without complaint. Trouble at Oxnead followed a pattern that became familiar in the Pastons' contests over land: a family that once held an estate, especially for a lengthy period, felt a bond of ownership with it even after legal sale and the passage of time and, if chance provided the opportunity, reoccupied it. Typically, in the fifteenth century, some color of legality could be sustained by an incomplete or obscure record of ownership.

Such quasi-legal seizures were encouraged by the political situation of the late 1440s, when the duke of Suffolk, William de la Pole, rose to royal favor and power. Wealthy wine and wool merchants of Hull, the de la Poles had climbed to the successive ranks of earl, marquis, and duke to become the dominant magnates of their region. The present duke, whose position in the national government was approximately that of prime minister, tyrannized East Anglia (Norfolk, Suffolk, and parts of neighboring counties) through a trio of lieutenants, John Heydon, Thomas Tuddenham, and John Ulveston, lawyers, local officeholders, and bullies who threatened, robbed, and extorted from their fellow countrymen.

Heydon, a Norwich justice of the peace, was a particularly uncomfortable neighbor whom the Pastons blamed for many of their land troubles. His domestic life was the subject of gossip. Margaret wrote her husband in 1444, "Heydon's wife had a child on St. Peter's Day. I heard say that her husband will have nothing to do with her nor with her child that she had last neither. I heard say that he said that if she came in his presence to make her excuse, he would cut off her nose to make her be known for what she is; and if her child come in his presence he

said he would kill it. He will not be entreated to have her again in any wise, as I heard say."[10]

The trouble at Oxnead arose from a claim by a Carmelite friar named John Hauteyn, whose family had once held the manor, which, according to him, had been entailed and therefore could not be sold out of the family. Nevertheless, in 1361 such a sale had taken place, with no legal objections raised, and William Paston had purchased the place from the buyer's heir in 1420 for the large sum of 749 marks (about five hundred pounds), bestowing it the following year on Agnes as her jointure.[11]

Friar Hauteyn, petitioning the Lord Chamberlain, claimed that he could not get a fair hearing in court because of the influence exercised by William Paston as a judge and by William's son John, "also a man of court."[12] The friar had his own powerful source of influence, noted by Margaret Paston, who wrote John that he had "said plainly . . . that he shall have Oxnead, and that he has my lord of Suffolk's good lordship"—the duke's support. Agnes, in her turn, had been warned "that she should be wary."[13] In March 1448, James Gresham, formerly Judge William's clerk and now a Paston agent, wrote John that Agnes had heard from "a true and trusty man, whose name she shall tell you by mouth at your next meeting, that there was proposed a great gathering of shipmen"—unemployed sailors who were readily hired as thugs and ruffians—"about Covehithe to come to Oxnead and put me out." Oxnead was to have been pillaged and Friar Hauteyn established there, "but this purpose did not hold, for they were countermanded, by what means I cannot know yet. And it is given here to know that they intend to be at Oxnead about mid-Lent, and I am promised that I have two days' warning by a good friend." John was to keep his eyes open for Hauteyn's arrival in the area and to "send my mistress word as hastily as you may."[14]

Hauteyn came, with three companions. Duly warned, Ed-

mund Paston and the parson of Oxnead rode out to intercept them en route. What followed was related in an unsigned, undated, and unaddressed document in the hand of James Gloys, the Pastons' chaplain. "And Edmund Paston said to John Cates [one of Hauteyn's men], 'Welcome,' and he asked him what their cause was in coming. The friar said he came to speak with the good lady [Agnes], and Edmund said that he should speak with her, [but] at this time she was so occupied that he might not . . . and he said that [nevertheless] he should try."

Hauteyn's party proceeded to Oxnead, with Edmund, the parson, and Gloys trailing them. At the manor gate the friar "alighted and knocked . . . and we followed to hear as we might." When a servant appeared, Hauteyn said that he wanted to speak with Agnes; he was refused. "And then came Edmund Paston and the parson, and asked him what was the cause of his coming at this time. And he said to enter into the manor of Oxnead," once more stating his claim. "And then Edmund Paston answered him and said that it would be best to declare his evidence in Westminster Hall [in the royal courts]. And he said again, so he should when he might."

Then, turning to his companions, Hauteyn said, "Sirs, I charge you bear record how I am kept out with strong hand and may not take possession." Pushing forward to put his hand on the gate, he was barred from it by Edmund, who said, "If it were not for reverence of thy lord and mine [the king], if thou lay any hand on the gate I shall see thy heart's blood or thou mine." Then Hauteyn made the symbolic gesture of picking up a clod of earth and handing it to his men, saying, "I charge you all on the king's behalf that you bear record that I here take possession of my inheritance." Edmund replied that "this taking of possession meant nothing. And then the friar said that since he might not have it now, he should come again another time. . . . It was told us this afternoon," Gloys concluded, "that there were three men

come from Skeyton and met with the friar in the field, and spoke with him a good while, and then rode back the same way that they came."[15]

The case went to court in 1449. "As for the friar," Agnes wrote at that time, "he has been at St. Benet's [abbey], and at Norwich, and made great boast of the suit that he has against me."[16] But in 1450 the fall from power of the duke of Suffolk left Friar Hauteyn bereft of his chief support.

The trouble at Oxnead was the first of the three simultaneous battles the Pastons had to fight over title to their lands. With Judge William departed from the scene, John Mariot, son of the fishing fleet owner, brought suit claiming East Beckham. Mariot was backed by Edmund Winter, surviving head of the family that had previously held the manor. With the collusion of a man named Simon Gunnor who had leased the property from Judge William, Mariot took possession. There the matter remained for two decades.[17]

Just south of East Beckham lay Gresham, Margaret Paston's jointure. In February of 1448, men hired by Robert Hungerford, an adventurer from Wiltshire now styled Lord Moleyns, suddenly appeared at Gresham and began collecting rents from the tenants. Moleyns's claim to the manor was based on a far more complicated chain of events than Friar Hauteyn's or Edmund Winter's. It involved four generations of the Moleyns family, a forfeiture due to failure to meet the terms of a will, and the manor's assignment as jointure for a marriage with the daughter of the mayor of London that did not take place. In 1426 the manor was sold to William Paston by a Moleyns executor, Thomas Chaucer, son of the poet. As guardian of the last Moleyns heiress, Thomas Chaucer also arranged her marriage to Robert Hungerford, who thus acquired the artificially created title of Lord Moleyns; joining the duke of Suffolk's affinity,

Moleyns became an ally of the notorious John Heydon. The Moleyns family apparently had no legal right to Gresham but merely the feeling, almost a superstition, that property once held by their forebears still somehow belonged to them.[18] Robert Hungerford could not even share the sentiment, since he was not really a Moleyns. One of his men accused the Pastons of manufacturing their own evidence of ownership—"the seals of them were not yet cold"—to which Margaret retorted stoutly that her husband's evidence of ownership was better than anyone else's and "the seals of them were two hundred years older than he is."[19]

A confrontation in Norwich in May 1448 between James Gloys, the Pastons' chaplain, and John Wyndham, a Paston enemy and confederate of Heydon and Lord Moleyns, was dramatically reported by Margaret. Gloys, "having been in the town," was returning to Agnes Paston's Norwich house when he encountered Wyndham standing in his gate nearby, "and John Norwood his man stood by him, and Thomas Hawes his other man stood in the street by the canal side." It was necessary for Gloys to pass between Wyndham and Norwood, and in doing so he failed to remove his hat. Wyndham challenged him, and Gloys, something of a hothead, replied defiantly. "And when Gloys had passed by three or four strides," Margaret continued,

Wyndham drew out his dagger and said, "Shalt thou so, knave?" And therewith Gloys turned and drew out his dagger and defended himself, fleeing into my mother's [Agnes's] place, and Wyndham and his man Hawes followed into my mother's place and cast a stone as big as a farthing loaf into the hall after Gloys, and then ran out of the place again.

And Gloys followed out and stood outside the gate, and then Wyndham called Gloys thief and said he should die, and Gloys said he lied and called him churl, and bade him come

himself or else the best man he had, and Gloys would answer him one for one. And then Hawes ran into Wyndham's place and fetched a spear and a sword and took his master his sword. And with the noise of this assault and affray my mother and I came out of the church from communion, and I bade Gloys go into my mother's place again, and so he did. And then Wyndham called my mother and me strong whores, and said the Pastons and all their kin were [here two or three words have been cut out of the letter, apparently "churls [villeins] of Gimingham"] and we said he lied, knave and churl as he was. And he had much large language, as you shall know hereafter by mouth.

That afternoon Agnes and Margaret appealed to the prior of Norwich Cathedral, who sent for Wyndham; meanwhile, another street encounter brought actual bloodshed. Gloys was attacked by Hawes, and "Thomas, my mother's man," was wounded in the hand. Margaret concluded:

And for the perils of what might happen by these premises . . . and by the advice of my mother and others, I send you Gloys to attend upon you for a season for ease of my own heart, for in good faith I would not for £40 have such another trouble.[20]

Attempts were made to arbitrate the Gresham dispute directly with Lord Moleyns, whom John traveled to Salisbury to interview but who evidently avoided him.[21] John then sought the intervention of William Waynflete, the bishop of Winchester, one of the leading prelates of England and a man close to King Henry VI. Arbitration by the Church was an established custom in land disputes. The bishop wrote Moleyns, who responded disingenu-

ously that he would agree to mediation "unless it should hurt me too greatly."[22] Again no agreement was reached. In October 1448, John decided "to inhabit himself in a mansion within the said town [Gresham]," a square, fortified, and moated manor house with towers at the corners.[23] Gresham being Margaret's jointure, it was she who moved into the building, just as Agnes had occupied Oxnead against Friar Hauteyn's arrival.

Margaret was soon writing John to send crossbows and quarrels [arrows], "for your house here is so low that there may no man shoot out with a long bow.... And also I would that you should get two or three short poleaxes . . . and as many jacks [a form of body armor] as you may." Lord Moleyns's man John Partridge and his "fellowship" were holed up in a nearby building, "and they have made great ordnance there—bars to bar the doors crosswise, and they have made loopholes on every quarter of the house to shoot out at, both with bows and with hand guns."

From this military exposition, Margaret calmly turned to domestic matters:

> I pray you that you will vouchsafe to order for me one pound of almonds and one pound of sugar, and that you will order some frieze [a coarse woolen cloth] to make your children's gowns. You shall have best price and best choice of Hayes's wife, as it is told me. And that you would buy a yard of broadcloth of black for a hood for me, of 44d. or 4s. a yard, for there is neither good cloth nor good frieze in this town. As for the children's gowns, if I have the cloth I shall have them made [the two boys were evidently in school in Norwich].[24]

The opposing parties continued in uneasy propinquity throughout the fall without an open confrontation. At the end of

November, John Damme wrote John Paston in London report-
ing a conversation with Moleyns's man Partridge. "And I bade him
remember that he might not abide there if you would have
him out. And he said he knew that well. But he said, if you put him
out, you should be put out soon after again." Damme replied
that in that case Moleyns's men would be ousted in their turn.
John Mariot, the Pastons' adversary at East Beckham, "stood by
and said that that would be no marvel while they were only two
men," implying that their ranks would soon be strengthened, to
which Damme replied that John Paston would prevail, "though
they made all the strength which they could make . . . and more
language there was, too long to write at this leisure."

Partridge put on a swaggering exhibition, holding dinners
and "great feasts" at which he proclaimed his master's inten-
tions: "He is lord there and will be, and shall be." Damme cau-
tioned John Paston to beware of John Heydon, protected by
"color of justice of the peace, being of my lord's [Moleyns's]
council and not your good friend or well-willer." After one of
Partridge's dinners, Simon Gunnor, the tenant who had delivered
East Beckham into the hands of the Pastons' enemies, cornered
Margaret after evensong (another scene in a churchyard) to warn
her that she should make her men abandon "their battle-axes
and their jacks." Margaret answered that her men would attack
no one, but when she herself was openly threatened she would
not suffer harm meekly. In a postscript, Damme recommended
that John Paston order a "fetys [well-made] jack" for himself.[25]

In a letter in December, James Gloys described to John, with
some amusement, a visit that Margaret's uncle, Philip Berney,
had paid her at Gresham. A few days before, Partridge had deliv-
ered a fresh threat, and "my mistress made us don our jacks and
sallets [helmets]." At the sight of the armor Berney "waxed
pale," and after dinner "he had much haste to be thence, so my
mistress desired and prayed him that he would come again before

long." Berney's answer was less than enthusiastic, but he promised to come "if he might." Harry Collis, the servant who had accompanied him, complained to Margaret's men that the quarrel was no concern of Berney's. "What should my master do here? Let your master send after his kinsmen at Mautby [that is, Margaret's relations on her father's side] for they have nothing to lose."

The following week, Berney sent another servant, Davy, to Margaret, asking to be excused from the visit, with an elaborate pretext: he had hurt his horse and ordered Davy to saddle another, and while Berney "stood by and made water," Davy saddled the horse, which made a sudden move "and took his master such a stroke on the hip . . . that he broke his hip." Margaret accepted the excuse and declared herself "right sorry." Gloys, however, discredited the tale: "I know well that it was not so." The day following the alleged accident, Gloys had ridden to Norwich, where the parson of Oxnead had informed him and Agnes that Davy had told him that Berney was "hale and merry." Gloys cautioned John not to tell Margaret the truth about her uncle's behavior, however, "for if my mistress knew that I sent you such a letter I would never be able to look at her, nor to abide in her sight."[26]

Very suddenly, in January 1449, the armed standoff exploded in violence, as Moleyns's besiegers launched an assault on the Paston stronghold, overpowering the defenders, wreaking havoc on the house, and carrying Margaret herself out bodily (without, however, doing her injury). John Paston subsequently described the assault in a petition to Parliament:

A riotous people to the number of a thousand persons [surely an exaggeration, but indicative of a large number] . . . arrayed in manner of war, with cuirasses, brigandines, jacks [all

forms of body armor], sallets, glaives [swords], bows, arrows, shields, guns, pans with fire . . . burning therein, long crooks to pull down the walls, and long trees with which they broke up gates and doors, and so came into the said mansion, the wife of your beseecher at that time being therein, and twelve persons with her; the which persons they drove out of the said mansion, and mined down the wall of the chamber wherein the wife of your said beseecher was, and bore her out at the gates, and cut asunder the posts of the houses and let them fall, and broke up all the chambers and coffers within the said mansion, and rifled [them], and in the manner of robbery bore away all the stuff, array, and money that your said beseecher and his servants had there, to the value of £200, and part thereof sold, and part thereof given away, and the remainder they divided among them, to the great and outrageous hurt of your said beseecher, saying openly that if they might have found there your said beseecher and one John Damme, who is of counsel with him, and divers other of the servants of your said beseecher, they should have died.[27]

In another petition, to the archbishop of York, John Paston blamed the attack squarely on "the excitation and procuring of John Heydon."[28]

As was often the case, the peasants suffered in the conflict between their betters.

The said misdoers and riotous people unknown, contrary to your laws, daily keep the said manor with force, and lie in wait [for] the friends, tenants, and servants of your said beseecher, and grievously vex and trouble them . . . and seek them in their houses, ransacking and searching their sheaves and straw in their barns and other places with spears,

swords, and battle-axes, as it seems, to slay them if they might have found them; and some have been beaten and left for dead, so that they, for fear of their lives, dare not go home to their houses, nor occupy their husbandry.[29]

Lord Moleyns's Wiltshire retainers, headed by Walter Barrow, Esquire, now took over Gresham. Margaret Paston had taken refuge in John Damme's estate of Sustead, a mile from Gresham, while Damme was in London with her husband. In February 1449 she reported that Moleyns's men were putting pressure on neutral tenants to make complaints in the court against those who were friendly to the Pastons ("feigned plaints," in the words of John's petition). They refused to let Harry Goneld, the Pastons' farmer (the man who leased the manor), see copies of these complaints and threatened reluctant tenants with being "beaten and losing their houses and land and all their goods." Meanwhile, Moleyns's men "gather money fast of all the tenants" and

lie in wait sundry days and nights about Goneld's, Purry's, and Beck's places, and some of them went into Beck's and Purry's houses, both in the halls and the barns, and asked where [the tenants] were, and they were answered that they were out; and they said again that they should meet with [the tenants] another time. And by divers other things I know, if [the tenants had] been caught, either they should have been slain or sore hurt.

Margaret sent a servant named Katherine to Walter Barrow to protest,

for I could get no man to do it, and sent with her James Haiman and Harry Holt; and she desired of Barrow to have

an answer of her messages, and if these foresaid men might live in peace . . . and he made her great cheer, and them that were with her, and said that he desired to speak with me, if it should not be displeasing to me; and Katherine said to him that she supposed that I did not desire to speak with him. And he said he should come by this place [while] hunting after noon, and no one should come with him but Hegon and one of his own men; and then he would bring such an answer as should please me.

Barrow appeared at the appointed time,

and sent in to me to know if they might speak with me . . . and they abided still without the gates; and I came out to them, and prayed them that they would hold me excused that I brought them not into the place. I said inasmuch as they were not well-willing to the good man of the place [John Damme], I would not take it upon me to bring them in to the gentlewoman [his wife].

Negotiations began. Barrow announced that

they had communed with all their fellowship on such matters as I had sent to them for, and . . . they dared undertake that there should no man be hurt of those that were mentioned, nor no man that belongs to you, neither by them or any of their fellowship, and that they answered me by their troths. Nevertheless I trust not to their promise, inasmuch as I find them untrue in other things.

She believed them, however, when they said that they were sorry they had come to Gresham and wished they had not been commanded to do so. Barrow had himself been dispossessed

through the agency of the duke of Suffolk, and Margaret reminded him of the fact. Therefore, Barrow "should have compassion on you and others that were disseised of their livelihood." Barrow agreed, saying that he had sued to the duke of Suffolk "divers times and would do until he might get his goods again." Margaret remarked that the Pastons' case was similar; John had sued to Lord Moleyns for the manor of Gresham numerous times "and could never get any reasonable answer of him," and therefore John "entered against him [took possession]."

The discussion had grown almost cordial. Barrow explained that he did not blame the duke of Suffolk for his dispossession; the duke had been misled by "a false shrew," and Margaret said that the same was true of the Pastons' trouble with Lord Moleyns. Neither party mentioned John Heydon by name, but he was evidently the "shrew" they had in mind. "Much other language we had, which would take long leisure in writing," Margaret concluded.

The conference with Barrow ended with a brief dispute over the value of the goods that had been stolen or given away at Gresham. John had set it at £200; Margaret now estimated it at £100, while Barrow and his companion declared it was "scarce worth £20." Despite this disagreement, Barrow maintained his conciliatory tone, promising that if he should go to London he would drink with John. Margaret transmitted the message to her husband, but added:

I pray you heartily, beware how you walk there, and have a good fellowship with you when you walk out. The Lord Moleyns has a company of brothell [ruffians] with him that care not what they do. . . . They that are at Gresham say that they have not done as much hurt to you as they were commanded to do.

She entreated him to send her assurance of his well-being, "for by my troth I cannot be well at ease in my heart, nor shall be until I hear tidings how you do."[30]

Margaret remained at John Damme's house until February 1449, when she heard a rumor that the enemy was planning to kidnap her. Telling "the goodwife," Mistress Damme, that she was going to Norwich for two or three weeks to do some shopping, she fled to her mother-in-law's house. On 28 February she let John know of her move, "beseeching [you] not to be displeased" by her retreat and adding what sounded like a veiled reproach. Her would-be kidnappers, according to report, "said it should be but a little heart-burning to you"—implying misgivings on her part about John's rescuing her.[31]

A month later, Lord Moleyns wrote confidently to the tenants at Gresham, reassuring them that the rents they paid to Partridge would discharge their obligations and he would protect them "against those that would grieve you, to the best of my power. And as heartily as I can, I thank you for the good will you have had, and have, toward me." His title to the land would very soon be determined in his favor by the law, "and you shall all be glad that have owed me your good will."[32]

The Pastons' prospects at Gresham, in fact, did not improve. John's petition to Parliament in 1450 produced no favorable action. Margaret even suggested that perhaps John should court the duke of Suffolk's favor:

> Sundry folk have said to me that they think truly [unless] you have my lord of Suffolk's good lordship while the world is as it is you can never live in peace. . . . Therefore I pray you with all my heart that you will do your part to have his good lordship and his love in ease of all the matters that you have to do, and in easing of my heart also.[33]

The duke of Suffolk, however, was about to disappear from the scene, as large historic events intruded to overwhelm the quarrels of the gentry. A ten-year truce in the Hundred Years War had ended in 1445, with the war resuming in earnest in 1448. A French offensive forced the English out of Maine and Normandy, and public feeling demanded a scapegoat. The duke of Suffolk was impeached, charged with corruption, bribery, and treason by Parliament, which had by now come to play a significant role in the government of the realm, though its exact power remained indeterminate. In March 1450, Margaret Paston heard a credible report that "the duke of Suffolk is pardoned . . . and is right well at ease and merry."[34]

The report proved false. The following month an English expeditionary force was prepared, at substantial cost, with the mission of recovering the lost territories. Instead it met disaster at the battle of Formigny (15 April 1450), where the French employed gunpowder artillery with devastating effect against the English archers. In London the outcry against Suffolk redoubled.

More than national pride was involved. Suffolk was guilty in the eyes of the Commons—the non-noble taxpayers—of persuading the king to give away much of his private estates to Suffolk and his friends, thus shifting more of the burden of supporting the government to the gentry: "Your Commons of this your realm have to be so importably charged that it is nigh to their final destruction."[35]

Suffolk's tyranny in his East Anglia fiefdom also told against him, and King Henry reluctantly gave in to the pressure of public opinion. He absolved his favorite of the capital crime of treason, allowing him to be convicted of the lesser crimes of corruption and bribery and banished from the realm. On 5 May, John Paston's agent and friend William Lomnor reported shocking news, in a letter that is the primary source of details about the

historic event: "As on [4 May] Monday next after May Day
there came tidings to London that on the Thursday before, the
duke of Suffolk came unto the coasts of Kent full near Dover
with his two ships and a little pinnace." While the duke waited in
his own ship, the pinnace was dispatched to Calais to sound out
how the duke would be received there. But shortly after it sailed,
the pinnace encountered a small fleet led by a ship called *Nicholas
of the Tower,* and the crew informed the master of the *Nicholas*
of the duke's presence. The master sent a boat to the duke's ship,
and "the duke himself spoke to the crew and said he was by the
king's commandment sent to Calais.

> And they said he must speak with their master. And so he,
> with two or three of his men, went forth with them in their
> boat to the *Nicholas;* and when he came, the master bade
> him, "Welcome, Traitor," . . . and desired to know if the
> shipmen would hold with the duke, and they sent word they
> would not in any wise, and so he was on the *Nicholas* until
> the Saturday next following [2 May].
>
> Some say he wrote many things to be delivered to the
> king, but that is not verily known. He had his confessor with
> him, etc.
>
> And some say he was arraigned on the ship about the
> impeachments and found guilty, etc.

When the duke asked the name of the ship and learned that it
was *Nicholas of the Tower,* he was dismayed, remembering that
one of his supporters had said that if he escaped the dangers of
the Tower (of London), he should be safe—yet here was another
Tower.

> And then his heart failed him . . . and in the sight of all his
> men he was drawn out of the great ship into the boat; and

there was an ax, and a block, and one of the lowest [men] of the ship bade him lay down his head, and [said] he should be fairly treated and die on a sword; and took a rusty sword, and smote off his head with half a dozen strokes, and took away his gown of russet, and his doublet of mailed velvet, and laid his body on the sands of Dover; and some say his head was set on a pole by it, and his men [were] set on land with great circumstance and prayer. And the sheriff of Kent doth watch the body, and sent his undersheriff to the judges to know what to do, and also to the king what shall be done.[36]

Though John Paston doubtless shared the general revulsion at the murder, he must have realized the favorable effect the

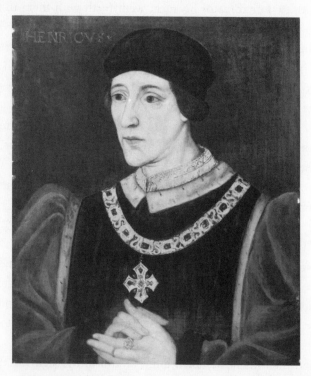

King Henry VI. *(National Portrait Gallery, London)*

duke's fall from power would have on the Pastons' land wars. In the end, the battle over Gresham was settled in the Pastons' favor by the impersonal forces of death and attrition.

During the final two years of this turbulent decade, the Paston family lost one member to death, gained two by birth, and failed in its efforts to marry off a third.

In 1449, John's younger brother Edmund died, at the age of twenty-four, from causes unrecorded; only his will remains, dated 21 March and dictated on his deathbed, providing for his burial in London in either the Temple or White Friars, the Carmelite church, and bequeathing "all his goods and chattels" to his brother John Paston "in great confidence . . . that he will dispose of them for the good of [Edmund's] soul."[37] Shortly after, Margaret wrote John, "My mother [-in-law] prays you that you will send my brother William at Cambridge a *nominale* and a book of sophistry of my brother Edmund's, which my said brother promised . . . that he should have sent to my brother William."[38]

At some time between 1448 and 1450, in the midst of her troubles at Gresham, Margaret had managed to bear two more children, a daughter, Margery, probably in 1448, and a son, probably in 1450. The only hint of her pregnancy occurs in a letter written at Norwich to her husband, apparently after her flight from Damme's house in Sustead: "I pray you if you have another son that you will let it be named Harry, in remembrance of your brother Harry"—a reference to a child of Agnes's who did not survive, of whom this mention is the only evidence. "Also I pray you that you will send me dates and cinnamon as hastily as you may," she added, perhaps an expectant mother's self-indulgence. The letter's closure gives another hint: "By your groaning wife, M.P." The son she bore was named after an uncle, but not Harry; rather, the recently deceased Edmund.[39]

Besides deaths and births, there were marriage arrangements. For the Pastons at the moment the problem was John's sister Elizabeth, now about twenty and of concern to her mother. Agnes thought of Stephen Scrope, Sir John Fastolf's stepson, a widower disfigured by smallpox and, at nearly fifty, seeming to fail Judge William's criterion of equal age. Brushing aside both obstacles, Agnes wrote John that Elizabeth Clere, a Fastolf niece and close friend of the Pastons, had spoken with Scrope about the match to good purpose: "My cousin Clere thinks that it would be folly to forsake him unless you know of another as good or better, and I have assayed [tested] your sister, and I found her never so willing to anyone as she is to him, if it be that his lands stand clear." She added a cautionary note: "Sir Harry Inglose [an old comrade-in-arms of Fastolf] is right busy about Scrope for one of his daughters."[40]

Elizabeth herself was desperate to be married. Agnes made life miserable for her. "She was never in so great sorrow as she is nowadays," Elizabeth Clere wrote John, "for she may not speak with any man, whomsoever comes . . . nor with her mother's servants" without her mother suggesting that

she is hinting something other than she means. And since Easter she has been for the most part beaten once or twice a week, and sometimes twice in one day, and her head broken in two or three places. Wherefore, cousin, she has sent to me by Friar Newton in great counsel, and prays me that I will send you a letter about her unhappiness, and pray you to be her good brother, as her trust is in you.

A more serious concern about Scrope than age or smallpox was his daughter's claim on his estate. When Margaret pressed him about this, he gave assurance that, if he married and had a son and heir, his daughter would have 50 marks of his income of

330 marks a year and no more. "And therefore, cousin," Elizabeth Clere concluded, "meseemeth he were good for my cousin your sister, unless you might get her a better." But whatever was done should be done quickly. "[Your sister] says if his children and heirs may inherit, and she is to have a reasonable jointure . . . she will have him . . . notwithstanding it is told her that his person is simple [unattractive], for she said men shall have the more respect for her if she submits herself to him as she ought to do."

Nevertheless, "Cousin, it is told me there is a goodly man in your inn, whose father died lately, and if you think that he were better for her than Scrope, it could be managed. . . . Give Scrope a goodly answer that he be not put off until you be sure of a better." Scrope was beginning to be discouraged; he had not been able to see Elizabeth, Agnes apparently having grown cool to his suit. Elizabeth Clere was uneasy about intervening with John behind Agnes's back, for she added, "Cousin, I pray you burn this letter . . . for if my cousin your mother knew that I had sent you this, she should never love me."[41]

For whatever reason, negotiations with Scrope failed to progress, and Elizabeth Paston remained unmarried as the family entered the new decade.

Chapter 5

SIR JOHN FASTOLF, A SOLDIER IN RETIREMENT

1450–1452

he marriage project between Stephen Scrope and Elizabeth Paston was one sign of the ever closer connection between the Pastons and Sir John Fastolf, a connection that harked back to Judge William's service as Fastolf's legal counsel in the 1430s. John Paston had succeeded his father in that role in 1444. In the 1450s he became one of the old soldier's principal advisers and finally his chief adviser, not merely on legal matters but on all questions of finance and property.

Another important member of Fastolf's large staff was William Worcester, an Oxford-educated secretary of wide-ranging intellectual interests who, in spite of Fastolf's incessant demands, found time to become a pioneer of English antiquarian and topographical studies.[1] Shortly after Fastolf's death, Wor-

cester set out to write *Acta domini Johannis Fastolf,* a biography of his master, which has been lost. A miscellany entitled *Itineraries,* however, survived. In it, amid measurements of churches, burial places of notables, geographic descriptions, and a roster of knights at the battle of Verneuil, Worcester presented, with obvious pride, a chronological list of the offices and titles held by his master in France: "Lieutenant of Normandy, King's Counsellor, Grand Master of the Household of Regent Bedford, Governor of Anjou and Maine, . . . Captain of the Bastille of Paris, Captain of the Castle of Calais, Captain of Caen, Marshal of Normandy, Constable of Bordeaux."[2]

The long and distinguished military career thus summarized had brought Fastolf honors, power, and wealth, though he is known today, outside scholarly circles, only through Shakespeare's caricature as the cowardly, buffoonish Falstaff.

Born in 1380 at his family's manor of Caister, near the seacoast north of Yarmouth, John Fastolf was descended from wealthy merchants and shipowners; his father married into the lesser nobility. After his father's death, his mother married John Farwell, who served in the household of the duke of Norfolk's grandmother, and young Fastolf may have been educated there; in 1398 he served as page to Thomas Mowbray, duke of Norfolk. When he came of age he entered the service of one of Henry IV's sons, Thomas of Lancaster, lieutenant of Ireland. In Ireland he met and married Millicent Tiptoft, a wealthy widow of baronial family twelve years his senior.[3]

When Henry V reopened the Hundred Years War by invading France in 1415, Fastolf, now a well-to-do thirty-five-year-old but still only a squire, contracted to serve as a captain with ten men-at-arms and thirty archers. In the brief but brilliant campaign, he took part in the siege of Harfleur, where the expeditionary force landed, and distinguished himself in the great victory of Agincourt. When Henry V withdrew to England after

the battle, Fastolf was appointed to share the command of the garrison of Harfleur.[4]

Upon the resumption of the war in 1417, Fastolf fought in the sieges of Caen and Rouen and was knighted at the age of thirty-seven.[5] In 1420 the Treaty of Troyes made Henry heir to the French crown and gave Paris to the English; Fastolf was appointed governor of the city's great fortress, the Bastille. Two years later, Henry's death from dysentery left the infant Henry VI heir to two thrones and made Henry's able brother, the duke of Bedford, regent. Fastolf was chosen grand master of the regent's household.[6]

He continued his active campaigning and in 1424 executed a coup at the battle of Verneuil, where he and another captain, Lord Willoughby, captured the young duke of Alençon, a prince of the royal blood. The prisoner was turned over to Regent Bedford, and Fastolf's share of the ransom was fixed at the splendid figure of 5,000 marks—3,300 pounds—which, however, he never entirely collected.[7] The following year (1425) Fastolf captured Le Mans, in Maine, was made lieutenant of the town (second in command) under the governorship of William de la Pole, earl of Suffolk, and was inducted into the prestigious Order of the Garter.[8]

Fastolf showed himself as able in financial matters as in military ones. His profits from pay, ransoms, spoils, lordships acquired in France, and emoluments of office were prudently forwarded through English intermediaries in Normandy or through Italian merchants in Paris to agents in London, who acted as his bankers and brokers.[9]

In March 1427, Regent Bedford launched an all-out offensive in central France, and in October 1428 the English began the fateful siege of Orléans, with an army under the command of Sir John Talbot and Thomas Lord Scales. On 12 February 1429, Fastolf led a large commissary train from Paris bringing "herring

and Lenten stuff" to the besieging army. When an enemy force intercepted him, he deployed his wagons in a circle, from which his archers drove off the attackers. A mounted counterattack then turned the "Battle of the Herrings" into a rout of the French.

Fastolf's name and reputation were consequently well known to Joan of Arc, who arrived two months later to join in the relief of Orléans. With her companions, who included Fastolf's former captive, the duke of Alençon, Joan drove the English from the fortifications around the city and went on to expel them from other strongholds on the Loire. In June, Fastolf led a relief army from Paris, rendezvousing north of Orléans with Sir John Talbot, at the head of reinforcements from England and Normandy. At a council of war, Fastolf, whose characteristic advice to young soldiers was "Be hardy, but not foolhardy,"[10] advised caution: their combined forces were insufficient; they should make a truce and return to their "castles and strong places" to recoup. Talbot, more impetuous, insisted on fighting. The battle of Patay that resulted (18 June 1429) was an Agincourt in reverse, with the English army virtually destroyed. Talbot and Lord Scales were taken prisoner; Fastolf and his contingent were forced into flight. When Talbot regained his freedom, he brought a charge of cowardice against Fastolf, and though it was dismissed (William Worcester helped his master clear himself),[11] English chroniclers perpetuated the story. Shakespeare accepted their view in *Henry VI, Part I*, though altering the name to "Falstaff."*

*In the first (folio) edition of the play. He later amended it to "Fastolfe." When still later he wrote *Henry IV*, he first named the disreputable old knight, friend of young Henry V's carousing days, after a Sir John Oldcastle, but Oldcastle's descendants persuaded him to change the name back to "Falstaff." The character proved so successful that it was given a final bravura appearance, by command of Elizabeth I, in *The Merry Wives of Windsor*.

No portrait of Fastolf exists to testify whether he was fat or thin, but his intelligence and ability are beyond question, and his long and distinguished military career leaves little doubt of his courage. Shakespeare, however, fixed for posterity the image of "Falstaff" as a corpulent, bibulous, and craven clown.

That Regent Bedford gave no credit to Talbot's charge is evident from Fastolf's subsequent career, in which he served as governor of Caen and as Bedford's representative in the negotiations at Arras that led to the truce of 1435. When Bedford died suddenly five days after the conclusion of the treaty, Fastolf was named an executor of his will (the faithful Worcester helped straighten out the tangled estate).[12] During his stay at Arras, Fastolf prepared a famous memorandum for Henry VI's council at Rouen, advocating the abandonment of sieges for a scorched-earth strategy—actually a candid description of the old English tactic of the destructive *chevauchée,* or mounted raid, which had by now proved a failure. Technically, the memorandum was most notable for its lack of appreciation of gunpowder artillery, which was in the process of revolutionizing siege warfare.[13]

In 1439, at the age of fifty-nine, Fastolf returned to England to stay. At least a decade earlier he had begun the transformation of the manor house on his Norfolk place of birth into Caister Castle, an outstanding example of a new building style, the first flowering of English domestic architecture. Built of brick, then a novelty, the structure contained a great hall, twenty-six bedrooms, and a chapel. Though encircled by a moat and crowned with a single 98-foot tower, and eminently defensible, it was primarily a habitation rather than a fortress. As a harbinger of the future, it stood in contrast to the duke of Norfolk's twelfth-century Framlingham Castle thirty miles to the south, consisting mainly of an immense circuit of tower-studded curtain walls. Displayed in Caister's great hall was Fastolf's coat of arms, a bush of feathers supported by two angels, each with four wings,

the whole encircled by a representation of the Garter with the motto "*Me faut faire,*" "I must be doing."[14]

What he had long been doing was collecting properties—at Hellesdon, Cotton, Norwich, Dedham, and Yarmouth. Ultimately he owned ninety-four manors, mostly in Norfolk. Reverting to his grandfather's métier, he owned several ships and sold the products of his manors, wool and grain. The income from his English properties in 1445 came to over a thousand pounds, mostly from land purchased with his war profits. At the same time his estates in France, dwindling with falling English military fortunes, still yielded an annual four hundred pounds.[15] Only a handful of magnates enjoyed larger revenues.

Second only to Caister as his dwelling was the house Fastolf built himself in Southwark, south of London Bridge, where from 1439 to 1454 he spent most of his time, in order to remain close to the Court and the royal council, which sought his advice on

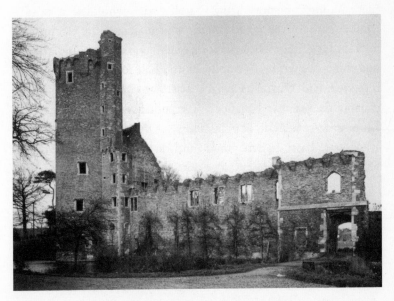

Ruins of Caister Castle. *(Hallam Ashley)*

the war. To the Southwark mansion he added numerous messuages (houses and lots) nearby, the Boar's Head and Hart's Head inns, two water mills, and a variety of gardens, fields, meadows, and wharves.[16]

His household and estates absorbed the services of a small army of lawyers, agents, and domestics. In the early 1450s, John Paston made his residence conveniently across the river, a short boat trip away, at the Inner Inn of the Temple, whence he could serve Fastolf while conducting his own battles over Gresham by correspondence with Margaret and with his agents in Norwich. At the head of Fastolf's staff was the indefatigable William Worcester, who, in his roles of secretary, searcher of legal records, tracer of pedigrees for titles to land, overseer of scattered manors, and collector of medicinal herbs, traveled continually on his master's business. Between journeys he kept the old knight company, writing his letters, preparing astronomical tables, and even on one occasion composing a Latin poem, "*Laudes Millicente Scrope*," memorializing Fastolf's wife, who died in 1446.[17] Unlike many of the professionals who managed the estates and households of the rich, he was a layman, with a wife and at least one child—a fact, he told John Paston half jokingly, that Fastolf regretted; had Worcester been a priest he could have been more cheaply paid with a benefice.[18] Two other of Fastolf's chief servants were tonsured: Thomas Howes, Worcester's wife's uncle, who was Fastolf's chaplain, and Friar John Brackley, his Franciscan confessor.

None of these three had legal training. To fight his legal battles Fastolf had, besides John Paston, William Jenney and William Yelverton, the latter a justice of the King's Bench. Every fifteenth-century landowner was well advised to keep at least one Westminster lawyer on his payroll, not only for legal advice but as a fiscal officer.[19] Indeed, it was nearly impossible to separate the two functions, in the light of the endless litigation such a

landowner might be embroiled in. Fastolf had more than his share, some of it dating back to his days in France. He had never received his share of Alençon's ransom after Verneuil; loans he had made to Regent Bedford and the king remained unpaid; he had borne expenses in the "safeguard and keeping of certain fortresses, castles, and towns" in France; and money was still owed him for his wages and those of his retinue.[20] One prisoner of Fastolf's had been appropriated by Regent Bedford to use as a hostage and afterward released; Fastolf had never been compensated.[21] Meanwhile, income from his French properties, ever shrinking, had by 1450 disappeared, while his new English estates brought him more problems. Absentee management was awkward and inefficient. Rents were hard to collect; stewards were incompetent or dishonest.

On 27 May 1450, Fastolf wrote from London to Thomas Howes in Norfolk, demanding to be informed about those who had infringed against him.

I pray you send me word [as to] who dare be so hardy to kick against you in [the matter of] my right. And say [to] them on my behalf that if they will not dread nor obey that, then they shall be dealt with by Blackbeard or Whitebeard, that is to say by God or the Devil. . . . I hear oftimes many strange reports of the governance of my place at Caister and other places . . . in my wines, the keeping of my wardrobe and clothes, the use of my coneys [rabbits] at Hellesdon, and improvement of my lands.[22]

Six months later he was writing Howes and John Bocking, one of his agents:

Item: Sir John Buck, parson of Stratford, fished my [fishponds] at Dedham, and helped break my dam, destroyed my

new mill ... to the damage of £20. ... He and John Cole have by force this year, and other years, taken out of my waters at Dedham to the number of 24 swans and cygnets.[23]

Like the Pastons, Fastolf was the victim of the depredations of the duke of Suffolk and his lieutenants. The original source of disaffection between the two men, who had fought together in France, is obscure, but from the late 1430s they were enemies. Their conflict centered around three manors in Norfolk and Suffolk—Drayton, Hellesdon, and Cotton—and Dedham, an estate in Essex. All four had been legitimately purchased by Fastolf; all were seized by the duke of Suffolk's agents during the 1440s.

Cotton, some thirty miles south of Norwich, was the duke of Suffolk's birthplace; he had sold it to Fastolf in 1434 to raise money to pay his ransom after being captured during the Loire campaign. Once free, the duke hated to accept the loss of family property. Accusing Fastolf of defaulting on his payments, he sent his officers to seize the manor. Fastolf never recovered it.

Dedham had belonged to the duke's grandfather, who had lost it in 1388; Fastolf purchased it from the present owners and paid for it, but in 1447 the duke's men moved in. Drayton and Hellesdon, just northwest of Norwich, near the duke's own manor of Costessey, were also claimed by him in the 1440s, Hellesdon on the pretext that it had once belonged to someone named Pole, with the implication of kinship with the ducal (de la Pole) family.[24]

In at least one case, Fastolf's title was not altogether clear. He had purchased the manor of Titchwell in 1431 from a widower whose childless wife, Margery Lovel, had apparently been the last member of her family. Seventeen years later, a Sir Edward Hull, a knight with connections both at court and with Suffolk's lieutenant John Heydon, appeared to claim the property. Hull asserted that his wife and her sister had been Margery

Lovel's heirs under an entail and, furthermore, that the estate had been held "in chief"—directly from the king—and that Margery had entered into her inheritance without the necessary formalities. The sale to Fastolf, who had paid for it in full, was therefore allegedly improper. In 1448 a royal inquisition of dubious legality found for Sir Edward Hull, the manor was seized for the king, and Hull was granted the farm of the manor at low cost. Shortly after Christmas 1448, Hull's men took it over.

Fastolf set several people to work to research the Lovel pedigree and the status of the manor. First they searched the royal archives: the Exchequer, the Tower of London, Domesday Book, and Chancery rolls, in each case paying a fee for the service. Copies of documents, neatly bundled together, were brought to Fastolf's Southwark dwelling. Then his agents sought out local information about the Lovel family. William Worcester was dispatched to Somerset in May 1449 "to inquire into the true genealogies of the lords of Lovel and to investigate the genealogy of the wife of Sir Edward Hull." After Worcester returned to London, a friend in Bristol, John Crop, continued the investigation, traveling about the West Country, home of the Lovels, interrogating old people: Edward Hull's wife's uncle, monks at Glastonbury Abbey, the abbot's carver, a baker who had lived in Glastonbury, and many others. "And in every place," Crop complained to Worcester, "I might not find three men or two men [who agreed] in one tale, but every man had divers tales and so I never knew after whom to write the ready truth." Other researches turned up a confusing plethora of Lovels. An inquiry was launched into Margery Lovel's great-grandfather's coat of arms, but the result was further confusion.

In the end, the genealogical search was abandoned in favor of attacking the judicial inquisition that had pronounced for Sir Edward Hull. In 1450, Fastolf sent Nicholas Bocking, another of his servants, riding all over Norfolk to locate the jurors and press

them to "tell the truth" about the "false conspiracy" that Sir Edward Hull had hatched. Bocking was successful in persuading the jurors to deny that they had ever attached their authenticating seals to the inquisition document. Fastolf proposed to Thomas Howes that John Dalling, the official responsible for the document, be "brought by force to Caister without damage of his body, and there to be kept in hold, that he may confess the truth of the false office he forged of my manor of Titchwell." But Dalling eluded capture, and the case remained open with Hull still in occupation.[25]

The duke of Suffolk's disgrace and death in 1450 seemed at first as good news for Fastolf as it was for the Pastons; he was invited to join the royal council, and Suffolk's agents were ousted temporarily from Dedham. But the event brought an unexpected backlash. A rumor that the king planned retribution against the southeast coastal region where Suffolk's murder had taken place provoked a rebellion in Kent under a leader who called himself Jack Cade. The movement began as a protest march on London to petition for reform. King Henry VI was urged to rescind the large gifts he had made to Suffolk and his friends, which had so impoverished the royal demesne that, according to the rebels, the king was in debt 40,000 marks (actually he was in debt a good deal more).

The king assembled an army at Blackheath, southeast of London, while several lords loyal to him invaded Kent with their armed retinues (18 June 1450). Their pillaging provoked further rebellion, just when cooler heads around the king were conceding that some of the rebel complaints were justified. Cade's band was reported moving on London, and the draw span of London Bridge was raised, barring entry to the city.[26]

Sir John Fastolf, whose Southwark home was on the wrong side of the Thames, summoned a servant named John Payn,

whose own home was in Kent, and told him to take a man and "two of the best horses that were in his stable," ride to meet the rebel host, and ascertain their demands. Fifteen years later Payn recorded his subsequent adventure in a letter to John Paston. On encountering the rebels at Blackheath, he sent his companion

> away with the two horses; and I was brought forthwith before the captain of Kent [Jack Cade]. And the captain demanded of me what was my cause of coming thither, and why I made my fellow steal away with the horses. And I said that I came thither to visit with my wife's brothers, and others that were my allies and friends of mine that were present there.

Someone, however, recognized him as one of Sir John Fastolf's men and said that the horses were Fastolf's, "and then the captain had treason cried upon me through all the field." Cade had a herald declare that Payn

> was sent thither to spy their strength and their habiliments of war, for the greatest traitor that was in England or in France . . . one Sir John Fastolf, Knight, who had diminished [reduced] all the garrisons of Normandy, and Le Mans and Maine, which was the cause of the losing of all the king's title and right of inheritance that he had overseas. And moreover he said that the said Sir John Fastolf had furnished his place [in Southwark] with the old soldiers of Normandy and habiliments of war, to destroy the commons of Kent when they came to Southwark, and therefore he said plainly that I should lose my head.

Payn was taken to the captain's tent, and "an ax and a block [were] brought forth to have smitten off my head," but at that

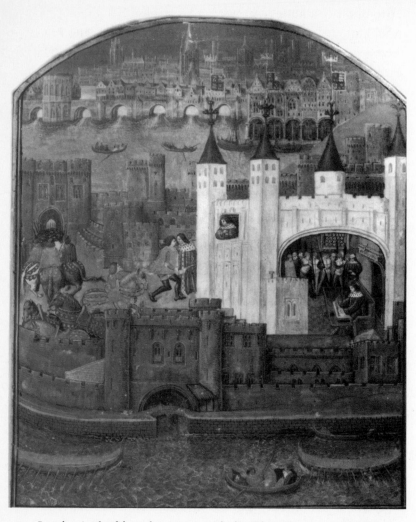

London in the fifteenth century, with the White Tower center right
and London Bridge in the background left.
(British Library, MS Roy. 1G. F2, f.73)

moment Robert Poynings, a Paston acquaintance who was Cade's sword-bearer, intervened to rescue him. "And then I was sworn to the captain, and to the commons, that I should go to Southwark and array me as best I could and come again to them to help them."

Payn returned to Southwark with a copy of the rebels' petition. Couched in reasonable (and notably literate) terms, it asserted that the king's false counsel was ruining him, "for his lands are lost, his merchandise is lost, his commons destroyed, the sea is lost, France is lost, himself so poor that he may not pay for his meat nor drink; he owes more than ever did a king of England."

Sir John Fastolf left Payn in charge of the Southwark house and retreated across the river ahead of the rebels, who moved into Southwark on 1 and 2 July, lodging peacefully for the most part in inns and hostelries. John Payn succeeded in preventing the rebels from burning Fastolf's house but was subsequently seized at the White Hart Inn and despoiled of his "array"—"a fine gown of musterdevillers furred with fine beaver, and two pairs of brigandines [body armor] covered with blue velvet and gilt nails, with leg harnesses, the value of the gown and the brigandines £8." Then the men went to his room at the inn where they "broke up his chest" and stole money and other valuables, as well as armor and clothing, and once more threatened to kill him; again Robert Poynings saved him.[27]

As a conciliatory gesture toward the rebels, the king appointed a commission of oyer and terminer (literally, to hear and determine, an ad hoc judicial body) to investigate the charges; however, the rebels chose the same day (3 July) to turn violent. Fighting broke out on London Bridge, whose draw span had been lowered. Cade cut the draw cable, making it impossible to raise the span, and the mob flowed into the city. Cade issued an order prohibiting looting to reassure Londoners, who, how-

ever, were not reassured; as Shakespeare later described it, "Jack Cade hath gotten London Bridge, the Citizens fly and forsake their houses" (*Henry VI, Part* 2). Lord Say, who was to Kent what the duke of Suffolk was to East Anglia, was dragged out of the Tower, where he had been imprisoned, and beheaded. The even more unpopular William Crowmer, former sheriff of Kent and stepbrother of Robert Poynings, was taken from Fleet Prison and beheaded. Less distinguished prisoners were released from Marshalsea Prison and invited to join the rebels.[28]

On Sunday evening, 5 July, a fight broke out on London Bridge that lasted all night. John Payn found himself thrust into the melee and "was wounded, and hurt near to death, and there I was six hours in the battle, and might never have come out of it." He survived, as did his family in Kent, though the rebels "took away all my goods movable and would have hanged my wife and five of my children, and left her no more goods than her kirtle [underdress] and her smock."[29]

The battle of London Bridge marked the high tide of the insurrection; over the next few days the rebels straggled home. Cade was captured in Sussex and died of injuries en route back to London, where he was beheaded in order to display his head on London Bridge. His body, ritually quartered, was distributed among four cities suspected of harboring subversive thoughts, Norwich being one of the four.[30]

Unlucky John Payn was now arrested as a rebel and thrown into Marshalsea Prison. Pressure was put on him to "impeach my master Fastolf of treason"—that is, of siding with the rebels. Payn refused and, with help from relatives, gained a pardon from the king.[31]

Disturbances continued throughout the summer in Kent, Sussex, and the whole south and southeast of England. James Gresham wrote John Paston (19 August 1450) an exaggerated report that

nine or ten thousand men had risen in Wiltshire.[32] Mingled with the antigovernment sentiment were many local quarrels and long-standing grudges.[33] As rebellion ebbed, a general pardon was drawn up, in the form of a roll to be signed by all those needing pardon, a list that turned out to include many who had taken no part in the rebellion but felt they needed pardons for more private actions.

Lord Moleyns was evidently not among the pardon seekers, though John Paston may have felt he should have been. In July, Moleyns sued John for trespass; in turn, John petitioned the Lord Chancellor, Cardinal Kemp, for a special assize (court hearing) against Moleyns, his wife Eleanor, and John Heydon, and also an oyer and terminer "to inquire, hear, and determine all trespasses, extortions, riots, forcible entries" and other misdemeanors committed by them.[34] The chancellor responded by writing Moleyns to "command his men being at Gresham to depart thence" and to arrange for the profits of the manor to be handled by a neutral party ("an indifferent man") until a settlement could be reached. Moleyns replied that he was at the moment on the king's business in Wiltshire, helping to "still the people there and restrain them from rising," and could not come to Norfolk for the trials. Furthermore, he was sure of his title to Gresham and trusted that the Lord Chancellor would not ask him to remove his men from there; it was his wife's right, and it would be unreasonable to ask him to "void utterly his possession."[35]

John Paston suspected Moleyns of employing delaying tactics in the hope of converting the judicial proceeding into a bargaining session, in which the judges would invite from the two parties "offer and proffer, in my opinion as men buy horses . . . for title he has none." John was determined not to allow such a procedure, though he thought Moleyns might show good will by paying for the two hundred pounds' worth of goods and chattels

that his men had pillaged.[36] To John's chagrin, Moleyns not only made no such move but succeeded in getting a still higher authority to intervene on his side. On 18 September, John received a letter from the king himself informing his "trusty and well-beloved" John Paston that his "trusty and well-beloved the Lord Moleyns" was about to undertake a royal commission: "We therefore desire and pray that . . . you will respite us for anything attempting against him . . . or any other of his servants, well-willers, or tenants until such time as he may be present to answer thereunto"—in other words, postpone the hearings until Moleyns had returned from his peacekeeping mission in Wiltshire.[37]

In October 1450 political events took a fresh turn when Richard, duke of York, suddenly arrived from Ireland, where he had served since 1447 as lord lieutenant. This noble occupied a unique position. He was a great-grandson of Lionel, duke of Clarence, elder brother of John of Gaunt, from whom the reigning Henry VI was descended, and thus had a very legitimate claim to the throne. The whole Lancastrian line of kings—Henry IV, Henry V, and Henry VI—were, in fact, usurpers, but Henry V having won the battle of Agincourt, and Henry VI having sat on the throne for twenty-six years, nobody questioned their right. The duke of York himself was at pains to affirm his loyalty to Henry VI. Nevertheless, his ancestry and his popularity with the opposition gave him a special place in all minds.

When, soon after his return, the duke of York visited Norfolk and conferred at length at Bury St. Edmund's with the duke of Norfolk, the Pastons were anxious observers. John Paston, in London, had just received a letter from William Wayte, clerk to Judge Yelverton, urging him to stand for Parliament as one of Norfolk's two knights of the shire, elected by the county's better-off subjects—its "forty-shilling freeholders," men with freely held land producing forty shillings of rev-

enue a year.[38] Whatever John thought of the proposal, the prospect went glimmering when he received a much terser note from the duke of Norfolk: "Forasmuch as our uncle of York and we have fully appointed and agreed of such two persons to be knights of the shire of Norfolk . . . we therefore pray you . . . that you make no labor contrary to our desire. And God have you in his keeping."[39] Two days later the earl of Oxford notified John that the two candidates agreed on by the dukes were Sir William Chamberlain and Henry Grey.[40]

Thus a pair of powerful lords could discourage a potential candidate for Parliament and by the same token lend substantial assistance to their own choice. They could not, however, guarantee election; in the event, only Henry Grey was elected, along with Sir Miles Stapleton. John Paston must have studied the result with interest.

But of even greater interest in the meeting of the two dukes was their concerted agreement on prosecuting the lawless followers of the late duke of Suffolk. Several were soon indicted, among them John Heydon. Paston agent James Gresham reported a conversation between Heydon and Judge Yelverton, in which Heydon asked if he was indicted of felony and Yelverton told him he was. Heydon replied, "Sir, you would record that I was never a thief," and added that he "well knew the laborer" of the indictment, "and my master Y. thinks H. meant you."[41]

As the judicial commission prepared to meet at Lynn in January 1451, Sir John Fastolf wrote a long letter to his aide Thomas Howes expressing his concern about the presence on it of an old enemy from the French wars, Thomas Lord Scales. The likelihood was that Lord Scales would "maintain the said Tuddenham and Heydon in all he can" and that people like himself who had suffered from extortion must look elsewhere for justice. For if they did not "hold the hand well and steadfast . . . the poor people and all the great part of both shires of Norfolk

and Suffolk will be destroyed. . . . The most part of the common-
ers have little or nought to maintain their living and household,
nor to pay the king's taxes, nor their rents and services to the
lords they are tenants unto." And along with the poor people,
"the gentlemen that have their poor livelihood amongst them
[would] be greatly diminished and hindered of their profits and
living."

Turning from high moral ground to practical measures, he
instructed Howes to approach prospective jurors who might be
persuaded to be "good friends . . . and do them good cheer and
spend upon them what the case shall require."[42]

Heydon and Tuddenham countered by getting the session
postponed and moved to Walsingham, roughly halfway between
Lynn and Norwich, where they had numerous supporters.

Early in 1451, John Paston reentered Gresham without opposi-
tion from Lord Moleyns, though the issues of title and damages
remained unresolved and the "mansion" had not only been
looted but damaged beyond repair. The Pastons remained in pre-
carious occupation.

In March, Margaret, in Norwich, heard fresh rumors that
Tuddenham and Heydon were threatening to return to power
with the king's backing. "It is said that they shall have as great
rule in this country as ever they had, and many more folks are
sorry therefor than merry." The Gresham tenants favorable to
John were anxious that he should send "some men of yours to
bide amongst them" and protect them. Her letter concluded with
practical matters: "I pray you that you will send me word in
haste if you will have red for your livery, as you were
advised. . . . And also I pray you that you will have bought two
good hats for your sons for I can get none in this town."[43]

Two weeks later she wrote, "It is noised about Gresham and
all that country that the Lord Moleyns should soon be there."

Her uncle Philip Berney had been at an inn in Lynn, and one of his men had overheard a conversation between Partridge and the bailiff of Lynn, neither man realizing that Berney was a Paston relation. Partridge and the bailiff were "well acquainted," and the bailiff said that Lord Moleyns had written that he was coming to Lynn "this week" and that he (the bailiff) "was right glad that he should come into this country."[44]

Meanwhile William Jenney reported to John that the proposed new sheriff of Norfolk, John Jermyn, would be favorable to the Pastons; "he shall and will be ruled well enough."[45] But in May the word was that the sheriff "is not so whole [reliable] as he was, for now he will show but a part of his friendship." Walsingham was full of a "great press of people," and few of them were friendly to Fastolf and the Pastons. "Also the sheriff informed us that he has writing from the king that he shall make such a [jury] panel as will acquit the Lord Moleyns . . . and also his men."[46] Paston agent William Lomnor reported that Moleyns was offering "a treaty for the goods, and amends to be made," but John was now unwilling to settle for damages alone, or indeed for anything short of full title to Gresham.[47]

At the sessions of oyer and terminer finally held at Walsingham on 4 May 1451, John Paston represented both Fastolf and himself. Thomas Howes sent Fastolf a lengthy report on the proceedings, which were marked by scarcely disguised prejudice, especially on the part of Chief Justice of the Court of Common Pleas John Prisot. As expected, the town was crowded with Heydon and Tuddenham's friends, whose presence intimidated plaintiffs and witnesses: "It would have been right dangerous and frightening for any of the plaintiffs to have been present. . . . There was not one [of them] there except your right faithful and trusty well-willer John Paston." Prisot "would suffer no man [learned in law] to speak for the plaintiffs, but took it as a poison, and took them by the nose [interrupted them] at every

third word." Howes spoke bitterly of Lord Scales, Fastolf's enemy, and "some of your faint friends," including Fastolf's kinsman Sir John Heveningham, who "at the time that my Lord Norfolk sat at Norwich on the oyer and terminer could not find it in his heart to go four furlongs from his dwelling place to the shire house [to speak for his friend], but now he could ride from Norwich to Walsingham to sit as one of the commissioners." Howes advised Fastolf for his next court case to "labor to have Yelverton judge at that time," and particularly to beware that "Prisot have anything to do in any wise [with it], for then all will be nought."[48]

Lord Moleyns was acquitted, but John Paston and Sir John Fastolf continued their action against his men. A Paston servant, John Osbern, delicately hinted to John Jermyn that he should send a man to collect "that which was left with his undersheriff"—evidently a bribe—but Jermyn refused on ethical grounds, saying he had done nothing to earn it. Osbern "reminded him of his promises made before to you [John Paston] at London, when he took his oath and office." Jermyn replied that he would do anything he could for John Paston except in the present action, inasmuch as "the king has written to him to show favor to the Lord Moleyns and his men," and it was for the king, not John, to indict them. Furthermore, "the Lord Moleyns is a great lord," and if Jermyn did not favor him, the sheriff might lose much more than the hundred pounds or so that John Paston had offered him. Osbern retorted that if such were the practice, "Every man may be put from his livelihood." He advised John Paston to get the king to write a letter to the sheriff in his own behalf, "to show you favor," just as Moleyns had done. Such a letter, he thought, could be had cheaply, "for a noble," he wrote ironically. Osbern added that the sheriff had evidently "made a promise to do his part that the men should be acquitted, but I suppose he has made no other promise against you . . . but he

looks for a great bribe"—though the deed is frequently hinted at, the word itself is used only twice in the Paston Letters. However, Osbern warned, he was not to be trusted.[49]

One April morning in 1452, John Paston was suddenly attacked at the door of Norwich cathedral by a band of six men, "with swords, bucklers, and daggers drawn." He had no trouble recognizing their leader, a notorious member of the duke of Norfolk's affinity named Charles Nowell. In a complaint addressed to the sheriff of Norfolk, John wrote: "He and five of his fellowship set upon me . . . he was smiting at me, while one of his fellows held my arms at my back." One of John's servants was "smitten upon the naked head with a sword and polluted the sanctuary" with his blood. The attackers were driven off, but John was left shocked and mystified. Why should the duke of Norfolk's men assault him? It was "to me a strange case. . . . My lord was my good lord, and . . . I had been with my lord at London within eight days at Lent, at which time he granted me his good lordship, so largely that it must cause me ever to be his true servant, to my power. I thought also that I had never given cause to any of my lord's house[hold] to owe me evil will."[50]

On the same day (according to a complaint to Parliament) Margaret Paston's uncle Philip Berney and a servant were ambushed by others of Nowell's gang, who "shot at them and smote their horses with arrows, and then overrode him and broke a bow on the said Philip's head and took him prisoner, calling him traitor."[51] Both attacks, and several others perpetrated by the same gang, were evidently not launched by the duke of Norfolk but were in the interest of another client of Nowell's. As usual, a land dispute was at the bottom of it, and John Paston was attacked because one of the parties was a kinsman of Margaret's.

John Osbern had a long discussion with the bishop of

Norwich about the attack in the cathedral, the bishop expressing himself as regretting that he had not had an opportunity to speak to John Paston directly before his return to London, and inquiring after his health. "I said [you were] well, for I trusted that [the duke of Norfolk] . . . would see that Charles [Nowell] should be sharply corrected for his trespass and misrule." The bishop expressed certainty that justice would be done and treated Osbern to "great cheer," having him taken to the episcopal cellar

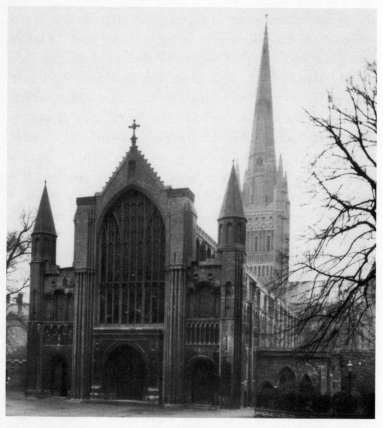

West front of Norwich Cathedral, where, in 1452, John Paston was attacked by a band of six men. *(Royal Commission on the Historical Monuments of England)*

"to drink wine and ale both."[52] Later the bishop had another leader of the gang, Roger Church, arrested and his goods seized "for what he owes the bishop," Margaret reported.[53]

Unlike John Paston, Philip Berney never recovered from the attack. He had been sickly for some time, Margaret having once the previous year forwarded to him a pot of treacle sent by John from London.[54] Treacle, or theriac, was not the sweetening syrup it later became but a pharmaceutical mixture of great antiquity and repute, though of little value. Its more than sixty ingredients included flesh of roasted viper, and it took forty days to prepare and up to twelve years to age. The Pastons employed it liberally, probably in the prescribed dosage of twice daily in clear wine, ale, or rosewater. Besides unblocking intestinal stoppage, treacle was credited with curing fevers and heart trouble, inducing menstruation, combating insomnia, and counteracting poison, among still other virtues.[55]

It failed to cure Uncle Philip's affliction. In the fall Margaret visited the invalid, reporting to John:

He has been so sick since I came to Reedham that I fear he will never escape it, nor is like to do unless he has ready help; and therefore he shall [go] into Suffolk this next week to my aunt, for there is a good physician [there], and he shall look to him.[56]

Philip died the following summer, "with the greatest pain that ever I saw," Agnes wrote John. She also reported the death of Sir John Heveningham, Fastolf's relative and "faint friend" who had been a commissioner at the session in Walsingham:

On Tuesday Sir John Heveningham went to his church and heard three masses, and came home again never merrier, and said to his wife that he would go say a little devotion in his

garden and then he would dine; and forthwith he felt a fainting in his legs and sat down. This was at nine of the clock, and he was dead before noon.[57]

Of her uncle's death, Margaret wrote, "God has purveyed for him according to His will."[58]

Chapter 6

SIR JOHN FASTOLF AND JOHN PASTON

1453–1459

n the early months of 1453 the Pastons were occupied with a new building project, probably at Mautby; though Margaret gives details about the construction, she does not say where it was to take place. The Pastons acquired a house on Elm Hill in Norwich at about this time, but evidently it was purchased rather than built, and its site seems too small for the structure Margaret describes to her husband (30 January 1453):

> Sir Thomas Howes has purveyed four dormants [beams] for the drawing room, and the malt house, and the brewery, whereof he has bought three, and the fourth, the longest and greatest of all, he shall have from Hellesdon, which he says my master Fastolf shall give me, because my

chamber shall be made therewith. . . . They shall be placed next week, because of the malt house, and as for the rest, I think it shall wait till you come home, because I can neither be purveyed of posts nor of boards yet.

She added details of the house's furnishings:

I have taken measure in the drawing chamber, where you want your coffers and desk to be set. . . . There is no space beside the bed, even if the bed is removed to the door, to set both your [counting] board and your coffers there, and to have room to go and sit beside it. Wherefore I have purveyed

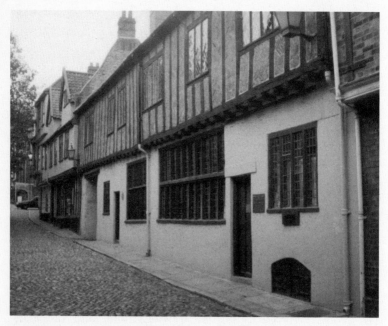

Sixteenth-century house on Elm Hill, Norwich, replacing a house owned by the Pastons in the fifteenth century.

that you shall have the same drawing chamber that you had before there, where you shall lie by yourself; and when your gear is moved out of your little house, the door shall be locked, and your bags laid in one of the great coffers, so that they shall be safe, I trust.

In the same letter Margaret passed on a message from Agnes about John's sister, Elizabeth, now twenty-four and still unmarried.

My mother prays you to remember my sister and to do your part faithfully ere you come home to help to get her a good marriage. It seems by my mother's language that she would never so fain to be rid of her as now. It is said here that [William] Knyvett, the heir, is marriageable, both his wife and child be dead. . . . Wherefore [Agnes] would have you inquire whether it be so, and what his livelihood is, and if you agree to let him be spoke with thereof.[1]

In April of 1453, Margaret of Anjou, Henry VI's queen, visited Norwich en route to the shrine at Walsingham, where Margaret herself had journeyed at least once and where ten years earlier Agnes had donated a wax image to cure John's illness. Margaret described the event to John:

The queen came into this town on Tuesday last past after noon and abode here till Thursday, at three in the afternoon; and she sent after my cousin Elizabeth Clere by [Thomas] Sharburne to come to her. . . . And when she came into the queen's presence, the queen made right much of her and desired her to have a husband, which you shall know about hereafter. . . . The queen was right well pleased with her answer and . . . says, by her troth she saw no gentlewoman

since she came into Norfolk that she liked better than she
does her.

She concluded with a request:

> I pray you that you will buy me something for my neck.
> When the queen was here, I borrowed my cousin Elizabeth
> Clere's necklace, for I durst not for shame go with my beads
> among so many fresh [well-dressed] gentlewomen as were
> here at that time.[2]

Though Margaret did not mention it, the queen's purpose in
visiting the shrine was to invoke the aid of the Virgin in produc-
ing an heir to the throne. She bore as a gift a tablet of gold
encrusted with jewels, which proved extraordinarily efficacious;
the queen in fact must have been already pregnant, for she gave
birth the following October to a son who was given the name
Edward and the title of Prince of Wales.

The birth was an event of primary political importance, but
in the intervening months one of even greater impact took place
in France. Gascony, a centuries-old possession of the English
crown, had been lost to the French but had rebelled against the
heavy taxes imposed by the French king and had appealed for
English help. Sir John Talbot, the captain whose impetuosity had
contributed to the disaster of Patay twenty-four years earlier,
was given command of an expeditionary force. Among the
nobles who volunteered to serve under him was Lord Moleyns.
Once more Talbot's impatience was fatal; at Castillon near
Bordeaux, the English suffered the final defeat of the long war
(17 July 1453). Talbot was killed and Lord Moleyns taken pris-
oner. No peace treaty was signed, but the Hundred Years War
was over, Calais alone remaining in English hands.

Castillon brought discredit to the duke of Somerset, who had

succeeded the duke of Suffolk as chief counselor to Henry VI. It had an even more severe effect on Henry himself. Never very strong mentally, he now lapsed into a state of total distraction, in which the governing apparatus passed completely out of his hands and into those of the unpopular Somerset.

By Christmastime the outcry against Somerset had swelled to the point where the royal council was moved to oust him from office and imprison him in the Tower of London, accusing him of much the same misdeeds as the duke of Suffolk: corruption and the loss of "two such noble duchies as Normandy and Guienne [Gascony]." No sentence was pronounced, however, and in his comfortable lodging in the Tower the duke remained a threatening offstage presence.

A newsletter written in mid-January of 1454, apparently by an informant of the duke of Norfolk, gives a pathetic picture of King Henry, living disconsolately in Windsor Castle, as his three-month-old son was first brought to visit him. The duke of Buckingham

took [the infant prince] in his arms and presented him to the king in goodly wise, beseeching the king to bless him. . . . The king gave no manner of answer. Nevertheless, the duke remained still with the prince near the king; and when he could have no answer, the queen came in, and took the prince in her arms and presented him in like form as the duke had done, desiring that he should bless [the baby], but all their labor was in vain, for they departed thence without any answer or countenance, saving only that once he looked at the prince and cast down his eyes again, without any more.

The letter went on to report ominous activity in the capital. Cardinal Kemp, the chancellor, a strong supporter of Somerset, had "commanded all his servants to be ready with bow and

arrows, sword and buckler, crossbows, and all other habiliments of war." Other lords were mobilizing their private armies and swearing alliances. The duke of Somerset's party had preempted all the lodgings in the vicinity of their imprisoned chief. The king's council was to meet in February, when Queen Margaret intended to present it with a demand that she be made virtual regent, with the right to appoint the chancellor and other high officials.

Somerset's great rival, the duke of York, was expected within the week, "with his household retinue, well attired [well armed]," to be shortly followed by the earl of Salisbury and his son, the earl of Warwick, powerful supporters of the duke of York. The anonymous writer warned the duke of Norfolk to come to London only with a strong retinue and to beware of ambushes; the duke of Somerset had spies everywhere, "some as friars, some as shipmen . . . and some otherwise."[3]

The plans of Somerset and Queen Margaret were suddenly dealt a fatal blow by the death of Cardinal Kemp (22 March 1454). The council at once named the duke of York Protector of the Realm, a decisive rebuff to the queen. The effect was to crystallize the maneuvering lords into two clearly identified armed factions, that of the duke of York and that of Queen Margaret— "Yorkists" and "Lancastrians" in the nomenclature of a later day.

In July, John Paston's brother William wrote him:

> And as for tidings, the duke of Somerset is still in prison, in worse case than he was. Sir John Fastolf recommends himself to you, etc. He will ride toward Norfolk as on Thursday, and he will dwell at Caister, and [Stephen] Scrope with him. He says you are the heartiest kinsman and friend that he knows. He would have you dwell at Mautby.[4]

Sir John Fastolf, in fact, had left his house at Southwark to spend the rest of his days at Caister Castle. There the old soldier lived in all the comfort and luxury the fifteenth century could bestow. An inventory made in 1448, after his wife's death, listed gowns of cloth of gold, velvet, and fine wool, some lined with silk or trimmed with fur; silk canopies; silk and velvet pillows; bedcovers embroidered with gold; and some forty costly tapestries; as well as bolts of damask, linen, velvet, satin, cloth of gold, and worsted. His gold and silver plate, worth some £2,500 in metal alone, most of it in safekeeping at St. Benet's Abbey near Caister, was elaborately fashioned, decorated with gilt and enamel and adorned with figures and heraldic beasts. Cash in the amount of £2,643 was also on deposit at St. Benet's.[5] He was said to "wear daily about his neck" a gold cross and chain valued at £200.[6] His finest jewel was "a great pointed diamond set upon a rose enameled white," incorporated into "a very rich collar called in English 'a White Rose.'"[7] This ornament, probably the most valuable jewel in England outside the royal treasury, had been bought by the duke of York for the large sum of 4,000 marks and was given to Fastolf by the duke partly as payment for a loan, partly as a reward for "the great labors and vexations" Fastolf had sustained as "the king's lieutenant in France and later in England."[7] (McFarlane remarks, "It is pleasant to think of Fastolf wearing round his neck a collar that had cost as much as his nine Suffolk manors.")[8] Another inventory made in 1450 listed his collection of hand-copied books in Latin, French, and English: several histories of England, *The Romance of the Rose,* a *Book of King Arthur,* and scientific and moral treatises.[9]

In accordance with Fastolf's wish, John Paston followed his client to Norfolk, where he divided his time between the Paston house in Norwich and the manor of Mautby, making occasional visits to London, usually on Fastolf's business. Letters to him from Margaret and Agnes ceased, as did his letters to them, but

Fastolf's messages to John increased, even though they lived only miles apart and conferred frequently.

At the moment, the matter that occupied Fastolf and his entire legal staff—John Paston, William Yelverton, and William Jenney—was a contest over wardship of a young relative, Thomas Fastolf. Wardships were valuable assets, giving their possessors control of inheritances and the right to sell the ward's marriage to interested parties. The boy's father, John Fastolf of Cowhaw, had chosen Sir John guardian, but Sir Philip Wentworth, a member of the queen's household, induced King Henry to grant the privilege to Wentworth's brother-in-law. Fastolf's fortunes in the litigation fluctuated with the political situation; with King Henry's collapse in 1453 and the rise of the duke of York, his legal team managed to have the wardship placed in friendly hands; Fastolf then purchased it. Wentworth made an attempt to kidnap the boy but accidentally carried off "another child like him," whom he took "two miles beyond Colchester," at which point the mistake was discovered and the child sent back.[10]

Fastolf thanked John Paston for his efforts in the wardship matter "right heartily. . . . I pray you to continue forth your good labors . . . though it cost me the more of my money." He then added a signal indication of his regard for John: "Certain of your well-willers" had suggested that "an alliance should take between a daughter of yours and the said ward, which motion I was right glad to hear of and will be right well-willing and helping that your blood and mine might increase in alliance"—that is, beyond the existing alliance through Margaret Paston.[11] The Paston daughter in question can only have been Margery, then about six years old. Thomas Howes expressed concurrence: "My master was glad when he heard that suggestion, considering that your daughter is descended of him on the mother's side." He warned John that "Geoffrey Boleyn makes great labor for mar-

riage of the said child to one of his daughters. I wish him well, but you better."[12]

The proposal went no farther. Meanwhile, several new attempts were made to arrange a marriage for John's sister Elizabeth, now about twenty-six, almost too old to be marriageable. Relations between her and Agnes were worse than ever, and she asked Margaret to enlist John's help. "She told me that she was sorry that she might not speak with you before you went," Margaret wrote her husband, "and she desires if it pleases you that you should give the gentleman that you know"—unnamed in the letter—"such language that he might feel that you would be well-willing to the matter . . . for she told me that he has said . . . that he conceived that you have set but little thereby. Wherefore she prays you that you will be her good brother, and that you might have a full answer at this time whether it shall be yea or nay."

Elizabeth's plight was not alleviated by her mother's attitude. Agnes spoke contemptuously of her daughter's prospects, saying that "she had no confidence [in the marriage project], but that it shall come as a joke," and advising poor Elizabeth that "there is good craft in daubing"—applying makeup. Agnes's language was such that "Elizabeth is right weary thereof. . . . She says her full trust is in you, and whatever you do therein, she will agree thereto."[13]

Whoever the prospect was, nothing came of it, and despite Elizabeth's readiness to welcome any suitor, one subsequent match after another fell through. An offer was made by Sir William Oldhall, chamberlain to the duke of York, a distinguished man but as old as Scrope. Again Elizabeth expressed herself as willing, and Agnes wrote, "If you think that his land stands clear . . . I hold me well content."[14] Nothing resulted. With John Clopton, a young lawyer, the negotiations got as far as the drawing up of a marriage settlement between Agnes and

the prospective groom's father, William Clopton of Long Melford; again the scheme fell through.[15] In July 1454 a member of the titled nobility, Lord Grey of Ruthin, offered John Paston "a great gentleman born, and of good blood," who turned out to be his lordship's ward, whom he was trying to sell to the highest bidder. The ward, however, proved intractable and wanted to make his own marriage arrangements.[16]

Scrope still remained unmarried, six years after his first offer. William Paston wrote from London that Sir John Fastolf wanted to "make a conclusion between Scrope and my sister. . . . Many wish it should not take place, for they say it is an unlikely marriage." London was experiencing one of its periodic visitations of the plague. William ended his letter, "Here is great pestilence. I propose to flee into the country."[17]

In December 1454, King Henry suddenly regained his senses. On 9 January following, Edmund Clere, a member of the royal household, wrote John:

> Blessed be God, the king is well amended, and has been since Christmas Day, and on St. John's Day [27 December] commanded his almoner to ride to Canterbury with his offering, and commanded the secretary to offer at St. Edward's [shrine].
>
> And on the Monday afternoon the queen came to him and brought my lord prince with her. And then he asked what the prince's name was, and the queen told him Edward, and then he held up his hands and thanked God therefor. And he said he never knew [about the child] until that time, nor knew what was said to him, nor knew where he had been while he had been sick until now. And he asked who were godfathers, and the queen told him, and he was well pleased.

Edmund Clere's letter continued:

> And my lord of Winchester [Bishop Waynflete] and my lord
> of St. John's [the prior of the Order of St. John of Jerusalem]
> were with him on the morrow after Twelfth Day, and he
> spoke to them as well as ever he did; and when they came
> out, they wept for joy.[18]

If the king's recovery brought tears of joy to some, it was less
favorable news to others. By terminating the Protectorate of the
duke of York, it precipitated a crisis. The duke of Somerset was
released from the Tower and returned to office, and a month
later (4 March 1455) the king revoked all the measures of the
Protectorate. Parliament was summoned for May, but without
new elections, and the duke of York's supporters were excluded,
while the duke of Somerset instructed his own followers to bring
their armed retinues. The duke of York, meanwhile, forged an
alliance with the powerful Neville family, headed by the earl of
Salisbury and his son the earl of Warwick, who wanted York's
help against their rivals in the North, the Percys of Northumber-
land.

Thus local feuds began to fuse with national political antago-
nisms, bringing the peril of civil war close; as one modern historian
puts it, "If Henry VI's insanity had been a tragedy, his recovery
was a national disaster."[19] The duke of York demanded that
Somerset be dismissed, and when the king refused, he assembled
his followers and their affinities in the north and west of the
country and marched on London, perhaps three thousand
strong. On 22 May they met the forces of Somerset at St. Albans,
northwest of London, in what turned out to be the first battle of
the Wars of the Roses. The clash took place in the streets of the
little town, did not last long, and produced only a few score
casualties, but it was nonetheless decisive: the duke of York was

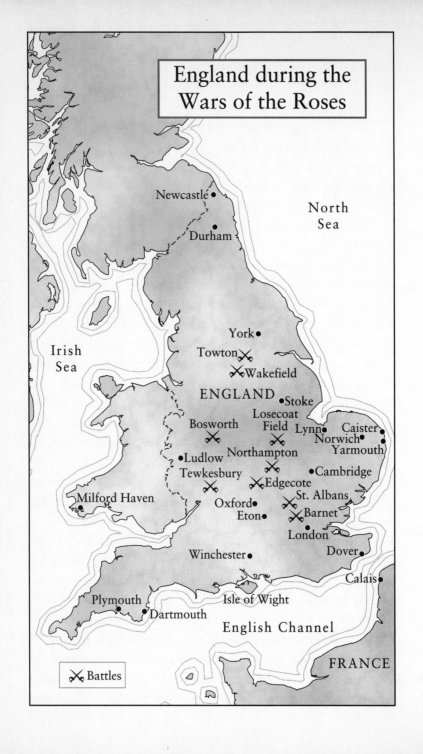

England during the Wars of the Roses

Newcastle

Durham

North Sea

Irish Sea

York
Towton ✗
✗ Wakefield
ENGLAND
• Stoke
Losecoat
Bosworth ✗ Field Lynn • Caister
✗ Norwich •
Ludlow Northampton Yarmouth
Tewkesbury • Cambridge
✗ ✗ Edgecote
Oxford St. Albans
Eton ✗ Barnet
Milford Haven
London
Winchester • Dover •

Calais •

Plymouth • Isle of Wight
Dartmouth
English Channel

FRANCE

✗ Battles

victorious and the duke of Somerset slain. King Henry, a passive participant, suffered a slight arrow wound in the neck.

Three days after the battle, John Crane, another Paston relative, wrote John Paston an account from Lambeth:

These three lords are dead: the duke of Somerset, the earl of Northumberland, and Lord Clifford. . . . Many [other lords] were hurt. . . . And as for the lords that were with the king, they and their men were pillaged and despoiled of all their harness and horses; and as for what rule we shall have now I do not know, save only that there are made certain new officers:

My lord of York [is made] Constable of England, my lord of Warwick is made captain of Calais; my lord Bourchier is made treasurer of England. . . .

And as for our sovereign lord, thanked be God, he has no great harm.[20]

The king returned to London in the company of the victorious Yorkists, who had taken care to insist that they were not fighting against him but against Somerset and his minions. A month later William Barker, one of Fastolf's men, sent William Worcester further details, including the fact that Sir Philip Wentworth, Fastolf's adversary in the wardship case, "was in the field and bore the king's standard, and cast it down and fled. My Lord Norfolk says he shall be hanged for it, and he deserves it. He is in Suffolk now. He dare not come near the king."[21]

Though no one guessed that St. Albans marked the opening of a prolonged, intermittent conflict over the royal power, the small battle exhibited the main characteristics of the Wars of the Roses: private armies mobilized extemporaneously and retained for very brief campaigns.

The duke of York ordered a new Parliament elected to meet

in July (1455). John Paston again entertained thoughts of offer-
ing his candidacy as a knight of the shire but again had to with-
draw precipitately on receipt of a letter from the duchess of
Norfolk: "As our special trust is in you, [we hope] you will give
and apply your voice to our right well-beloved cousin and ser-
vants, John Howard and Sir Roger Chamberlain."[22] John Jenney,
a friend of John Paston's, wrote him reporting that he had told
the duke of Norfolk that some voters objected to Howard as an
outsider, without property in Norfolk, and would have preferred
John Paston. The duke expressed his concern lest Sir Thomas
Tuddenham, or someone else of the duke of Suffolk's party, win
election. Jenney added a shrewd comment: "Some men hold it
right strange to be in this Parliament, and methinks they be wise
men that do."[23]

Such proved the case when King Henry again lapsed into
depression and the rift between the queen and the duke of York
widened. "The queen is a great and strong-labored woman,"
wrote Fastolf's agent John Bocking to his master (February
1456), "for she spares no pain to sue her matters to an intent and
conclusion to her power."[24]

Fastolf took a special interest in events at court and in Parliament
in the light of his claims against the Crown. McFarlane com-
ments, "Though he owed much to the Lancastrian dynasty, all he
cared to remember as he and it sank together into the grave were
the debts it had not paid him."[25] Yet he had real grievances.
These, being pursued by John Paston, included damages done
him by the duke of Suffolk, his losses in France, loans to the
king, and claims against the estate of the old regent, the duke of
Bedford. Fastolf wanted Parliament to pass a bill authorizing the
sale of lands Bedford had acquired by purchase, since these
would be unencumbered with family claims.[26] John Paston's ser-
vice became more and more important, as William Worcester

made clear in a series of letters in which lighthearted (if academic) banter alternated with serious communication.

Fastolf's demands were not confined to legal and financial problems; he was concerned about his unpopularity. To his alleged cowardice at Patay were now added charges of avarice and cupidity. Once he heard of "scornful language of me" voiced at a dinner in Norwich at which John Paston had been present: "Where shall we go to dinner? To Sir John Fastolf's—only he will make us pay for it!" Fastolf urged John Paston to

> give me knowledge by writing . . . what gentlemen were present. . . . And I shall keep your information . . . secret, and with God's grace so purvey for them as they shall not all be well pleased. At such a time a man may know his friends and his enemies asunder.[27]

William Worcester wrote John, urging him to

> be as soon as you may with my master to ease his spirits. He questions and disputes with his servants here, and will not be answered nor satisfied . . . for it suffices not our simple wits to appease his soul; but when he speaks with Master Yelverton, you, or with William Jenney and such others as are authorized in the law . . . he is content and holds himself pleased with your answers and motions. . . . So would Jesus, one of you three . . . might hang at his girdle daily to answer his matters.

He concluded wryly, "I had but little to do when I scribbled this note."[28]

That John was becoming Fastolf's principal reliance was clear to Worcester. "He emboldens himself to write you for the great love and singular affection he has in you above all others in

speeding his causes," Worcester wrote on 27 January 1456.[29] In May, Fastolf expressed the same sentiment in nearly the same words: "Although my writings put you many times to great labor and business, I pray you to take it that I do it for the singular affection and faithful trust unto you."[30] On another occasion he thanked John "for the great labor and pain that you daily take upon you for the good speed and advancement of my chargeable matters, as I know and feel right well. And I feel well that I was never beholden so much to any kinsman of mine as I am to you, who tenders so much my worship and my profit."[31]

Such approval did not extend to other members of Fastolf's staff, who felt discontented and unappreciated. Henry Windsor, one of the corps of agents, begged John Paston not to let Fastolf hear of an error Windsor had made in handling the case of Thomas Fastolf's wardship. Quoting Scripture (in Latin) to John to remind him of Christian forgiveness, Windsor wrote, "It is not unknown that cruel and vengeful [Fastolf] has ever been, and for the most part without pity and mercy." Nevertheless, "I shall be his servant and yours until such time as you will command me to cease and leave off."[32] Thomas Howes also complained, writing John Paston an angry, incoherent letter about his master's inconsistent behavior in the matter of the wardship but concluding, "I shall not leave this master to serve the worst enemy that he has in England. I want none of his wealth. I would liever other men go to the devil for his wealth than I."[33]

Even William Worcester, unfailingly loyal and diligent, was unhappy. When things went wrong, he told John, he was blamed; when they went right, others took the credit. "I never bore my master's purse nor conducted an important matter of his in law," he went on, "for my discretion and craft know not what such matters mean. I never knew anything of oyer or terminer, nor read patent before, nor did my master know the conduct of such things, and when he wrote of his grievances to his friends,

he commanded no man to be indicted, for he knew not what belonged to such things, nor the parson [Howes] neither, but remitted it to his learned counsel." He recalled occasions on which Fastolf had lost land or money because of ignorance of legal maneuvering. Ought he not to take the blame, along with Thomas Howes? He concluded the letter: "I am eased of my spirits now that I have expressed my lewd [foolish] meaning, because of my fellow [Fastolf agent William] Barker, as of such other barkers at the moon, to make wise men laugh at their folly" (12 October 1456).[34]

As time went on, he became much concerned about the inefficient management of Fastolf's property and household, writing John (20 April 1457):

> You urged a good matter to the parson [Howes] and to me at your last being in Caister, that my master should learn what his household stands upon yearly . . . and, that done, then to see by the revenues of his yearly livelihood what may be laid and assigned out of that to maintain his said household, and, over that, what may be assigned to [his lawsuits, alms, and other charges]. . . . My master cannot know whether he goes backward or forward till this be done.[35]

A week later he returned to the subject. Among other things, the auditors should "faithfully and plainly inform my master . . . of the truth of the yearly great damage he bears in disbursing his money on ships and boats and keeping a house at Yarmouth to his great expense," as well as his dealing in grain and wool. Where formerly "my master was wont to lay up money yearly at London and Caister . . . now the contrary—*de malo in peius* [from bad to worse]." He closed the letter, "I pray you and require you keep this matter to yourself."[36]

But one question above all others loomed in Worcester's

mind: Fastolf's will. The old man had no direct heirs to his large fortune. His wife Millicent had died without bearing him children; her son Stephen Scrope had his own fortune and moreover was not on the best of terms with his stepfather. Fastolf's own illegitimate son William, a Benedictine monk, had died after a career in the Church in Normandy.

The subject had been on Fastolf's own mind for some time. In January 1456, Worcester had written John, "My master demands of me sundry times when you shall be here. . . . I asked leave to ride into my country, and my master did not grant it; he said his will needed to be made. God give him grace of wholesome counsel and of a good disposition; *non est opus unius diei, nec unius septimanae* [it is not the work of a day nor of a week]." He recalled that the duke of Bedford's will had been so hastily drawn and couched in "so brief and general terms that unto this day, after twenty years, it cannot be brought to an end, but is always open to new construction and opinion." He himself, he concluded, had "said no word, for I cannot meddle in high matters that go beyond my wit; and therefore if you and W. Jenney meet together, you know and can divine best what is to be done."[37]

Free of the family obligations that had troubled Judge William Paston in a similar task, Fastolf had set his heart on an enterprise for his own salvation, similar to Judge William's perpetual chantry but on a larger scale: the foundation at Caister of a "college"—not an educational institution but a philanthropic and religious one—maintained by income from certain of his estates. There prayers would be said perpetually for his soul and for the souls of his parents, kinsfolk, and benefactors.

The plan presented serious difficulties. Most important, a royal license had to be obtained to grant land to a religious body. Securing such a license required much "laboring" even in normal times, but in the king's current mental state it promised to be

especially difficult. Fastolf wrote John Paston (November 1456), "I am sore set upon and that is why I write now, to remind you again [about] the license to be obtained, that I might have [it] without a great fine, in recompense of my long service . . . to the king and to his noble father, whom God assoil." He called on John to "make you and me known to a chaplain of my lord [the archbishop] of Canterbury . . . likewise to my Lord Chancellor [Bishop Waynflete]."[38]

While John Paston devoted himself to Fastolf's problems, wife Margaret and mother Agnes busied themselves with the family's own affairs, foremost among which was still the marriage of Elizabeth. She had been sent to London to live with a "Lady Pole," possibly the wife of Sir Thomas de la Pole, a cadet of the Suffolk de la Poles. A list of errands drawn up by Agnes Paston in January 1458, to be executed in London (presumably by William Paston II), ordered payment to Lady Pole of 26s. 8d. for Elizabeth's board and included the impatient injunction, "Say to Elizabeth Paston that she must use herself to work readily, as other gentlewomen have done, and somewhat to help herself therewith."[39]

Elizabeth evidently followed her mother's advice, for that same year she married Robert Poynings, Jack Cade's sword-bearer, the man who had twice saved Fastolf's servant John Payn from the rebels in 1450. A younger son of the nobility, Poynings had been embroiled in a long-running land dispute with the powerful Percy family of Northumberland, a feud that may have been related to his joining the rebellion. In the aftermath he had spent time imprisoned in the Tower and in Kenilworth Castle, but when the battle of St. Albans changed the political climate in favor of the rebels, he was freed.[40]

The conclusion of the marriage did not end all difficulties for Elizabeth. In January 1459 she wrote her mother a letter so obse-

quious in tone as to suggest irony, but apparently Elizabeth was merely trying to persuade Agnes to fulfill the terms of the marriage agreement.

> Right worshipful and my most entirely beloved mother, in the most lowly manner I recommend me unto your good motherhood, beseeching you daily and nightly of your motherly blessing, evermore desiring to hear of your welfare and prosperity, which I pray God to continue and increase to your heart's desire. . . . As for my master, my best beloved, as you call him, and I must needs call him so now . . . he is full kind to me, and is as busy as he can [be] to make me sure of my jointure.

Poynings had given his bond for a thousand pounds to Agnes, John, and William II, as guarantee that he would produce the jointure. But the family had failed in its payments on Elizabeth's dower, making it difficult for him to meet his own installments on the bond.

> Wherefore I beseech you, good mother, as our most singular trust is in your good motherhood, that my master, my best beloved, fail not of the hundred marks at the beginning of this term, the which you promised him to his marriage, with the remnant of the money of father's will.

Lady Pole had also not been paid for "all the costs done to me before my marriage," and Elizabeth prayed that Agnes would "be my tender and good mother that [Lady Pole] may be paid."[41]

Second only to Elizabeth's marriage as Agnes's concern was the education of her youngest son, Clement, sixteen in 1458 and, after a period at Cambridge, studying law in London at an Inn of

Chancery. Agnes monitored his progress from Norwich. In the same list of errands that included payment of Elizabeth's board with Lady Pole, she wrote William:

> Pray Greenfield to send me faithfully word in writing how Clement Paston has done his duty in learning. And if he has not done well, or will not amend, pray him that he will truly belash him, till he will amend; and so did the last master, and the best that ever he had, at Cambridge. And tell Greenfield that if he will take it upon him to bring him into good rule and learning, that I may verily know he does his duty, I will give him ten marks for his labor, for I had liever he were fairly buried than lost for default [of discipline].

She was also concerned about his clothing.

> Item: to see how many gowns Clement has, and those that are [thread]bare, let them be raised [the nap teased]. He has a short green gown and a short musterdevillers gown that were never raised; and a short blue gown that was raised and made out of a long gown when I was last in London; and a long russet gown, furred with beaver, was made two years ago this time; and a long murry [purple] was made this time twelvemonth. And if Greenfield has done well his duty to Clement, or will do his duty, give him a noble.[42]

As the king continued to alternate between lucidity and mental collapse, characterized by depression and withdrawal, England became increasingly polarized between the "Lancastrian" party of the strong-willed queen, Margaret of Anjou, and the "Yorkist" party of Richard, duke of York. In December 1458 the queen's party was reported to be in the process of arming, and in April 1459 it convened a meeting of the royal council to take

place in the Lancastrian stronghold of Coventry in June. The
duke of York was pointedly not invited.

Taking alarm, the duke sent out an urgent call to his own
supporters, foremost among whom was the earl of Warwick,
captain of the Calais garrison, the country's only standing armed
force. Warwick was able to furnish a six-hundred-man contin-
gent of professional soldiers under the command of Andrew

Schoolboys being disciplined. *(British Library, MS. Burney 275, f.94)*

Trollope, an experienced officer. But apparently Warwick failed to brief Trollope adequately on the situation: when the two armies confronted each other at Ludlow, in the West, in October, Trollope defected with all his men. Announcing, somewhat disingenuously, that he had expected to be engaged only in a fight among the nobility and not one against the king, he declared his intention of joining the king's side. The rest of the Yorkist army at once disintegrated, everyone heading for home in the "rout of Ludlow" (12 October 1459). York himself fled to Ireland, where he had estates and friends.

Friar Brackley, Fastolf's confessor and John Paston's friend, wrote John describing the aftermath of the Yorkist fiasco. "A lewd [foolish] doctor of Ludgate preached on Sunday a fortnight ago at St. Paul's" a sermon attacking the Yorkists, "and he had little thanks, as he deserved." All the old gang of the duke of Suffolk's supporters were appointed commissioners of the peace, with powers to arrest and punish Yorkists and seize their lands. Among them were John Wyndham, John Heydon, Thomas Tuddenham, and Philip Wentworth, all enemies of the Pastons and Fastolf, with powers "to take traitors and send to the nearest gaol all persons favorable and well-willing" to the duke of York. John Paston was not among the commissioners, "for you are held favorable" to York. Furthermore, "Lord Scales is [gone] to my Lord Prince [Edward, Prince of Wales] to wait on him, etc. . . . By my faith, here is a cosy world." The friar concluded with a volley of scriptural quotations in Latin meant to comfort John, notably, "Fret not thyself because of evildoers, neither be thou envious against the workers of iniquity; for they shall soon be cut down like the grass, and wither as the green herb"—a prescient forecast.[43]

On 1 June 1459, William Worcester reported that Fastolf was ill with asthma and "a hectic fever,"[44] and on 14 June the old sol-

dier at last made his will. A lengthy document, it named ten executors, including distinguished outsiders Bishop Waynflete, Lord Beauchamp, and the abbot of Langley; Fastolf's nephew Henry Filongley; a clergyman named John Stokes; and trusted members of his own staff: John Paston, Friar Brackley, William Yelverton, William Worcester, and Thomas Howes.

Foremost among the will's provisions was the establishment of the college at Caister, to be constituted by the prior of St. Benet's Abbey and six monks of that order, and "seven poor men" who were "to pray for my soul and for the souls of my father and my mother, and of all my kinsfolk and good-doers, and for the souls of the blessed memory of Kings Harry the Fourth and Harry the Fifth, and the noble duke [of Bedford]," and for the present king "during his lifetime and after for his soul, and for all Christian souls," in daily divine service and perpetual prayers.

Income was also assigned for other purposes: prayers for the soul of Fastolf's father in the parish church of St. Nicholas of Yarmouth where he was buried; a tithe of the yearly value of any of his "lordships, manors, lands, tenements, and rents" to go to the churches and poor people of such places; prayers for his own soul and that of his wife Millicent in the abbey church of Langley founded by Millicent's ancestors; for his mother Mary in the church of Attleborough; and for deceased servants, friends, and kinfolk—his sister Margaret Branch and her husband Sir Philip "that died and was slain in France"; Fastolf's stepfather John Farwell; his old friend and comrade-in-arms Sir Harry Inglose; Sir Hugh Fastolf "that died in Caen in Normandy"; Fastolf's nephew Sir Robert Harling "that was slain at the siege of St. Denis in France"; John Kirtling, "my right trusty chaplain and servant domestical thirty winters and more"; and others.

His household was to be kept together for six months (a common practice) and his servants paid six months' wages. The

vestments and ornaments of his chapel, "garments of silk or velvet, robes, and my gowns," were to be given to "the monastery church of St. Benet's, where I shall be buried," with a "reasonable and a competent part of said relics and ornaments [to] be kept and given to the said college to be made at Caister." A "convenient stone of marble [graven with] a flat figure, after the fashion of an armed man"—one of the stock figures on tombs—was to be erected over the grave of his father, "with the escutcheons of arms of him and his ancestors, with an inscription on the stone making mention of the day and year of his death"; his mother's grave in the parish church of Attleborough was to be covered with a similar stone, with the equally conventional figure "of a gentlewoman in her mantle, with an inscription in Latin" and the escutcheons of her three husbands.

To carry out the provisions of the will, the executors were instructed to sell all of Fastolf's properties except those designated to provide for the college. They were to pay his debts, making restitution for any wrongs he had committed (another standard clause in wills), and relieve the condition of "such of my consanguinity and kindred who are poor and have but little substance to live by." Particular consideration was prescribed for his cousin Robert Fitzralph "for his good, true, and long service to me," but no specific bequests were made to any living person. The remainder of the proceeds were to be used "for my soul and for the souls before mentioned, as [the executors] shall think best to the pleasure of God."[45] Thus the disposition of a large part of the estate was left to the discretion of the ten executors.

On 3 July 1459, Fastolf wrote what proved to be his last letter to John Paston, reminding him of several pending problems and concluding with an injunction to "think upon all other matters that I cannot write easily now."[46]

Three months later, on 2 October, he made a startling move. He signed over all his movable goods to John Paston and

Thomas Howes, in what appears to be anticipation of the "deathbed bargain" he was soon to make with John Paston.[47]

John Paston's later explanation of the dying man's decision was that Fastolf was under pressure from a trio of great lords— "Viscount Beaumont, the duke of Somerset, and the earl of Warwick"—who proposed to buy Caister. Afraid that his executors would sell the property rather than establish the college there, and since no license had yet been obtained from the king, Fastolf felt, according to John, that "the whole foundation of the

Ruins of St. Benet's Abbey, burial place of Sir John Fastolf.
(Hallam Ashley)

college hung in doubt," and therefore "he desired to make the said bargain with John Paston hoping that he would have a genuine wish to complete the said college and would keep it from falling into the hands of the lords."[48]

In late October or the first days of November, Friar Brackley wrote an urgent letter to John, who was apparently in London:

> Right reverend master, as soon as you goodly may, come to Caister, and [William] Yelverton with you . . . and by grace of God and your politic wisdom, you shall conclude more effectually in great matters of substance to my master's and your worship and profit. It is high time; he draws fast homeward, and is brought right low, and sore weakened and enfeebled.

John should bring with him a petition to the king for the indispensable license, drawn up in London by "Mr. R. Popy"— Robert Popy, a clerk who had assisted in drawing up the will.

> God bring you soon hither [Brackley wrote] for I am weary till you come. . . . Every day this five days [my master] says, "God send me soon my good cousin Paston, for I hold him a faithful man, and ever one man [reliable]." *Cui ego* [to which I], "That is sooth," etc., *et ille* [and he], "Show me not the meat, show me the man."[49]

What happened in the days immediately preceding Fastolf's death was the subject of several "inquiries post mortem" over the next few years. From the recorded testimony emerges an arresting picture of the intimate activity of a rich man's household while the master lay dying: men arriving to collect money owed them for barley, entering the hall at eight A.M. to find the servants at breakfast; horses being shod; the porter on duty at the

gate; the barber coming to shave the sick man; two men dis-
patched to Yarmouth with a cartload of malt; the washerwoman
sending her son to deliver clean linen; a young *agricultor* (farmer)
dispatched by his father to deliver capons to the purveyor of vict-
uals for the household. A distant relative, a tailor named Richard
Fastolf, came down from London and found the dying man tot-
tering about his chamber on the arms of two servants. The tailor
begged for money to enable him to marry, but "Sir John made
answer that he had within a few [days] made his will, which he
would not alter," and that "it contained no such provision."

A smith named John Monk who had been "frequently in Sir
John's chamber" on the Friday and Saturday (2 and 3
November) before his death recalled that

> he was so weak for want of breath that he could not speak
> distinctly; those about him could not hear what he said with-
> out inclining their ears to his mouth, and even then they
> could barely understand him. When people spoke to him to
> comfort him in his illness he only answered by sighs. . . .
> Moreover, Sir John was accustomed when in health daily to
> say certain prayers with his chaplain, but on that day the
> chaplain said the service alone, while Fastolf lay on his bed
> and said nothing.[50]

Monk's description of Fastolf's condition was significant,
bearing as it did on the dying man's ability to revise his will.
This, according to John Paston, he did, and radically. On 3
November, Fastolf dictated a new will that made John his princi-
pal executor, seconded only by Thomas Howes. In return for a
payment of 4,000 marks to the other executors, in biennial
installments of 800 marks, John would have all Fastolf's manors,
lands, and tenements in Norfolk and Suffolk, "there to dwell and
abide and keep household." The inheritance was limited only by

provision for the college at Caister, now simplified to seven priests or monks and seven poor men, and by the bequests to Fastolf's servants and to charity. If John was unable to found the college at Caister Castle, the revised will stated, he should "have the said mansion pulled down, every stick and stone thereof, and the said seven priests or monks established three at St. Benet's, one at Yarmouth, one at Attleborough, and one at St. Olav's church in Southwark."* Fastolf "said and declared that John Paston was his best friend and helper and supporter." The other eight executors were demoted to the status of advisers.[51]

Two days later (5 November), the old knight died.

Was the smith bribed to exaggerate Fastolf's helplessness? Corroborating the provisions of the will was testimony given by Fastolf's cousin Robert Fitzralph on 24 November. Fitzralph said he had been present in Fastolf's chamber, "leaning upon the great bed," and had heard the dying man

> appoint and conclude that the said John Paston should take upon him the rule of my master's household and of all his livelihood in Norfolk and Suffolk during his life; and after his decease the said John Paston should cause to be founded a college at Caister of seven monks or priests . . . and the said John Paston should have all the livelihood that was my said master's in Norfolk and Suffolk to him and his heirs. . . . And after this matter had been stated, my master said these words, "Cousin, I pray you and require you, let this be settled in all haste without tarrying, for this is my very last will."

Fitzralph added, "Also be it known to all men that I had knowledge of this bargain divers times this past half-year, and how my

*Adding up to six—Fastolf apparently forgot one priest or monk.

said master Fastolf and the said John Paston were near a conclusion of the said matters a quarter of a year before this last bargain was made."[52]

Despite Fitzralph's testimony, the circumstances of the new will provoked a violent reaction, mainly from William Yelverton and William Jenney, who suddenly found themselves deprived of their powers as executors. Who, they demanded, had written down Fastolf's last wishes? Were they put on paper while he was still alive? Who were the witnesses? How had the document been sealed? Was it in English or Latin? How and where were the copies left? At inquisitions held in the years 1464 through 1466, John Paston stated that he and Friar Brackley had copied down Fastolf's corrections to his will of 14 June and that the ink of the last lines had been dried by scattering ashes over them, in the presence of Thomas Howes. John had not used Fastolf's signet ring to seal any document; it had remained on the dying man's finger and afterward had been locked in a box in the presence of witnesses. Friar Brackley kept copies of the will of 14 June and its corrections as long as Fastolf lived "and a year after," and John himself had also kept copies.

On the evening of Fastolf's death, John and Thomas Howes had been sitting at table in the hall at Caister when William Worcester, who had not been present at the deathbed, appeared. "Rising from supper," the two men had discussed the matter with him and had subsequently entrusted him with a copy of the new will. Shortly afterward, the document was transcribed on parchment.[53]

The truth about Fastolf's last will cannot be extracted from the angry flood of charges and countercharges of bribery and perjury that followed. Some facts, however, weigh in John's favor: a number of people coveted Caister, as subsequent events showed, threatening Fastolf's college; the college was a project close to the

old knight's heart; and John Paston afterward did everything in his power to carry it out. Colin Richmond concluded in 1990 that "against my instinct and almost against my better judgment, [John] gets the benefit of the doubt."[54]

The one certainty is that Fastolf's final testament brought the Paston family wealth and status but, along with them, troubles that lasted long after John's death.

Chapter 7

THE FASTOLF WILL CONTESTED

1459–1465

ohn Paston wasted no time in asserting his claims and enlisting aid to vindicate them. Fastolf had been dead less than a week and was not yet buried when John went to work in Norfolk, while his brother William sought out influential friends in London who could facilitate matters.

In company with William Worcester, William Paston paid a call on Chancellor Waynflete, bishop of Winchester and a Fastolf executor, reporting to John (12 November 1459), "I found him right well disposed in all things." Waynflete advised William to tell John "to gather [Fastolf's] goods together . . . and lay them secretly where you thought best at your discretion" until the bishop could speak to John himself, "and he said you should have all lawful favor." Richard Southwell, escheator for Norfolk and

Suffolk—the royal officer who held inquiries over inheritances—was also well disposed toward John, as was the archbishop of Canterbury, in whose Church court the will might be challenged.

But there were danger signals. William was advised to "put no trust" in the Lord Treasurer, the earl of Wiltshire, whose officials were busy searching for a legal excuse to seize Fastolf's property for the Crown. Another noble enemy, the duke of Exeter, had his eye on the house in Southwark.[1]

More immediate trouble lay close to home, among Fastolf's former officials and servitors. Principal among these was William

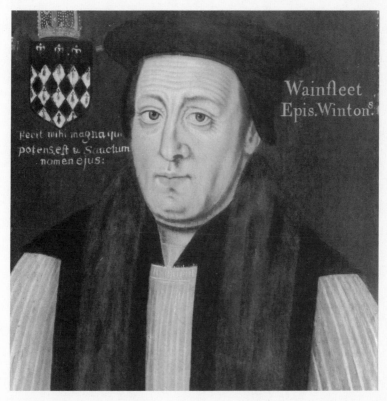

William Waynflete, Bishop of Winchester. *(Eton College Library, Courtauld Institute of Art)*

Worcester, who quite reasonably expected to be rewarded for his lengthy and arduous service to Fastolf.

> I doubt not [William wrote John] if he may verily and faith-fully understand you [well] disposed toward him, you shall find him faithful to you in like wise. I understand by him he will never have another master after his old master, and to my mind it were a pity if he is not treated so that he should never need [to do] service again, considering how my master trusted him, and the long years that he had been with him, and the many hard journeys for his sake.[2]

Unfortunately, John did not see fit to take the advice. Worcester became a man with a grievance, his chief complaint at the moment the money he had spent out of his own pocket after Fastolf's death and the refusal of "the lawyers" (meaning John Paston) to reimburse him. They had "estranged themselves from me," he wrote a friend, "and mistrusted me." Yet he had been "one of the chief that kept both ... Paston and my uncle [Thomas Howes] in my master's favor and trust." Fastolf had "granted me a livelihood according to my degree, that I, my wife, and my children, should have cause to pray for him. And because I demanded my right and duty of Master Paston, he is not pleased." Unless the situation were repaired, "all the world shall know" the great wrong that had been done him.[3]

John spent Christmas in London pursuing his legal affairs, while Margaret, at home in Norwich, worried about possible criticism of the family on grounds of the etiquette of mourning. She sent their eldest son to inquire of Lady Morley, a wealthy and noble widow, "what sports were used in her house on the Christmas following the decease of my lord her husband." Lady Morley replied that "there were no disguisings [theatricals] nor harping, nor luting, nor singing, nor loud disports [games], but

playing at the tables [backgammon], and chess and cards. Such games she gave her people leave to play and no other." Margaret noted that seventeen-year-old John II had done his errand well and had comported himself creditably. She had afterward sent her second son, John III, to Lady Stapleton, who echoed Lady Morley's advice. Margaret concluded, "I am sorry that you shall not [be] home for Christmas. I pray that you will come as soon as you may. I shall think myself half a widow. . . . God have you in his keeping."[4]

In early April 1460, Friar Brackley, who had remained friendly to the Pastons, reported another disaffection. Justice William Yelverton and his wife had called on the friar, and Yelverton, having "eaten and drunk enough" at dinner, launched into a torrent of complaints against John, accusing the friar of bias in John's favor: "I have seen the day when you loved me better than him, for he never gave you cause of love as I have done." Brackley replied, "Sir, he has given me such cause as I am beholden to him for." More angry words followed, and Yelverton went so far as to tell the friar that "the Lords in London are informed about you, and they shall deal with you well enough." To which Brackley retorted (according to his own account): "I shall not be afraid to say what I know for any lord of this land." The prior of Brackley's monastery, who happened to be present, expressed regret at the falling-out between two former friends and colleagues like Yelverton and Paston, to which Yelverton replied, "No man is trying to bring us together, so I can only think it is of little importance," perhaps a tentative overture toward compromise. Neither Brackley nor the prior responded. Meanwhile, Brackley told John, Yelverton continued daily to spread slander about him.[5]

A month later came still another defection. "I spoke this day with [Fastolf agent] John Bocking," William Paston wrote John at Caister.

He had but few words, but I felt by him that he was right evil disposed to the parson [Howes] and you, but he had but covert language. . . . I understand that this Bocking and Worcester have great trust in their own lewd conceit. . . . Bocking told me this day that he stood as well in favor with my master Fastolf three days before he died as any man in England. I said I supposed not, nor three years before he died. I told him that I had heard divers reports of his statements . . . and he swore that he never talked with any man in any matter against you. It is he that makes William Worcester as bold as he is.

William went on to suggest that Robert Inglose, son of Fastolf's old comrade-in-arms Sir Harry Inglose, would make a good witness in the inquiry about the will, "even though he witnessed no more than that [Fastolf] had his wits." The Pastons' friend James Arblaster also was "right faithfully disposed toward" John and "would do much good if he goes to London, for he can labor well among the Lords. . . . It is full necessary to make you strong by lordship and other means." What the other means were he indicated in a Latin postscript: *"Omnia pro pecunia facta sunt"*—All things are done for money.[6]

In the year following Fastolf's death (1460), John and Margaret affirmed their new position by financing a large-scale repair of St. Peter Hungate, the Norwich church near their Elm Hill house, rebuilding it, in the words of Francis Blomefield, "as a neat building of black flint." The date of reconstruction appears on a buttress near the north door. A tree trunk without branches symbolizes the dilapidation of the old church, while a branch springing from the root represents the new building.[7]

During the summer of 1460 the national political course took another abrupt turn, with some favorable consequences for the Pastons. Since the bloodless "rout of Ludlow" the previous October, the struggle for control of the government had resumed. On 26 June the earl of Warwick recrossed the Channel, landing at Sandwich with a part of the Calais garrison. Reinforced by Kentish volunteers, he entered London on 2 July. A few days later, Lancastrian and Yorkist affinities clashed again on the battlefield at Northampton; this time part of the Lancastrian army changed sides, and the Yorkist victory turned into a rout. Warwick gave his troops the word to spare the common folk among the enemy but cut down "everyone in coat armor"—the Lancastrian nobility and gentry—the beginning of a

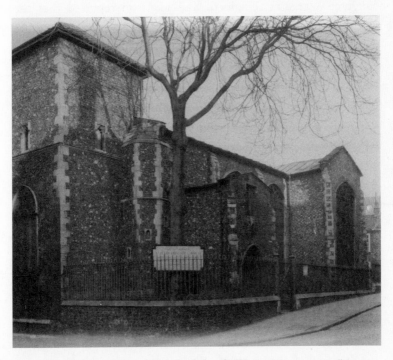

St. Peter Hungate, Norwich, rebuilt by the Pastons in 1460 as "a neat building of black flint." *(Hallam Ashley/Castle Museum, Norwich)*

ferocious policy that sharply differentiated the Wars of the Roses from the Hundred Years War, where ransom of noble prisoners was the rule.

In October, an advance party preparing the return of the duke of York from Ireland sought suitable lodging in London for the duchess, released from captivity at Wallingford, while she awaited the arrival of her husband and children. A house was found in Southwark: Sir John Fastolf's old mansion, now the property of John Paston. Christopher Hansson, John's agent, assured the duchess, in John's name, that she and her children could stay "till Michaelmas"—the following September. The duchess herself was soon summoned by her husband to meet him in Hereford, but two of the sons, George and Richard, and the daughter Margaret remained, and Hansson reported that the duke's eldest son, the earl of March, "comes every day to see them."[8]

When the duke of York himself finally entered London it was with processions, trumpets blowing, and banners flying. The banners produced a sensation. Instead of his own arms of York, the duke displayed the arms of England, announcing his claim to the throne on the basis of his royal descent and his followers' battlefield victory.

Though the Pastons had never openly proclaimed themselves Yorkist, they were so labeled by popular opinion because of their troubles with the duke of Suffolk, pillar of the Lancastrian dynasty. John now at last stood for Parliament and was elected at the shire meeting.

Early in October 1460, Friar Brackley wrote to congratulate John and wish him well:

You have much to do; God speed you. You have many good prayers, of the convent, city, and country. God save our good lords, Warwick, all his brothers, Salisbury, etc. . . . and

preserve them from treason and poison . . . for if aught come
to my Lord Warwick but good, farewell you, farewell I, and
all our friends![9]

From Hellesdon, where she was now living, Margaret wrote
John a long letter about the local progress of his claim on
Fastolf's lands. The undersheriff and the underescheator had held
"a great day"—a hearing—at Acle, and her cousin John Berney
of Reedham had been present, "and divers other gentlemen and
thrifty [respectable] men of the country; and the matter is well
sped after your intent (blessed be God)." All his wool had been
sold, at a good price. Three horses had been bought for him at St.
Faith's Fair, "and all be trotters, right fair horses." His mills at
Hellesdon had been leased for 12 marks, the miller to pay for
their repair, "and Richard Calle has let all your lands at Caister."
As for politics, the people were well disposed toward the duke of
York and the earl of Warwick: "They have no fear here but that
[Warwick] and others should show great favor to them that have
dwelt in this country for a long time."

Finally, a sign of the Pastons' new prestige, she reported that
the mayor and mayoress of Norwich had invited themselves to
dinner at Hellesdon. In order not to trouble their hostess they
had sent their dinners on ahead. "I am beholden to them," she
wrote, "for they have sent to me divers times since you went
hence. The mayor says that there is no gentleman in Norfolk that
he will do more for than he will for you, if it lie in his power."[10]

As Parliament met in October, a shaky compromise was worked
out between the king and the duke of York: Henry would remain
king, but the duke of York would again be made Protector of the
Realm, with broad powers and the right to succeed to the throne.
The solution disinherited six-year-old Prince Edward, son of
Henry and Margaret. King Henry, more and more of a cipher,

did not object, but Queen Margaret, more and more of a power, did. Before the year 1460 was out, she had an army in the field, or rather two armies, one in the North and one in the West. The Northern army scored a fortuitous success, of a kind not uncommon in medieval warfare, where leaders joined in the melee along with everyone else. At Wakefield (30 December 1460), Queen Margaret's army not only defeated a force led by the duke of York, it killed the duke himself. Suddenly the whole conflict seemed to be resolved in favor of Queen Margaret and the Lancastrians.

But the Yorkists had another string to their bow, in the person of York's son, the nineteen-year-old earl of March, who defeated the Lancastrian force in the West and marched toward London. The city was in a panic; Queen Margaret's Northern army, its ranks filled with Scots, notable fighters and pillagers, was marching south, sending a shock wave ahead of it.

Clement Paston, in London, wrote John in Norwich (23 January 1461), urging him to raise troops in Norfolk, "both footmen and horsemen." John should "come with more men, and cleanlier arrayed than others" for the sake of his reputation and what he had at stake. Volunteers from elsewhere were rallying to defend the city, Clement reported, "for the people in the North rob and steal, and are prepared to pillage all this country, and give away men's goods and livelihoods in all the South country." He concluded, "I pray you recommend me to my mother, and that I prayed her of her blessing. I pray you excuse me to her that I write her no letter, for this [letter] was enough to do."[11]

Whether John Paston responded to the appeal is not known (probably he did not), but Elizabeth Paston's husband Robert Poynings did, joining the earl of Warwick, commander of the Yorkist forces in the capital. On 17 February the earl met the queen's army at St. Albans, for the second time the scene of a battle. This time Warwick was defeated, and among the slain

was Robert Poynings. His death left Elizabeth in a precarious situation, her property threatened by the encroachments of the Percys of Northumberland. For a time she apparently kept her husband's fate secret, or perhaps was not certain of it; "she acts as though she knows not where he were," Thomas Playter, a former Fastolf agent, wrote John.[12]

But while panic again gripped London and Paston hopes sank, another of the war's strange unmilitary turns occurred. Queen Margaret spared the city by holding her army outside the walls, and in a few days most of her forces slipped away homeward, laden with loot. The earl of March, coming from his victory in the West, entered London unchallenged (26 February 1461) and henceforth called himself Edward IV.

London cheered the young, handsome new monarch, and did more; it responded to his request for money with a loan of £12,000, permitting him to recruit a powerful army, including a contingent of mercenaries from Burgundy, to pursue Queen Margaret in her retreat toward Lancastrian lands in the North. At Towton, near York, on Palm Sunday, 29 March 1461, the largest and bloodiest battle of the entire Wars of the Roses was fought, with Edward IV and the Yorkists victorious. An important role was played by the duke of Norfolk, who arrived at the head of his affinity at a decisive moment.

News of the battle reached John Paston in Norfolk by a circuitous route: Edward's dispatch to the city of London was read by William Paston on 4 April and the information forwarded to John in a letter signed by William and Thomas Playter that provides a unique though not entirely trustworthy source of details on the battle:

First, our sovereign lord has won the field, and upon the Monday next after Palm Sunday, he was received into York with great solemnity and processions. . . . Item: King Harry,

the queen, the prince, the duke of Somerset, the duke of Exeter, Lord Roos, be fled into Scotland and they be chased and followed.

On a paper pinned to the letter were the names of noblemen and knights killed in the battle and a grossly exaggerated count "numbered by the Heralds" of 28,000 dead commoners. Among

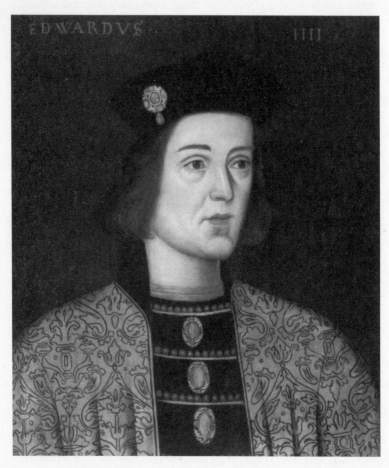

Edward IV. *(National Portrait Gallery, London)*

the dead knights was Sir Andrew Trollope, whose defection had caused the "rout of Ludlow."[13]

Elizabeth Poynings profited from the bloody battle by getting rid of two of her husband's Percy enemies: the new earl of Northumberland, slain on the field, and the earl of Wiltshire, also regarded as a Paston enemy, who was among those captured and beheaded, "his head set upon London Bridge," as Thomas Playter reported to John.[14] Elizabeth's troubles, however, were far from over; the widow of the earl of Northumberland promptly occupied the Poynings lands.[15]

The Pastons' prestige was enhanced by the Yorkist victory; unfortunately, so was that of the duke of Norfolk, who had long cast a covetous eye on Caister Castle. The duke no sooner returned from the battlefield than he arranged a "purchase" of the castle from a party of Fastolf executors headed by Justice William Yelverton. John Paston at once appealed to the new king and obtained letters addressed to the duke. Richard Calle, the Paston bailiff, carried them to the duke's castle at Framlingham, just across the Suffolk border. Calle was a natural emissary to choose; his family were shopkeepers in Framlingham, and it was the present duke who had recommended him to the Pastons' service. He was unable to speak to the duke, but he delivered the letters. The duke sent him a temporizing answer, saying that several would-be heirs had appealed to him for justice. He directed Calle to go home, as the bailiff reported to John Paston, "for other answer could I have none."[16] The duke sent an emissary to talk to the king and presently yielded, reserving the right to dispute John Paston's claim to Caister in the courts but giving up the castle. John Paston once more took possession.[17]

The king's coronation, scheduled for May, was delayed by a minor military action against a pocket of Lancastrian resistance

in the North; meanwhile John Paston learned that he was to be among those honored with knighthood at the coronation. Thomas Playter wrote a congratulatory letter; if John decided to accept the honor, "to the gladness and pleasure of all your well-willers, it is time to assemble your necessary gear . . . and also you must hie you to London, for I conceive the knights shall be made on the Saturday before the coronation."[18] But knighthood was widely perceived as more of an obligation than a benefit, involving as it did payment of a fee and liability for military service, and John refused the honor.

That spring he arranged for his eldest son, John II, to join the king's court. In June he himself was reelected to Parliament, summoned to meet in November. His election, however, was protested by his enemies, who included the new sheriff, Sir John Howard, a cousin of the duke of Norfolk. A new election was held, and when John Paston visited the shire house he got into a violent altercation with Howard, one of whose underlings tried to stab him. News of the affair reached John II, traveling with the king's household. "It is spoken here," he wrote his father from Lewes (23 August), "of how you and Howard strove together on shire day, and one of Howard's men struck you twice with a dagger, and you would have been hurt but for a good doublet [evidently leather armor]. . . . Blessed be God that you had it on."[19]

The young man's venture as a courtier was not going particularly well, at least in part because his father kept him short of money. On the same day that John II penned his letter from Lewes, John Russe, another former Fastolf agent, wrote John I that he had asked Chancellor Waynflete about the young man's progress, and the chancellor had spoken well of him; "he was well in acquaintance, and beloved with gentlemen about the king." In fact, the chancellor said, "Nothing shall hurt him but your straitness of money to him, for unless he has money in his purse, that he may reasonably spend among them, they will not

set store by him; and there are gentlemen's sons of less reputation that have money ten times more liberally than he has, and . . . Waynflete said it was full necessary for you to remember that."[20]

John heard the same message from the son himself:

I suppose you understand that the money I had of you at London may not last me until the king goes to Wales and comes home again. Wherefore I have sent to London to my Uncle Clement to get a hundred shillings from Christopher

John Howard. *(His Grace the Duke of Norfolk: Photograph, Courtauld Institute of Art)*

Hansson, your servant, and to send it to me by my servant, and my harness [armor] with it, which I left at London to be cleaned.

He added, "I beseech you not to be displeased . . . for I could make no other arrangement except borrowing from a stranger, one of my fellows, which I think you would not like to hear of later."

He assured his father that he was ceaselessly diligent in the family's interest. He had "labored daily my lord Essex [Henry Bourchier]," Treasurer of England, to intervene with the king about Dedham, one of Fastolf's disputed manors, speaking to him

> every morning before he went to the king, and often times [I] inquired of him if he had moved the king in these matters. . . . I prayed Baronners, his man, to remind him of it. . . . And now of late, I inquired if he had moved the king's Highness therein; and he answered me that he had . . . beseeching him to be your good lord therein, considering your service and loyalty . . . and the right that you have thereto. . . . [The king] said he would be your good lord therein as he would be to the poorest man in England. He would hold with you in your right; and as for favor, he will not be understood as showing favor more to one man than to another, not to one [man] in England.

The young courtier's letter passed on to another matter that had been troubling his father and that remains a small but tantalizing mystery. John had learned that a copy of a page from the court roll of Gimingham Manor had fallen into the hands of a Paston enemy, Sir Miles Stapleton—"that knavish knight," in John's description—which evidently bore on the imputation of

the Pastons' servile ancestry, Gimingham being the manor in which they were said to have been bondsmen. John wrote Margaret that Stapleton and his wife, who was related to the de la Poles, and their friends "have blathered here of my kindred" but truculently declared that his own ancestors "shall be found more worshipful than his or his wife's." The matter suddenly became threatening when someone gave King Edward a "bill copy [file copy] of the court roll" presumably of Gimingham Manor. Was it the same "bill" that Stapleton had acquired?

On behalf of the Pastons, the earl of Essex inquired about it and reported to John II that in response the king "smiled and said that such a bill there was, saying that you wanted to oppress sundry of your countrymen, and therefore he kept it still." This cryptic reply suggests that the paper in the king's possession referred merely to a contest over lordship of land. John II continued, "Nevertheless he said he would look it up in haste, and you should have it." He made several efforts to obtain the paper; "twice or thrice" Baronners promised that he should have it in "two or three days," but "he is oftentimes absent, and therefore I have nothing yet; when I get it I shall send it to you, and out of the king's mouth the name of the man that took it to him." For the time being, this was the last heard of Gimingham. The specter of servile descent remained to haunt the Pastons for another five years.

The young man also wrote that he was sending home William Pecock, the servant his father had designated to accompany him. "He is not for me," John II wrote. "God send grace that he may do you good service, but by my estimation that is not likely. You shall have knowledge later how he has behaved here with me. I wish, saving your displeasure, that you were delivered of him, for he shall never do you profit nor worship."[21]

Notwithstanding John II's complaint, Pecock remained in the Pastons' employ for many years. The young man was evidently

angry because the servant, older and more experienced, was critical of his master's behavior. Pecock kept Clement Paston, John I's youngest brother, informed about his nephew's slow progress at court.

> I learn by W. Pecock [Clement wrote John I] that my nephew is not yet verily acquainted in the king's house as belonging to that house; for the cooks are not charged to serve him, nor the servers to give him any dish, for [they] will take dishes to no men until they are commanded by the controller. Also he is acquainted with nobody but Wykes [usher of the king's chamber and a friend of John I], and Wykes told him that he would bring him to the king, but he has not yet done so. It might be best for him to take his leave and come home, till you have spoken with somebody to help him forth, for he is not bold enough to put himself forward. But then I considered that if he should now come home, the king would think that when he was needed to do him any service somewhere, that you would have him at home, which would cause him not to be held in favor; and also men would think that he was put out of [the king's] service.

On one important point Pecock supported John II: the young man needed more money. Chancellor Waynflete and Clement Paston agreed.

> W. Pecock tells me that his money is spent [wrote Clement] not riotously but wisely and discreetly, for the costs are greater in the king's house when he travels than you thought them to be, as William Pecock can tell you, and we must get him a hundred shillings at the least. . . . I shall be fain to lend it to him from my own silver. . . . Therefore I pray you send me as hastily as you may five marks, and the rest, I trust, I

shall get from Christopher Hansson and Luket. I pray you send me it hastily, for I shall leave myself right bare.[22]

In mid-October 1461 an urgent letter from Clement in London reached his brother John in Norwich. News of John's altercation with Sheriff Howard in the shire house, in Howard's version, coupled with complaints from the duke of Norfolk, had attracted King Edward's unfavorable attention. Clement was informed that the king had angrily announced that he had sent two summonses to John, and John had ignored them. "But we will send him another tomorrow, and by God's mercy, if he comes not then he shall die for it. We will make all other men beware by his example of disobeying our writs." The king explained, "A servant of ours has made a complaint of him. I cannot think that [the servant] has informed us all truly, yet nonetheless, we will not suffer [John] to disobey our writs; but since he disobeys we may the better believe the complaint is as we are informed."

Clement's unknown source advised John to come "as hastily as possible" and with "a great excuse." Clement added, "Come in strength, for Howard's wife boasts that if any of her husband's men might come to you, your life would not be worth a penny; and Howard has a great fellowship [following]." Howard also had a valuable ally in the young son of the murdered duke of Suffolk, who had married King Edward's sister, Elizabeth. "My lord of Suffolk and Howard . . . every day complain to the king against you."[23]

John rode at once to London, but too late—he was arrested on his arrival and conducted to Fleet Prison. The shock must have been great, but his plight was not quite as bad as it sounds. The Fleet was no dungeon crowded with cutthroats but a gentleman's prison for lesser offenders of the upper classes, especially

debtors (the Tower was reserved for state prisoners). Detention in the Fleet was reasonably comfortable. Visitors were permitted, and food and bedding could be purchased from the jailer or brought in. A servant named Spring was hired to attend John, and his agents came and went freely.[24]

The arrest itself was less unusual than one might suppose, even when the king was not involved. A Venetian diplomat in London called it "the easiest thing in the world to get a person thrown into prison in this country; for every officer of justice, both civil and criminal, has the power of arresting anyone, at the request of a private individual, and the accused person cannot be liberated without giving security . . . nor is there any punishment for making slanderous accusations."[25]

After a fortnight, John's friends were able not only to obtain his release but somehow to turn the tables on Sheriff Howard. Margaret wrote, probably from Caister, on 2 November 1461, expressing her relief at the news:

> I could not be merry since I had the last letter until this day when the mayor sent word to me that he had knowledge for very truth that you were delivered out of the Fleet, and that Howard was committed there for divers great complaints that were made to the king about him.

Margaret noted that John's imprisonment had excited sympathy locally.

> The people were right sorry, both in Norwich and in the country. You are much bound to thank God, and all those that love you, that the people have so great love of you. . . . I pray that you will send me word whether you want me to move from here, for it begins to wax cold staying here. . . . My brother [William Paston] and Playter should have been

with you before this time, but they wanted to wait until this day passed because of the shire court.[26]

Once again John spent Christmas away from home. Margaret wrote him on 29 December:

And as for such matters as John Jenney and James Gresham spoke to me [about], I sped them as well as I could; and they both told me that you should verily have been at home before Christmas, and that caused me not to write you an answer. . . . I think it right long since I have had tidings from you. I fear me that it is not well with you that you be away from home at this time. And many of your countrymen think the same.[27]

In December the king appointed a new sheriff, a knight of the royal household named Sir Thomas Montgomery, to bring order to an increasingly unsettled Norfolk. The mission, however, had little effect. In January 1462, Margaret wrote that the people of Norfolk were beginning to "wax wild," amid rumors that the king's younger brother, George, duke of Clarence, in company with the young duke of Suffolk, "and certain judges with them," were about to descend on the county to put down "such people as be judged riotous." There was talk of sending a delegation to London to complain of the "false shrews"— Tuddenham and Heydon—who were misleading the king, rather than to allow themselves to be slanderously accused and "be hanged at their own doors." The people "love in no wise the duke of Suffolk nor his mother"—Alice, granddaughter of Geoffrey Chaucer and formidable widow of the murdered duke. "Men know that if the duke of Suffolk comes, there will be a harsh rule. . . . The people fear much more to be hurt because you and my cousin Berney come not home." In this disturbed cli-

mate, Richard Calle was having trouble collecting rents. He could get "but little . . . of what is owing, either of your livelihood or of Fastolf's," Margaret said, and her second son, John III, reported dryly that "those that could pay best pay worst."[28]

At the end of January 1462, John Paston's election to Parliament was confirmed, and Margaret wrote him that the people of Norfolk "be right glad that the day went with you. . . . You were never so welcome in Norfolk as you shall be when you come home, I trow."[29]

Despite his wife's pleas, John remained in London, striving to move the ponderous machinery of justice in defense of his Fastolf inheritance. In March, John II, still at court, traveling with the king's household, and still in need of money, wrote his father from Stamford:

> Please you to understand the great expense that I have daily traveling with the king, as the bearer hereof can inform you; and how long I am likely to tarry in this country ere I may speak with you again, and how I am charged to have my horse and harness ready, and in hasty wise, beseeching you to consider these causes, and to remember me that I may have such things as I may do my master service with and pleasure. . . . Especially I beseech you that I may be sure where to have money somewhat before Easter, either of you or by my uncle Clement, when I need it.[30]

◻

In the fall of 1462, Judge Yelverton, now Sir William Yelverton, and his fellow executor William Jenney, recommenced open war over the Fastolf estates. The manor of Cotton, in Suffolk, isolated from most of the other Fastolf manors, had been sold by the old duke of Suffolk to Fastolf in 1434, but the de la Poles still claimed it, and now Yelverton and Jenney moved to seize it. John

Pampyng, a trusted Paston servant, visited Cotton in September and found that the pair of rival executors had come two days earlier and distrained "twenty-six or more" bullocks belonging to Edward Dale, the man who was farming the manor for the Pastons. Distraint was the legal seizure of property by court order in payment of an obligation, usually a debt; animals were favored objects of distraint because they were both valuable and easily moved. In this case the court order, readily obtained, since Jenney was a justice of the peace in Suffolk, was aimed at forcing Dale to pay his farm rents to Yelverton and Jenney at Michaelmas (29 September). Pampyng reported that Yelverton had dined at Cotton that day, and had told the tenants they must pay their rents only to him, and had "flattered them," telling them he would "remedy all their wrongs."

Learning that Yelverton and Jenney would be at Nacton, another Fastolf manor near Ipswich, on 6 September, Pampyng undertook to go and parley with them. In Ipswich at an inn, the Sun, he overtook the pair, together with Thomas Fastolf, Sir John's former ward. When they discovered his identity, they proposed to have him arrested for "surety of peace." Jenney sent for an officer to take Pampyng to prison, but the innkeeper pledged to vouch for him for that night.

The next day Pampyng encountered the three men at mass at St. Lawrence church, and an argument ensued. Yelverton asserted his rights, saying that

> he was enfeoffed as well as you; and as for that I told him he knew the contrary . . . and I told him that he should be served the same within a few days. And he said he knew well you were not enfeoffed in his land, and if you took it upon you to make any trouble in his land you shall repent it. And also he said that he would do likewise in all manors that were Sir John Fastolf's in Norfolk . . . and other language as

I shall tell you. And so I am with the gaoler, with a clog [shackle] upon my heel for surety of the peace; wherefore please your mastership to send me your advice.

Some other old Paston enemies were present; Pampyng said that John Wyndham, the man with whom James Gloys had fought in the Norwich street, and Gilbert Debenham, a retainer of the duke of Norfolk, approached Yelverton at mass and spoke with him.[31]

John ordered his eldest son to leave court and return to Norfolk to oppose the threat to Cotton. In October, John II and Richard Calle rode thither with a small troop, Calle presently reporting the result to John I in London: "Mr. John and I, with other men, were at Cotton on Friday last, and there Jenney had summoned the [manorial] court"—a sign that he had taken possession—"on the same Friday. . . . And it fortuned that we had entered the place ere he came; and he heard thereof and turned back again to Hoxne" to seek out the bishop of Norwich and beg his mediation. The bishop sent an emissary to Cotton the next day to speak with John I, "to put your matter in a treaty," Calle said—that is, to work out a compromise. The emissary was informed that John was not present. The Paston party then proceeded to hold the court Jenney had called. Calle reported:

The court was held in your name, and the tenants right well pleased thereof, and no resistance was offered. And Mr. John was there Friday all day and Saturday till noon; and then he took his horse with thirty men with him and rode to Jenney's place, and there took [a retaliatory] 36 head of cattle, and brought them into Norfolk; and so was I left still at Cotton with twelve men with me, because they reported that if we abode there two days we should be put out head first. And so we abode there five days, and I walked about all the lord-

ships and spoke with all the farmers and tenants that belong to the manor to understand their disposition and to receive money of them; and I find them right well disposed toward you.

Edward Dale, the farmer whose cattle had been seized by Yelverton and Jenney, was ready with payment of his money.

Calle added that the tenants were afraid they would be distrained again when his party left and that the archbishop of Canterbury and other magnates would release the manor to Yelverton and Jenney. He suggested that John request a letter from the archbishop and his colleagues to the tenants declaring "that it is their will and intent that you should have the rule and governance, and receive the money of that manor, and others that were Sir John Fastolf's . . . for I doubt not if such a letter came down to the tenants there should any man say nay to it."[32]

The advice was sensible, but John either could not or would not take it. Yelverton and Jenney got indictments for forcible entry issued against John Paston II, Richard Calle, and several other Paston servants, and Jenney, repossessing Cotton, sold it to Gilbert Debenham. Tardily reacting, John petitioned Chancellor Waynflete and the duke of Suffolk, vainly asserting his claim to Cotton on the grounds that Fastolf had made "a grant and bargain" of it.[33] Calle, who was imprisoned and threatened with trial in London, was soon freed, but Cotton remained in the hands of Gilbert Debenham.

John had succeeded in placing his second son, John III, in the household of the new duke of Norfolk, who had assumed the title in 1461 at seventeen and was the same age as John III. Despite the trouble over Caister, the Pastons had a history of friendly relations with the Mowbray dukes; Judge William Paston had served as steward to the second duke, and Richard

Calle had come to the Pastons on recommendation of the third duke, recently deceased.

Traveling with the fourth duke's household, John Paston III was in Wales in December of 1462 when his new lord received urgent orders from King Edward to go to Newcastle. Persistent rumors of a landing by the Lancastrians had at last been realized; Queen Margaret and her followers had seized three castles on the Northumberland coast near the Scottish border, and the king had sent a force under the earl of Warwick to recapture them. The duke of Norfolk made his headquarters at Newcastle, while "the king lies at Durham," a few miles to the south. John III wrote his father (4 December 1462):

> My lord of Warwick rides every day to all these castles to oversee the sieges, and if they want victualing or any other thing, he is ready to purvey it for them. The king commanded my lord of Norfolk to conduct victuals and ordnance out of Newcastle to Warkworth Castle, to my lord of Warwick . . . and so we were with my lord of Warwick with the ordnance and victuals yesterday. . . . In case we abide here, I pray you purvey that I may have more money here by Christmas Eve at the latest, for I may get leave to send none of my waged men home again; no man can get leave to go home unless they steal away. . . . Make merry as you can, for there is no jeopardy yet. If there is any jeopardy, I shall soon send you word, by the grace of God.

He noted with satisfaction that Yelverton and Jenney were likely to be "greatly punished" because they had not responded to a summons from the king. Two Paston friends, Thomas Playter and John Billingford, had done the same, "wherefore I am right sorry." John III offered to assist in making their excuses, "for I am well acquainted with my lord Hastings and

my lord Dacres who are now greatest about the king's person; and also I am well acquainted with the younger Mortimer, Ferrers, Haute, Harper, Crowmer, and Boswell, all of the king's house."[34] Thus the younger son was experiencing little difficulty in making influential friends, whether because it was easier on campaign to become "verily acquainted in the king's house" or because of his superior social skills.

The Lancastrian threat was soon eliminated, with Queen Margaret and her son, Prince Edward, narrowly escaping when their ships were wrecked on the Scottish coast. John III returned to Norfolk with the duke's household.

When John II came of age the following year (1463), he received the honor that his father had cautiously rejected for himself: he was knighted. What his father paid for the dignity is not recorded, and for the time being there were no requirements of service. The young man did not even remain at court. By May he was back at home, apparently at his father's order, and chafing at the confinement. The Norfolk public was now regaled with the spectacle of a son openly showing his dissatisfaction with the role assigned by his father. The vicar of Caister, no doubt at the young man's behest, wrote John I:

> Some say that you and he both stand out of the king's good grace, and some that you keep him home out of niggardliness and will spend nothing on him. At the reverence of God, to avoid such gossip, see that he is worshipfully provided for, either in the king's service or in marriage.[35]

Six months later, without telling anyone that he was going, John II (now Sir John) slipped away to join the royal court, at the moment in Yorkshire. At Lynn he paused to dispatch a messenger with a letter to Margaret at Caister. She was disappointed and angry at the position he had placed her in. "I was right evilly

paid through you," she reproached him in reply (15 November 1463). "Your father thought, and still thinks, that I assented to your departure, and that has caused me great heaviness." She had heard that he had written his father a letter; she urged him to write again, "as humbly as you can, beseeching him to be your good father. . . . I wish you would send me word how you are doing, and how you have shifted for yourself since you departed hence, by some trusty man, and in such a way that your father will have no knowledge thereof. I dare not let him know of the last letter that you wrote me, because he was so sore displeased with me at that time." She continued with domestic details about the young man's horse and gear, left at home, concluding, "Your granddam would fain hear some tidings from you. It were well if you sent a letter to her about how you are doing as hastily as you may."[36]

For several months, Sir John remained with the court in the North, where the king was suppressing insurrection, but in March 1464, after the end of the campaign, he was back in Norfolk.

Early in May, Margaret wrote her husband "in haste" that orders had arrived in Norwich under Privy Seals calling for members of the nobility and gentry to arm and report for military duty. "One of them was endorsed to you . . . and [others] to five or six other gentlemen; and another was sent to your son [Sir John], and endorsed to himself alone, and signed within with the king's own hand . . . and also there were more special terms in his than were in the others." The men who received the orders were to be with the king at Leicester on the tenth of May "with as many persons defensibly arrayed as they might, according to their degree, and . . . they should bring with them [money] for their expenses for two months." Margaret asked John to let her know "how you want your son to act herein. Men think here, that are your well-willers, that you may do no less than send him

forth. As for his behavior since you departed, it has been right good, and lowly, and diligent. I hope he will behave so as to please you hereafter ... and I beseech you heartily that you vouchsafe to be his good father, for I hope he is chastened and will be the worthier hereafter."[37]

In June she wrote, "All the gentlemen of this country that went up to the king are countermanded and are come home again";[38] the mobilization, designed to cope with a fresh insurrection in the unruly North, had been canceled. Whether Sir John was among the "gentlemen" is unknown, but he did not come home—apparently his father had forbidden him the parental hearth.

John's own troubles had multiplied. His enemies—Yelverton, Jenney, and Worcester—had launched two separate legal offensives against him. While William Jenney instituted action in the Suffolk county court, Yelverton and Worcester sued in the Church court at Canterbury to overrule John's claim to be Fastolf's chief executor.

The hearings in the archbishop's court began in April 1464, and Clement Paston reported that Thomas Howes, hitherto a Paston ally, had arrived in London to testify for the opposition. Clement called on him, but Howes "bade the messenger say that he was not in, and I had [the messenger] say again that I came thither to him for his own worship and avail, and that I was sorry that I came so far for him; and after that he sent for me, and he could not find me, and I heard say thereof."

Clement then wrote a letter reminding Howes that he had sworn "to tell the truth of all manner of matters concerning Sir John Fastolf," and that if he testified contrary to the statement he had already made, John would "hereafter prove the truth ... and prove him in a perjury." Howes should also remember "what manner of men [Yelverton and Jenney] he dealt with, and ... how unruly they had acted."

Later Clement encountered Howes on the street, and the clergyman expressed himself as "sore troubled in his conscience" that John Paston intended to found the college at Caister with an income of "only a hundred marks." Clement noted ironically that Howes's conscience was apparently untroubled by the Yelverton-Jenney-Worcester plan to found the college elsewhere with a hundred-mark income "with the rest sold so that he might pocket [some of] the money." Clement concluded that Howes's quarrel with John stemmed entirely from a desire to share in the profits. "I felt by him that all his estrangement from you is because he deems that you would part from nothing; and I told him the contrary to be true."

Nevertheless, Clement predicted that Howes's testimony "would not be good." John's enemies were confident that he "could get no license to found [the college at Caister], wherefore they might lawfully found it in another place" and sell Caister.[39] The hearings began with the testimony of servants and agents who had been present at the time of Fastolf's death; they were fated to go on for several years without reaching any conclusion.

John had never abandoned his efforts to obtain the license for the college at Caister and in September of 1464, at a cost of three hundred marks to the king, was at last successful.[40]

By that time his health was suffering. Margaret warned him, "For God's sake, beware what medicines you take of any physicians of London; I shall never trust them because of your father and my uncle, whose souls God assoil."[41] Meanwhile he was summoned to appear in Suffolk county court in Ipswich at four successive sessions but failed to attend, perhaps because of illness or the pressure of business. Such nonappearance was commonplace and usually went unpunished, but John's enemies succeeded in getting a writ against him, leading to his being proclaimed an outlaw and threatened with seizure of his goods. He obtained a stay of confiscation, and the case was transferred to

the King's Bench. On 3 November 1464 he was committed a second time to Fleet Prison.

His confinement was once again brief but did nothing to improve his temper. In January 1465 he wrote Margaret, Richard Calle, and servant John Daubeney a long, angry, fault-finding letter. His house was not being well run and needed better supervision

> for provision of stuff for my household and for the gathering
> of the revenue of my rents or grains, or for setting my ser-
> vants to work, and for the more expedient means of selling
> and carrying my malt . . . so that when I come home I have
> not an excuse, saying that you spoke to my servants and that
> Daubeney and Calle excuse themselves that they were so
> busy that they might not attend; for I want my affairs so
> arranged that if one man may not attend, another shall be
> commanded to do it; and if my servants fail, I had rather hire
> some other man, for a day or a season.

Among the failures he imputed to his household was the fact that "my priests and poor men are unpaid," indicating that these beneficiaries had at least been selected, though John's letter does not tell whether they were lodged at Caister or not. His severest strictures were reserved for Sir John, still forbidden to return home, for reasons his angry father specified:

> In his presumptuous and indiscreet behavior he gave both me
> and you cause for displeasure, and to other of my servants ill
> example. . . . He let everyone understand that he was weary
> of biding in my house, though he was not assured of help in
> any other place; yet that does not grieve me so much as that I
> never could feel him wise or diligent in helping himself, but
> only as a drone among bees that labor to gather honey in the

fields, and the drone does nothing but take his part of it. And if this might make him know himself better and remind him what time he has lost, and how he has lived in idleness, and that he could eschew this behavior hereafter, it might fortune for his best. But I hear yet from no place that he has been of any wise behavior or occupation. And in the king's house he could put himself forth to be in favor or trust with any men of substance that might further him; nevertheless as for your house and mine I propose that he shall not come there, neither by my will nor any other unless he can do more than look around and make a show and countenance.

Finally, there was the general state of the family finances. John marveled that

before ever I had anything to do with Fastolf's livelihood [revenue], while I took heed to my livelihood myself, it both served for my expenses at home and in London and all other charges, and you laid up money in my coffers every year, as you know. And I know well that the payment of my priests and other charges that I have from Fastolf's livelihood are not so great as the livelihood is, though part of it be in trouble. And then consider that I had nothing of my livelihood for my expenses in London this past two months; you may verily understand that it is not looked after wisely or discreetly; and therefore I pray you heartily put all your wits together and see to the reformation of it.

The letter ran on about other matters: his hay wasted at Hellesdon, someone to pay a farm for the reeds and rushes in Mautby marsh, the purchase of oats, cutting of firewood at Caister and Mautby, the market for his malt. Furthermore, he wanted "an answer to all my letters and to every article in them."

He had heard from Richard Calle "that Sir Thomas Howes is sick and not likely to get well, and Berney tells me the contrary; wherefore I pray you take heed thereat, and let me know, for though I am not beholden to him, I would not, for more than he is worth, wish him dead."

He added a caution: "Item: remember well to watch at your gates by night and day for thieves, for they ride in divers countries with large companies, like lords, and ride out of one shire into another." And finally: "Item: that Richard Calle bring me up money so that my debts be paid, and that he come up securely in the company of other men and attorneys."[42]

In the six embattled years since Fastolf's death, John Paston had fought off enemies in the law courts and at dagger's point, had won election to Parliament, and had twice been arrested and lodged in Fleet Prison. He had seen one of his sons knighted and the other placed in the household of a duke, while the imputation of servile descent threatened his family.

His experiences had not made him easier to live with, nor had they weakened his grip on his petty domain. In Caister, Norwich, or London, in prison or out, John Paston was a more absolute monarch over his wife, his children, his servants, and his estate than Henry VI ever was over his kingdom.

Chapter 8

THE SACK OF HELLESDON AND THE DEATH OF JOHN PASTON

1465–1466

n the spring of 1465, on top of all his other troubles, John Paston received word of a new threat to the Fastolf inheritance. The death of the old duke of Suffolk had put an end to his claim to Hellesdon and Drayton, the two manors northwest of Norwich that flanked the duke's manor of Costessey. Fastolf's death encouraged the new duke to revive the claim, perhaps with the advice of Judge Yelverton, whose son was the duke's steward. The Pastons suspected that John Heydon was also involved. Once more the ancient ownership of the manors by a "Pole," the alleged ancestor of the Suffolk de la Poles, was put forward. The claim was devoid of merit—Margaret Paston had seen the seal of arms on the Drayton deed and reported that it was "nothing like that of the duke of Suffolk's ancestors"—and in any case Fastolf had legally purchased the properties.

In April, Margaret sent John a copy of the seal, along with a warning from John Russe that "all [Fastolf's] feoffees will make a release to the duke and help him as much as they can, in order to have his good lordship." Her letter went on to discuss the sale of John's malt, which had to be disposed of before the hot weather set in, but "the price is sore fallen." Also, some of the tenants' houses at Mautby were greatly in need of repair, but "the tenants are so poor that they have not the power to repair them." Margaret proposed that, rather than farming out the marsh, as John had planned, they allow the tenants to take the rushes to rethatch their roofs and that the "windfall wood of the manor that is of no great value" be allotted to repair the houses.

She concluded with another plea on behalf of Sir John, still out of favor with his father:

> I understand by John Pampyng that you will not let your son be taken into your house, nor [be] helped by you, till a year after he was put out thereof, which shall be about St. Thomas Day [probably 7 July]. For God's sake, sir, have pity on him; remember it has been a long season since he had aught of you to help him with, and he has obeyed you and will do so at all times, and will do what he can or may to have your good fatherhood. . . . I hope he shall ever know himself the better hereafter, and the more aware to eschew such things as should displease you, and to take heed of what should please you.[1]

In May, Margaret went to live at Hellesdon, to establish John's claim, first stopping at Drayton "to speak with divers of your tenants . . . and put them in comfort that all shall be well hereafter by the grace of God." She learned that Philip Lipgate, the duke of Suffolk's bailiff, had seized a plow horse belonging to

a tenant named Dorlet who was friendly to the Pastons; that act set off what became a battle of distraints.

Margaret added, "Your son [Sir John] shall come here tomorrow, as I trow, and I shall let you know how he demeans himself hereafter, and I pray you think not that I will support him or favor him in any lewdness, for I will not."[2]

A week later, she sent trusted servant John Daubeney with four men to Drayton, where they found Piers Waryn, "a flickering [wavering] fellow," loyal to the duke, plowing with a pair of mares. Unharnessing the animals, they drove them to Hellesdon "and there they be yet." The next morning Philip Lipgate and the bailiff of Costessey came to Hellesdon "with a great number of people, that is to say eight score men and more in armor, and there took from the parson's plow two horses, priced four marks, and two horses from Thomas Stermyn's plow, price forty shillings," leading them to Drayton and thence to the duke's manor of Costessey.

That afternoon the despoiled parson sent Thomas Stermyn and a servant to Drayton to parley with Lipgate. They were told that they could have their horses back when Piers Waryn's mares were returned, "and otherwise not"; furthermore, if any of the Paston servants "took any distress" (distraint) from Drayton, "even of the value of a hen, they would come into Hellesdon and take for it the value of an ox; and if they could not take that value they will break into your tenants' houses in Hellesdon and take as much as they can find therein. And if they are prevented from doing so—which, he said, would never lie in your power, for the duke of Suffolk is able to keep daily in his house more men than Daubeney has hairs on his head—then they would go into any livelihood that you have in Norfolk or Suffolk" and "take a distress" just as they would do at Hellesdon.

Richard Calle asked the parson and Stermyn if they were willing to sue for the return of their horses, but the parson

replied that he was "aged and sickly and did not want to be troubled"; he would rather lose his animals, because if he sued, he would be "so vexed by [Suffolk's men] that he would never have rest."

Accompanied by Skipwith, a local lawyer, Margaret called on the bishop of Norwich to protest "the riotous and evil disposition of Master Philip [Lipgate]. . . . My lord said to me that he would right fain that you have a good conclusion to your matters, and said by his troth that he owed you right good will, and would right fain that you were come home and that your presence among them should do more amongst them than a hundred of your men." Beyond that, he could promise nothing.

Margaret felt her position at Hellesdon more and more threatened. The duke of Suffolk was assembling men at Drayton,

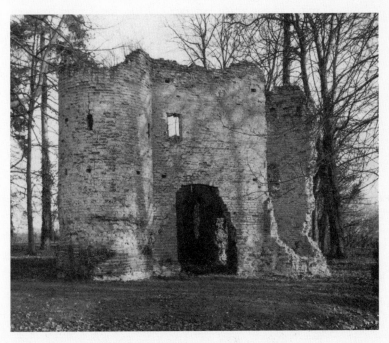

Remains of gatehouse, Drayton Lodge. *(Hallam Ashley)*

and Hellesdon "was like to stand in as great jeopardy soon as the other has done." Thomas Elys, a new mayor of Norwich favorable to the duke, had promised to provide him "a hundred men"; furthermore, "If any men of the town wanted to go to the Pastons' [aid] he would lay them fast in prison."

Margaret refused to be intimidated. She left Sir John at Caister "to keep the place there" and herself remained at Hellesdon, "to be captainess here," whatever the danger.

She was also concerned about an intrafamily dispute between John and his mother over some land that had belonged to Fastolf's relatives, the Cleres. "My mother told me that she thinks it right strange that she may not have the profits of Clere's place peaceably because of you; she says it is hers and she has paid most thereof yet." If John did not allow her to have the rents, Agnes would see to it that there was plenty of talk about it. "In good faith, I hear much language of the demeaning between you and her. I would right fain, and so would many of your friends, that it were otherwise between you than it is."[3]

Once more she urged him to bring his "matters" in London to a conclusion; three days later she repeated the injunction:

Make an end of them, either purvey to make them or mar them, for this is too horrible a cost and trouble that you have had to endure any while, and it is great heaviness to your friends and well-willers and great joy and comfort to your enemies. My lord of Norwich said to me that he would not abide the sorrow and trouble that you have abided to win all Sir John Fastolf's goods.[4]

So far no real violence had occurred, only distraints and threats. Contests over land were typically fought with a restraint that stopped action short of bloodshed, which might bring intervention by courts and king.

Typically, too, the main victims were the tenants caught in the middle. On a Saturday in mid-May, Paston servants appeared at Drayton "and there took a distress for the rent and farm that was owed to the number of 77 neat [cattle], and so brought them home to Hellesdon," Margaret reported to John, "and put them in the pinfold [for strays], and so kept them still there from Saturday morning to Monday at three o'clock in the afternoon. . . . The tenants followed upon [them], and desired to have their cattle again; and I answered them if they would pay such duties as they ought to pay you, then they should have their cattle delivered again," or they should find security for the debt, "and they said they dared not to take it upon them to be bound [for the debt], and as for money they had none to pay at that time, and therefore I still kept the beasts."

That same Saturday afternoon William Harleston, the duke's under-steward, summoned the luckless tenants and threatened to put them off their lands if they paid their rents to the Pastons. The following Monday he obtained a writ of replevin—an order for the return of wrongfully seized goods—and served Margaret with it, claiming that the cattle were taken on duchy property. Margaret sent two agents to question the tenants, who said that none of the cattle were on the duke's land, except Piers Waryn's, "and so we would not obey the replevin, and so they departed," only to return that afternoon with a new replevin, this time from the sheriff. "And so I, seeing the sheriff's replevin and under his seal, bade my men deliver them, and so they were delivered."[5] Margaret was still convinced that the majority of the Drayton tenants preferred Paston to Suffolk rule. "They had as lief almost be tenants to the Devil as to the duke."[6]

The struggle resumed. One morning in early June, two of the duke's men came to Drayton before sunrise, seized a flock of sheep belonging to the Pastons, and drove them away to Costessey. Margaret, alarmed, suggested that they strengthen the staff

at Hellesdon by borrowing men from Caister; "five or six of your folk . . . were enough to keep" Caister, where, apparently, the priests and poor men benefited by Fastolf's will were now in residence.[7]

Margaret sought a writ of replevin for the sheep that had been taken, but the sheriff refused to serve it; "he said plainly that he will not, nor durst not serve it, even though I would give him £20 to serve it . . . and so it is yet unserved."[8]

John, in London, urged Margaret to remain at Hellesdon and "comfort my tenants and help them till I come home." She was "a gentlewoman, and it is worshipful for you to comfort the tenants," the comfort to come from assurances that the duke's claim was false; his family "came not of the stock" of the original owners, and in any case the manors were "lawfully bought and sold." She should "ride to Hellesdon and Drayton and Sparham, and tarry at Drayton and speak with them, and bid them hold with their old master till I come."

He assigned no role to his eldest son, who remained in disgrace:

I would he did well, but I understand in him no disposition of wisdom, nor of self-control such as a man of the world ought to have. . . . I can only think he would dwell again in your house and mine, and there eat and drink and sleep. . . . Every poor man that has brought up children to the age of twelve years expects then to be helped and profited by his children, and every gentleman that has discretion expects that his kin and servants that live by him, and at his cost should help him forward. As for your son, you know well he never stood you nor me in profit, ease, or help, to the value of one groat. . . . Wherefore, give him no favor till you feel what he is and will be.[9]

That slight concession evidently encouraged Margaret to employ Sir John in the action that followed in July, when the duke of Suffolk raised the stakes ominously. Margaret heard that he assembled "great people [large forces] both in Norfolk and Suffolk to come down with him to put us to a rebuke." She suggested that John III ride to the duchess of Norfolk, "and there he may do some good." Margaret had been told that more than two hundred men had gathered at Costessey, "and there are coming, as it is said, more than a thousand."[10]

There were three hundred in the force that Philip Lipgate and the bailiff of Costessey actually led to Hellesdon a week later, according to Richard Calle. Forewarned, the Pastons had armed sixty men—tenants, servants, and perhaps hired recruits—with "guns and such ordnance that [Lipgate's force] would have been destroyed if they had set upon us."

The duke's men announced that they had a warrant to arrest several of the Pastons' servants, including Richard Calle and John Daubeney. "And my master, Sir John, answered them, and said that they were not within," Calle wrote John I, "and if we had been, they should not have had us; and so they desired one of our men." William Naunton, a Paston servant, "stood by my mistress and asked them whom they would have, and said if they would have him, he would go with them, and so he did. And the next day they carried him forth to my lord of Suffolk, in Claxton, through Norwich." In Norwich, "we found a remedy" to free Naunton, "but he would not, but needs go forth with them, but he was treated like a gentleman amongst them."

William Harleston now suggested that Sir John should go to see the duke of Suffolk at Costessey—"he would ride with him and bring him to my lord"—but Sir John replied that only when the duke acted as his father's good lord would he see him. Arbitrators sent to the scene by the bishop of Norwich at last

arranged a truce, and the duke of Suffolk's men withdrew, though remaining in the neighborhood and continuing the harassment. A dozen of the duke's followers, including eight in armor, ambushed Calle and "would have mischiefed me, but the sheriff prevented them, and they boast that if they catch me [again] I shall die . . . and so I dare not ride out alone."

He heard, furthermore, that there was to be an oyer and terminer "to inquire into all riots," with the duke of Suffolk and Yelverton as commissioners,

> and so they say as many of us as can be taken shall be indicted and hanged forthwith. Wherefore it like you to send word how my mistress shall do at Hellesdon, and we [shall do] in all other matters; and whether you want us to fetch back the Hellesdon flock, for they are now driven to Cawston and there they go on the heath; and my lord of Suffolk will be at Drayton on Lammas Day [1 August] and keep the court there; wherefore we must seek a remedy for it, or else it will not do well.

Calle suggested a solution: they should invite the duke of Norfolk to come to the rescue, paying him with the profits of Hellesdon and Drayton "and some money beside," and also come to some kind of arrangement with Yelverton. He apologized for taking the liberty of making such a proposal, but "I have pity to see the tribulation that my mistress has here, and all your friends."[11]

Margaret herself promised John to "do as you advise me to do," although "what with sickness and the trouble that I have had, I am brought right low and weak." The duke of Suffolk and both the duchesses—his wife and his mother—were expected soon at the duke's manor of Claxton, southeast of Norwich, and Margaret had been advised to try to conciliate them.

I said if I should sue for any remedy, I should sue further, and let the king and all the lords of this land know what has been done to us. . . . I pray you send me word if you want me to make any complaint to the duke or the duchess; for it is told me they do not know fully what has been done in their names.[12]

Margaret's letter crossed one from John written the following day congratulating her on her resistance to "the unruly fellowship that came before you" and advising her not to take the Pastons' troubles so seriously "that you fare the worse for it." He promised that "I shall have the manor more securely to me and mine than the duke shall have Costessey" and spelled out an exasperated refutation of the duke's genealogical claim:

The manor of Drayton belonged to a merchant of London called John Hellesdon long before any of the Poles that the said duke comes from were born to any land in Norfolk or Suffolk; and if they were born to no land, how can the duke claim Drayton by that pedigree? As for the said John Hellesdon, he was a poor man born, and from him the said manor descended to Alice his daughter.

He traced the de la Pole line, now dukes and before that earls of Suffolk, back to William Pole, merchant of Hull, "who was a worshipful man grown by fortune of the world," and became a knight and after that a banneret. None of the family had any claim to the manor of Drayton. All this John had sent word "to tell to my old lady of Suffolk [the dowager duchess, Alice Chaucer]."

As for the bishop of Norwich's suggestion that John show his "title and evidences" to the duke, John responded with a

burst of righteous indignation, asserting his own class conscious-
ness as a gentleman against the aggressions of the nobility:

> Item: let my lord of Norwich [the bishop] know that it is not
> profitable nor the common weal of gentlemen that any gen-
> tleman should be compelled by the entry of a lord to show
> his evidence or title to his land, nor will I initiate that exam-

Alice Chaucer, granddaughter of the poet, dowager duchess of Suffolk:
effigy in the church of St. Mary, Ewelme. *(Royal Commission on the
Historical Monuments of England)*

ple of thralldom for gentlemen. . . . It is good a lord take sad [serious] counsel before he begins any such matter.

As for the Poles who owned Drayton, if there were a hundred of them living—and there are none—they should have no title to the said manor.[13]

At Hellesdon, Margaret worried about John's health in London and the progress of his "troublous matters," advising him to "be of good comfort, and not take your matters too heavily." Despite their disagreement over the Cleres' land, his mother (Agnes) "is your good mother," she assured him, "and takes your matters right seriously. And if you think that I may do good in your matters if I come up to you . . . it shall not be long ere I be with you, by the grace of God." She added, "I have delivered your older son 20 marks that I have received of Richard Calle," concluding in a postscript: "Item: I took your son 10 marks of your father's old money, that was in the little trussing coffer, for my brother Clement says that 20 marks was too little for him."[14]

On Lammas Day, Margaret sent Paston chaplain James Gloys and a servant named Thomas Bond to hold the manorial court at Drayton in John's name. They found the duke's men, to the number of about sixty, already in occupation, as predicted. At their head were Harleston, Philip Lipgate, and young William Yelverton, the duke's steward. Some were armed with "rusty poleaxes and billhooks." Told of the Paston agents' mission, Harleston, "without any more words or any occasion given by your men," arrested Bond and turned him over to the new bailiff of Drayton, "and they led Thomas Bond to Costessey and bound his arms with whipcord, like a thief," to take him to the duke of Suffolk. Margaret, however, forestalled them and spoke with the Judges of Assize, who were meeting in Norwich

and informed them of such riots and assaults as they had made on me and my men, the bailiff of Costessey and all the duke of Suffolk's council being present, and all the learned men of Norfolk, and William Jenney, and much people of the country. The judge called the bailiff of Costessey before them all and gave him a great rebuke, commanding the sheriff to see what people they had gathered at Drayton.

The sheriff complied and afterward rode to Hellesdon, where he found that the Pastons had not assembled a large force; "he held himself well content" with the people there. He ordered that Thomas Bond be freed, "and they made excuses and said they had sent him to the duke of Suffolk." Later they delivered Bond to Norwich, insisting that he should pay a fine, but Margaret intervened and he was excused. "And in good faith, I found the judges right gentle and forbearable to me in my matters," Margaret wrote.

Although John had directed Margaret to hold a court at Drayton, she decided against it on learning that the duke was now said to have some five hundred men there; instead she said she was advised to "gather a fellowship to keep my place at Hellesdon, for it was told me that they should come and pull me out of the place, which caused me to keep the place the stronger at that time."

Writs of replevin were finally delivered by the sheriff for recovery of the sheep and other animals seized from Hellesdon, and the sheriff sent three of his men and two shepherds to reclaim the beasts. But "there they were answered that Yelverton claims the property, and so were they answered in all other places where any cattle were," and the sheriff's men returned empty-handed. Margaret pointed out to the sheriff that Yelverton could not claim the property unless he were present "in his own person. . . . What [the sheriff] will do I do not know."[15]

In mid-August, Margaret thought once more of going to London to see her husband but urged him, "At the reverence of God, if you may find a means that you may come home yourself, that shall be most profitable to you, for men cut large thongs here of other men's leather." Both Agnes and Fastolf's niece Elizabeth Clere were leaving town, Agnes going to Caister, "for the pestilence [plague] is so fervent in Norwich that they dare no longer abide there, so God help." Margaret added reassuringly, "Methinks by my mother that she would right fain that you did well and that you might speed right well in your matter." The sheriff, meanwhile, told her that "as for the replevins he would take counsel of learned men what he might do therein, and . . . he would do for you and yours what he might do."[16]

The inquiry into Fastolf's will that Yelverton and Worcester had launched in the ecclesiastical court—where matters regarding wills were heard—began its examination of John Paston in July 1465, questioning him about the conditions under which the final will was made and how it was transcribed.[17]

The interrogation continued in the Fleet, where John was imprisoned for a third time late in August. The Paston Letters do not reveal the reason for his arrest, except in later vague references to his having been jailed "because of the bondage." The Norwich municipal records, however, list a seizure of property in the city belonging to "John Paston, whom the Lord King seized as his bondsman."[18] Evidently the charge made in the "Remembraunce of the Worshipful Kin and Ancestry of Paston" had been raised again, undoubtedly by Yelverton and his friends; imputing servile descent was a legal trick sometimes employed as a pretext to seize land.

However it was contrived, John's prison stay was this time of longer duration. In September, Margaret traveled to London to visit him, leaving Sir John in charge at Hellesdon and John III in Norwich but taking her elder daughter, fifteen-year-old Margery,

with her. By now there were three younger children at home: Anne, born about 1455; Walter, 1456; and William, 1459. Anticipating her arrival in London, John III directed a letter to her there asking her to remind his father that a decision had to be made about the manor of Cotton. He added a request:

> Also, mother, I beseech you that . . . I might have sent home by the same messenger two pairs of hose, one pair black and the other pair russet, which are already made for me at the hosier's with the crooked back, next to Blackfriars Gate, in Ludgate; John Pampyng knows him well enough, I suppose. . . . I beseech you that this gear be not forgotten, for I have not a whole hose to put on; I trow they shall cost both pair eight shillings. . . . I pray you visit the rood [cross] at the north door [of St. Paul's] and St. Saviour's at Bermondsey while you abide in London, and let my sister Margery go with you to pray to them that she may have a good husband ere she comes home.[19]

Margaret's visit evidently cheered the prisoner. In this subsequent letter, dictated to John Pampyng (20 September 1465), instead of his usual cool salutation, "I recommend me to you," he began, "My own dear sovereign lady." He thanked her "for the great cheer that you made me here," adding wryly, "to my great cost and expense and labor." There followed a list of requests and instructions, first that she should send him "two ells of worsted [the high-grade woolen cloth deriving its name from the Norfolk town of Worstead] for doublets, to help me this cold winter, and that you inquire where William Paston bought his tippet of fine worsted, which is almost like silk, and if that is much finer than what you can buy me for seven or eight shillings, then buy me a quarter, with a nail [small strip] of it for the collars, even though it is dearer than the other, for I would make my doublet of worsted for the worship of Norfolk."

He continued with instructions about a Fastolf manor contested by the duke of Bedford's widow, suggesting that Thomas Howes move William Worcester to look into the evidence, and ended with an uncharacteristic burst of doggerel:

> *Item: I shall tell you a tale.*
> *Pampyng and I have picked your male [trunk],*
> *And taken out pieces five,*
> *For on trust of Calle's promise we may not soon thrive,*
> *And, if Calle brings us hither twenty pound,*
> *You shall have your pieces again, good and round;*
> *Or else, if he will not pay you the value of the pieces*
> * there*
> *To the post do nail his ear;*
> *Or else do him some other sorrow,*
> *For I will no more for his fault borrow;*
> *And unless the receiving of my livelihood is better plied*
> *He shall have Christ's curse and mine clean tried;*
> *And look you be merry and take no thought,*
> *For this rhyme is cunningly wrought.*
> *My Lord Percy and all this house* [Percy, son of the earl
> of Northumberland, who had been killed at the
> battle of Towton in 1461, apparently also a
> prisoner]
> *Recommend them to you, dog, cat, and mouse,*
> *And wish you had been here still,*
> *For they say you are a good gill [companion].*
> *But God save him that made this rhyme.*
> *Written on the Vigil of St. Matthew.*

In his own hand, John wrote at the bottom, "By your true and trusty husband, J.P."[20]

Margaret replied a week later "thanking you of your great

cheer that you made me, and of the cost that you did on me. You did more than I wanted you to do, but if it pleased you to do so, God give me grace to do what may please you." She reported that on her way home, evidently at John's instruction, she had gone to Cotton, the manor that had now been in the hands of Gilbert Debenham for three years; she had "entered" it, formally asserting possession. By prearrangement, John III met her there with a following of a dozen men "to receive the profits of the manor" at Michaelmas, the day of rent collection, less than a week off. By that time "I hope there shall be more [men] to strengthen them, if need be." John III had gone to the duke of Norfolk to enlist his "good lordship," and the duke had promised to send reinforcements.[21]

Michaelmas arrived, and John III proceeded to hold a manorial court and "began to distrain upon the tenants and gathered some silver—as much, I think, as will pay our costs." Debenham, taken by surprise, quickly raised a large force—three hundred men, John III said—to drive the Pastons out.

John III had recourse to a stratagem. A member of the duke of Norfolk's household "who owes me good will" was sent to warn the duke that an armed clash was about to take place between Debenham's men and the Pastons' own

> great fellowship, the numbers of which he reported as one hundred and fifty more than we were. And he said to my lord and my lady and to their council that unless my lord took a hand in the matter, there was likely to be great harm done to both our parties, which would be a great disworship to my lord, considering that both of us are his men, and well known as such.

Such a conflict "so near him, contrary to the king's peace," would be an embarrassment to his lordship.

The duke promptly summoned John III and Debenham to Framlingham, where he "desired of us that we gather no further fellowship, but that such men as we had gathered we should send home again," and that the manorial court be postponed until the duke or his deputy could "speak with both you and Yelverton and Jenney." Meanwhile, "an indifferent [neutral] man chosen by us both should be assigned to keep the place until you and they were spoken with."

John III replied that he needed to consult with "his master within the manor of Cotton, which was my mother," Margaret having providentially arrived "not half an hour before" the duke's messenger summoned John III. A messenger was sent to Margaret, who promised to adjourn the court "at the instance of my lord and my lady" and collect no more rents until the question of title was settled in London between the duke and John I. John III noted that they had already gathered "full nearly as much silver" as Richard Calle's books showed they were owed, "and as for possession of the place, we told him that we would keep it, and Sir Gilbert agreed, if Yelverton and Jenney would do the same." Debenham's acquiescence was given with ill grace— John III reported that the duke "told [Debenham] that he would chain him by the feet otherwise, to make sure that he made no insurrections until the time that my lord came again from London."[22]

The Pastons' enjoyment of victory at Cotton was short-lived. The duke of Suffolk concerted plans for an attack with his supporter, the mayor of Norwich, Thomas Elys. By accident or design, they chose a day (15 October 1465) when John Paston III had been summoned to London to attend the young duke of Norfolk's formal investment in his lands and titles.[23]

Mobilizing a force that Margaret estimated at five hundred men, the duke of Suffolk virtually occupied Norwich while simultaneously assaulting Hellesdon, two miles away. The small

Hellesdon garrison prudently avoided combat, a posture that the duke may have anticipated and that made possible a favorite tactic of land contests, a violent action with no bloodshed. Commandeering the tenants to help, the intruders razed the manor house, the lodge, and other buildings and ransacked the church, carrying off the images from the high altar. Several Paston servants, including the cook, were taken as prisoners to Costessey.

Three days later Margaret wrote John that the duke was trying to lay hands on "as many as they can get of your men and tenants that owe you good will or have been favorable to you," threatening to slay or imprison them. The duke of Suffolk himself had appeared in Norwich on the day of the attack, Margaret said, and had summoned the mayor, the aldermen, and the sheriff "in the king's name," asking them to have the constables of every ward in the city inquire "what men had gone to help or succor your men," and they should be arrested and "corrected." Which, Margaret added,

> the mayor did, and will do anything that he can for him and his. It is told me that the old lady [the dowager duchess] and the duke are set fiercely against us by the information of Harleston and the bailiff of Costessey. . . . This night at midnight, Thomas Sleyforth . . . and others had a cart and fetched away feather beds and all the stuff of ours that was left at the parson's and Thomas Waters's house.[24]

The following week Margaret visited Hellesdon and was appalled.

> In good faith, no creature can think how foully and horribly it is arrayed unless they see it. Many people come every day to wonder at it, both from Norwich and other places, and

they speak of it with shame. The duke would have been better off by a thousand pounds if it had never been done, and you have the good will of the people because it is so foully done. The duke's men . . . put the parson out of the church till they had done [pillaging it], and ransacked every man's house in the town five or six times. . . . As for the lead, brass, pewter, iron, doors, gates, and other stuff of the houses, men from Costessey and Cawston have it, and what they could not carry away they have hewn asunder in the most malicious way. If it might be, I wish some men of worship might be sent from the king to see how it is . . . before the snow falls, that they may make report of the truth, or it shall not be seen so plainly as now.

Once more she urged her husband to settle his "matters" in London,

for it is too horrible a cost and trouble that we have now daily, and must have till it be otherwise; and your men dare not go about to gather your livelihood, and we keep here [in Norwich] daily more than thirty persons to protect us and the place, for in very truth if the place had not been kept strongly, the duke would have come hither.[25]

The Pastons sued for the restitution of Hellesdon and Drayton, or compensation for them, but both manors were irretrievably lost to the powerful duke. So was Cotton, though its history is more obscure in the records; ultimately it became the property of Alice Chaucer, dowager duchess of Suffolk, to whom the Yelverton clique awarded it in 1469, and who named it in her will shortly before her death in 1475.[26]

The Pastons' losses could have been even more serious. In addition to the seizure of Paston property in Norwich, recorded in city

records, Caister was occupied for a time, as reported by William Worcester in his *Itineraries,* "under color of a rumor spread contrary to the truth that John Paston, Esq., was the . . . king's bondsman." Worcester believed that Yelverton was behind the seizure.[27]

John was released from Fleet Prison sometime in January or February, and he returned at once to his legal battles; in February, Paston servant John Wykes wrote Sir John that "Jenney desires a treaty with my master, and spoke to my master himself in Westminster Hall."[28]

Then suddenly, at the end of May 1466, John Paston was dead. He was only forty-four; the cause of his death is unknown. In a letter to John III four years later, Margaret attributed it to his legal troubles; the struggle over Fastolf's estate "was the destruction of your father."[29] Gairdner agreed, believing that John was worn out by years of combating "the intrigues of lawyers and the enmity of great men."[30] If that is so, he was also the victim of his own uncompromising nature. Hard-working, efficient, and reliable in the service of Sir John Fastolf and in his own family's interest, he was obstinate and intractable in defense of his Fastolf inheritance, and thus bequeathed to his heirs large problems along with a large estate.

John evidently died at an Inn of Court, perhaps his own Inner Temple; the record of his funeral expenses includes a payment by Margaret to "the keeper of the Inn where my husband died."[31] His body was brought back to Norwich from London accompanied by a cortege headed by a priest, with "twelve poor men," six on either side of the bier, carrying torches. The arrival of the body in Norwich was greeted by bell ringers at St. Peter Hungate, where the body lay for a night and where the funeral service was performed by a large assemblage of clergy, including representatives of "the four orders of friars," thirty-eight priests, thirty-nine "boys in surplices," and the warden and nuns of

Norman's Hospital in Norwich. The prioress of Carrow was among the local luminaries present.

The next day the body was carried for burial to Bromholm Priory, near Paston, famed for its fragment of the True Cross and with special connections with the Paston family, who claimed one of their ancestors as the founder. The roll of expenses at Bromholm listed fees to a large number of servers, more bell ringers, and "two men that filled the grave."

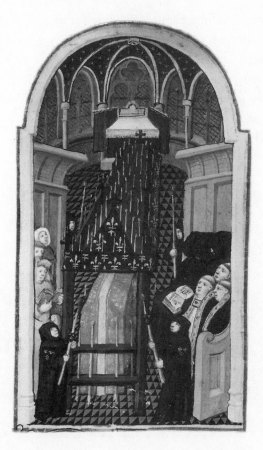

Funeral Mass for the dead. *(The Pierpont Morgan Library, M.359, f.199v)*

The burial repast included eighteen barrels of beer (one of them "of the best quality") and fifteen gallons of red wine, as well as large quantities of fish, eggs, bread, geese, capons, chickens, calves, lambs, sheep, milk, butter, and cream. In the course of the observance, eight pieces of the prior's pewter disappeared and had to be paid for. Another fee was paid to the glazier "for taking out two windowpanes of the church to let out the reek of the torches at the dirge, and the soldering again of the same."[32]

John did not live long enough to enjoy his most important victory. Two months after his death, and nearly a year after his imprisonment on the charge of being the king's bondsman, a royal pronouncement once and for all contradicted the "Remembraunce," declared the charge false, and cleared the Paston name. Addressed to the bailiffs of Yarmouth and signed by King Edward, the proclamation stated:

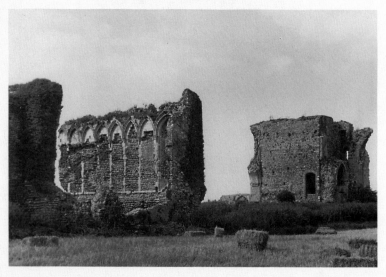

Ruins of Bromholm Priory, burial place of John Paston.
(Hallam Ashley)

Our trusty and well-beloved knight Sir John Paston, our well-beloved William Paston, and Clement Paston, and others, have been before us and our council worshipfully cleared of the charge that was made on our behalf against John Paston deceased and them . . . so that we hold them and every one of them as gentlemen descended lineally of worshipful blood since the Conquest; and besides that [we] have commanded that . . . the manor of Caister and all other lands and tenements with goods and chattels that the said John Paston deceased had of the gift and purchase of Sir John Fastolf, knight, shall wholly be restored unto our said knight Sir John Paston. . . . Wherefore, since our said knight intends to live at Caister, we desire and pray you for our sake that you will be friendly and neighborly unto him in his right.[33]

To this letter was added a certificate in the king's name setting forth the Pastons' own version of their pedigree, in support of which they had "showed divers great evidence and court rolls." These indicated that the family had long enjoyed the appurtenances of lordship; they had held bondsmen for generations; they had "had license to have a chaplain and have divine service" and had endowed religious houses; they had enjoyed the privileges of "homage . . . wardship, marriage, and relief," and had married within the nobility. Here appeared for the first time the Pastons' probably fictitious forebear, Wulstan de Paston, companion of the Conqueror, with his descent spelled out step by step. "And this was showed by writings of ancient hand and by old testaments and evidences."[34]

If they concocted an ancestry for themselves, the Pastons broke no new ground. Since the twelfth century, aristocratic families of Europe had filled in the inevitable blank in their early genealogies by inventing a noble progenitor, always in the form of a heroic

adventurer such as "Wulstan de Paston." Whatever the truth of the new Paston pedigree, the skeleton was permanently expelled from the family closet. Freed from this long-standing threat from their enemies, the Pastons were strengthened to deal with new threats to come.

Chapter 9

ROYAL MARRIAGES AND MISALLIANCES

1466–1469

ir John, now head of the family at the age of twenty-four, presented a marked contrast to his father. Where John was hardheaded, acquisitive, and an implacable defender of the family property, Sir John was a free spender, a collector of books, a devotee of knightly pleasures (including the pursuit of women), and a sometimes indifferent guardian of his estates. If the father was a typical English gentleman of the fifteenth century, as has been said, the son was perhaps a more typical English gentleman of a later era.

Despite his relaxed attitude toward the family problems, Sir John in the long run did surprisingly well with them. For the immediate future, however, the Pastons' fortunes were precarious and money was scarce.

Mindful of the recent brief seizure of Caister, as

well as the covetous eyes still fixed on it, the Pastons had moved into the castle, Margaret occupying it in October 1466. It was a place "where I would not be at this time but for your sake," she wrote Sir John.[1] In January 1467, John III relieved his mother and undertook to collect the revenues of the manor. He encountered resistance; a peasant named Hugh Austen "croaked many threatening words" while John III's men were collecting the barley owed by the tenants. Austen was apparently collecting for Yelverton; he had a wagonload of barley ready to carry to Yarmouth to sell. "And when I heard of it," John III wrote, "I let slip a pack of whelps that gave the cart and the barley such a turn that it was forced to take cover in your bakehouse cistern at Caister Hall, and it was wet within an hour . . . and is nearly ready to make good malt, ho! ho!" (apparently a refrain from a song).

Yelverton was busy making trouble elsewhere. He had visited Fastolf's old manor of Guton, ten miles northwest of Norwich, and "has put in a new bailiff there, and has distrained the tenants, and has given them until Candlemas to pay such money as he asks of them." He had also been to Saxthorpe, another nearby Fastolf manor, and "distrained the farmer there and taken surety from him." He had eight men at his back, all armed and "ready to ride," and one of them had told a bystander that they were going to "take a distress in certain manors that were Sir John Fastolf's." John III planned to send servant John Daubeney to order the tenants to pay their rents only to the Pastons. Yelverton's officers rode out daily, making a display of guns and body armor, by way of intimidating the neighborhood. John III suggested that Sir John might be able to get a royal order to make them cease and desist.[2]

That measure was evidently beyond Sir John's capabilities. He was, however, improving in the art of the courtier. He discovered a skill in jousting, the favorite sport of King Edward and

also of the king's new brother-in-law, Anthony Woodville. This young man had married into the family of Thomas Lord Scales, Fastolf's old enemy, and had himself acquired the title of Lord Scales on his father-in-law's death. It was he who had coveted, and briefly seized, Caister Castle and other Paston property when John I was in prison in 1465. All that was forgotten now as he and Sir John fought their mock battles side by side. In one tournament, at Eltham, Sir John suffered a hand wound but wrote his brother enthusiastically, "I would you had been there and seen it, for it was the goodliest sight that was seen in England this forty years. . . . There was on one side, within, the king, my Lord Scales, myself, and St. Leger; and without, my Lord Chamberlain [Lord Hastings], Sir John Woodville, Sir Thomas Montgomery, and John Aparre, etc."[3] In its long evolution, the tournament had reached a peak of athletic skill and showmanship, a sport governed by rules and embellished by ritual and display, making it, in eyes such as Sir John's, a "goodly" sight.

John III, at Caister, was unimpressed. He replied dryly, "Whereas it pleases you to wish me at Eltham, at the tourney, for the good sights that were there, by my troth I had rather seen you once at Caister Hall than to see as many king's tourneys as might be between Eltham and London." He had news that he judged of more import than his brother's jousting. Friar Brackley, who had died the previous year, shortly before John Paston's death, had remained faithful to the last; his confessor, Friar Mowght, reported to John III and Margaret that "the will that [John Paston] put into the court was as truly Sir John Fastolf's will as it was true that he should die." After his confession, Brackley had recovered briefly, then relapsed, and once more calling on Friar Mowght, reiterated his statement. "I desire that you will report after my death that I took it upon my soul at my dying that the will that John Paston put in to be proved was Sir John Fastolf's

will."[4] The confession added valuable weight to the Pastons' claim for Caister.

At the moment, John III was negotiating for a possible marriage with Alice Boleyn, youngest daughter of the late Sir Geoffrey Boleyn, the first of a long series of marriage projects initiated by him and Sir John during the next few years. Of this one, Sir John wrote him in March 1467:

> I cannot in any wise find [Lady Boleyn, the girl's widowed mother] agreeable that you should have her daughter, for all

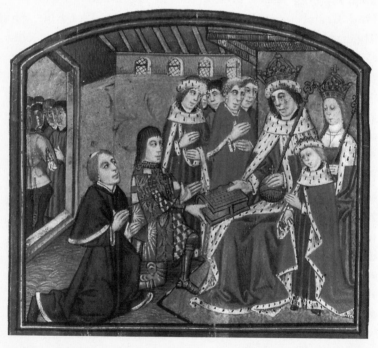

Anthony Woodville, second from left, presenting a book to his brother-in-law, Edward IV; his sister, Queen Elizabeth Woodville, is at the extreme right. *(The Archbishop of Canterbury and the Trustees of Lambeth Palace Library)*

the secret means that I could use. . . . I had so little comfort . . . that I disdained to discuss it with her in my own person. Nevertheless I understand that she says, "If he and she can agree, I will not forbid it, but I will never advise her thereto in any wise." And on Tuesday last, she rode home to Norfolk. Wherefore, you should find the means to speak with her yourself, for without that, in my opinion, it will not be.

Sir John added one of the few clues in the letters to a Paston's physical appearance: "You are personable, and perhaps your being once in the maid's sight, and a little discovering of your good will to her, binding her to keep it secret," all might not be lost. "Keeping it secret" was a fifteenth-century lover's stratagem. Sir John further counseled, "Bear yourself as lowly to the mother as you like, but to the maid not too lowly, neither that you be too glad to speed the matter, nor too sorry to fail."[5]

John III did not, however, succeed in seeing Alice Boleyn while she was in Norwich; she and her mother were there the week after Easter, he wrote his brother, "from Saturday to Wednesday . . . and I was at Caister and knew not of it."[6] Evidently the Boleyns did not intend to give him any encouragement. Nothing further is heard of the match.

In July 1467, Margaret reported an alarming rumor: John Fastolf of Cowhaw, father of Thomas Fastolf, was said to be preparing an assault on Caister with a hundred men "and sends spies daily" to ascertain the strength of the garrison. "By whose power or favor or support he will do this, I do not know." She was probably too discreet to name the duke of Norfolk, but Sir John must have read between the lines. John III and seventeen-year-old Edmund Paston were now in London, and Margaret entreated Sir John to send help.

You know well that I have been afraid there before this time, when I had other comfort than I have now, and I cannot well guide nor rule soldiers, and they do not hold with a woman as they would with a man. Therefore I would that you should send home your brothers, or else Daubeney, to take charge. . . . Your enemies begin to wax right bold, and that puts your friends both in great fear and doubt. Therefore purvey that they may have some comfort, that they be no longer discouraged; for if we lose our friends, it shall be hard in this troublous world to get them again.[7]

Sir John responded by sending John III to take command of the castle and began enlisting men to strengthen the little garrison. At the same time he moved to effect a substantive settlement of the whole question of the Fastolf inheritance. Abandoning the intransigent posture of his father, he came to an agreement with Fastolf's other executors, headed by Bishop Waynflete and including William Yelverton and William Jenney, that released some of Fastolf's lands at Caister and elsewhere to the Pastons as part of a general settlement (Drayton and Hellesdon were not included).[8]

The settlement also attempted to come to grips with the problem of Fastolf's college of priests and poor men. Most of the executors now agreed that the college should be founded, but there was disagreement over its location. Despite the fact that John Paston I had succeeded in obtaining a license for a college at Caister, many of them wanted it elsewhere. Bishop Waynflete proposed Oxford; William Worcester, though an Oxford man himself, recommended Cambridge, closer to Norfolk and Suffolk, and suggested, instead of a college, "some other memorial . . . perhaps with two clerks or three or four scholars" that might be supported "with much less cost," thereby leaving more revenues available to reward executors and deserving old servi-

tors. It could be endowed with the income from "good benefices and rich parsonages," which could be purchased "much more cheaply than lordships or manors." No immediate action was taken.[9]

At Christmas, Bishop Waynflete took the opportunity to make peace between Worcester and the Pastons. "Would Jesus," Worcester wrote Margaret, "that my good master that was once your husband . . . could have found it in his heart to have trusted and loved me as my master Fastolf did, and that he would not have given credence to the malicious contrived tales that Friar Brackley, William Barker, and others untruly imagined of me."

He denied any connection with Yelverton's and Jenney's hostile actions. "I appeal to all the world I never put manor nor livelihood of my master Fastolf's in trouble, or entitled any creature to any place." As for Caister, he was "right glad" that it should be in the Pastons' hands. "A rich jewel it is, needed by all the country in time of war; and my master Fastolf would rather he had never built it than it should be in the governance of any lord that would oppress the country."[10]

In bringing about the settlement, Sir John probably had assistance from two patrons whom he had successfully cultivated. One was John de Vere, the earl of Oxford, who was, after the dukes of Norfolk and Suffolk, the largest landowner in East Anglia. In the period following Judge William's death, John Paston I had fostered a connection with the present earl's father, who was executed for treason early in the reign of Edward IV. Sir John continued the relationship with the son.

The second noble who may have helped in the settlement was the earl of Oxford's brother-in-law, Richard Neville, the mighty earl of Warwick, destined to be known to history as "Warwick the Kingmaker." For several years Warwick had been the most important figure in the government of Edward IV, but

recently, and largely beneath the surface, a shift had taken place. The brilliant and presumptuous earl perhaps underestimated the youthful Edward, who felt capable of making decisions for himself.

In Western Europe at this moment, three powers competed, England, France, and Burgundy, the last a strong and wealthy amalgamation that stretched from eastern France to the North Sea, encompassing Flanders and the Netherlands. In the early 1460s, while Sir John, not yet knighted, was trying to make a

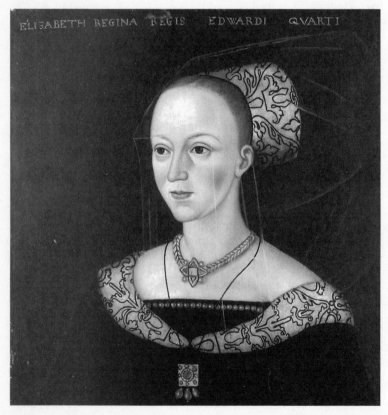

Portrait of Elizabeth Woodville. *(The Royal Collection © 1998 Her Majesty Queen Elizabeth II)*

place for himself at court and the Pastons were battling for the manor of Cotton, Warwick conceived an Anglo-French entente, to be sealed by a marriage between bachelor king Edward IV and a French royal princess. Edward, on the other hand, favored a revival of the Anglo-Burgundian alliance of the Hundred Years War, with its connections to the vital wool trade, profitable to the Crown. Warwick's French negotiations were nearly completed when one September day in 1464 Edward explained to a startled royal council that he could not marry the French princess because the previous May he had secretly wed Elizabeth Woodville (or Wydeville) Grey, an English lady from an obscure knightly family with a history of Lancastrian allegiance. Edward, a notorious womanizer who had rarely encountered resistance either from a lady or from her husband or father, had fallen in love with Elizabeth, had been refused entry to her bed—so London gossip ran—and had allowed himself to be cajoled into marriage.

Edward's announcement had stunned and outraged the earl of Warwick. The casual dismissal for a frivolous reason of his grand diplomatic project was bad enough, but worse followed when Edward put forward his own diplomatic enterprise: an alliance with Burgundy to be cemented by the marriage of his sister Margaret—one of the children who had sojourned in the Fastolf mansion in Southwark in 1461—to the duke of Burgundy's son, a bellicose young man remembered in history as Charles the Rash.*

In the rapprochement with Burgundy that followed, Lord Scales sent a friendly challenge to the Bastard of Burgundy, natural son of the duke and a noted jouster. A match, to be accompanied by suitable festivities, was planned to take place in London but had to be canceled upon news of the death of the duke of Burgundy (June 1467).

*Charles le Téméraire, sometimes translated as "Charles the Bold."

The duke's death and Charles the Rash's succession to the Burgundian title and lands gave the projected marriage greater immediacy, and it was scheduled for June 1468, the ceremony to take place in Bruges, the rich capital of Charles's Flemish territory. Just before the duke's death, Sir John had made a wager with a London merchant, carefully written out in John Pampyng's hand and validated by the seals of both parties, that the projected wedding would not take place for two years, the stake being a reduction of two pounds in the price of a horse he

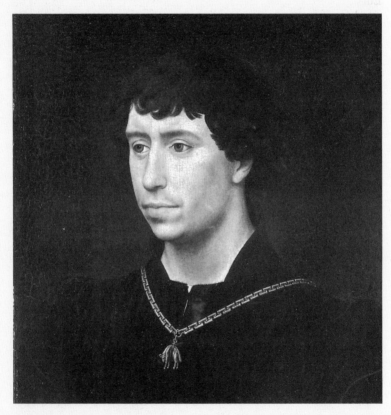

Portrait of Charles the Rash, duke of Burgundy, by Rogier van der Weyden. *(Staatliche Museen zu Berlin—Preussischer Kulturbesitz Gemäldegalerie; Photo: Jörg P. Anders)*

was buying from the merchant.[11] Loss of the bet must have been more than compensated, in Sir John's eyes, by the formal invitation he presently received from the king to be part of the entourage recruited to escort Princess Margaret.[12] The bride's chief lady attendant was the duchess of Norfolk, among whose retinue was John Paston III, so that both Paston brothers figured in the wedding party. John III wrote his mother an enthusiastic description of the ceremony and the accompanying tournaments and spectacles, which set a standard for official pageantry in Europe.

My lady Margaret was married on Sunday last past, at a town that is called Damme, three miles out of Bruges, at five o'clock in the morning; and she was brought the same day to Bruges to her dinner; and there she was received as worshipfully as all the world could devise, as with processions of lords and ladies, the best arrayed of any people that ever I saw or heard of. Many pageants were played on her way to Bruges to her welcoming, the best that ever I saw.

And the same Sunday my lord the Bastard took upon him to answer twenty-four knights and gentlemen within eight days of jousts of peace [with blunted weapons]; and when they had fought, the twenty-four and himself should tourney with another twenty-five the next day after, which is on Monday next. And they that have jousted with him up to this day have been as richly arrayed, and himself also, as cloth of gold, and silk, and silver, and goldsmiths' work might make them; for of such gear, and gold, and pearl, and stones, they of the duke's court, neither gentlemen nor gentlewomen, want none. . . .

This day my Lord Scales jousted with a lord of this country, but not with the Bastard; for they promised at London that neither of them should ever deal with the other in arms;

but the Bastard was one of the lords that brought the Lord
Scales onto the field, and unfortunately a horse struck my
Lord Bastard on the leg, and has hurt him so sore that I think
he shall be unable to fight; and that is great pity, for by my
troth I think God made never a more worshipful knight.

And as for the duke's court, as of lords, ladies, and gen-
tlewomen, knights, squires, and gentlemen, I never heard of
any like it, save King Arthur's court. And by my troth, I have
no wit nor memory to write you half the worshipful things
that are here; but what is lacking, as it comes to mind, I shall
tell you when I come home, which I trust to God shall not be
long hence; for we depart out of Bruges homeward on
Tuesday next, and all folks that came with my lady of
Burgundy out of England, except such as will abide with her,
which I know well shall be but few.[13]

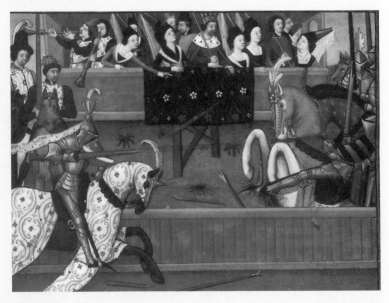

Fifteenth-century tournament. *(British Library, MS. Nero D IX, f.32v)*

Other observers added more precise details. Like many late medieval tournaments, this one was designed around a chivalric romance, in this case the story of a captive giant and the princess of an unknown isle; the champion who freed the giant would win the princess. On the first day, a dwarf dressed in crimson and white satin led the giant into the lists by a chain, tied him to a gilded tree, and sounded a trumpet, summoning the "Knights of the Golden Tree," attired in velvet and ermine. A different kind of joust marked each day, ending on the last day with the melee, twenty-five knights to a side. At the first banquet a female dwarf in cloth of gold rode into the hall mounted on a mechanical lion to present a daisy (marguerite) to the new Duchess Margaret; the feast on the last day featured a sixty-foot mechanical whale, its tail and fins working, its mouth emitting music, and a battle between twelve sea knights and twelve giants.[14]

John III concluded his report:

We depart the sooner because the duke has word that the French king [Louis XI] is intending to make war on him soon, and that he is within four or five days' journey from Bruges, and the duke rides forward to meet him next Tuesday. God give him good speed and all his men, for by my troth they are the goodliest fellowship that ever I came among.[15]

Home again in England, Sir John took up residence in Caister Castle, anticipating the pleasant life of a wealthy landowner. However, the settlement with Bishop Waynflete had cost so many revenue-producing properties that though he lived in luxurious surroundings he was pressed for ready cash. One of his first acts was to commission a "Great Book" of treatises on knighthood, war, and other chivalric topics to be handwritten by

a scribe named William Ebesham. That fall Ebesham penned a pathetic dunning letter to his "most worshipful and most special master" asking that he be "somewhat rewarded" for his work on the Great Book and several other copying tasks. He had already written John Pampyng, without result, and now concluded:

And in especial, I beseech you to send me as alms one of your old gowns, which will, I know well, cancel much of the charges, and I shall be yours while I live, and at your commandment; I have great need of it, God knows, whom I beseech preserve you from all adversity. I am somewhat acquainted with it.[16]

As the fall progressed, a new threat to Caister suddenly materialized. Although his kinsman William Worcester had made peace with the Pastons, Thomas Howes, once John Paston's friend and ally, had gone over to the other side, as John's brother Clement had feared four years earlier at the beginning of the hearings in the Church court. In the summer of 1467, Howes had made a statement addressed "to all men," denying the Pastons' charges that Yelverton had bribed witnesses and declaring his own "great remorse for the untrue forging and contriving" of the will "in my said master Fastolf's name after he was deceased."[17] Now, in 1468, he made a long, detailed declaration about the circumstances of Fastolf's final days.

On the fateful Monday, 5 November, he asserted, he had entered the lower hall of the castle "about six o'clock after midday," with Fastolf dead on the floor above, and had seen John Paston with "a little scrowe [screw? scroll?] of paper in his hand in his own writing in English, part of said scrowe lately written and moist of ink; he took ashes out of the chimney to dry it."

The following day, Howes said, John had summoned him-

self, Friar Brackley, William Worcester, an Austin friar named Clement Felmyngham, and several servants and had asked the two friars to set their seals to the new will. John had then sealed it himself, opened it, and asked the friars to read it. They informed Howes that it contained a covenant bequeathing the Fastolf estates "in Norfolk, Suffolk, and Norwich" to John Paston for a payment of four thousand marks and named Paston and Howes sole executors. But, Howes declared, "The said Sir John Fastolf made no such testament, ordinance, nor will." For a year before Fastolf's death, Howes claimed, he had "labored" to persuade Fastolf to sell his lands to John Paston on condition that John found the college at Caister, but Fastolf "would in no wise assent." On the contrary, he had sworn "by Christ's sides, 'If I knew that Paston would buy any of my lands or my goods, he should never be my feoffee nor my executor.' Albeit he said that he would suffer the said Paston for the term of his life to have lodging in a convenient place in the said manor of Caister." Even for the mercurial Fastolf, the words attributed to him by Howes seem implausible in light of the many expressions recorded by Fastolf and others of the trust and affection he reposed in John Paston.

According to Howes, the attendants who were present during Fastolf's illness—his chaplain, physician, barber, and others—"neither heard nor knew of any such schedule, testament, or nuncupative will said, made, declared, nor written by the said Fastolf's orders."[18] Yet among the attendants he listed was Fastolf's cousin Robert Fitzralph, who had delivered strong testimony in direct contradiction of Howes's claim; according to Fitzralph's sworn memorandum of 26 November 1459, not only had Fastolf stated the terms of the "covenant" on his deathbed, but Fitzralph had known about them for "this half year past."[19]

Howes went on to assert that Friar Brackley and Friar Clement had joined in the forgery of Fastolf's "bargain" with

John. A servant, John Russe, had removed Fastolf's seal and signet from a sealed purse to supply authenticity. "These things so forged and contrived," Howes declared, had caused him "to believe and mistrust that all those writings and matters comprehended in them were untrue"—although it had taken him several years to articulate his doubts.

To his charge of forgery, Howes added an incidental one of "wastefulness," really meaning bribery: John Paston had brought the two friars and other "suspect witnesses" up to London to testify in his behalf, but the judge "would not admit and receive" them, and therefore they "wasted that season in London in meat, drink, and rewards and other expenses from the said Fastolf estate . . . to the amount of 100 marks and more."[20]

In October 1468, Howes followed up his accusation with an obsequious letter to the archbishop of Canterbury that suggests a motive for his change of allegiance. According to Howes, "my lord of Norfolk's council" had approached Yelverton and Howes about the purchase of Caister "and certain other lordships that were my master Fastolf's, whom God pardon." As for the college, whose foundation Fastolf had set his heart on, Howes disposed of it in cavalier fashion: "I with other of my master Fastolf's executors" would arrange for other suitable charities "for his soul."[21]

Howes's plan for the sale of Caister to the duke of Norfolk did not meet with universal approval. A Paston friend—the letter of 28 October 1468 is unsigned—wrote Sir John Paston reporting on an exchange of words that had taken place in the king's chamber between George Neville, archbishop of York, and his brother, the earl of Warwick, on the one hand, and the duke of Norfolk on the other. The conversation was "openly in every man's mouth in this country." The archbishop had said that rather than have the duke of Norfolk take possession of Caister, "he would come dwell there himself." Archbishop Neville had

recently been chancellor of England and was hoping for reappointment; the Pastons' adversaries swore he "should never be chancellor till this matter be sped"—until he agreed to the duke of Norfolk's occupation of Caister.

Sir John's anonymous informant reminded him that "there are witnesses [ready to] swear against you," including some "that never knew of the matter and never heard Sir John Fastolf speak." Everybody knew "what sort of jury there is in this country [Norfolk] in matters that are favored" by the Paston enemies. "Some of the same men that found you a bondsman" when Sir John's father was alive "will witness against you."

The writer added that Thomas Howes was coming to London and suggested that the friendly bishop of Ely, together with the archbishop of York, might induce him to "go home again and leave all his fellows." Waxing sarcastic, the writer indicated that he thought Howes susceptible to bribes or threats; if he could either be promised that "he should be pope" or menaced with loss of "all ecclesiastical benefices for simony, lechery, perjury, and double changeable peevishness . . . it should make him depart, for he and Yelverton are half at variance now."[22]

The opposition of Archbishop Neville and his brother the earl of Warwick was probably all that prevented the duke of Norfolk from laying hands on Caister. As it was, his agents visited the dependent manors and warned the tenants to pay no rents to Sir John Paston. The danger was enough to rouse Sir John to extraordinary measures. Leaving Caister in the hands of John III and Daubeney, he returned to London to resume recruiting men for the garrison. He soon wrote John III to announce that he had engaged "four trustworthy and true men," professional soldiers,

cunning in war, and in feats of arms [who] can shoot both guns and crossbows well, and mend and string them, and

devise bulwarks or anything to strengthen the place; and they will, when needed, keep watch and ward. They are wise and sensible men, except one of them, who is bald, and called William Penny, who is as good a man as can be found on earth, except that he is, I understand, a little inclined to be cup-shotten [drunk], but yet is no brawler, but full of courtesy. The other three are Peryn Sale, John Chapman, and Robert Jackson. As yet they have no harness [armor], but when it comes it shall be sent to you, and meanwhile I pray you and Daubeney to purvey them some. They also need a couple of beds, which I pray you by the help of my mother to purvey for them till I come home to you. You will find them gentlemanly, comfortable fellows, and they will abide by their agreement; and . . . I sent you these men because men of the country thereabouts would fear the loss of their goods.[23]

Sir John spoke of coming home soon, but he remained at court, leaving Margaret and John III to deal with the threatening situation in Norfolk. In March, Margaret reported that Yelverton, his son, and followers armed with spears and lances "like men of war" had been at the manor of Guton to take "distresses." As earlier at Cotton, Drayton, and Hellesdon, they had seized plow animals and made it impossible for the tenants to do their spring plowing. Unless something were done within the week "so that they may peaceably harrow their lands without assault or distress by Yelverton or his men . . . their tilth in the fields will be lost for the year and they will be undone." Furthermore, Sir John would lose his rents for the year, "for they may not pay you unless they can work their lands; they no sooner set a plow out at their gates than there is a fellowship [gang] ready to take it." He would also "lose the tenants' hearts

and . . . be greatly hurt; for it is a great pity to hear the sorrowful and piteous complaints of the poor tenants that come to me for comfort and succor sometimes six or seven together."

John's will was still not probated, and Margaret urged Sir John to broach the matter with the archbishop of Canterbury "while he lives, for he is an old man," and if he died, his successor might be "a needy man" who would be more difficult—that is, more expensive—to deal with. She drove the point home: Sir John should "act hastily and wisely . . . and do not make delays as you did when my lord of York [George Neville] was chancellor, for if you had labored during his time as you have since, you would have been through with your matters . . . let sloth no more take you into such fault."[24]

Sir John had not been slothful in all matters. During the winter he had made the acquaintance of a lady of the court named

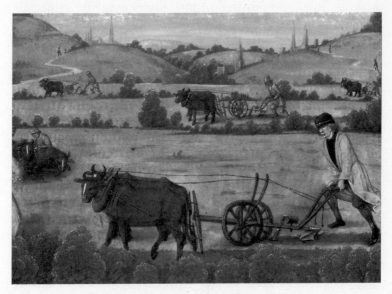

Plowing in the fifteenth century.
(British Library, MS. Cott. Aug. V, f.161v)

Anne Haute, who was a first cousin of the queen and of Sir John's jousting friend, Lord Scales. He had pursued Mistress Haute to such effect that the two had exchanged vows that in the present state of the Church's evolving definition of marriage were binding, even though no actual ceremony had taken place. Commitment to marriage was normally made at the church door, where Chaucer's wife of Bath boasts of having stood five times, but the location was immaterial, provided the words spoken were "words of the present" ("I take you for my wife/husband") rather than "words of the future" ("I will take you . . . "). English courts recorded vows exchanged under an ash tree, in a bed, in a garden, in a blacksmith's shop, in a kitchen, at a tavern, and in the king's highway.[25] Often, whether the verbal commitments represented mere betrothal or actual marriage was not easy to determine; sometimes, as proved to be the case with Sir John and Mistress Anne Haute, even the principals were uncertain.

So was Margaret, who in April wrote her son, "I have no more knowledge of your ensurance [betrothal] but if you are ensured I pray God send you joy and worship together, and so I trust you shall have, if she is as good as is reported; and in the sight of God you are as greatly bound to her as if you were married, and therefore I charge you on my blessing that you are as true to her as if she were married to you in all degrees." However: "I want you not to be too hasty to be married until you are more sure of your livelihood, for you must remember what expenses you will have, and if you cannot maintain it, it will be a great rebuke; therefore labor that you may have releases of the lands and be surer of your land before you are married." She urged him to "speed your matters" so that he would need to keep a smaller garrison at Caister, "for the expenses and costs are great."

The letter included a hint of family troubles to come:

I would that you should purvey for your sister [Margery] to be with my lady of Oxford, or with my lady of Bedford, or in some other worshipful place, wherever you think best, and I will help with her expenses, for we are both of us weary of each other. I shall tell you more when I speak with you. I pray you do your duty herein if you wish my comfort and welfare, and your worship, for diverse causes which you shall understand later.

For the moment she said no more about Margery but passed on to express gratitude for Lord Scales's promise to give help over the duke of Norfolk's high-handed conduct at Caister, where he had distrained some of the tenants, sent men to fell wood, and other "such matters."[26] Lord Scales kept his promise. Writing to the duke's council to protest the depredations, he explained his interest in the matter.

And forasmuch as marriage is fully concluded betwixt the said Sir John Paston and one of my nearest kinswomen, I doubt not that your reason will conceive that nature must compel me . . . to show my good will, assistance, and favor unto the said Sir John in such things as concern his inheritance.[27]

◩

The ambiguities of the church marriage laws also played a role in one of the most dramatic episodes of the Paston story. In May 1469 the problem with daughter Margery that Margaret had hinted at in April suddenly burst into the light. At some point within the past two or three years, the girl had fallen in love with the Pastons' bailiff, Richard Calle, and the two had exchanged secret vows amounting, as they believed, to a clandestine mar-

riage. To her mother and brothers the news brought shock and outrage. Margery at about twenty—her exact birth date is unknown—was of a marriageable age and had been on the marriage market for several years. The first mention of negotiations for her marriage had occurred in the Letters five years before; more recent negotiations may have forced the secret vows with Calle into the open. (Calle seems to have broken the news to Margaret.)

A letter from John III to Sir John reveals the depth of the family's anger and the explanation for it.

> I conceive by your letter . . . that you have heard of R.C.'s labor which he makes with the assent of our ungracious sister; but when they write that they have my good will therein . . . they falsely lie, for they have never spoken to me of that matter, nor to anybody else.

One of Calle's friends had felt John out, however. "I think it was at Calle's suggestion, for when I asked him whether C. desired him to ask me that question, he wanted to reply by hums and by haws, but I would not so be answered." The friend then pretended that he had a marriage prospect in mind for Margery,

> but I know he lied, for he is wholly with R. Calle in that matter. Wherefore so that neither he nor they should get any comfort from me, I answered him that even if my father, whom God assoil, were alive and had consented thereto, and my mother, and you both, he should never have my good will to make my sister sell candles and mustard in Framlingham; and thus, with more which were too long to write to you, we parted.[28]

Candles and mustard in Framlingham: that was the crux of the problem. Though the Paston men did not find the widows and daughters of rich wool merchants beneath their consideration as prospective wives, Calle's family were shopkeepers. Their son had been an able, loyal, upper-level servant for fifteen years, trusted with the Pastons' most vital missions; he had just brought to a successful conclusion, after two years' determined effort, the family's struggle to validate Judge William's purchase of East Beckham. The Pastons appreciated his hard work, intelligence, and expertise, but the match was a definite step downward, an impermissible misalliance. Medieval marriage involved much more than the principals; it was about family interests, both material and social: land and money, status and alliances (on higher levels, national and international politics). Although the idea of love was by no means absent, it was a secondary consideration, valued for making a marriage harmonious. Often, like John Paston and Margaret Mautby, the partners hit it off immediately or came to love each other; this was desirable, but love did not come first.

In the case of Richard Calle and Margery Paston, the family's wrath was probably compounded by the secrecy of the affair. It seems likely that they had consummated the marriage, although the concern of both family and Church focused on what they had said rather than on what they might have done. Calle was some years older than Margery, probably in his late thirties; the Pastons may have felt he had taken advantage of the young girl. John III's anger was such that he told Sir John that he needed money, but "so God help me" he would not ask Calle to send him any of the manorial receipts.[29]

Throughout the painful ordeal that they were now forced to undergo, the two principals maintained a bearing of courage and dignity. Probably at about the same time as John III's angry

candles-and-mustard letter, Calle wrote Margery a letter equally heartfelt and equally expressive, one of the best known in the collection. Margery, like her aunt Elizabeth years earlier, had been placed under strict surveillance. Calle wrote:

My own lady and mistress, and before God my true wife, I with heart full sorrowful recommend me to you as one that cannot be merry nor shall be until it be otherwise with us than it is now; for this life that we lead now is no pleasure to God or to the world, considering the great bond of matrimony that is made between us, and also the great love that has been and I trust yet is between us, and on my part never greater.

Wherefore I beseech Almighty God to comfort us as soon as it pleases Him, for we that ought by right to be most together are most asunder; it seems a thousand years ago since I spoke with you. I had rather be with you than have all the goods in the world. Also, alas! good lady, they that keep us thus asunder remember full little what they do.

I understand, lady, you have had as much sorrow for me as any gentlewoman has had in the world, as would God all the sorrow that you have had had rested upon me, so that you had been discharged of it, for I know, lady, it is to me a death to hear that you are treated otherwise than you ought to be. This is a painful life that we lead. I cannot live thus without its being a great displeasure to God.

Also like you to know that I had sent you a letter from London by my lad, and he told me he could not speak with you, there was made so great a watch upon him and you both. He told me John Thresher came to him from you, and said that you sent him for a letter or a token from me, but my lad trusted him not. . . . Alas, what do they mean! I sup-

Conclusion of letter from Richard Calle to Margery Paston.
(British Library, MS. Add. 36889, 79, and 79v)

pose they think we are not contracted together, and if they do, I marvel, for then they are not well advised, remembering the plainness with which I broke [the matter] to my mistress [Margaret] at the beginning, and I suppose you too, if you did as you ought to have done; and if you have done the contrary, as I have been informed, you did not do it according to conscience or for the pleasure of God, unless you did it out of fear, and for the moment to please those that were around you; and if you did it for this purpose, it was a reasonable cause, considering the great and importunate pressure on you, and that many an untrue tale was told to you about me, which God knows I was never guilty of.

My lad told me that my mistress your mother asked him if he had brought my letter to you, and many other things she insinuated. . . . I know not what her mistress-ship means, for by my troth there is no gentlewoman alive that my heart is more tender for than her, or is more loath to displease, saving only yourself. . . . I suppose if you tell them plainly the truth, they would not damn their souls for us; though when I tell them the truth, they will not believe me as well as they will do you; and therefore, good lady, at the reverence of God, be plain to them, and tell the truth, and if they will in no wise agree thereto, between God and the Devil and them be it. . . .

I marvel much that they should take this matter so hard as I understand they do, remembering that it is in such case as it cannot be remedied, and my deserts in every way are such that there should be no obstacle against it. . . . Mistress, I am afraid to write to you, for I understand you have showed my letters that I have sent you before this time; but I pray you let no creature see this letter. As soon as you have read it, let it be burnt, for I would no man should see it; you have had no writing from me this two years, and I will send

you no more; Jesus preserve, keep, and give you your heart's desire, which I know well should be God's pleasure.

This letter was written with as great pain as ever a thing I wrote in my life, for in good faith I have been right sick, and yet am not verily well, God amend it.[30]

Chapter 10

THE SIEGE OF CAISTER

1469

esides Margery's love affair and the threat to Caister, the Pastons in the spring of 1469 had a more general worry: money. Richard Calle gave Sir John a revealing account in a letter written shortly before or just after his letter to Margery. "I take not a penny in all Suffolk and Flegge for your livelihood," he wrote, "nor Boyton nor Haynsford. . . . At Guton, I am fain to gather from the tenants myself, for the bailiff will not come there" (for fear of the Paston enemies). Calle was able to scrape together "six or seven marks" to permit Daubeney, in charge of the household accounts, to keep afloat for the next few weeks, but all of the servants' pay was in arrears, including Calle's own for the past year. "The men complain grievously," as did the master of the college now operating at Caister. Calle recommended selling the

malt that was being held for a rise in price—otherwise "there is like to grow . . . an evil noise." Lending sources were drying up—he could "none borrow of Master William," Sir John's uncle, who was himself pressed.

The letter concluded with a reminder of the peril to Caister. Jackson's crossbow was broken; "send him word if you know a man in London that can mend it."[1]

The following month (June 1469) a glimmer of hope shone when King Edward went on a pilgrimage to the shrine at Walsingham, by a route that led through Norwich. John III reported that the king was "worshipfully received." Accompanying him was a large party that included his brother Richard, duke of Gloucester; Earl Rivers, the queen's father; and Sir John's friend Lord Scales. Both John III and his uncle William Paston "labored" them and other members of the king's entourage about the Pastons' problems with their powerful neighbors and received generally encouraging responses.

Earl Rivers promised that he would "move the king to speak to the two dukes of Norfolk and Suffolk, that they should leave off their titles of such land as was Sir John Fastolf's." Failing this, John III wrote his older brother, "If [the two dukes] would do nothing at the king's request, then the king should command them [at least] to do no destruction, or make any assaults or affrays upon your tenants or places until such time as the law has determined for you or against you." As for whether Earl Rivers really spoke to the king as he promised, "I cannot say; my uncle William thinks not." Lord Scales was himself not sure whether his father had done so, but whether he had or not, "The matter should be well enough."

The king's route toward Walsingham passed through Hellesdon. One courtier, a Suffolk knight named Thomas Wingfield who was friendly toward the Pastons, undertook, with the help of Richard of Gloucester, to steer the party past the lodge that

had been destroyed by the duke of Suffolk's raiders. The king was unmoved by the sight, telling William Paston "by his own mouth" that it might well have fallen down by itself. John III quoted his uncle William: the king thought that if they had really been wronged, the Pastons would have sued when his judges were sitting on the oyer and terminer in Norwich, in his presence. William explained that the Pastons hoped the king would help them negotiate a settlement, but "the king answered that he would neither treat nor speak for you, but let the law proceed, and so he says they parted."

However, John III reported, he had entertained several members of the royal party at dinner at his mother's house in Norwich, in her absence: among others, Lord Scales, John I's old enemy Sir John Howard, and Sir John Woodville. He had "made them good cheer, so that they held them content."

Although John III himself had been in the duke of Norfolk's service for six or seven years, this year the duke had not offered him livery, thereby discharging him. The young man turned to the duchess, whom he had served the year before at Princess Margaret's wedding, and "offered my service . . . but it was refused, I suspect on advice; wherefore I propose to do so no more." Other former members of the duke's household had joined the retinue of Richard of Gloucester, but, John told his older brother, "I stand yet at large; notwithstanding my Lord Scales spoke to me to be with the king, but I made no promise so to be, for I told him that I was not worth a groat without you, and therefore I would make no promise to anybody till they had your good will first; and so we parted." He had heard that there was an order for Sir John to "attend the king northward," but he thought it was a ruse "to have you out of London by craft, that you should not labor your matters to a conclusion this term."[2]

The king's projected journey "northward" prefaced another of the dramatic turnarounds of the Wars of the Roses. The expedition had the purpose of putting down a rebellion in Yorkshire headed by a leader calling himself Robin of Redesdale, whose manifesto declared that the king had turned his back on the old nobility in favor of his wife's upstart relatives, the Woodvilles. Behind the insurrection was the earl of Warwick, to whose affinity Robin of Redesdale belonged.

Arriving at his castle at Fotheringhay, near Peterborough (Northamptonshire), King Edward learned that on 11 July the earl of Warwick had executed a major coup. The king's young brother, George, duke of Clarence, had crossed the Channel to Calais, where Warwick was still in command, to marry Warwick's own daughter Isabel, against the king's express wishes. George Neville, the archbishop of York and Warwick's brother, officiated, and young John de Vere, earl of Oxford, was a wedding guest.

The new alliance thus formed now launched an invasion of England, employing a trustworthy contingent of the Calais garrison as the nucleus of an army that joined forces with Robin of Redesdale to fight and win the battle of Edgecote Field (16 July 1469). The subsequent execution of several of King Edward's supporters, including the queen's father, Earl Rivers, and brother, Sir John Woodville (recently a guest of John III at the dinner in Norwich), reflected the ferocity of the feud between the Nevilles and the Woodvilles. But when Warwick's forces captured King Edward himself near Coventry, they scarcely knew what to do with him. He supplied the solution by surrendering to Archbishop Neville, thus placing himself under the protection of the Church.

The result was a sudden vacuum at the top of the government. The old king, Henry VI, had been captured in Lancashire four years earlier and lodged by Edward in the Tower of

London, no longer a king, but plain Henry Windsor. Until Warwick decided who should wear the crown, the country was without a sovereign, leaving the great local lords free of all hindrance in their own regions.

The duke of Norfolk did not waste the opportunity. In his *Itineraries,* William Worcester described what happened: the duke first sent an emissary, Sir John Heveningham, son of Fastolf's old comrade-at-arms whose abrupt demise Agnes had recorded in 1453, to demand that John Paston III yield the castle on the grounds that the duke had legally purchased it from William Yelverton. John refused, replying that "he had not taken custody of it from the duke but from John Paston his brother." Ten days later, "the duke himself with his army to the number of 3,000 armed men laid siege to the castle. Three parts of it were under fire from . . . guns and culverins, and other pieces of ordnance of artillery, with archers, etc." Worcester also listed the names of the defenders, numbering twenty-seven including John III himself. One recruit noted by Worcester was "Thomas Stumps, handless," who despite his handicap, "wished to shoot"—specifically, "to shoot arrows" (Worcester's Latin word was "*sagittare*").[3]

Worcester probably exaggerated the numbers of the duke's force, although the besiegers had to be numerous to be deployed effectively for siege. That twenty-seven men could hold the place testifies to the castle's defensive strength. The garrison was armed with steel crossbows[4] and a number of gunpowder weapons—a score are listed in an inventory of the following year.[5]

The siege began on 21 August 1469. Ten days later Margaret reported that Sir John Heveningham had been in Norwich and had spoken to her at Agnes's house; the duke of Norfolk had made him "one of the captains at Caister." An old friend of the Pastons, Heveningham advised Margaret that if her sons would agree to let the duke take over Caister, he would "recompense all

wrongs." A more reasonable proposal came from another media-tor, who suggested that a neutral party—"indifferent men"—col-lect the rents and administer the manor until the law decided between the duke and the Pastons.

Margaret transmitted the offers to Sir John in London and added that the garrison "be sore hurt, and have no help. And if they have help soon it shall be the greatest worship that ever you had, and if they are not helped it shall be a great disworship to you, and look never to have favor of your neighbors and friends unless this speed well."[6]

Scarcely second to the siege of Caister in Margaret's concern was the unresolved problem of daughter Margery's unsuitable romance. In the face of redoubled efforts by the family to separate her from Richard Calle, Margery remained immovable. Calle sought and finally obtained the intervention of the bishop of Norwich. Margaret, backed by Agnes, immediately called on the bishop to urge him to postpone any action until the men of the family could be assembled. But it was no use, as Margaret wrote Sir John:

> He said plainly that he had been required so often [by Calle and his friends] to examine her that he might not nor would no longer delay it, and charged me, on pain of cursing [excommunication] that she should not be deferred but should appear before him the next day; and I said plainly that I would neither bring her nor send her; and then he said that he would send for her and charged that she should be at liberty to come.

Yet the bishop's sympathies were with the family.

> He said by his troth that he would be as sorry for her if she did not do well as if she were right near of his kin, both for

my mother's sake and mine, and others of her friends, for he knew well that her behavior had pierced our hearts sorely. . . . Then he said that he would speak to her as well as he could before he examined her.

The following day, the bishop kept his promise, prefacing the examination with a lecture, reminding Margery "how she was born, what kin and friends she had, and that she should have more if she were ruled and guided by them; and if she did not, what rebuke, and shame, and loss it would be to her . . . and cause of her forsaking any good or help or comfort that she should have of them." Then he said that he had heard

that she loved such a one that her friends were not pleased that she should have, and therefore he wished to know the words that she had said to him, whether they made matrimony or not.

And she rehearsed what she had said, and said boldly if those words did not make it sure, she would make it surer before she went thence, for she said that she thought in her conscience she was bound, whatsoever the words were. These lewd words grieve me and her granddam as much as all the rest. And then the bishop and the chancellor both said that neither I nor any friend of hers would receive her.

And then Calle was examined apart by himself, to see if her words and his accorded.

Finding that they did, "the bishop said that he supposed there might be other things . . . that might prevent [the marriage], and therefore he would not be too hasty to give sentence thereupon, and said that he would hold it over until the Wednesday or Thursday after Michaelmas, and so it is delayed."

Margaret remained at Agnes's house during the examina-

tion, and when it was reported to her how Margery had behaved, "I charged my servants that she should not be received in my house. I had given her warning . . . and I sent to one or two more [people] that they should not receive her if she came." The bishop's servants conducted Margery back to Margaret's house, but the Paston chaplain, James Gloys, stood in the door and turned her away, and the bishop had to find lodging for her at the house of a man named Roger Best until the hearing could be concluded. "God knows full evil against [Best's] will and his wife's, if they durst do otherwise," Margaret wrote. "I am sorry that they are encumbered with her," yet they were sober, sensible people, and

> she will not be suffered to play the brethel [worthless person] there. . . .
>
> I pray you and require you [Margaret went on to Sir John], that you take it not too hard, for I know well it goes near your heart, and so it does to mine and others'; but remember, as I do, that we have lost of her but a brethel, and take it less to heart, for if she had been good, this would not have happened, wheresoever she was. . . . Even if he [Calle] were dead at this hour, she should never be in my heart as she was.

Sir John had evidently mentioned the possibility of annulment, but this Margaret rejected.

> I pray you upon my blessing that you do not, nor cause anyone else to do, anything that should offend God and your conscience. . . . For know well, she shall full sore repent her lewdness hereafter, and I pray God she might soon. I pray you for my heart's ease, be of good comfort in all things.[7]

At Caister, the situation had deteriorated further. Where the Pastons' previous disputes had involved threats, destruction of property, and seizure of animals and plows, now for the first time shots were fired: arrows, crossbow bolts, musket balls, and even a few cannonballs. Yet the exchanges usually did little damage on either side and probably were not intended to; for besieged and besiegers in such a situation, the less blood shed, the better.[8] Unfortunately, this time there were fatalities—one man of the Pastons' garrison and two of the besiegers, whose deaths caused considerable trouble for the Pastons in subsequent years.

Early in September, the Pastons enlisted the king's brother, George, duke of Clarence, backed by Archbishop Neville and the earl of Oxford, in an attempt to negotiate a treaty on terms similar to those proposed to Margaret by Sir John Heveningham in August. But the duke of Norfolk, angry at the castle's resistance, responded by ordering the siege pressed harder.

Margaret wrote Sir John in London a frantic letter, urging him to take immediate action. "Your brother and his fellowship stand in great jeopardy at Caister and lack victuals," she reported. She had been told that John Daubeney and Osbert Berney, illegitimate son of her uncle John Berney of Reedham, were dead,

and divers others greatly hurt; and they lack gunpowder and arrows, and the place is sore broken down by the guns of the other party, so that unless they have prompt help they are likely to lose both their lives and the place, with the greatest rebuke to you that ever came to any gentleman, for every man in this country marvels greatly that you suffer them to be so long in such great jeopardy with no help or other remedy.

The visit from the duke of Clarence's man, Writtle, had only made matters worse.

> The duke [of Norfolk] has been more frequently set there-upon, and crueler . . . than he was before, and he has sent for all his tenants from every place, and for others, to be at Caister on Thursday next . . . and they propose to make a great assault, for they have sent for guns to Lynn and other places by the seaside.

She urged Sir John to appeal to the duke of Clarence or the archbishop of York, to request safe-conduct for the garrison. If the duke of Norfolk would not agree, Sir John should appeal to friendly lords and to the earl of Oxford to rescue the garrison, ceding the castle to Oxford for his lifetime; "I had rather you lost the livelihood than their lives."[9]

In reply, Sir John defended his conduct and accused Margaret of exaggerating the bad news. With money and troops, he believed, they could keep Caister. "On Saturday last, Daubeney and Berney were alive and merry, and I suppose there came no man out of the place to you since that time that could have told you of their deaths," he wrote. Actually only Daubeney was dead, victim of a crossbow bolt.

As for the "fierceness of the duke or of his people," a truce had just been concluded for two weeks, during which time he hoped "a good direction shall be had." He could not appeal to the duke of Clarence or the archbishop of York because they were absent from London, and in any case their letters to the duke of Norfolk had done little good. Rescuing the garrison would be expensive,

> but they shall be rescued if all the lands and friends that I have in England may do it . . . and that as quickly as possi-

ble. And the greatest earthly lack is money and friends and neighbors to help; wherefore I beseech you to send me comfort with what money you can find the means to get or borrow on sufficient security, or by mortgaging or selling livelihood, and send me word in all haste what forces your friends and mine could raise on short notice.

But, mother, I feel by your writing that you think I would not do my duty unless you wrote me some heavy tidings and, mother, if I needed to be stirred by a letter, I would indeed be too slow a fellow; but, mother, I assure you that I have heard ten times worse tidings since the siege began than any letter that you wrote me, and sometimes I have heard right good tidings too. But I assure you that those within [Caister] have no worse rest than I have, nor face more jeopardy; but whether I had good tidings or ill, I take God to witness that I have done my duty as I would have done to me in similar case, and shall until there is an end to it.

He had, he said, written to the king "and to the Lords," though certainly with little hope of assistance. He assured Margaret that he would "rather lose the manor of Caister than the life of the simplest man within, if that would save him." Sir John had not quite grasped the fact that Caister was lost; he was convinced that if he could only raise the funds and recruit the forces, he could hold on to it.

Wherefore I beseech you to send me word what money and men you think I am likely to get in that country [Norfolk]. . . . You send me word that I should not come home unless I come strong; but if I had another strong place in Norfolk to come to, though I brought few men with me, I should with God's grace have rescued it by this time. . . . But mother, I beseech you, send me money, for by my troth I

have but ten shillings. I know not where to get more, and moreover I have been ten times in like case or worse in these ten weeks. I sent to Richard Calle for money, but he sends me none.[10]

Calle had been dismissed from the Pastons' service, but it had not taken them long to discover that they could not do without him; he kept the records and the "evidence"—the deeds and other documents—and knew how to interpret them, and he collected the rents from the tenants and farmers. Calle let it be known that he wanted to return; Margaret wrote Sir John in late September that "[Calle] would fain . . . have your good mastership, as it is told me, and deliver the evidence of [East] Beckham, and all other things that belong to you. . . . And he says he will not take a new master until you refuse his service." She reminded her son that "your livelihood must be set in such order that you may know how it is, and what is owing to you; for by my faith, I have helped as much as I can . . . and therefore take heed before it becomes worse."[11]

Calle was accordingly reinstated, accepted as an employee but never as a member of the family. Marriages normally produced in-law relationships that were scarcely distinguishable from blood ones, but Calle was never son to Margaret or brother to Sir John and John III.

Margaret's letter advising reengagement of Calle was written in response to Sir John's self-justifying letter of September 15.

You think I am writing you fables and imaginations, but I do not. I have written as I have been informed, and will continue to do so. It was told me that both Daubeney and Berney were dead, but for certain Daubeney is dead, God assoil his soul; whereof I am right sorry, and wish it had pleased God that it might be otherwise.

And, reverting to her critical mode:

> Remember, you have had two great losses within this twelve-
> month, of him and of Sir Thomas [Howes—suggesting that
> perhaps Howes, who had just died, had reconciled with the
> Pastons]. God visits you as it pleases him in various ways; He
> wants you to know Him, and serve Him better than you
> have done before this time, and then He will send you more
> grace to do well in all other things. And for God's love,
> remember this well and take it patiently . . . and if anything
> has been other than it ought to have been, either in pride or
> in lavish spending, or in any other thing that has offended
> God, amend it, and pray for His grace and help.[12]

Margaret had not yet finished when news arrived from
Caister: the garrison had surrendered on terms (26 September
1469). Sir John's appeal to the duke of Clarence and other lords
had resulted in the duke of Norfolk's offer of safe-conduct.
Under it, John III and his men marched out with bag and bag-
gage, horse and harness, but leaving behind, in addition to arms
and ammunition, all the castle's contents, the costly furnishings
accumulated by Sir John Fastolf, and the gowns, books, and
other private possessions of Sir John Paston.[13]

The Paston fortunes had struck rock bottom. Margaret
resumed her letter in no cheerful mood.

> As for money I could get but ten pounds upon pledges, and
> that is spent for your matters here, for paying your men that
> were at Caister, and other things, and I know not where to
> get any, either for security or for pledges; and as for my own
> livelihood, I am so poorly paid . . . that I fear I shall have to
> borrow for myself, or else break up household, or both.

She lamented that Caister had not been surrendered sooner, "and then there should not have been done so much harm . . . for many of our well-willers are put to loss for our sakes." But she urged him to "set no land to mortgage, for if any advise you thereto, they are not your friends."[14]

John III wrote his brother a brief account of the surrender: "John Chapman can tell you as well as myself how we were forced to it." He had provided for each member of the garrison to receive forty shillings, which "together with the money that they had from you and Daubeney, is enough for the time that they have done you service. . . . We were more lacking in victuals, gunpowder, and men's hearts, and lack of certainty of rescue drove us to make the treaty."[15]

A week later he reported on the financial arrangements for the garrison in more detail, asking whether Sir John could keep the men in his service or whether they should look elsewhere. Margaret had agreed to supply them with "meat and drink" until Hallowmas (November 1).

> If you could get [Osbert] Berney, or any of those that you do not intend to keep, any service in the meantime, it would be more worship for you than to put them from you like masterless hounds, for by my troth they are as good men as any alive, and especially Sir John Stylle and John Pampyng. And if I had the power to keep them and all the others, by [my] troth they should never part from me while I lived.

Also, Daubeney's debts had to be settled; his executors were being pressed by the bishop to administer his will. "Daubeney said that you owed him £12 and 10s. Whether it is so or not, his bills in his own hand will not lie, for he made them clear before the siege began."

In spite of the safe-conduct, John and his men were threat-ened by the duke of Norfolk's people; he himself and his "house-hold men" had in fact refused the safe-conduct—"it were shame to take it."[16]

In October the bizarre national interregnum came to an end. Unrest in the countryside, of which the siege of Caister was a conspicuous example, caused Warwick to cancel a summons to Parliament, and Edward's continuing popularity made it awk-ward to hold him captive. In return for the king's approval of a campaign against a Lancastrian rebellion in the North, Warwick gave Edward virtual parole. The king made good use of it. Gathering his chief supporters around him at Pontefract Castle, he headed south for London. The capital received him in tri-umph. Sir John Paston reported that George Neville, archbishop of York and Warwick's brother, had come with the king from York and was staying at the Moor Inn with the earl of Oxford, but they

> came not to town with the king. Some say . . . that the king sent them a messenger that they should come when he sent for them. I know not what to suppose therein; the king him-self has good language [speaks well] of the lords of Clarence, of Warwick, and of my lords of York and of Oxford, saying that they are his best friends, but his household men have other language, so that what shall soon happen I cannot say.[17]

When the earl of Warwick and the duke of Clarence finally returned from their Northern campaign, they took their seats on the royal council as if nothing had happened. An uneasy and hypocritical peace reigned.

It brought no advantage for the Pastons. With Caister gone, along with the properties Sir John had yielded in his agreement

with Bishop Waynflete, revenues were sharply reduced, and with the cost of the siege, expenses were up and creditors pressing.

Meanwhile, the bishop of Norwich had made a final decision in favor of Margery Paston and Richard Calle, and they were at last formally married, taking up residence in October in the Benedictine nunnery of Blackburgh, near Lynn. Sir John had hoped to delay the wedding "for divers considerations" and had asked Margaret "on both my behalf and yours to speak to the bishop to tarry it until Christmas. . . . And if so they shall be married in haste, send me word thereof . . . and how he purposes to deal with her, and how he will guide her, and where he will dwell."

In the same letter, Sir John voiced for the first time a concern about a threatening rift within the family—the disaffection of his uncle William Paston: "He and I be as good as fallen out, for he has let me plainly know that he shall have all my granddam's livelihood of her inheritance and of her jointure also. . . . I will not yet speak of it, and I pray you do not."[18]

In November, despite his mother's adjuration, Sir John was reduced to mortgaging the recently recovered manor of East Beckham to a Norfolk lawyer and moneylender named Roger Townshend for a hundred marks.[19] The following month John III sent his brother still more bad news: "My lord of Norfolk's council has this Christmas gotten the two widows whose husbands were slain at the siege of Caister . . . to sue against me and such as were there with me within the place." The object of the suit was to keep Sir John from suing, in turn, for the recovery of Caister; "therefore they do the worst to me for your sake," John wrote. Unlike his mother, John offered no recriminations. "Item: as for my coming up to London, I come not there, for *argent me faut* [I lack money]." Sir John must find a new representative in Norfolk. "As for me, since our matters and clamor are so great, and our purse and wit so slender, I will rub on as long as I may with my own."[20]

Chapter 11

THE BATTLE OF BARNET

1470–1471

ate in February 1470, Sir John, in London, wrote his brother John, in Norwich, important news: Bishop Waynflete had been appointed to administer Fastolf's estate. Both Sir John and Sir William Yelverton had agreed to accept the bishop's binding arbitration. "Wherefore I hope this next term there shall be a way [course] taken, and an end; and, in confidence, I fear not the outcome."

The bishop was now chief executor, "and Sir William Yelverton is excluded." Yelverton apparently did not fully realize what had happened, "and I think you should not tell him. But this you may say . . . that you understand that such a treaty is made between him and me, and that you pray God make an end between us, and then we shall all be good fellows again." John III should also tell Yelverton that John

Heydon was strongly opposed to the agreement, "for he loves not Sir William Yelverton . . . nor me either, and he has for a great while sued us both; and . . . we twain [should be] agreed that neither of us needs to come to deal with him, for of old malice he loves us not but hates us both." For the present, the whole matter should be kept secret, told to "nobody but my mother and you, neither to Sir James [Gloys] or anybody."

The letter dealt with a number of other matters, including Sir John's efforts on his brother's behalf with a Mistress Katherine Dudley:

> I have many times recommended you to her, and she is nothing displeased with it. She does not care how many gentlemen love her; she is full of love. I have broached the matter for you, without your knowledge, as I told her [untruthfully]. She answers me that she will have no one these two years, and I believe her; for I think she has a life that she is well content with.

He managed to put a good face on his own courtship of Mistress Anne Haute—"I am offered to have [her], and I shall have help enough"—which, however, was still hanging fire and, in light of recent Paston setbacks, not in a promising state. Sir John could not even lay hands on enough money to travel home for a Lenten visit. He asked John III if Margaret would help him with the expense, "ten marks or thereabouts; I pray you find out her disposition and send me word."

Sir John's long letter also contained three characteristic ingredients—first, errands to be done both in London and Norwich: a clock he had sent home to be repaired and oranges that he would forward "by the next carrier"; second, court gossip: about a "new little Turk" visiting at court, "a well-visaged fellow of forty years," short of stature, but "his legs are good, and it is

reported that his pintell [penis] is as long as his leg"; and third, "tidings": "The king is verily disposed to go into Lincolnshire," where insurrection smoldered, and it was reported that "my lord of Norfolk shall bring ten thousand men. . . . My lord of Warwick, it is supposed, shall go with the king. . . . Some men say that his going shall do good, and some say that it does harm."

He concluded: "I pray you show or read to my mother such things as you think are for her to know, after your discretion, and to let her understand . . . about the treaty between Sir William Yelverton and me." And finally: "I pray you ever keep an eye on Caister, to know the rule there, and send me word; and whether my wise lord and my lady are still as besotted with it as they were, and whether my said lord resorts there as often as he did or not, and of the disposition of the country."[1]

John III replied promptly, but on the subject of his brother's proposed visit to Norwich he was not encouraging—"I cannot find that [our mother] will part with any silver [money] for your expenses"; also, the clock would not be ready before Easter because the clockmaker had had some of his tools stolen. John hoped the oranges would arrive soon, because cousin Elizabeth Calthorp "is a fair lady and longs for oranges, though she is not with child." Beyond those matters, John pressed his older brother to facilitate the settlement of John Daubeney's estate by providing a "quittance" to show that Daubeney, killed during the siege of Caister, was not in debt to the Pastons—which was certainly true; if any money was owed, it was from Sir John to Daubeney, whose friends were complaining about the fact that "there is nothing done for him, saying that he had done no more for us but lose his life in your service and mine; and now he is half forgotten among us. Wherefore, I pray you, let this be sped."

John added a postscript voicing a personal concern: "I pray, get us a wife somewhere, for *melius est nubere in Domino quam*

urere," a slightly garbled version of St. Paul's "It is better to marry than burn." John had a final thought: Sir John should find some remedy for the threatening situation he and his friends were in.

> As for our affrays here, John Pampyng can tell you, they have sworn that if they get me, you will lose a brother. . . . While our duke is thus cherished with the king, neither you nor I shall have a man unbeaten or unslain in this country, nor ourselves either, you as well as I. . . . The duke [of Norfolk], the duchess, and their council are wroth that you make no overtures to them yourself.[2]

◘

Sir John's misgivings about King Edward, the earl of Warwick, and the insurrection in Lincolnshire were soon violently borne out. Never able to leave well enough alone, the powerful earl had instigated the rebellion, which the king now crushed in a battle popularly known as "Losecoat Field" (13 March 1470). The name, a play on that of the earlier battle of Edgecote Field, derived from the ignominious flight of the defeated rebels, who discarded their distinguishing livery as they ran. Warwick and his fellow conspirator, the duke of Clarence, fled across the Channel, taking refuge at the court of Louis XI in Paris. As champion of an Anglo-French alliance and an enemy of Burgundy, Warwick commanded a warm welcome and in no time was planning a new invasion of England.

For the Pastons, the turn of events was far from favorable. Their patron, young John de Vere, thirteenth earl of Oxford, had fled abroad with his brother-in-law Warwick, leaving the Pastons without a "good lord" and with a well-recognized connection to a man now officially branded a traitor. They were further discomforted by the duke of Norfolk's next move, already foreseen

by John III: a legal offensive begun by the widows of the two servants of the duke killed at the siege of Caister. Late in June, John wrote his brother in London a full report: "On Wednesday last, you and I, Pampyng, and Edmund Broom were indicted of felony at the sessions here in Norwich for shooting a gun at Caister on August last, which slew two men: I, Pampyng, and Broom as principals and you as accessory." The suit illustrates the advance that the process of law had made in England; in earlier centuries no one would have had recourse to the law court over a death in private warfare. The Pastons' lawyers correctly believed that the indictment was invalid because two members of the jury did not agree to it, but John III suspected that the duke of Norfolk's council would press the widows to institute a private suit, removing the case to King's Bench.

John warned that the matter must not "be slept." But he had some good news. Richard Southwell, the escheator of 1459 whom William Paston had found "well disposed," now a member of the duke of Norfolk's council, informed John that the duchess had promised John her "good ladyship" and was willing to forget "the great displeasure" of the siege and remember only his "old service." Southwell optimistically prophesied that Sir John would eventually have "both good lordship and ladyship, and money or land, or both," presumably to compensate him for the loss of Caister, though John wrote, "What he means, I cannot say."[3] That the Pastons could hope to use the duchess of Norfolk as an ally against her husband seems surprising, but the tactics were effective, as subsequent history showed.

Three days later John III wrote again, to express another concern. The threat that William Paston had made to Sir John the previous October, that he would have "all my granddam's livelihood of her inheritance and of her jointure also," was about to be realized.

William had contrived to make a brilliant marriage. His

wife, Lady Anne Beaufort, was one of five daughters of the duke of Somerset, the all-powerful minister of Henry VI who was killed at the first battle of St. Albans. In March, Lady Anne had been "churched," a rite following childbirth, in this case of a daughter. The household was now moving to London, to occupy the earl of Warwick's former palace, Warwick Inn, taking Agnes with them from Norwich.

John III and Sir John took alarm. While Judge William still lived, Agnes had agreed to settle her own inherited property on the main branch of the family. John III reminded his brother that he had a copy of her statement, sworn before Justice William Goodrede "in my grandfather's days." Sir John would do well to look for it at once among their father's effects and be prepared to produce it when needed, and "if you do not have [it], look that you spare no cost to search for it." In the aftermath of the Warwick debacle, Sir John was staying somewhere outside London; John III, about to depart on foot on a pilgrimage to Canterbury, believed that Uncle William and Agnes counted on Sir John's not daring to come to London or Westminster to interfere with their plan. John III expected to reach Canterbury "this day seven-night, and upon Saturday come seven-night I trust to God to be in London; wherefore I pray you leave word at your place in Fleet Street where I shall find you, for I intend not to be seen in London until I have spoken with you."[4]

In July, Sir John had the satisfaction of formally concluding the settlement of the Fastolf estate on the basis of Bishop Waynflete's arbitration, to which Judge Yelverton had agreed in advance. In the formal accord, Sir John relinquished claim to all the Fastolf manors and appurtenances except Caister, Hellesdon, Drayton, and some lesser holdings, in return for the cancellation of the obligation of four thousand marks that his father had undertaken toward the Fastolf executors. The question of the college was settled along the lines discussed in 1467, the institu-

tion to be established at Oxford's Magdalen, itself founded by Waynflete some twenty years earlier. The bishop had obtained a dispensation from the pope for the transfer with a change in the eleemosynary beneficiaries; the seven priests and seven poor men became seven priests and seven poor scholars. Sir John was conceded title to all Fastolf's movable goods at Caister Castle. Finally, the bishop promised his support to Sir John in regaining Caister from the duke of Norfolk and Drayton and Hellesdon from the duke of Suffolk.[5]

The agreement was a qualified triumph for Sir John, though it brought no immediate change in the Paston fortunes. Debts continued to press. Sir John succeeded in raising the money to

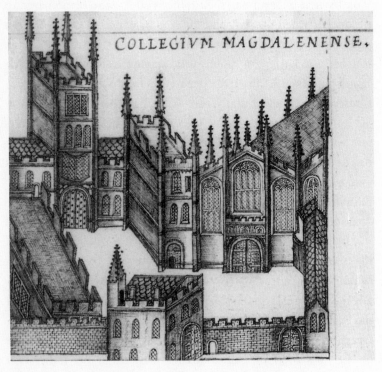

Magdalen College in 1566, drawing.
(Bodleian Library, MS. Bodleian 13, f.8–11)

pay the men who had defended Caister, and John Pampyng man-
aged to find places for most of them. Some had already gone
home. Thomas Stumps, whom William Worcester had described
as "handless," had found a place with the abbot of St. Benet's,
who welcomed him and expressed himself as "ready to do any-
thing for you [Sir John] and for any servant of yours." "As for
myself," Pampyng wrote, "my mistress [Margaret] says she will
give me meat and drink for a season"; nevertheless, he was wor-
ried about the widows' suit, in which he was named. He also
reminded Sir John of several outstanding bills: the parson of
neighboring St. Edmond's was owed ten shillings for malt and
wheat; a limeburner fourteen shillings four pence for lime; a
blacksmith ten shillings for shoeing.[6]

On the same date (15 July 1470), Pampyng penned a letter
for Margaret, in which she allowed her habitual exasperation
with Sir John to overflow, the occasion being a large bill for
repairs that some of the tenants had deducted from their rent,
saying Sir John had approved.

> I wish you would provide for yourself as quickly as possible,
> and come home and take heed to your own property and to
> mine otherwise than you have previously, both for my profit
> and yours, or else I shall provide for myself otherwise in
> haste. . . . I have little help or comfort of any of you yet; God
> give me the grace to have hereafter. . . . My power is not as
> great as I wish, . . . if it were, we should not long be in dan-
> ger.[7]

◨

In late summer of 1470 a new political storm was heralded by
another rising in the fractious North. Sir John wrote cautiously
to John III that Henry Percy, the chief magnate in the region, had
not been able to suppress the rebels, and the king had sent for

help from loyal lords, "for he will go to put [the rebels] down." Sir John had heard a rumor—false—that Lord Courtenay had landed in Devonshire, and another—true—"that the lords Clarence and Warwick will essay to land in England any day now, as folks fear."

The tirelessly scheming Warwick had by now put together a new political combination. He had sealed an alliance with Queen Margaret and her loyal Lancastrian exiles by betrothing his daughter Anne to the queen's son, Prince Edward, thus combining Lancastrian support with the backing of Louis XI for another invasion of England. With his French-furnished army, he landed in the southwest corner of England, at Plymouth and Dartmouth. King Edward, taken by surprise, could not find a means of effective resistance. Deserted by Warwick's brother, Marquis Montagu, in whom he had placed rash trust, the king was forced to flee abroad in his turn, ending up in Bruges, the Flemish capital where two years earlier the wedding extravaganza of his sister and Charles the Rash had taken place.

On 6 October 1470, Warwick and Clarence once more entered London, relieving the capital of terror inspired by their bands of French mercenaries now pillaging the suburbs. A week later Warwick fetched Henry VI out of the Tower and set the crown back on his head.

Accompanying Warwick from France was the earl of Oxford, whose return to power was the best thing that could have happened to the Pastons. Within a week John III was writing his mother of the bright prospects now opening before him and his brother:

I trust that we shall do right well in all our matters soon; for my lady of Norfolk has promised to be ruled by my lord of Oxford in all such matters as belong to my brother and me, and as for my lord of Oxford, he is better lord to me in many

matters, by my troth, than I would wish him. . . . The duke and duchess [of Norfolk] sue to me as humbly as ever I sued to them.

I trust we shall soon have . . . offices fitting for us, for my master the earl of Oxford bids me ask and have. I think my brother Sir John shall have the constableship of Norwich Castle, with £20 fee—all the lords are agreed to it.

He added news of the aftermath of the Lancastrian restoration:

Tidings: the earl of Worcester is likely to die today, or tomorrow at the latest. . . . The queen that was [Elizabeth Woodville] and the duchess of Bedford [her mother] are in sanctuary at Westminster. . . . When I hear more, I shall send you more.

Bright prospects did not provide ready cash; John added a postscript: "Mother, I beseech you to speak to Broom, to gather up my silver [coins] at Guton in all possible haste, for I have no money." And, perhaps anticipating military service:

May John Milsent be spoken to, to keep well my gray horse, if he is alive, and that he spare no food for him, and have clever lackeys to look after him.

As for my coming home, I know no certainty, for I tarry until my lady of Norfolk comes to carry matters through, and she shall not be here until Sunday.[8]

Thus the success of their "good lord," the earl of Oxford, turned the Pastons overnight from downcast to delighted and from Yorkists to Lancastrians. Margaret satisfied John III's need for money by sending him "silver vessels" of her own, part of the family treasure, which she listed in an accompanying note—

"Two platters, six dishes, and six saucers," whose weights she included. She "marveled" that John had not informed her of the price of silver in London, for it would have been less hazardous, if there was no difference in price, to have sold the silver in Norwich and sent the money. In Norwich, silver was selling at three shillings the ounce, at which price she calculated her package to be worth "some £20 4s. 3d." She added sensible advice to both brothers to exercise prudence in their expenditures, lest they impoverish both themselves and their friends in anticipation of fortune. They were both still in "great danger and need." She herself was in such want of money that she was on the point of breaking up her household "to sojourn, which I am right loath to have to do," for her straitened situation had bred talk in gossipy Norwich.

She was concerned too about her dead husband's neglected grave.

> He was so worshipfully buried . . . and so little done for him since. And now though I would do for him, I have nothing except my livelihood that I may borrow against . . . and my livelihood increases little, for I am fain to take Mautby into my own hands and set up husbandry there. . . . The farmer owes me £80 and more. When I shall have it I know: . . . never.

Despite her shortage of cash, she sent her sons cloth for two shirts,

> each of three yards of the finest in this town. I should have had them made here, but it would have taken too long before you had them. Your aunt or some other good woman will do her alms for you by making them. I thank you for the gown you gave me. . . . Let your brother see this letter. As for your

sister [Margery] I can send you no good tidings of her. God make her a good woman.[9]

In November, John III returned to Norfolk to await the earl of Oxford's visit, Sir John remaining in London to negotiate for the recovery of Caister. Sir John wrote his brother advising him to take a group of friends with him when he went to meet their patron, "all as one body . . . so that my lord of Oxford may understand that some strength rests therein." Taking note that their old enemy John Heydon was still active against them, Sir John anticipated that Heydon might infiltrate some of his followers into the Pastons' party and create a disturbance. John III had best advise his men to leave their arms at home and show that they were not "riotous people" but "men of substance." If their enemies tried to get the attention of the earl, John's people should

> press in to my lord before them. . . . If you . . . could find the means to cause the mayor to tell my lord in his ear . . . that the love of the country and city rests on our side, and that other folks are not beloved, and never were, this would do no harm.

As for himself, he would have given a hundred pounds to be in Norwich to wait on the earl, but "those matters that I told my lord I thought might prevent me were not finished till yesterday." Also, he had been ill, and

> every other day might not hold my head up, nor yet may, insomuch that . . . in Westminster Hall and other places, I have gone with a staff, like a ghost, men say, more as if I rose out of the earth than out of a fair lady's bed . . . and still I am in like case, but am in good hope to amend.[10]

He did amend, with or without the aid of medical science. Margaret, meanwhile, worried about her younger daughter, Anne, who was about fifteen. For several years the girl had been living at Burnham Thorpe as a member of the household of Margaret's cousins, the Calthorps. Now Sir William Calthorp suddenly wrote Margaret that he was having trouble collecting rents from his tenants and had therefore decided to "lessen his household and live straitlier." "Wherefore he desires me to provide for your sister Anne," she wrote John III. "He says she waxes tall, and it is time to purvey her with a marriage." Why he had written, Margaret could only speculate; "either she had displeased him or he has caught her in a fault." Margaret asked John to talk to her cousin Robert Clere in London to find out how he was disposed toward Anne—"otherwise, I shall be fain to send for her"—and at home Anne would be wasting her time, not to mention that she would upset her mother "and put me in great unquietness. Remember what labor I had with your sister," Margaret wrote, "and therefore do your part to help her, for your sake and mine."[11]

In December, in the winter sunshine of the Lancastrian restoration, the recovery of the Paston fortunes reached its zenith. The duke of Norfolk was persuaded to allow Sir John to repossess Caister Castle and manor, in accordance with the agreement Sir John had reached with Bishop Waynflete. In return for a payment of five hundred marks by Sir John, who also assumed the costs of repair and other charges, the duke released Caister and certain other properties he had received from Yelverton and Howes. The only source of information about the transaction is a petition that Sir John addressed to the king five years later.[12]

Sir John may have served on the Lancastrian-dominated Parliament that in late 1470 pronounced Edward IV a bastard on the basis of an old slander of his mother, thereby rendering irrel-

evant the birth of an heir to his queen, Elizabeth Woodville. That decision seemed to settle everything firmly in favor of the Pastons' lucky star, the earl of Warwick.

But Warwick's politicking in France now rose to haunt him. He had promised Louis XI help in the French king's projected war with Burgundy, and in February 1471 he fulfilled his pledge by declaring war on Charles the Rash. Louis was encouraged to move troops to threaten Burgundian Flanders. That move provoked Charles in turn to mobilize for defense and to lend financial aid to Edward IV in Bruges, permitting Edward to start hiring Flemish mercenaries for a return to England. On 14 March 1471 he landed at Ravenspur at the mouth of the Humber, in the northeast of the country, setting off the alarm bells of war once again.

The earl of Oxford promptly sent out summonses to all men who owed him service. The summons received by the Paston brothers did not survive, but doubtless it was worded similarly to one that did, addressed to several other Norfolk gentlemen, dated 19 March 1471:

> Trusty and well-beloved, I commend me to you, letting you know that I have credible tidings that the king's great enemies and rebels, accompanied with foreign enemies, are now arrived and have landed in the north part of this land, to the utter destruction of his royal person and subversion of his realm. . . . [The king] had commanded and assigned me, under his seal, sufficient power and authority to call, raise, gather, and assemble, from time to time, all his liege people of the shire of Norfolk and other places, to assist, aid, and strengthen me in the same intent.
>
> Wherefore, in the king's name, and by aforesaid authority, I straitly charge and command you, and in my own behalf

heartily desire and pray you, that, all excuses set aside, you, and each of you in your own persons defensibly arrayed, with as many men as you may gather, be on Friday next at Lynn, and thence forth to Newark, where with God's permission I shall not fail to be.[13]

Once more the Paston men were called to battle, and once more they had to make a choice, between York and Lancaster and between fighting and staying out. Despite their old Yorkist allegiance, and despite the serious step of taking arms against Edward IV, whom they had recognized and served as king, they apparently did not hesitate. Sir John and John III rallied to the banner of their "good lord," the earl of Oxford.

By chance, this single campaign in which both Paston brothers are known to have fought is also one of the few about which we have a contemporary report that casts light on the military aspect of the Wars of the Roses. *The Arrivall of King Edward IV* is an anonymous but official (Yorkist) account, partly eyewitness and partly "by true relation of them that were present."

While the affinities of Oxford and Warwick were mobilizing, the Pastons among them, Edward IV, with his compact invading force, marched south, passing straight through his gathering enemies. He paused to challenge Warwick to battle, but Warwick refused, choosing to await the assembling of his supporters and allies. Chief among these was the duke of Clarence. This spoiled brother of Edward IV, now Warwick's son-in-law, was coming up from the South with four thousand men. But once more in this capricious, unpredictable war a decisive shift in allegiance occurred. Clarence, after parleying with Edward at Banbury, brought his whole force over to the Yorkist side. Edward absorbed the new recruits and resumed his march on London, re-entering the capital on 11 April 1471 and unceremoniously bundling Henry VI back to his apartments in the Tower.

Warwick, now desperate, followed him south. Edward came out to meet him, and the two forces clashed at Barnet, some ten miles northwest of London, on a foggy Easter morning (14 April 1471). The earl of Oxford commanded Warwick's vanguard, which on the battlefield became the army's right wing. Facing it was Edward's left wing, commanded by Lord Hastings. The two Paston men, along with their half-dozen servants-in-arms, helped form the block of Lancastrian soldiers, among whom were posted a few pieces of gunpowder artillery. Horses, notoriously vulnerable to longbows and crossbows, were tethered in the rear. The army's three groupings of left, center, and right, called "bat-

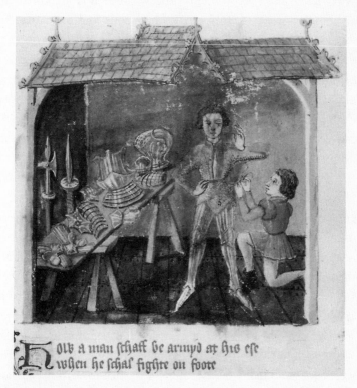

olb a man fcf}aff be armpð at ƒ}is efe
wfjen fje fcfjaf figfjte on foote

"How a man shall be armed at his ease when he shall fight on foot."
C.1480. *(The Pierpont Morgan Library, M.775, f.122v)*

tles" in the vocabulary of the day, were not further subdivided; there were no regiments, battalions, or companies, merely parties of armed men massed together. Maneuvering in any modern sense was out of the question. Almost the only command function was the leader's signal for the attack, usually given by moving his own banner forward. Typically, following some preliminary exchanges by the archers and the artillery, the opposing "battles" collided and fought it out with sword, ax, mace, pike, and iron flail.

At Barnet, according to the *Arrivall,* King Edward bivouacked his army the night before the battle close to Warwick's and "kept them still, without any manner, language, or noise. . . . Both parties had guns and ordnance, but the earl of Warwick had many more men than the king, and therefore . . . weening greatly to have annoyed the king, and his host, with shot of guns," the earl kept his artillery firing all night. "But, thanked be God! it so fortuned that they always overshot the king's host, and hurted them nothing, and the cause was [that] the king's host lay much nearer than they deemed."

King Edward aroused his army early for a surprise attack "betwixt four and five of the clock, notwithstanding there was a great mist [that hampered] the sight of either [party], yet he committed his cause and quarrel to Almighty God, advanced banners, did blow trumpets, and set upon them, first with shot, and then soon they joined and came to hand strokes."

But owing to the thick mist, the two hosts did not join battle exactly front to front: "One end of [Warwick's] battle overreached the end of the king's battle, and so, at that end, they were much mightier than was the king's battle . . . which was the west end," and many on the king's side "fled toward Barnet, and so forth to London."[14]

The victorious right wing of Warwick's army was the former vanguard, commanded by the earl of Oxford, in whose ranks the Paston brothers fought. The flight of the enemy left, commanded by Lord Hastings, had the effect of also disorganizing Oxford's pursuing force; only with difficulty were their leaders able partly to regroup and bring their men back to the battlefield. There, in

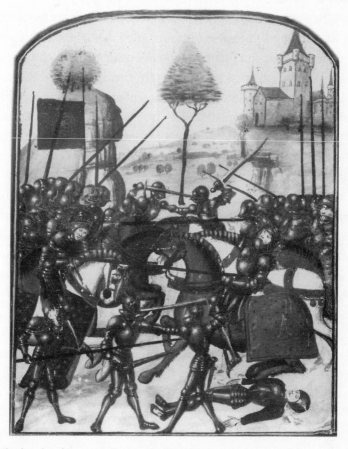

The battle of Barnet, illustration from a French version of the official Yorkist account, *The Arrivall of Edward IV.*
(*University of Ghent*, MS. 236, f.23)

the still heavy fog, they blundered into disaster. Coming sud-
denly in sight of the men of Warwick's center, commanded by
Lord Montagu, they mistook friend for foe, and were similarly
mistaken; Oxford's banner of the Enrayed Star looked much like
King Edward's Sun in Splendor, and apparently the multiplicity
of livery colors did not help. Oxford's men received a shower of
arrows, and the disorganized mass broke and fled.

The *Arrivall* skips over this part of the battle to focus instead
on King Edward's prowess in maintaining the fight with his out-
numbered center and right; but another contemporary chronicler,
John Warkworth, makes the friendly fire episode the decisive
event of the day, an interpretation accepted by most modern his-
torians.[15] The panic spread rapidly from Oxford's men to the rest
of Warwick's, and the battle's outcome was swiftly decided.
Warwick was cut down as he sought to escape; Oxford, more
fortunate, got away.

So did the Paston brothers, although John III was painfully
wounded with an arrow in the forearm, perhaps received in the
friendly fire mishap. He was doubtless assisted by his servants in
escaping on his horse. Sir John also made good his retreat, and
four days later, safe in his Fleet Street lodgings, wrote Margaret,
who must have been filled with anxiety by the early reports of
the battle:

> Mother, I recommend me to you, letting you know that,
> blessed be God, my brother John is alive and fares well and is
> in no peril of death. Nevertheless he is hurt with an arrow in
> his right arm beneath the elbow; and I have sent him a sur-
> geon, who has dressed [the wound], and he tells me that he
> trusts that he shall be all whole within right short time. It is
> true that John Milsent is dead, God have mercy on his soul!
> and William Milsent is alive, and his other servants all have
> escaped, in all likelihood.

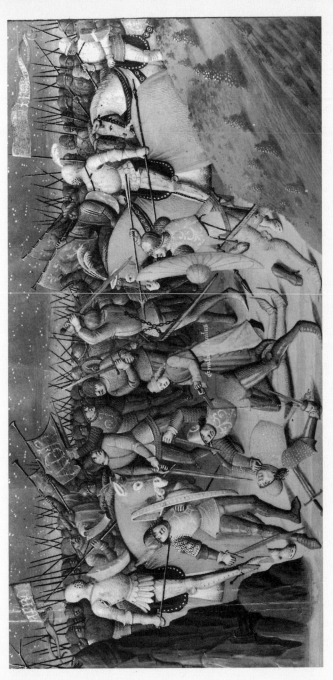

Armies in close combat, with banners as rallying points, from a late-fifteenth-century manuscript. This depiction of a melee is probably closer to the reality than the *Arrivall's* orderly version. (From *Les Fais et les Dis des Romains et des autres Gens, British Library, MS. Harley 4374, f.161*)

The Milsent brothers had been in the Pastons' service for several years; William had been a member of the Caister garrison.

> Item: as for me [Sir John continued], I am in good case, blessed be God, and in no jeopardy of my life, as I think. . . .
>
> Item: my lord archbishop [of York] is in the Tower; nevertheless I trust to God that he shall do well enough; he has a promise of safety for himself and me both. Nevertheless, we have since been troubled, but now I understand that he has a pardon, and so we hope well.

Turning to the battle itself, he reported:

> There were killed on the field, half a mile from Barnet, on Easter Day, the earl of Warwick, the Marquis Montagu, Sir William Terrell, Sir Lewis Johns, and divers other esquires from our country. . . . And in King Edward's party, Lord Cromwell, Lord Say, Sir Humphrey Bourchier of our country, who is a much lamented man here, and other people of both parties to the number of more than a thousand.
>
> As for other tidings, it is understood here that Queen Margaret is verily landed with her son [Prince Edward] in the West Country, and I believe that tomorrow or the next day King Edward will depart from here toward her to drive her out again.

He took care to preserve a neutral tone about Queen Margaret's arrival and appended a word of caution for his mother to convey to their friend William Lomnor in Norwich: "The world, I assure you, is right queasy," and Lomnor should "be well wary of his dealing or language as yet."

In spite of the sudden reversal of his fortunes, Sir John was

able to be philosophical and even guardedly optimistic. "God has showed Himself marvelously like Him that made all things and can undo them again when He pleases; and I can think that in all likelihood He shall show Himself as marvelous again, and that in short time."

Finally, he mentioned that his brother needed money—"I have helped him to my power and more"—and concluded cryptically, "I trust all shall be well. If it thus continues, I am not completely undone, nor any of us; and if otherwise, then etc. etc."[16]

John III himself wrote hopefully (30 April 1471)—"With God's grace it shall not be long until my wrongs and other affairs shall be redressed, for the world was never so likely to be ours as it is now"—but he pressed Margaret for money, "for by my troth, my leechcraft and physic and payment to those that kept me and took me to London have cost me since Easter more than £5, and now I have neither meat, drink, clothes, leechcraft, nor money except by borrowing; and I have tried my friends so far that they begin to fail now in the greatest need that ever I was in."

He was concerned, too, about the care of his horse that was having its own "leechcraft," perhaps having also suffered a wound. "Mother, I beseech you that . . . [he] not be taken up for the king's hawks"—for horsemeat—but "that he be brought home and kept in your place . . . and that the gate be shut . . . and he have as much food as he can eat; I have hay enough of my own, and as for oats . . . whoever provides it, I will pay. And I beseech you that he have every week three bushels of oats, and every day a pennyworth of bread."

He asked for clothing to be sent him: two shirts "that were in my casket . . . three long gowns and two doublets," a jacket out of his coffer, and a hat. James Gloys had the key. "Item: that such other writings and stuff as were in my casket be in your

keeping, and that nobody looks at my writings." He concluded with a touch of his usual jaunty style, "If it please you to have knowledge of our royal person, I thank God I am well of my sickness, and trust to be clean well of all my hurts within a week at the most."[17]

Queen Margaret had indeed landed in the West with a body of French mercenaries, to which were soon joined Lancastrian supporters of the region and survivors of the battle of Barnet. The effort was useless. King Edward swiftly remustered his forces, already scattered for home, and marched west to seek out the enemy. Battle was joined at Tewkesbury (14 May 1471). Neither John Paston III nor Sir John was present, but two of their uncle William Paston's in-laws, brothers of his wife Anne, played conspicuous roles: the duke of Somerset, who commanded the queen's army, and his younger brother John Beaufort. Neither survived. John Beaufort was slain in the melee, the duke was captured and beheaded next day.

Queen Margaret's son, seventeen-year-old Prince Edward, the child born after his mother's visit to Walsingham in 1453, was also killed in the battle, snuffing out the Lancastrian line. Queen Margaret was brought back to London a prisoner. The night of her arrival, her husband, King Henry VI, was quietly put to death in the Tower.

The queen's capture and the deaths of Prince Edward and King Henry at least put an effective end to Lancastrian hopes. Sir John and his brother joined the crowd of defeated Lancastrian gentry seeking a pardon from King Edward, restored to power with no challenger in sight. Such pardons were fairly routine in the Wars of the Roses, but they might be speeded or delayed, depending on one's court connections. The Pastons thought first of their Yorkist friend Anthony Woodville, Lord Scales, who had succeeded to the title of Earl Rivers after his father's execution at Edgecote. He promised to

The execution of the young Duke of Somerset, brother of William Paston's wife, Lady Anne Beaufort, after the battle of Tewkesbury, from *The Arrivall of Edward IV*. (*University of Ghent*, MS. 236, f.72)

be their "good lord and help to get my pardon," John III wrote his mother early in July, but John had his doubts; young Rivers's position at court had declined. A dreamy young man given to writing poetry, he was regarded by his royal brother-in-law as unreliable and had just been relieved of his post as lieutenant of Calais. "As for pardon," John concluded, "I can never get it without paying too much money for it, and I am not so provided."[18]

He was overly pessimistic. Though his petition moved more slowly than that of his brother, which was promptly approved, John III eventually got his pardon, thanks in good part to the efforts of his old acquaintance Sir Thomas Wingfield, who was now a member of the duke of Norfolk's council. John wrote his mother in mid-July:

> This Wednesday Sir Thomas Wingfield sent to me and let me know that the king has signed my bill of pardon, which the said Sir Thomas delivered to me, and so by Friday at the furthest I trust to have my pardon sealed by the chancellor, and soon after . . . I trust to see you.

If Sir Thomas came to Norwich, John entreated his mother to welcome him as "the man that I am most beholden to for his great kindness and good will, for he takes fully my part against my greatest enemies." These included Sir William Brandon, the duke's chief councillor, and Brandon's son, as well as Wingfield's own brother William, who had openly threatened John. To his mother, John declared that he had no fears of William Wingfield as long as "he may meet me on even ground." But the matter of the pardon was extremely touchy, and John warned Margaret to say "but few words" about it except to her cousin and close friend Lady Calthorp.[19] The formal sealing of the two pardons

was excruciatingly delayed, Sir John's until December, John III's till February 1472.[20]

William Paston also found it necessary to negotiate a pardon. He had evidently not taken up arms himself, but was tainted by his wife's Lancastrian connections: her father had fallen in 1455 at the first battle of St. Albans; her oldest brother commanding Lancastrian forces in the north in 1464, had been executed after the battle of Hexham, and now her two remaining brothers had perished at Tewkesbury. Uncle William may also have been suspect on the grounds of his position as a feoffee of the countess of Oxford.[21]

Operating in favor of all three Paston men was the distinction frequently made throughout the Wars of the Roses between defeated gentry and defeated nobility; in the wake of Barnet and Tewkesbury, the Pastons safely if impatiently awaited their pardons while their patron, the earl of Oxford, fled for his life. A letter from the earl survives, signed with a deliberately illegible flourish and addressed anonymously, "Right reverend and worshipful lady," evidently to his wife, asking her to send him "all the ready money that you can make, and as many of my men as can come well horsed."[22] Oxford made good his escape abroad, where he spent the next several years. The worst that happened to the Pastons was that someone in Norwich called John III a traitor.[23]

Not quite the worst. The duke of Norfolk, promoted to Earl Marshal for his continuing valiant service to the Yorkist cause, found the moment propitious for repossessing Caister Castle. As William Worcester reported in his *Itineraries:*

Caister Fastolf was taken a second time by the trickery of a servant of the Duke of Norfolk, namely John Colby the

duke's groom, when the servants of John Paston knight were asleep in the afternoon, namely on Sunday 23 June, to the great harm of the goods of J. Fastolf knight in the keeping of the said Paston [1471].[24]

The few Paston servants present made no resistance, and the Pastons did not dare protest as the castle once more changed hands.

Chapter 12

FAMILY DISCORD, FOREIGN WAR, AND OTHER DISTURBANCES

1471–1475

ir John did not tamely resign himself to the permanent loss of Caister. He had twice lost it; he might twice regain it. For the time being, he contented himself with suggesting that John III speak to the duchess of Norfolk and ascertain "her disposition and the household's toward me and you, and whether it is possible to have Caister again and their good will; and also I pray you find out what the garrison and administration is at Caister, and have a spy going in and out so that you may know the secrets among them." He added a caution about the political atmosphere:

> There is much trouble in the North, as men say; I pray you beware of your behavior and especially of your language, so that . . . no man perceives that you favor any person contrary to the king's pleasure.

But, written from Bishop Waynflete's see of Winchester to John
III in Norwich, Sir John's letter was more concerned with a viru-
lent outbreak of plague in Norwich than with the duke's seizure
of Caister.

> I pray you send me word if any of our friends or well-willers
> are dead, for I fear that there is great death in Norwich and
> in other borough towns in Norfolk. For God's sake, let my
> mother take heed to my young brothers that they are not in
> any place where that sickness is reigning, or that they disport
> with any other young people who live where any sickness is;
> and if there are any dead or infected . . . in Norwich, for
> God's sake, let her send [the children] to some friend of hers
> in the country, and you do the same. . . . Let my mother
> rather move her household into the country.

His relationship with Anne Haute, three years after their ini-
tial commitment, remained distant; although still "ensured"—
betrothed—they rarely saw each other. "I had almost spoken with
Mistress Anne Haute," he wrote, "but I did not. Nevertheless this
next term [at court] I hope to settle with her one way or the other;
she has now agreed to speak with me, and she hopes to do me
ease, as she says." At the moment, John III was courting Lady
Elizabeth Bourchier, widow of Sir Humphrey Bourchier, killed at
Barnet, and Sir John inquired about the progress of the affair.
"You have chafed it a little, but I do not know how; send me
word whether you are in better hope or worse."[1]

Sometime during the summer of 1471, Sir John had suc-
ceeded in wangling a hundred marks from his mother, who bor-
rowed the sum from her cousin Elizabeth Clere. By November,
Elizabeth was asking for the money, which a friend of hers
needed desperately. Margaret chose to write to John III, tem-
porarily in the capital, rather than appeal directly to his brother.

I know not what to do, for by my troth I have it not, nor can I make shift for it, even if I should go to prison; therefore, commune with your brother about it and send me word in haste how he will manage it. Otherwise I must sell all my woods, and that would cost him more than two hundred marks when I die; if I should sell them now, no man will give me within a hundred marks of what they are worth, because there are so many sales of wood in Norfolk at this time.

She once more fretted that people were gossiping over her financial predicament; that her money troubles were public knowledge was "to my heart a very spear," particularly considering Sir John's indifference and his profligacy with "all the money he has received."

The plague was still raging in Norwich. "Your cousin [John] Berney of Witchingham has passed to God. . . . Veyly's wife and Lodon's wife and Picard the baker of Tombland [the old Norwich marketplace] are gone also; all this household and this parish is as you left them, pleased be God; we live in fear, but we know not whither to flee to be safer than we are here." Plague or no plague, she closed with instructions for the usual errands and sent money, despite her poverty, to buy sugar and dates, also requesting the price of pepper, cloves, mace, ginger, and cinnamon, as well as of almonds, rice, saffron, and raisins of Corunna, which might be cheaper in London than in Norwich.[2]

At about the same time, Margaret's third son, Edmund, wrote John III a letter mostly devoted to London shopping. Edmund wanted "three yards of purple camlet [a fine wool] at 4s. a yard; a bonnet of deep murrey [purple], price 2s. 4d.; a hose cloth of yellow kersey [a coarse woolen cloth]—I think it will cost 2s.; a girdle of plunket [blue-gray] ribbon, price 6d.; three dozen points [laces] with red and yellow, price 6d.; three pairs of pattens [working shoes]. . . . They must be low pattens; let them

be long enough and broad on the heel." He conveyed Margaret's greetings and blessing and her wish that John would "buy her a runlet [cask] of malmsey. . . . And if you send it home, she bids that it be wound in canvas, to prevent its being broached by the carriers, for she says she has known that to happen before." Edmund, who had just finished his education in law at the Staple Inn, one of the Inns of Chancery, was seeking employment and asked John to try to find him "any profitable service. . . . I would have a right easy service until I am out of debt."[3]

Sir John predictably failing to produce Elizabeth Clere's hundred marks, Margaret voiced her complaints to John III:

> Remembering what we have had before this and how lightly it has been spent, and with little profit to any of us, and now we are in such case that none of us may help another without doing what would be too great a disworship for us to do— either selling wood or land or such stuff as it is necessary for us to have in our houses. . . . It is a death to me to think upon it. . . . [Sir John] writes me also that he has spent £40 this term. It is a large sum, and I think with discretion much of it might have been spared. Your father, God bless his soul, had as great matters to do as I believe [Sir John] has had this term, and had not spent half the money on them in so little time, and did right well.

Mention of her provident husband reminded Margaret of another fault to find with his oldest son: five years after John I's death, his burial place at Bromholm Priory still had no gravestone. "It is a shame and a thing that is much spoken of in this country." Sir John had actually asked his brother two months earlier to obtain precise dimensions of the space available at Bromholm but was dilatory in pursuing the project. "I think by your brother's attitude," Margaret went on, "that he is reluctant

to write me and therefore I will not encumber him by writing to him." As for her cask of wine,

> I would send you the money for it, but I dare not put it in jeopardy, there are so many thieves about. John Loveday's man was robbed down to his shirt as he came home. I think if you ask Townshend or Playter or some other good countryman of ours to lend it to you for me until they come home, they will do so for me, and I will repay them.

She concluded with news that their old ally and agent James Gresham had been "passing sick, and still is." She had heard that Sir John had been advised to sue him. "For God's sake, let no unkindness be shown him, for that would soon make an end of him. Remember how kind and truehearted he has been to us to the best of his power. . . . Let it be remembered, or our enemies will rejoice."[4]

His mother's censure had little discernible effect on Sir John, who early in January 1472 wrote her blithely that his pardon had arrived and he had divided the Christmas holidays pleasantly between visits to his Aunt Elizabeth [Paston Poynings], now married to Sir George Browne, and the archbishop of York. At the archbishop's he had enjoyed "as great cheer and been as welcome as I could wish; and if I had been certain that Caister was ours again, I would have come home today." He was concerned about his personal belongings at Caister and urged John III, who had gone home for Christmas, to "do his duty that I may have again my stuff, my books and vestments, and my bedding," even though, as John III had thought might be necessary, he had to give money to Lady Brandon, wife of Sir William Brandon. Tidings: the king had "kept a royal Christmas."[5]

In Norwich, John III was striving without success to "make my peace with my lord of Norfolk or my lady, yet every man tells

me that my lady speaks passing well of me notwithstanding."
The suit of the two widows of the Caister siege still hung fire;
during the previous autumn Sir John had suggested that his
brother check to see if "they are married since, or not, for I
believe the whores are wedded; and if they are, the appeals
would be abated thereby."[6] Investigation at least partly vindi-
cated the strategy. A servant who prudently signed himself only
"R.L." reported that he had talked to "the woman who was the
fuller's wife of South Walsham, who is now married to one Tom
Steward, dwelling in the parish of St. Giles in Norwich, which
woman said to me that she never sued the appeal, but that she
was by subtle craft brought to the New Inn at Norwich, and
there was Master Southwell [the duke's man], and he entreated
her to be my lord's widow"—in other words, to bring suit. But
she "said plainly that she would have no more of that matter,
and so she took her a husband."[7] The other widow accepted
money to carry on the litigation, but the affair eventually was
allowed to lapse.

In January 1472, John III was called on to defend the Fastolf
manor of Saxthorpe. William Gurney, a member of a family that
had lost the manor early in the century, suddenly "entered into
Saxthorpe" and summoned the tenants to a manorial court by
way of demonstrating his possession. John III, getting wind of his
intentions, "came thither with your [Sir John's] man and no
more, and there, before [Gurney] and all his fellowship . . . I
charged the tenants that they should proceed no further." When
they disregarded his command, "I . . . sat me down by the stew-
ard and blotted his book [the court record] with my finger as he
wrote, so that all the tenants affirmed that the court was inter-
rupted by me in your [Sir John's] right, and I required them to
record that there was no peaceable court kept, and so they said
they would."[8]

That winter Sir John's relationship with Mistress Haute took an unexpected turn. In mid-February he wrote John III that he had spoken with the lady "at a pretty leisure" and, "Blessed be God, we are as far forth as we were heretofore, and so I hope we shall continue; and I promised her that the next leisure I could find thereto I would come again and see her."[9] Not, however, to arrange a marriage. On the contrary, the pair had decided to part company. No hint of a reason for breaking off the betrothal appears in the Letters. The political events of the past three years, aligning them on opposite sides, may well have influenced the decision. Perhaps the decline in the Pastons' fortunes cooled the lady; Sir John Paston living in Fleet Street lodgings was not as attractive a figure as Sir John Paston presiding over Caister Castle.

Whatever the cause, the parting was mutually desired and amicable, but not easy or cheap. Mistress Haute, like Margaret Paston with Margery and Richard Calle, took the Church's rulings on marriage very seriously, and apparently she and Sir John had fulfilled the requirements for a legal compact. The possibility that they may have had sex might also help account for Mistress Haute's insistence on an annulment.[10] For Sir John, the long-drawn-out affair had brought him the temporary favor of the Woodvilles, but prevented him for years from looking for another marriage partner and producing a legitimate heir.

In the spring of 1472 the Pastons suffered another loss of property. Learning that Bishop Waynflete had sold two of Fastolf's much embattled manors, Saxthorpe and Titchwell, to young Henry Heydon, son of the old Paston enemy, Margaret commented bitterly,

We beat the bushes and have the loss and the disworship and other men have the birds. My lord [Bishop Waynflete] has false and simple [stupid] counsel that advises him thereto;

and as it is told me, Guton is likely to go the same way soon. What shall befall the rest God knows—I think as bad or worse. We bear the loss among us. . . . It was told me lately that those that are at Caister say that I am likely to have but little good of Mautby if the duke of Norfolk still has possession at Caister; and if we lose that [Mautby] we lose the fairest flower of our garland.[11]

In addition to the Pastons' large concerns, their household suffered internal dissension. John III and his brother Edmund were living with their mother alternately at Mautby and Norwich, and at either place found the presence of the family chaplain, Sir James Gloys, increasingly irksome. The hotheaded young cleric who had brawled in the Norwich street with John Wyndham's men in 1448 had evolved, in John III's eyes, into a "proud, peevish, and ill-disposed priest to us all."[12] But to Margaret he was a trusted adviser, who penned many of her letters and was her closest confidant.

In May, Edmund, at Mautby, wrote John, in Norwich, telling him about the dismissal of Edmund's servant Gregory, for which he held Gloys responsible:

[Gregory] happened to have a knave's lust—in plain terms to swive a queen [to couple with a whore]—and did so in the Coningsclose. He happened to be espied by two plowmen of my mother's who were as keen as he in the matter and desired him to share, and as good company required, he said not nay; insomuch that the plowmen had her all night in their stable. Gregory was entirely rid of her, and he swears had naught to do with her in my mother's place. Notwithstanding, my mother thinks that he began the matter; wherefore there is no remedy but that he must go. And

inasmuch that the last time you were here you asked to have him if he should leave me, I am sending you the reason for his leaving, according to my mother; but . . . I am sure that it is really no more than that he cannot please all parties. That gentleman [James Gloys] . . . has said that he will get rid of whomever he pleases. . . . If we among us do not get rid of [Gloys], I pray God we may never thrive.

If John III would take Gregory into his employ, "you will be the better master to him for my sake, for I am as sorry to part from him as any man alive from his servant, and by my troth, as far as I know, he is as true as anyone alive."[13]

That summer, when both John and Edmund were staying with Margaret in Norwich, the friction increased. "Many quarrels are picked to get my brother and me out of her house," John III reported (July 1472).

We go not to bed lightly unchidden; all that we do is ill done, and all that Sir James and Pecock do is well done; Sir James and I are at odds. We fell out in front of my mother with "Thou proud priest" and "Thou proud squire," my mother taking his part, so I have almost shot the bolt as far as my mother's house goes; yet summer will be over before I get myself any master.

Margaret, furthermore, was planning to make a new settlement of her lands in her will, partly to assure income for her younger children and a dowry for daughter Anne, and partly to build a new aisle in the parish church at Mautby where she intended to be buried. "And because of this anger between Sir James and me," John wrote, "she has promised me that my part shall be naught; what yours shall be, I cannot say. God speed the

plow; in faith you must purvey for my brother E. to go over with you [to Calais], or he is undone. . . . My mother will neither give nor lend either of you a penny henceforth."[14]

In her dissatisfaction with her eldest son, Margaret may have been surprised that summer when Sir John demonstrated his address as a courtier. He managed to enlist as his "good lord" one of the most powerful men in the kingdom, Lord Hastings, who served in the dual capacity of chamberlain in Edward IV's household and commander of the garrison of Calais (whence the reference to Sir John's "going over" to Calais). With Hastings's support, Sir John now proposed to stand for one of the two parliamentary seats from Norfolk, with John III as his local agent.

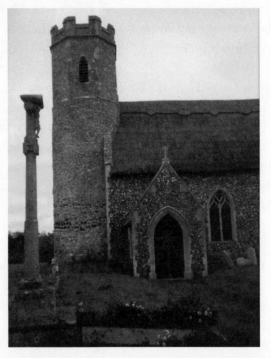

Parish church of Mautby, where Margaret Paston directed that a new aisle be built where she would be buried.

But when the dukes of Norfolk and Suffolk agreed on two other candidates, John III quickly moved to withdraw his brother's name, explaining to those whom he had invited to Norwich to vote that Sir John did not expect to be in England when Parliament met. He paid their expenses—9s. 1d. 1 obole (halfpenny), including breakfast—and "thanked them in your name," he wrote his brother, "and so they came not to the shire house; for if they had, it was thought by your friends that your adversaries would have reported that you had tried to be [elected] and that you could not bring about your purpose." John suggested angling for a borough seat: each borough (town) had a seat in Parliament, and several usually went begging because the towns did not trouble to choose representatives. Uncle William Paston had sat several times for such boroughs.

In the same letter (21 September 1472), John III made a surprisingly sanguine report on the prospects of regaining Caister. He had visited the duchess of Norfolk at Framlingham, following up a letter that Sir John had written the duke's council. The council had submitted the letter—which, according to John III, was "better than well written"—not to the duke but to the duchess, and John had reinforced it with the promise of a gift of money for the duke "and [for] her a better" one. The duchess was sympathetic but hesitated to speak to the duke unless the council addressed him first. John returned to the council and offered his brother's services plus forty pounds "for the having again of your place and lands in Caister. . . . They answered me that your offer was more than reasonable, and if the decision were theirs, they said, they knew where conscience would lead them."

The council passed the offer on to the duke, "but then the tempest arose, and he gave them such an answer that none of them would tell it to me." However, they hinted that "if some lords or greater men moved my lord about it, the matter would

be yours (keep this secret), and with this answer I departed. . . . If my Lord Chamberlain [Hastings] would send my lady a letter with some privy token between them, and also move my lord of Norfolk when he comes to Parliament, certainly Caister is yours."

Besides the duchess, there was another party to the intrigue. John reminded his brother to "get some goodly ring, priced 20s. . . . and no less" for him to give to Jane Rodon, the duchess's maid, "for she has been the most special laborer in your matter, and has promised her good will henceforth, and she can do anything with her mistress."

The duchess had apparently hinted that the forty pounds offered by Sir John would not suffice for both her and her husband. John III wondered if Lord Hastings might help out there too, observing, "My lady must have something to buy her handkerchiefs besides [what she gets] from my lord." He had had expenses of his own, including a supper for the duke's council in Framlingham, for which he asked his brother in payment

> only a goshawk . . . if I have not a hawk I shall wax fat for lack of exercise and dead for lack of company. . . . No more, but I pray God send you all your desires, and me my mewed goshawk in haste or . . . a young hawk. There is a grocer dwelling right over against the well with two buckets, a little distance from St. Helen's [Priory], who always has hawks to sell. [And, in a postscript:] Rather than nothing, a proved tercel [male hawk] will occupy the time until I come to Calais.[15]

In mid-October, John III wrote his older brother that Margaret had learned, through a servant "who runs on with open mouth in his worst way," that Sir John had mortgaged East Beckham to Roger Townshend.

My mother weeps and takes on marvelously, for she says she knows well it shall never be recovered; wherefore she says that she will provide for her land so that you shall sell none of it, for she thinks you would if it came into your hands. As for her will and all such matters as were in hand when you were last here . . . it shall not lie in our powers to stop it in any point.

His troubles with James Gloys persisted. "Sir James is ever chopping at me when my mother is present, with such words as he thinks anger me and also cause my mother to be displeased with me, as if he wants me to know that he sets nothing by the best of us." John refused to be drawn, however. "When he has the most unfitting words to me, I smile a little and tell him it is good to hear all these old tales. Sir James has been made parson of Stokesby by John Berney's gift. I think he bears himself the prouder for it."

He asked for "some tidings how the world goes," and whether Sir John had sent any of his servants to Calais, and "whether you have heard anything spoken of my going to Calais." And finally, Sir John had still not sent him his goshawk or tercel.

I thought to have had one of yours in my keeping before this time, but "far from eye, far from heart" [out of sight, out of mind]; by my troth, I die for lack of exercise. If it be possible by any means, for God's sake let one be sent me in all haste; for if it be not had by Hallowmas, the season shall pass soon. *Memento mei* [remember me], and in faith you shall not lose by it. Nor yet win much by it, by God, who preserve you.[16]

Some months earlier, John III had heard an interesting rumor: the duchess of Norfolk was at last pregnant, after ten years of

marriage. "The women about her ... expect the quickening within these six weeks at the latest."[17] In July, the duchess was "for certain great with child."[18]

Heretofore John III had acted as intermediary with this lady, who had showed herself friendly to the recovery of Caister (for a price), but in October, on the occasion of a visit of the duke and duchess to Yarmouth, Sir John undertook to charm her. His attempt, made with maladroit banter as he accompanied her to her lodgings, went amiss. On 4 November he wrote John III asking him to find out her "disposition toward me, and whether she took any displeasure at my language, or mocked, or disdained my words."

Sir William and Lady Brandon had told him that the duchess did indeed complain of his language; he had said that "my lady was worthy to have a lord's son in her belly, for she could cherish it and take care of it; in truth I said those words or others much like them, which I meant as I said." But he was also reported to have said that "my lady was of good stature and had long and large sides, so that I hoped she would bear a fair child; he was not laced or braced in to his pain, but she left him room to play in. And they say that I said my lady was large and fat, and that it should have room enough to go out at." Sir John protested being misconstrued and asked John III to find out "whether my lady takes it to displeasure or not, or whether she thinks I mocked her, or if she thinks it but my own lewdness [foolishness]. I pray you send me word, for I know not whether I may trust this Lady Brandon or not."[19] The accusation was not so much that Sir John was indelicate as unflattering. Whatever he really said, it is clear that fifteenth-century England had liberal standards of verbal propriety, even in conversing with duchesses.

Late in November 1472, Sir John made another attempt to regain Caister. He succeeded in getting the king to write letters in his favor to the duke, the duchess, and their council, entrusting

them to one of the king's secretaries, William Slyfeld, "a man of worship and one in great favor" with the king. Sir John attached much weight to the king's intervention, giving Slyfeld a generous five pounds for expenses, even while cutting back on the presents offered the duke and duchess. He had at one time been willing to go as high as a hundred marks, apparently with the hope of a contribution from Bishop Waynflete, but the duke and duchess had found the sum too small and Sir John now found it too large.

"Yet forasmuch as men may not lure any hawks with empty hands," he confided, "I would yet agree to give my lady £20 to buy a horse and saddle if I am restored to my place, and to have a release from my lord and my gowns and books to be restored." Since the pregnant duchess was now confined to her chamber, where no man could be admitted until after the child was born, he thought it might be wise to enlist his mother in the project. Margaret would be a more personal representative for him than Slyfeld, "somebody . . . having authority to conclude for me." He emphasized his readiness to do service to the duke and duchess, though making it clear that he would not become the duke's "sworn man; I was never yet a lord's sworn man, yet have I done good service and not left any lord when he needed me nor for fear"—in short, he was loyal and trustworthy. The duchess, indeed, "should have had my service above any earthly lady, which she should well have known," except that "all his errands [to the duke and duchess] had been understood to be for Caister, which was not acceptable," and therefore he was "the worse welcomed."[20]

A visit to Framlingham by Bishop Waynflete to christen the duchess's baby daughter brought another gleam of hope. The bishop managed to find time between his arrival on Wednesday night and departure the following noon to speak to the duchess about Caister and told John III afterward that he had "a right agreeable answer" from her ladyship. But once more, disappoint-

ment followed. The duchess was warm, the duke cold. In fact, John presently found the chill reaching a point where his old enemies in the duke's household who had formerly only "lowered" at him "now laugh at me."[21] Their attitude proved a better barometer than the bishop's assurances.

For the next year (1473), the recovery of Caister remained in the background as the Pastons occupied themselves with family matters. Margaret was especially concerned with the education of Walter, whom she sent off to Oxford at the age of seventeen. She hoped he would enjoy there "good and sad [sober] rule. . . . I would be loath to lose him, for I trust to have more joy of him than I have of those that are older." Walter was to have made the journey with the son of Thomas Holler, a Norwich associate, but when she had no word from Holler she sent the boy with an adult companion, possibly James Gloys. The Hollers were a social cut below the Pastons, and Margaret wished that Walter could be "paired with a better person than Holler's son, but [Walter] should not make less of him, because he is a countryman and a neighbor." She intended Walter for the priesthood but prudently advised him "not to take orders that should bind" him until he was at least twenty-four, "for often 'haste rues.' I would love him better as a good secular man rather than a lewd [foolish] priest." Margaret was now spending most of her time at Mautby. "I like my abiding here in the country right well," she wrote, "and I trust when summer comes and fair weather, I shall like it better."[22]

In April, Sir John departed for Calais, leaving the annulment of his marriage with Anne Haute still in abeyance. "If I had had six days more," he wrote John III, "I would have hoped to have been delivered of Mistress Anne Haute. Her friends, the queen, and [William] Attcliffe agreed to commune and conclude with me, if I can find the means to discharge her conscience, which I trust to God to do."[23]

Meanwhile, he was having trouble with his servants, he thought because he had been overgenerous in his dealings with them. Four were leaving him; one, William Wood, had promised, when he was retained for Sir John after the siege of Caister, that "he would never leave me, and I have kept him these three years to play St. George and Robin Hood and the Sheriff of Nottingham, and now when I would have a good horseman, he is gone to Barnedale." Evidently Sir John regaled guests with amateur theatricals, a popular form of amusement for the gentry.

He added that he had found the road to Dover crowded with soldiers returning from the Continent, thanks to a truce that had just been signed. "My carriage was two hours farther behind me than I expected." He had feared that "all my finery and pride" might be stolen, "but all was safe."[24]

In June 1473, Sir John was back in London still trying to find retainers; one of his men was sick, and Pampyng was leaving to enter the service of the duchess of Norfolk. "Wherefore if you know any likely men," he wrote John, "and fair-conditioned, and good archers, send them to me . . . and I will have them, and they shall have four marks a year and my livery." He had hoped to have been "very merry" at Calais at Whitsuntide, but the troubles with his retinue and negotiations with Bishop Waynflete and Anne Haute kept him busy and alternating between London and Calais.[25] There Edmund had joined the garrison; John III remained in Norwich, leaving in July to board a ship in Yarmouth for a pilgrimage to St. James of Compostela, in Spain, stopping off in Calais on his way home.[26]

A persistent source of friction between Sir John and Margaret during this period was the manor of Sporle, west of Norwich, first because he had been selling its wood and later because she feared he would lose it altogether to his creditors. One of Judge William's acquisitions, Sporle had been appropriated by John I after the judge's death, and inherited by Sir John.

Judge William had intended it (or so Agnes claimed) for one of his two younger sons, Clement (now dead) or William. Margaret, however, wanted it for her own youngest son, William, now fourteen. Sir John protested; he had other provisions in mind for his brother and needed Sporle himself. He felt aggrieved, with some reason; as long as Margaret and Agnes lived, they controlled so much of the family property that he had scarcely enough to live on—or at least to live well on. "My father, God rest his soul, left me scant £40 land [in revenue], and you [Margaret] leave me what pleases you, and my granddam at her pleasure; thus may I have little hope of the world. . . . As for Sporle, it shall not go if I can help it, not by my will; and if there had been given me as generously as was promised me . . . I would have been sure it would not go."[27]

But Margaret's apprehensions were justified; at some point that year Sir John mortgaged Sporle to Roger Townshend. When he had second thoughts and wanted to borrow a hundred pounds from her as part of the money needed to redeem it, so that he could put it out to farm, Margaret refused.[28]

Nevertheless, a few months later he was able to pay off the mortgage by raising four hundred marks from various sources: one hundred from Bishop Waynflete, another hundred from a London merchant, a third from a loan guaranteed by Margaret, and apparently the final hundred directly from Margaret. He had rejected an offer from Uncle William, who had proposed to put up a quantity of plate (half of it belonging to Agnes) as security. Sir John was suspicious of his uncle's interest; he was "passing inquisitive" about the loan, and, his nephew concluded, "If I may do otherwise, I propose not to borrow any money by this means."[29]

One reason for Margaret's about-face on the matter of Sporle may have been the death of her trusted chaplain, James Gloys, early in October 1473. This loss, severe to Margaret, was

received with cheerful equanimity by her sons. "I am right glad that [our mother] will now do somewhat by your advice," Sir John wrote John III. "Beware henceforth that no such fellow creep in between her and you. . . . If you are willing to make a little effort, you may live right well, and she be pleased." He suggested that John III might act for his mother just as well as Gloys or Richard Calle and "ride with a couple of horses at her expense."[30]

Late in 1473 the will of John Paston I was at last probated. It proved an unpleasant surprise for Uncle William, who had counted on being named one of the executors. But as Sir John wrote John III, "[My father] never named any more [executors] but my mother and me, and afterward you . . . saying he thought that you were good and true." He added, "Keep this secret. If my uncle is not executor, it might perhaps bring back a trussing coffer with two hundred old noble pieces, which he took from me as an executor."[31]

This sounds very much like the coffer belonging to Judge William that John Paston I had removed from the cathedral priory after the judge's death. It was said to contain the very large sum of five thousand marks, given to the priory for Judge William's perpetual masses. After the death of John I, Uncle William had gotten hold of the coffer "as executor" and had turned it over to a neutral party, Paston agent and friend William Lomnor. From Lomnor's hands it had passed into those of Henry Colett, a wealthy merchant and later mayor of London, apparently for safekeeping.

One day Uncle William had invited Sir John to Colett's house to see the coffer opened. According to John III's account, included in a later list of complaints against his uncle, the lid was lifted to reveal, not the five thousand marks allegedly placed there by Judge William, but only two hundred "old noble pieces"—gold coins worth in all about a hundred marks.

William Paston promptly laid hands on the nobles and kept them.[32] Now Sir John hoped that his uncle's exclusion from the office of executor might cause him to return the coffer. But it was a futile hope; Uncle William kept the coffer and the nobles. Had he also kept the difference between five thousand marks and two hundred "old noble pieces"?

Mistress Anne Haute's conscience, it turned out, required intervention by the pope. In November 1471, Sir John was informed by his agent in Rome that an annulment would cost the huge sum of a thousand ducats. But another "Rome runner" [representative at the Papal Court] said that a hundred or at most two hundred would do the trick, commenting in Latin, "*quod Papa hoc facit hodiernis diebus multociens*" (since the pope does this often nowadays).

As head of the family, Sir John was equally concerned with his mother over the unmarried state of his sister Anne. Margaret had succeeded in arranging a match for her with young William Yelverton, grandson of the Pastons' old enemy—past quarrels, however bitter, had little place in marriage bargaining, and in any case this breach had been patched up three years before—but negotiations had stalled over the financial arrangements. Young Yelverton told Sir John that "he would have her if she had her money, and otherwise not," leading Sir John to conclude that "they are not very sure. But above all else," he hastily added, "I pray you beware that the old love of Pampyng does not renew."[33] Anne had earlier shown a disposition to follow in her sister Margery's footsteps by falling in love with a servant. Pampyng, like Richard Calle, was a trusted agent; he had fifteen loyal years of service to his credit and was a veteran of the siege of Caister, singled out for special praise by John III. Nevertheless, he was a servant. The alarm over Anne's predilection was muted by Pampyng's departure to enter the duchess of Norfolk's service.

Throughout 1473, rumors of war had reached Sir John, despite the truce that had been signed in April by England, France, and Burgundy. Another subject of tidings was the earl of Oxford, who had made two landings on the English coast, withstood a siege in a castle off Penzance, and finally surrendered to become a prisoner in a castle near Calais. From time to time, Sir John forwarded news of their adventurous lord to Norwich without comment. He was more concerned with a series of marriage projects on behalf of John III. There was a London draper's daughter named Elizabeth Eberton for whom, Sir John told her mother, John III had conceived a "fantasy" such that he preferred her to a London lady for whom he had been offered "600 marks and better." A "rich widow of Blackfriars" presented another possibility; her late husband's executor happened to be Sir John's apothecary (as well as the earl of Warwick's). John III asked his brother to speak to the man and find out "what [she] is worth, and what her husband's name was."[34] He failed to land either of these prizes.

Another prospect, Lady Walgrave, declined to accept the ring Sir John offered on his brother's account, although he assured her that "she should not be in any way bound thereby," adding that he knew well that his brother would be glad to give up the dearest thing that he had in the world, if it might be daily in her presence to remind her of him. Sir John playfully purloined a musk-ball (perfume ball) of the lady's and confessed the theft to her, saying he had not sent it to his brother for fear that it might disturb his sleep. "But now, I told her . . . I would send it to you, and give you my advice not to hope much of her, too hard-hearted a lady for a young man to trust." Lady Walgrave was "not displeased, nor forbade me that you should have the keeping of her musk-ball." Sir John sent back the ring along with "the unhappy musk-ball," advising John to "do with it as you

like." He had done his best to no avail and wanted to call it quits. "I am not happy to woo either for myself or any other."[35]

Early in 1475 the Paston men again went to war, again briefly and this time without bloodshed. Sir John and Edmund (now twenty-four) were both recovering from a fever and ague, but both were engaged along with John III and the two younger boys, Walter and William, eighteen and fifteen respectively. This time the enemies were foreign rather than domestic, and the Pastons enlisted under the king against whom Sir John and John III had fought at Barnet. The perpetual diplomatic maneuvering among England, France, and Burgundy simmered toward a renewal of the Hundred Years War, with Edward IV again allying himself with Duke Charles the Rash of Burgundy against France. The king undertook to raise an exceptionally large army: twelve thousand archers plus men-at-arms. Such a force necessitated a special tax, which brought a heartfelt complaint from Margaret:

> I know not what to do [for money]; the king goes so near us [is so hard on us] in this country, both poor and rich, that I know not how we shall live unless the world amend. We can sell neither corn nor cattle at any good price. . . . William Pecock will send you a bill for what he has paid for you for two taxes at this time.

She was concerned, also, for her younger sons, adding:

> For God's love, if your brothers go overseas, advise them as you think best for their safeguard. For some of them are but young soldiers, and know full little what it means to be a soldier, or to endure to do as a soldier should do. God save you all, and send me good tidings.[36]

She was also worried about old Agnes, still living in London
with William. "Recommend me to your granddam," she wrote
John III, who had not yet left for Calais. "I wish she were here in
Norfolk, as well at ease and as little ruled by her son as ever she
was, and then I would hope that we all should fare the better for
her." She asked John to speak with the bishop of Norwich for
her, to request a license to have mass said in the chapel at

Edward IV lands at Calais in 1475 to
launch a bloodless invasion of France.
From *Mémoires de Philippe de Commines.* (Nantes, Musée Dobrée,
MS.18, f.109v, early sixteenth century. Giraudon/Art Resource)

Mautby, "because it is far to the church, and I am sickly, and the parson is often out."[37]

John's main purpose in remaining in England was to arrange a retinue for himself and Sir John for "these wars in France." Sir John planned to ride into Flanders to "provide myself with horse and harness," intending to visit Neuss, on the Rhine, where Duke Charles was conducting a siege. This military effort was apparently a popular object of sightseeing; the king's ambassadors were just now returning from it, "and as for me, I think, I should be sick unless I see it."[38]

Edmund Paston's indenture, of 7 April 1475, has survived, and it illuminates the indenture system of recruitment practiced at this time. He engaged to serve under the duke of Gloucester (King Edward's brother, future King Richard III) for one year as a man-at-arms supported by three mounted archers, to receive 18d. per day for himself and 6d. per day for each of the archers, service to commence on 24 May. He promised to obey the king's proclamations and ordinances, carry out the duke's orders, mount watch, and do guard duty. The duke was to receive the "thirds" of Edmund's booty and the "thirds of thirds" of booty captured by his retinue. He was to be informed of the name, rank, condition, number, and value of prisoners taken, but Edmund could keep all ransom money unless the prisoner was of high rank, in which case the captive belonged to the king or the duke, who would provide suitable recompense.[39]

At the eleventh hour, war was averted. The duke of Burgundy's siege of Neuss dragged on with no end in sight, and King Edward, giving up hope of support from his ally, allowed himself to be bought off by Louis XI. In September, Sir John reported that much of the army was already back in England, including "my lord of Norfolk and my brothers," and the rest were crowding into Calais to make the crossing.[40]

That autumn of 1475 the Pastons' hopes for recovering Caister once more revived. Before taking ship in Calais, the king had spoken to the duke of Norfolk about Caister, and it was reported to Sir John that he had urged the duke to settle with the Pastons. John III, in Norwich, talked with sympathetic members of the duke's household, who advised him that Sir John should "labor" the king to write a letter directly to each of the duke's councillors, charging them to "commune with my lord in the said matter" immediately. The duchess was in Norwich, again awaiting the birth of a child, but John had not managed to see her. He had been sick since he returned from Calais—from the cold, he told Sir John, which he was now combating by wearing several layers of garments—"I was never so armed for the war as I have now armed me for the cold." He concluded with a conciliatory

Siege of a town, from the fifteenth-century *Chroniques d'Angleterre.*
(British Library, MS. Royal 14 E IV, f.23)

word from Margaret: "My mother sends you God's blessing and hers, and she would fain have you at home with her; and when you have once met, she tells me you shall not lightly depart until death parts you."[41]

But when John at last was able to talk to the duchess two weeks later, the result was another disappointment, as he duly reported to his brother. Sir John had given up his Fleet Street lodgings on departure for what he apparently expected to be a lengthy hitch with the army and, on his early return to London, had taken rooms at the George Inn at Paul's Wharf. Sir William Brandon, who had been present at the interview between King Edward and the duke, had told the duchess that the king "had had no such words to my lord for Caister" as Sir John had heard. The king had simply asked the duke, as he was leaving Calais, "how he would deal with Caister, and my lord answered never a word." The king had then asked Sir William Brandon what the duke intended to do, saying that he had asked him before to "move" the duke in the matter. "And Sir W. Brandon answered the king that he had done so . . . and my lord's answer to him was that the king might as soon have his life as that place; and then the king asked my lord whether he had said that or not, and my lord said yes. And the king said not another word, but turned his back and went his way."

John III "gave [the duchess] warning that I will do my lord no more service; but before we parted, she made me promise her that I should let her know before I committed myself to any other service."

He concluded his letter:

I pray you bring home some hats with you, or if you come not soon, send me one, etc., and I shall pay you for it a comb [four bushels] of oats when you come home.

My mother would fain have you at Mautby; she rode

thither out of Norwich on Saturday last past, to purvey your lodging ready against your coming.

I have been right sick again since I wrote to you last, and this same day have I been passing sick; it will not [move] out of my stomach by any means. I am undone. I may not eat half enough when I am most hungry; I am so well dieted, and yet it will not be. God send you health, for [I] have none three days together, do the best I can.[42]

Chapter 13

CAISTER REGAINED,
A MARRIAGE NEGOTIATED

1475–1478

he sequence of events that followed John III's disappointing conversation with the duchess turned the duke's words, as reported by Sir William Brandon, into an uncanny prophecy.

On his return from Calais in early October of 1475, Sir John set to work to compose an elaborate petition to the king, reciting the history of the controversy over Caister, beginning with the duke of Norfolk's claim to the castle and subsequent siege thereof. He detailed his specific losses, starting with the "6 sheep and 30 neat [cattle] and other stuff and ordnance ... of the value of £100" removed after the siege, plus damages that "could not be repaired with 200 marks"; also, "the revenues of the said lands for the space of three years, to the value of seven score pounds [viixx *li*] ... and the outrents of the same

never paid." He recounted the arbitration of Bishop Waynflete, which had restored the castle to Sir John in return for a payment of five hundred marks, plus one hundred for needed repairs, and the repossession by the duke, "by sinister motive and advice," after just six months.

The duke had now been in possession five years and more, and "of all that time [the duke] would never suffer [Sir John] to come into his presence, nor hear him, nor . . . [allow him] to declare or show his grief." He had tried approaching the duke's council, but "they answered that they have showed my said lord [my] request, and that he was, and is always, so moved and displeased with them that they dare no more move him therein. And thus your said suppliant has lost all his cost and labor . . . and now is out of remedy, without your abundant grace be shown in his behalf." The law was of no use "against mighty and noble estate." If the king would intervene and persuade the duke to let go of the properties he had seized, Sir John was prepared to forget "all the damages above written, which amount to the sum of £1,340 6s. 7d." If the king would act, Sir John would be "the more able to do you service, and also specially pray to God for the conservation of your most noble person and royal estate."[1]

The effect on the king of Sir John's petition is unknown. But it is significant that three months later, in January 1476, Sir John paid a visit to the duke and duchess at Framlingham. Obviously the duke had ceased to "never suffer [Sir John] to come into his presence, nor hear him." Whatever course their conversations now took, under whatever pressure from the king, while Sir John was there the problem was abruptly transformed. Without warning, the intractable duke, who had sworn to surrender Caister only with his life, suddenly died.

Sir John, sometimes slow to act, wasted no time on this occasion, which he might have seen as heaven-sent. He at once dispatched a trusted servant to Caister to lay formal claim—a

crucial legal step—while notifying the duke's council of his intention and not failing to make a proper contribution to the duke's funeral. This included the loan of a valuable cloth of gold he had purchased for his father's tomb, to be used "for the covering of [the duke's] body and the hearse. . . . I deem hereby to get great thanks, and great assistance in time to come," he wrote Margaret,[2] who later authorized him to sell the cloth to the duke's household if the price was right.[3]

After a brief visit to Norwich, Sir John hastened to London to consolidate his claim for Caister. John III, meanwhile, raised a difficulty. Sir John's action in sending his representative to Caister so soon after the duke's death and without the advice of the duke's council had been "evil taken among my lord's folks," as insufficiently respectful of the duke. If the duchess's expected child was a boy, or if an anticipated betrothal took place between her four-year-old daughter Anne and the king's younger son, the three-year-old duke of York, "she might occupy Caister . . . and lay the blame on your unkind hastiness of entry without her assent."[4]

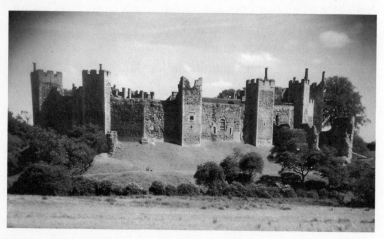

Framlingham Castle. *(Royal Commission on the Historical Monuments of England)*

Sir John replied immediately with a long self-justifying letter. Even if the duke had treated him as kindly as he should have, considering the service their grandfathers, father, and the brothers themselves had given the duke and his predecessors, "and even if I had wedded his daughter, yet must I have done as I did." As for the duchess, "I think that she is too reasonable" to be angry with him, "for I did it not unknownst to her council [and] there was no man thought that I should do otherwise." Furthermore, in London "all the lords of the [king's] council" agreed that he had not "dealt unkindly or unfittingly; wherefore, let men deem what they will." He was more concerned about the possibility mentioned by John III of a betrothal of the two children: "If the king's son marries my lord's daughter, the king will want his son to have a fair place in Norfolk"—in other words, Caister Castle. So "Let us all pray God send my lady of Norfolk a son."[5]

In late March 1476, as the duchess's confinement approached, John III urged Margaret to attend her. "I understand that my lady would be right glad to have you about her at her labor. . . . I think that your being here should do great good for my brother's matters." But communication with Margaret might be a problem: "For God's sake, have your horse and all your gear ready wherever you are, out or at home. . . . I need to know where to find you, or else I shall perhaps seek you at Mautby when you are at Fritton [a Suffolk manor that was part of Margaret's inheritance] . . . and my lady might fortune to be far forth on her journey before you came, if she were as swift as you were once on Good Friday"—evidently a reference to one of Margaret's confinements.[6]

Whether Margaret managed to be present at the birth is unknown, but the infant did not survive, leaving the duchess's first child, young Anne Mowbray, heir to the duke's estates. Two years later Anne did indeed marry the duke of York, but Sir

John's apprehension that the king might want Caister for his son proved groundless.

In March 1476, Sir John took ship with Lord Hastings for Calais, whence he wrote Margaret and John III startling news: England's bellicose ally, Charles the Rash of Burgundy, after conquering Lorraine, had undertaken an invasion of Switzerland and had met disastrous defeat.

> They bearded him at an unnamed place [Grandson, just inside the Swiss border] . . . and have slain the most part of his vanguard, and won all his ordnance and artillery, and moreover all the stuff that he had in his host with him . . . the rich sallets, helmets, garters, gilt buckles, and all is gone, tents, pavilions, and all, and so men deem his pride is abated. Men told him that they were froward [bold] churls, but he would not believe it, and yet men say that he will to them [attack them] again.[7]

On Sir John's return in May 1476, John wrote that Caister was so lightly garrisoned that "a goose might take it," but advised against any forcible seizure, since the place was so near to falling legally. He asked his brother's help in yet another marital fishing expedition. "I understand that Mistress Fitzwalter has a sister, a maid, to marry. I trow, if you entreated [Master Fitzwalter], she might come into a Christian man's hands."[8] She did not, however, come into that Christian man's hands, and nothing more is heard of her.

However, John's prediction about Caister came true that month when, in spite of the opposition of Richard Southwell and Sir William Brandon, the royal council pronounced the title to Caister Castle and manor to belong to Sir John Paston. The procedure—much "laboring"—had been expensive, and Sir John complained, "I have much pain to get [borrow] so much

money."[9] Privy seals were made out for the duchess to give up possession, and an inquisition in October 1477 dotted i's and crossed t's. Attenuation of the process of recovery made the victory seem a little anticlimactic, but it was nonetheless substantial. Never again was the Pastons' right to the jewel of Sir John Fastolf's estate challenged.

Except for Richard Calle and Margery Paston's rebellious union, the Letters to this point show marriage as a practical arrangement involving money, property, and social standing, its materialistic aims sometimes masked by playful flirtation and sentimental protestation. The letters of 1477, which provide a rare detailed record of a late-medieval courtship, show a match that was clearly based on mutual attraction: that of John Paston III and Margery Brews, daughter of Sir Thomas Brews. But although the project met with general approval and good will on both sides, it presented problems that illustrate the intractable complexities of courtship among the landed gentry.

After the miscarriage of all his previous marriage attempts (at least ten), John had reached a point of exasperation at which he told Sir John that he would take "some old thrifty draff wife" (alewife) if she had a decent fortune. Then he met Margery. She was one of several children, and her dowry was inevitably small, but her family was a distinguished one. Her father had twice served as sheriff of Norfolk and Suffolk, had been a justice of the peace, and had several times been elected to Parliament. Her mother was the daughter of an old Paston enemy, Gilbert Debenham, and was heir to her brother, Sir Gilbert Debenham. John himself was only a second son, with little property and little to recommend him except his personal attractions and the fact that his elder brother was still unmarried. As with all marriage arrangements, the problem was the financial support of the couple and the new household they created. John had hitherto lived

either with his mother or in the household of the duke of Norfolk or in military service. To marry, he required property and income.

At their first meeting, Margery made a strong impression on John, whose feelings she enthusiastically reciprocated. Her mother, Dame Elizabeth Brews, also took a liking to him, inviting him to visit them at Topcroft, their Norfolk home, ten miles south of Norwich, to discuss terms with her husband.

Dame Elizabeth in fact proved an invaluable ally in the lengthy negotiations that followed. In their several letters of encouragement to John, both mother and daughter emerge as invincibly cheerful and optimistic, and intoxicated with the prospect of the marriage (John's letters to Margery have not been preserved). Dame Elizabeth's writing style was impetuous, making liberal use of the common device of "&c." (for *et cetera*): "Send me word again . . . how you will do, &c.";[10] "If this bill pleases not your intent, I pray you that it may be burnt, &c."; "Almighty Jesus preserve you, &c."[11]

Throughout the courtship, she remained firmly on the side of the lovers, writing John that Margery had "made her such an advocate for you that I may never have rest night or day for [her] calling and crying upon [me] to bring the said matter to effect, &c." She reminded him that

> Friday is St. Valentine's Day, and every bird chooses him a mate, and if it like you to come on Thursday night and so purvey you that you may abide there until Monday, I trust to God that you may speak to my husband; and I shall pray that we shall bring the matter to a conclusion, &c., for, cousin,
>
> > "It is but a simple oak
> > That is cut down at the first stroke."[12]

The encouraging bit of verse referred to the objections raised by sober heads in both families. Walter Paston's stay at Oxford was costing Margaret money; William was to be educated at Eton, where his expenses must be covered; and Anne's marriage, still in negotiation, had to be taken into account. On the other side, Sir Thomas Brews had younger daughters in need of dowries. With both parties determined not to get the worst of the bargain, the discussions, however friendly, were prolonged.

Margaret Paston considered that she was being dangerously generous in promising her son the mortgaged manor of Swainsthorp, plus part of the income from Sparham. John had at first thought he was getting Sparham outright, but, as Sir John carefully explained to him, he would receive "10 marks a year until £40 be paid, that is [for] but six years, and after [their mother's] decease . . . you should have that manor in jointure with your wife, to the longer liver of you both."[13] Swainsthorp was a property that Judge William Paston had acquired in the 1430s from one of the widows he exploited. In the nuncupative deathbed amendments to his written will, he had designated the income from it for one of his younger sons and for prayers for his own soul. John I had ignored his father's intentions; Margaret and Sir John now followed his lead. Sparham, on the other hand, was part of Margaret's own Mautby inheritance.

Sir Thomas, for his part, was prepared to furnish a dowry of £100, and Dame Elizabeth promised that her own father would give Margery fifty marks "on that day that she is married," adding, "If we accord, I shall give you a greater treasure, that is, a witty gentlewoman, and if I say it, both good and virtuous; for if I should take money for her, I would not give her for £1000."[14]

Soon after, Margery herself, dictating her letter to one of her father's agents, wrote to "my right well-beloved Valentine, John Paston, Esquire," telling him:

I am not in good health of body, nor of heart, nor shall be until I hear from you. . . . My lady my mother has labored the matter to my father full diligently, but she can get no more than you know of, for which God knows I am full sorry. But if you love me, as I trust verily that you do, you will not leave me therefor; for if you had not half the livelihood that you have, [and I had] to do the greatest labor that any woman alive might [do], I would not forsake you.

She was moved to poetize:

And if you command me to keep me true wherever I go
I will do all my might to love you and never no mo,
And if my friends say that I do amiss
They shall not prevent me so for to do.
My heart bids me ever more to love you
Truly over all earthly thing
And if they be never so wroth,
I trust it shall be better in time coming.

Margery, who shared her mother's partiality for "&c.," concluded:

I beseech you that this bill [letter] be not seen by any earthly creature save only yourself, &c.

And this letter was written at Topcroft, with full heavy heart, &c. By your own, Margery Brews.[15]

Margery's and Dame Elizabeth's letters are undated, but it was apparently a few days later that Margery wrote again, to convey bad news:

I let you plainly understand that my father will no more money part with in that behalf, but £100 and 50 marks,

which is right far from the accomplishment of your desire.

Wherefore, if you could be content with that good [money] and my poor person, I would be the merriest maiden on earth; and if you think yourself not satisfied, or [think] that you might have much more good, as I have understood by you before, good, true, and loving Valentine, [I ask] that you take no such labor upon you, but let it pass, and never more to be spoken of, as I may be your lover and bedeswoman [servant who prays for you] during my life. No more unto you at this time, but Almighty Jesus preserve you, both body and soul, &c. By your Valentine, Margery Brews.[16]

This touching communication was followed by one from Thomas Kela, the Brews family servant who had penned Margery's letters, with better news: Sir Thomas was willing to go as high as two hundred marks for the dowry, plus a trousseau worth a hundred marks. "And I heard my lady say that if the case required, both you and she should have your board with my lady three years after."[17]

On 8 March 1477, John III wrote his mother that "the matter is in a reasonable good way, and I trust with God's mercy and with your good help that it shall take effect better to my advantage than I told you at Mautby; for I trow there is not a kinder woman living than I shall have to my mother-in-law, if the matter take, nor yet a kinder father-in-law than I shall have, though he be hard to me at this time."

He asked Margaret to meet with Dame Elizabeth at Norwich; Elizabeth could "lie at John Cook's," but "she might dine at your house on Thursday, for there you should have most secret talking." The proposed meeting had at first been arranged for Langley, southeast of Norwich and roughly midway between Mautby and Topcroft, but it had been reported to John that the

flooding of the causeway just before Buckenham Ferry was such that there was "no proper way for you to pass over." And he urged her, "Mother, at the reverence of God, beware that you be so purveyed for that you take no cold on the way toward Norwich."[18]

That same day, Sir Thomas Brews brought his opposite number, Sir John Paston, as head of the Paston family, into the discussion. Sir John was still in London, though anticipating orders to return to Calais with Lord Hastings and "great company." In January, Duke Charles the Rash had been killed in a second battle with the Swiss, at Nancy, with vast political implications. The possibility of an Anglo-Burgundian offensive against France was replaced by the threat of a French attack on Calais. "It seems the world is all quavering," Sir John wrote his brother, "so that I deem young men shall be cherished."

Besides the threat of war, Sir John was distracted by the progress of his annulment—"the matter between Mistress Anne Haute and me has been sore broken both to the Cardinal [Bourchier], to my Lord Chamberlain [Hastings], and to myself, and I am in good hope"—but nevertheless he followed the marriage negotiations of his brother with great attention. On the one hand, he genuinely wished him happiness; on the other he had no intention of giving up any of his own revenue-producing land to seal the agreement.[19]

Sir Thomas's letter of 8 March 1477 assured him that no conclusion would be reached "until I have an answer from you again of your good will and assent." He would "be sorry to see either my cousin [in the courtesy sense] your brother, or my daughter, driven to live as mean a life as they should do" if the marriage were founded on an insufficient basis. At risk of robbing one of his younger daughters, for whose dowry a hundred pounds of the money had been earmarked, Sir Thomas agreed to lend the prospective bridegroom £120 to redeem Swainsthorp

from its mortgage, the loan to be repaid on easy terms. He now asked Sir John to contribute "your good will and some of your cost, as I have done of mine more largely than ever I propose to do for any two of her sisters."[20]

Almost simultaneously, Sir John was writing his brother (9 March), wishing him success in his courtship ("Bickerson tells me that she loves you well") yet suggesting it might be prudent to keep other candidates in mind. He mentioned a Mistress Barley, admitting that the undertaking was "but a bare thing." The dowry was not large enough and neither, apparently, was the lady: "She is a little one; she may be a woman hereafter. . . . Her person seems thirteen years of age; her years, men say, are full eighteen." He also had some lingering thoughts of an earlier enterprise, but concluded, "I had sooner you had [Margery Brews] than Lady Walgrave; nevertheless [Lady Walgrave] sings well with a harp."[21]

That letter crossed one coming from John III, sent care of Thomas Green, "good man" (innkeeper) of the George, at Paul's Wharf, "or to his wife, to send to Sir John Paston, wherever he is, at Calais, London, or other place." John reported that he had been at Topcroft again but was "yet at no certainty, her father is so hard; but I trow I have the good will of my lady her mother and her."[22]

At some point, Sir Thomas Brews dictated a memorandum stipulating his best offer: two hundred marks in hand, plus free board for the couple "for two or three years," or three hundred marks without board, and he would lend £120 for John to redeem Swainsthorp on condition that John find "a friend" to repay the loan at a rate of 20 marks a year, "so that it be not paid out of the marriage money, nor of the proper goods of my said cousin John." The offer was contingent on Margaret's contributing Swainsthorp and ten marks a year of the Sparham revenue as jointure.[23]

But Sir John, who was either in Calais or about to go there, wrote John that he had informed their mother of "all that I might and would do therein." It was not very much, in spite of his protestations that he would "do for you to my power, and take as much pain for your welfare," and "would be as glad if someone gave you a manor worth £20 a year as if he gave it to myself, by my troth."

He explained in detail the difficulty of contributing from his various properties. Snailwell had been entailed by Judge William "to the issue of my father's body"; Sporle was once more mortgaged; Winterton, left by the judge to John I's youngest brother, Clement, and reverting to John on Clement's death, and hence to Sir John, was not worth 20 marks a year, "which is not to the value of the manor of Sparham"; Caister had to be left untouched for "policy."

It should not be necessary for him to furnish an explanation for his refusal, he felt, "but your mind is troubled." John should not expect his friends to do so much for him. "If my mother were disposed to give me and any woman in England the best manor that she has, to have it to me and my wife and to the heirs begotten of our two bodies, I would not take it of her, by God." Apparently growing angrier as he wrote, he finished by asserting that if he had been consulted at the beginning, "I would have hoped to have made a better conclusion . . . this matter is driven thus far without my counsel. If it be well, I would be glad; if it be otherwise, it is a pity. I pray you trouble me no more in this matter."[24]

This testy communication, so uncharacteristic of the easy and friendly exchanges between the brothers, brought a response not from John III but from Margaret. That letter has not survived, but its content is indicated by Sir John's reply from Calais (dated 28 March).

Please you to know that I have received your letter, wherein I am reminded of the great hurt that in all likelihood might befall my brother if this matter between him and Sir Thomas Brews's daughter take not effect—for which I should be as sorry as himself, within reason.

He rehearsed the elements that made the match a good one:

the wealthy and convenient marriage [that would result]; her person, her youth, and the stock that she comes from; the love on both sides; the tender favor that she is in with her father and mother; the kindness of her father and mother to her; . . . the favor and good opinion they have in my brother; the worshipful and virtuous disposition of her father and mother, which prognosticates that the maid is likely to be virtuous and good.

In light of these factors, Sir John understood why his mother was being so generous in giving part of the revenue of Sparham as jointure; however, he wished she were conferring it as "fee simple land" (given absolutely, without limitations) rather than entailing it on John III and Margery and their heirs. What if they had daughters, and Margery died, and John had a son by a second marriage, and though that son was his father's heir he should have no land? "I know of a gentleman in Kent and his sister and the inconvenience that still exists between them, and I would that you took advice of your counsel on this point." However, he would not stand in the way of the Sparham grant, though he did not wholeheartedly approve. "The pope will suffer a thing to be practiced, but he will not license nor grant it to be done, and so I. My brother John knows my intent well enough heretofore in this matter; he will find me as kind a brother as I

may be." If Sir Thomas and his wife were afraid that Sir John would make trouble over Sparham, they need not worry; "I think they should make no obstacles about my not ratifying [the agreement], for I never had rights in that land, nor do I wish I had."[25]

But if Sir John Paston was grudgingly content, Sir Thomas Brews was not. He insisted that either his daughter have more land in jointure than Swainsthorp and ten marks' income from Sparham or that "some friend of [John III's] should pay the six score pounds [vixx *li*]" to redeem Swainsthorp. In a memorandum, John III recorded that he had then sworn on a Bible to Sir Thomas

> that I would never of my own doing endanger mother or brother more than I had done; for I thought that my mother had done much for me to give me that manor of Sparham on such terms as she had done. But Master Brews will not agree unless my mistress his daughter and I be made sure of [Sparham] now in hand, and that we may take the whole profits.

Margaret must be told of Sir Thomas's proposal, that if they were given "the whole manor during our two lives, and [the life of] the longest living," Sir Thomas would give them 400 marks, payable £50 down and £50 yearly. If that were done, Sir Thomas would lend the £120 to redeem Swainsthorp. But John could not recommend the agreement to his mother. He added, in conclusion: "Item: to advise my mother that she break not for the yearly value of Sparham above the ten marks during her life."[26]

Negotiations remained deadlocked. In April, Sir John wrote his brother from Calais expressing the hope that "God send you good speed in that matter as I would wish, and so I hope you shall have ere this letter comes to you; and I pray God send you issue between you that may be as honorable as ever were any

of your ancestors and theirs." He promised to be "a very son-in-law" to Sir Thomas and Dame Elizabeth.[27]

Calais was still on alert. Louis XI of France, having taken several of the duke of Burgundy's towns in nearby Picardy, was now besieging Boulogne. That threat presently subsided. John Pympe, a friend of Sir John's and relative of Anne Haute, wrote him a jesting letter warning against another danger to the Calais garrison. Not only were his "well-willers and servants" at home "in great dread lest the French king with some assaults should in any wise disturb you from your soft, sweet, and sure slumber," there were threats from the

> fraus of Bruges [who] with their high caps have given some of you great claps . . . and they smite at the mouth and the great end of the thigh; but in faith we do not worry about you, for we know well that you are good enough at defense. But we hear say that they are of such courage that they give you more strokes than you do them, and that they strike sorer than you also.

After more heavy-handed humor along the same line, he launched into a passage that apparently was a sly reference to a woman named Barley (surely not the Mistress Barley whom Sir John had suggested as a possible wife for John). "As for barley, it is of the same price as usual. . . . And, sir, where once was a little hole in a wall is now a door large enough and easy passage, whereof you were the deviser, and are thanked for your labor by many parties"—and more in the same vein. He concluded with what was probably the real purpose of the letter, a request for Sir John to find him a good horse in Calais.

I pray you send me word of his color, deeds, and courage, and also of his price, pretending that you wished to buy him yourself. . . . I think that the Frenchmen have taken up all the good horses in Picardy, and anyway, they are usually heavy workhorses, and those I love not, but a horse heavy of flesh and light of courage [spirit] I love well, for I love no horse that will always be lean and slender like a greyhound.[28]

In June the long-stalled marriage negotiations threatened to break off altogether. In a letter urgently requesting that Dame Elizabeth and Sir Thomas meet her in Norwich on the way to their manor of Salle, northwest of the city, Margaret Paston insisted that they must find some way to mend matters, "for if it did [break off], it were no honor to either party . . . considering that it is so widely spoken [of]. . . . My son intends to do right well by my cousin Margery and not so well by himself, and that would be no great pleasure to me, nor, I trust, to you." She recommended herself "to my cousin your husband, and to my cousin Margery, to whom I supposed that ere this time I should have given another name." The letter was carried by "my son Yelverton," showing that the lengthy and scarcely passionate courtship of Anne Paston by Judge Yelverton's grandson William had at last reached fruition.[29]

Margaret's letter was followed two weeks later by a remarkable communication from John consisting of a covering note and three enclosures (29 June 1477). John's note explained that Dame Elizabeth had been ill since she arrived at Salle, following the apparently unsuccessful meeting in Norwich. "Today with great pain" she discussed the problem with Sir Thomas, "but other answer than she has sent you in her letter enclosed herein can she not have of her husband."

Dame Elizabeth's letter, which has not survived, seems to have reiterated the terms of the Brewses' last offer. It is the other

two enclosures that are interesting. They consisted of letters that John had composed for Margaret to copy and sign. The first was addressed to Dame Elizabeth. It stated that Margaret understood Sir Thomas to be offering "but £100 . . . which is no suitable money for such a jointure as is desired of my son." When she had told Sir Thomas of "that large grant in the manor of Sparham" that she had made to the young couple, she had been informed that he would increase his own offer. Now, however, he seemed to be reneging. Adopting a censorious tone toward her son (as John scripted her role), she declared that if John had misinformed her of the Brewses' intentions in order "to deceive me of Sparham, by my troth, though he have it, he shall lose as much for it, and that shall be well understood the next time I see him." As for appeals to Sir John:

> I pray you pardon me from sending on to him any more; for, madam, he is my son, and I cannot find in my heart to become a daily petitioner of him, since he has denied me once my asking. . . . But, madam, you are a mother as well as I, wherefore I pray take it no otherwise but well that I may not do by John Paston as you will have me do; for, madam, though I would he did well, I have to purvey for more of my children than him, of whom some are old enough to tell me that I deal not fairly with them to give John Paston so much and them so little.

The second, shorter letter—"another letter, to me, that I may show," John had inscribed it—was to be addressed to himself, warning him to "be well wary how you bestow your mind unless you have substance whereupon to live; for I would be sorry to know you miscarry; for if you do, in your lack, look never for help from me."[30] Thus John undertook to stage-manage the four-month-old negotiations. Despite his ingenuity, two months later, in August,

matters had advanced very little. A fresh appeal to Sir John, in London, from Margaret brought a recital of Sir John's own financial difficulties. He would like to help his brother but needed help himself, most acutely in a debt owed a London merchant named Henry Cokett, for which Margaret had given security. Two matters were of prime importance to him: first, "the security of the manor of Caister" and, second, "the matter between Anne Haute and me," which promised soon to be "at a perfect end, which will cost me more money than I have as yet, or am likely to have before that time . . . and, as God help me, I know not where to borrow."

He owed four hundred marks to Townshend against the manor of Sporle, which must be repaid within three years or he would forfeit the property, and if that were to happen, "you were never likely to see me merry afterward." Margaret had once given him £20 toward it and had promised more. Now he urged her to keep her promise. But in the meanwhile, "as touching the marriage of my brother John, I have sent him my advice, and told him whereto he shall trust, and I have granted him as much as I may." As for Sporle, and Cokett, there was no need for Margaret to put pressure on him; "no need to prick nor threaten a free horse. I shall do what I can."[31]

Margaret replied (11 August) with an asperity that harked back to the days before Sir James Gloys's death. As regarded Cokett,

> I will never pay him a penny of that debt that you owe him, though he sue me for it, not of my own purse; for I will not be compelled to pay your debts against my will, and even if I were willing, I may not.

Sir John should see to it that the debt to Cokett did not cause her harm

for your own advantage in time coming, for if I pay it, in the long run you shall bear the loss. I marvel much that you have dealt again so foolishly with Sporle, considering that you and your friends once had so much to do to get it for you again. . . . It causes me to be in great doubt of what your disposition will be hereafter for such livelihood as I have been disposed up until now to leave you after my decease. For I think verily that you would be disposed hereafter to sell or mortgage the land that you should inherit from me, your mother, as gladly and more gladly than that livelihood that you have from your father. It grieves me to think upon your behavior, considering the great property that you have had in your control since your father died, whom God assoil, and how foolishly spent it has been. God give you grace to be of sober and good disposition hereafter to His pleasure, and comfort to me, and to all your friends, and to your worship and profit hereafter.

Still another matter troubled her: the expenses of Sir John's youngest brother, William, now at Eton, expenses that Margaret felt should now be transferred to Sir John as head of the family:

As I told you the last time that you were at home, I would no longer find for him at my cost and charge. His board and his school hire are owing since St. Thomas Day before Christmas, and he has great need of gowns and other gear that were necessary for him to have in haste. I would that you should remember and purvey them, for as for me I will not. I think you set but little by my blessing, and if you did you would have desired it in your writing to me. God make you a good man to His pleasure.[32]

Thus to the already complex problems of dowry and jointure trade-offs were added the financial problems of the bride and groom's relatives.

Difficult though it seems in the circumstances for anyone to get married in the fifteenth century, John Paston III and Margery Brews did succeed, sometime in the autumn of 1477. In the Letters there are no further details, but by mid-December they are married.

Late that year (1477), Sir John had the satisfaction of being once more sent to Parliament, not by a borough that otherwise would have gone unrepresented but by free election of the city of Yarmouth, in his home county of Norfolk, a clear recognition of his elevation in status and influence with the recovery of Caister

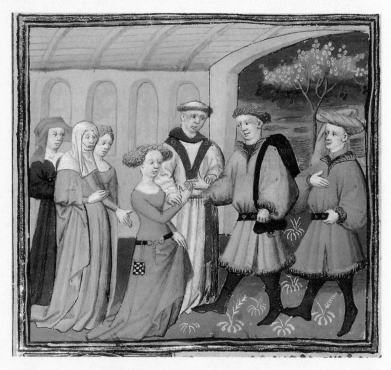

Fifteenth-century marriage ceremony.
(The Pierpont Morgan Library, MS. 394, f. 9v)

and also an indication of the value of the good lordship of Lord Hastings. The Parliament, which met in January 1478, is remembered for having voted the attainder for treason of the duke of Clarence, who had been guilty, if not of treason as charged, at least of being a royal nuisance to his brother, King Edward. The duke's execution, according to popular rumor and as recorded by Shakespeare, was accomplished by drowning in a "butt of malmsey"—a wine barrel—in the Tower. The duke had been helpful to the Pastons, notably in negotiating the capitulation of Caister Castle during the siege, but in the Letters his death is passed over in silence.

On the heels of his mother's refusal of money, Sir John received messages from his agent at Caister, veteran servant William Pecock, dealing with several matters. One was the swans at Caister, kept not for their decorative qualities but to market as food; there was "no man willing to deal with [them]." His herring could be sent by water, and "herring will be dear before Lent." Sir John's horses were not being properly kept either, and he needed to hire another keeper. The price of barley was down. But there was good news of a sort: "There is a great ship gone to wreck near Winterton, and there came upon your land a great plenty of [cargo, including] bow staves, and wainscoting, and cask boards. I got carts and carried to the town what was found upon your land." Mistress Clere, Margaret's cousin, had sent her own men to claim the wreckage, seizing boards that would be "good for windows and doors," but Pecock believed she had no right to "wreck or groundage." Furthermore, "men from Scrowby" had seized "four to six barrels of tar"; Pecock listed their names, so that Sir John could sue them for trespass. He suggested that Sir John confer with his uncle William Paston, who "shares with you both wreck and groundage in Caister." Another possible source of trouble, however, in claiming the cargo: "There are five men alive of the ship."[33]

Sir John had already begun legal action against the duke of Suffolk for the recovery of Hellesdon and Drayton in January 1478 when John III, acting as his brother's agent, wrote that he had "communed with divers folks of the duke of Suffolk" at Christmas and since, and they had let him know that the duke was short of money. "Wherefore, sir, at the reverence of God, let it not be delayed but act now, while he is in London and my lady his wife also; for I assure you that 100 marks will do more now in their need than you shall perhaps do with 200 in time to come." Sir John should approach the matter through the duchess; "as for my lord, he needs not to be moved with it until it is as good as ready for sealing."

He added, with a touch of pride, "And, sir, as for my house-wife, I am fain to carry her to see her father and her friends now this winter, for I trow she will be out of fashion in summer"[34]—in other words, Margery was already pregnant.

Despite the failure of the enterprise with Anne Haute, which precluded any other marriage projects that Sir John might have undertaken, he was far from forgoing feminine company. Besides frequent hints in the Letters—comments about his popularity among the women of Calais; a friend's remark that he was "the best chooser of a gentlewoman that I know"[35]—and the fact that he had an illegitimate daughter, there are preserved two letters from his mistresses. One, dated 21 March 1478, from a Constance Reynforth (probably the mother of his daughter), arranged, in oblique terms, a meeting, "If my simple service may be to your pleasure."[36] The other, of uncertain date, was from a Cecily Dawne. Mistress Dawne had heard reports that Sir John would marry "a daughter of the duchess of Somerset"—was it before his engagement to Anne Haute or after the annulment? She assured him that she would pray God daily to send him

someone who "will faithfully and unfeignedly love you above all other earthly creatures," which would be "the most excellent richness in this world. . . . For earthly goods are transitory, and marriage continues for term of life, which with some folk is a full long term." Therefore marriage needed careful consideration. Meanwhile:

> May it like your good mastership to understand that winter and cold weather draw nigh, and I have but few clothes except for your gift. . . . Wherefore, sir, if it like you, I beseech your good mastership that you will vouchsafe to remember me your servant with some livery, such as pleases you, against the winter, to make me a gown to keep me from the cold weather.[37]

In May 1478 the duke of Suffolk visited the disputed manor of Hellesdon where his men had wrought havoc in 1459. John Whetley, a Paston servant, reported to Sir John that the duke "was there on Wednesday in Whitsun week, and dined there, and netted great plenty of fish from the stew [fishpond], yet he has left you a pike or two against your coming." The duke had told everyone that he intended to hold onto both Hellesdon and Drayton, and Whetley reported that the duke's servants "daily threaten to slay my master your brother and me for coming on their lord's ground." Further, the duke had allowed the timber of both manors to be cut and sold. One of the purchasers was Richard Ferror, the mayor of Norwich, who insisted that he had no knowledge of "title or interest" by Sir John in Drayton, and who apologized profusely but went right on cutting down trees until by Corpus Christi Day (20 May) the woods were nearly all gone.

Whetley also reported that Margaret had been ill, "so sick that she thought she would die, and has made her will, which

you shall understand more about when I come, for it is every man for himself."[38]

John III, now settled at Swainsthorp with his pregnant wife, was looking for a suitable match for his brother Edmund. He had heard in London of

> a goodly young woman to marry, who was daughter to one Seff, a mercer [evidently deceased], and she shall have £200 in money to her marriage, and 20 marks by year of land after the decease of a stepmother of hers, who is about 50 years of age; and ere I departed from London, I spoke with some of the maid's friends and have gotten their good will to have her married to my brother Edmund.

He had also been advised to obtain the good will of one of Seff's executors, which he had proceeded to do, "and thus far forth is the matter."[39] Thus far and no farther; still another of the Pastons' marriage projects was destined never to bear fruit.

Sir John, meanwhile, promised Margaret that he would at last set his father's grave to rights; he protested that only the trouble with the duke of Suffolk had prevented his having already done so. To pay for the work, he proposed to sell the cloth of gold that had been diverted from the grave, first to embellish the funeral of the duke of Norfolk, then to serve as security for a loan, from which service it had been redeemed for twenty marks by Margaret. If she would send it to him and he could sell it,

> I undertake that before Michaelmas there shall be a tomb, and something else over my father's grave, on whose soul God have mercy, and that there shall be none like it in Norfolk. . . . God send me leisure that I may come home, and if I do not, yet the money shall be put to no other use,

but kept by someone that you trust until it may be bestowed accordingly as is above written, or else I will never give you cause to trust me while you and I live.

Even if he had to pay another twenty marks out of his own purse, he assured her, "there shall be such a tomb as you shall be pleased with"—adding, "if once I set upon it."[40]

Margaret replied, in the last of her letters to survive (27 May 1478), although she lived another six years, sending him the cloth of gold by Whetley, but

charging you that it be not sold to any other purpose than to the performing of your father's tomb, as you sent me word in writing; if you sell it to any other use, by my troth, I shall never trust you while I live. Remember that it cost me 20 marks the pledging out of it. Remember what expenses I have had with you of late, which will not be for my ease this two years. . . . If there should be nothing done for your father, it would be too great a shame for us all, and in chief to see him lie as he does.

She was disturbed about a quarrel Sir John had had with her cousin Robert Clere over some pastureland; Sir John had granted it to Clere, and William Pecock had then "let it to others" and threatened to distrain Clere's cattle.

I think this dealing is not as it should be. I would that each of you should do for the other, and live as kinsmen and friends, for such servants may make trouble between you, which would be against courtesy—such near neighbors as you are—and he is a man of substance and worship, and so is regarded in this shire, and I would be loath that you should lose the good will of such [persons] as may do for you.

Sir John's annulment had at last been formalized by Rome, at whatever cost, and Margaret had heard that he was contemplating marriage to another woman "right nigh of the queen's blood." If it would help him recover more of his lost lands, she urged him "at the reverence of God forsake it not, if you can find it in your heart to love her" and if "she be such a one as you can think to have issue by. Otherwise," she concluded, "I had rather that you never married in your life."[41]

In August, Sir John learned of the birth of a son to John III and Margery and wrote his brother, congratulating him but chiding him for not having communicated the news of "my fair nephew Christopher, which I understand you have, whereof I am right glad, and I pray God send you many, if it be His pleasure." He added a practical message: the duke of Suffolk was threatening their grandmother Agnes's advowson at Oxnead; they should defend her against the aggression for "our good granddam's sake" and also because of the family's interest after her decease. He was surprised that John III had not written him of this development also, "but you now have wife and child and so much to care for that you forget me."[42]

In November, in spite of "wife and child," John III was apparently in London when his youngest brother, William, wrote him from Eton reminding him of the 20s. owed "for my commons" (board). "Also I beseech you to send me a hose cloth, one for the holidays of some color, and another for the working days, however coarse it be makes no matter, and a stomacher, and two shirts, and a pair of slippers." He suggested that he might come "by water and sport me with you in London a day or two this term time, and then you may leave all this until the time that I come, and then I will tell you when I shall be ready to come from Eton."[43]

Chapter 14

DEATHS

1479–1484

he year 1479 witnessed the most severe visitation of the plague in England since the original Black Death of 1347–1348. The Paston family lost several members (possibly not all to the plague; medical details are few). Christopher, firstborn child of John III and wife Margery, had already died a year earlier, apparently not long after birth.

The death of twenty-three-year-old Walter Paston in August 1479 was an especially painful blow for Margaret. He had been her favorite. "I trust to have more joy of him than I have of them that are older," she had written six years earlier.[1] His education at Oxford had originally been for the priesthood, and in February, Margaret proposed to give him a benefice that was at her disposal. However, an inquiry addressed to William Pykenham, chancellor of the

diocese, met with a rebuff. Walter was too young (under twenty-four), he had not received the clerical tonsure, and he had not yet graduated. The chancellor wrote her dismissively that he had not communicated her request to the bishop of Norwich, "lest he take it to displeasure" or thought her ignorant. "Be not wroth though I send unto you thus plainly in this matter; for I would you did as well as any woman in Norfolk, to your honor, prosperity, and to the pleasure of God." The request had been accompanied by a gift, which he returned to her "in the box."[2]

Pykenham's reproof seems to have influenced Margaret and Walter to change their plans for his career from Church to law. In March, Walter's tutor, Edmund Alyard, wrote Margaret that he was "well sped in his labor and learning . . . in the Faculty of Art and may be Bachelor at such time as shall please you, and then go to law. I can think it to his preferring." He might get his degree at Midsummer, "and be with you in the vacation, and go to law at Michaelmas."[3]

Walter had planned to take his degree with Lionel Woodville, the queen's young brother, who he hoped would pay for the feast expected of new graduates. When young Woodville's graduation was postponed until Michaelmas, Walter had to pay for his own feast. To Sir John he explained that he had "beseeched [my mother] to send me some money, for it will be some cost to me but not much."

In June he reported to John III on the success of the feast. John had planned to attend, but his letter asking Walter to let him know the date had gone astray; the messenger had brought it in a bag that had "much money" in it and had forgotten to take out the letter, as Walter explained, "and so the fault was not in me."[4] Walter graduated on Friday the seventh and made his feast on the Monday after. "I was promised venison" by two people, "but I was deceived of both; but my guests held them pleased with such meat as they had, blessed be God."[5]

Shortly after his graduation, Walter fell ill. He managed to get home, but his condition quickly became serious. He drew up his will, asking to be buried in St. Peter Hungate "near the image of St. John the Baptist" and leaving money to the church for repairs. His principal possessions were the manor of Cressingham and a flock of sheep; the manor he left to Sir John, the sheep he divided among his brother Edmund, his sister Anne Paston Yelverton, and sister-in-law Margery Brews Paston. His clothing and furnishings left at Oxford he bequeathed to his master and friends there.[6]

Uncle William was on his way to Walter's funeral when he was overtaken by a messenger with the news that his mother, Agnes, was dying. He turned around at once, not to return to London to his mother's deathbed but to ride to Marlingford, one of her manors, to notify the tenants that he was laying claim to it. Word of Agnes's death reached the family in church in Norwich as funeral masses were being said for Walter.

Young Walter and old Agnes had scarcely breathed their last when Edmund reported yet another death: "My sister [Anne] is delivered, and the child passed to God, who send us His grace."[7]

Whatever feelings of grief her children and grandchildren may have felt, Agnes Paston's death inevitably provoked discord over her property. Both Sir John and his uncle William had been waiting for years to inherit revenue-producing lands they thought rightfully theirs; now the long-smoldering disagreement between them flared into active conflict.

Uncle William had the powerful support of the dowager duchess of Norfolk, an old ally of the Paston brothers but a lady whom William had served for several years. The lands he coveted fell into three categories—Agnes's jointure, Oxnead; her dower, including Paston and nearby manors; and her inheritance from her own family: Marlingford in Norfolk, Stanstead in Suffolk, and Horwellbury in Hertfordshire, her father's home. William's

justification for the seizure of all these estates was John I's disregard of the oral provisions of his father's will, as reported by Agnes. But neither of the first two categories was Agnes's to bestow, since they were hers for life only. The third she had assigned by written agreement during her husband's lifetime to her eldest son (John I) and the main branch of the family.

The Paston brothers, like their uncle, did not allow grief to distract them from protecting their property. In London, Sir John undertook to combat William's maneuvers with the escheator, in the process enlisting the backing of John Morton, bishop of Ely, one of the king's counselors, who showed himself "good and worshipful; and he said that he should send to my uncle William that he should not proceed in any such matter till he spoke with him, and moreover that he should cause him to be here [summon him] hastily." Sir John's stay in London, meanwhile, was made uneasy by the raging plague; "the first four days I was in such fear of the sickness, and also found my chamber and stuff not as clean as I deemed, which troubled me sore."[8]

Edmund and John III dealt with the manorial tenants in Norfolk. "Your tenants at Cromer say that they know not who shall be their lord," John III wrote his older brother. "They marvel that neither you nor any man for you has been there." It developed that several months before she died, Agnes had transferred possession of the manor of Paston to William. This she had no right to do, and Sir John now sent William Pecock to order the tenants to refuse rents to his uncle.

Uncle William claimed that arbitrators appointed by Bishop Morton had ruled that he should receive the rents. He predicted that, if the money was not collected (as John III reported his uncle's words), "some shall run away, and some shall waste it, so that it is never likely to be gathered, but lost." Despite acrimony, the feud remained notably nonviolent. John III himself was unsure his uncle did not have some justice on his side. If he was

Agnes's executor, or if the arbitrators had decided in his favor, as he claimed, he had a right to collect the rents. "I speak like a blind man," he told his brother. "Do as you wish."

The plague still raged. John III asked Sir John to send him

by the next man that comes from London, two pots of trea-cle of Genoa . . . they shall cost 16d.—for I have used all that I had, with my young wife, and my young folks, and myself, and I shall pay him that brings them to me, and for his car-riage. . . . The people die sore in Norwich, and especially near my house, but my wife and my women have escaped, and flee farther we cannot, for at Swainsthorp since I departed thence they have died and been sick in almost every house of the town.[9]

In spite of the plague and the quarrel with Uncle William, the Pastons did not cease pursuing marriage projects. Before Walter's death, in February, young William III wrote his brother John from Eton thanking him for paying his board of 13s. 4d., "which you sent by a gentleman's man," and telling him about a "young gentlewoman, sister of the bride," to whom he had been attracted at a wedding in Eton. "Her father is dead; there are two sisters; the elder is just wedded. . . . She is not abiding where she is now; her dwelling is in London," although she and her mother had been staying at "a place of hers" five miles from Eton, to be near "the gentleman who wedded her daughter." Mother and daughter were to return to London in a week,

and if it please you to inquire of her, her mother's name is Mistress Alborow, the name of the daughter is Margaret Alborow; her age is likely eighteen or nineteen at the most. And as for the money and plate, it is ready whensoever she were wedded; but as for the livelihood, I trow not till after

her mother's decease. . . . And as for her beauty, judge you that when you see her, if so be that you take the labor, and especially behold her hands, for if it be as it is told me, she is disposed to be thick [fat].[10]

As with so many of the Paston marital projects, this one came to nothing. But a little later William III's brother Edmund had another prospect for him,

a widow in Worstead, who was wife to one Bolt, a worsted merchant [who was] worth a thousand pounds and gave his wife a hundred marks in money, household stuff, and plate to the value of a hundred marks, and ten pounds per year in land. She is called a fair gentlewoman. I will for your sake see her. She is full sister, by both father and mother, to Harry Inglose. I propose to speak with him, to get his good will. This gentlewoman is about thirty years [old], and has but two children [whose support would be at the dead man's expense]; she was his wife but five years.[11]

William III was barely twenty-one, and perhaps the idea of marrying a thirty-year-old woman with children, for all her money, did not appeal to him. William seems to have remained unmarried for life.

Edmund, however, did marry; he was at this time trying to purchase the wardship of young John Clippesby, a step in his negotiations to marry the boy's "young mother," the widow Catherine Clippesby,[12] which soon after met with success. In a letter probably written in 1481, Edmund asked Margaret "to forgive me, and also my wife, of our lewd offense, that we have not done our duty, which was to have seen and have waited upon you ere now. My housewife trusts to lay to you her housewifery for her excuse," though Edmund instead attributed their negligence

to problems that Catherine was having with "the tilth of her lands." He continued, "I understand by the bringer hereof that you intend to ride to Walsingham; if it please you that I may know when, according to my duty, I shall be ready to wait upon you." Meanwhile, Catherine "is bold to send you a token"—a gift.[13]

Suddenly, on 15 November 1479, Sir John Paston was dead, apparently yet another victim of the plague. His life span— thirty-seven years—was short even by medieval standards, but he had been both reasonably happy and, despite his prolonged difficulties with Caister and Anne Haute, successful. His shortcomings, so often the subject of strictures, first from his father and then from his mother, had not prevented him from salvaging a large part of the Fastolf estate. Indeed, his methods of dealing with contention—by compromise and diplomacy—were not notably less effective than his father's mode of confrontation and litigation. Though he had suffered losses, he bequeathed to his brother a very substantial inheritance.

As new head of the family, John III's first care was to arrange for his brother's burial, his second to take command of the family property. Arrived in London, he found Sir John already buried, in accordance with his expressed wish, at White Friars, a Carmelite priory between Fleet Street and the Thames. "I supposed that he would have been buried at Bromholm," John wrote his mother, "[and] I intended to have brought home my granddam and him together; but that purpose is void now." Whether he then brought his grandmother's body back from London is unknown; Agnes was eventually buried in the Lady Chapel of White Friars in Norwich, with her parents, the Berrys, and maternal grandparents, the Gerbridges, and her own youngest son, Clement.

Finding his first obligation fulfilled, John turned to the second. He consulted Lord Hastings, trying

through him to win over my lord [the bishop] of Ely, if I can, and if I may by any of their means cause the king to take my service and my quarrel, I will . . . and, mother, I beseech you, if you can get and send any messengers, to send me your advice and my cousin Lomnor's to the house of John Lee, tailor, in Ludgate. I have much more to write, but my empty head will not let me remember it.

His empty head recovered enough to add important instructions:

Also, mother, I pray that my brother Edmund may ride to Marlingford, Oxnead, Paston, Cromer, and Caister, and enter all these manors in my name, and let the tenants of Oxnead and Marlingford know that I sent no word . . . to take any money of them but only their attornment [acknowledgment of his possession]. . . . But let him command them not to pay to my uncle's servants . . . under pain of payment again to me.

He explained his restraint:

I think that if any money should be asked in my name, peradventure it would set my lady of Norfolk against me. . . . I have sent word to enter at Stanstead and at Horwellbury, and I have written a letter to Anne Montgomery and Jane Rodon to make my lady of Norfolk favorable, if possible.[14]

A few days later, William Lomnor reported to John that, in accordance with his instructions, "my mistress your careful mother" had sent Edmund to Marlingford, where "before all the tenants, he examined one James, keeper there for William Paston," asking him where he was during the week that Sir John died. James admitted that he had been absent "from the Monday

until the Thursday evening, and so there was no man there but your brother's man at the time of his decease, so by that your brother died seised"—that is, in legal possession—"and your brother E. bade your man keep possession on your behalf, and warned the tenants to pay no man till he had spoken to them."

That afternoon Edmund went on to Oxnead, where a servant named Piers had "kept your brother's possession at that time"; Uncle William's man was not there when Sir John died. But after Sir John's death, William had sent his man to "keep possession." Lomnor advised John to bide his time in the matter; meanwhile, "if you might have my Lord Chamberlain's good favor and lordship it were right expedient." As for the bishop of Ely, Lomnor mistrusted him. "Deal not with him by our advice, for he will move for treaty"—in other words, compromise. Margaret sent a message: "Come out of that air"—the London pestilence that had presumably killed his brother. Edmund had taken Margery to her parents at Topcroft, "and they fare all well there."[15]

In December, John replied, explaining to Margaret that he could not obey her command to "hasten me out of the air that I am in." He had to place his trust in God, "for here must I be for a season, and in good faith I shall never, while God send me life, dread death more than shame [loss of face]; and thanks be to God the sickness is well eased here, and also the execution of my unkind uncle's intent, wherein I have as yet no other discouragement, but trust in God that [my uncle] shall fail in it."

He had spoken with the bishop of Ely several times and had his word that

he will be with me against my uncle in each matter that I can show that he intends to wrong me in; and he would fain have a reasonable end between us ... and it is certain that my brother, God have his soul, had promised to abide [by] the

rule of my Lord Chamberlain and of my Lord Ely; but I am not yet so far forth, nor will be till I know my Lord Chamberlain's intent, and that I propose to do tomorrow.[16]

During the following months, John evidently tried to intimidate some of his uncle's people; a letter from William II to his farmer at Horwellbury thanked him for his resistance to "many great threats" and promised him support "[even] if it should cost me as much as the manor is worth."[17] Reciprocally, William's men molested John's at other manors, beginning a new, more active chapter in the feud. Over the next several years, William sporadically occupied Oxnead, Marlingford, Stanstead, and Horwellbury, as well as Paston.[18] A letter from John Paston's man Robert Browne (undated, some time between 1479 and 1483) reproached John for not adequately supporting his "wellwillers" in "the matter with your uncle. . . . I pray you let your friends in this country understand. . . . Sir, you did out of policy some things that peradventure if they were yet to do, you would take other advice. I can say no more, but *sapienti pauca* [a word to the wise]."[19]

Browne's letter was addressed "to the right worshipful John Paston, Esquire, with my Lord Chamberlain"; following Sir John's example, John III had entered the service of Lord Hastings, whose powerful influence helped neutralize Uncle William's support by the duchess of Norfolk.

In a letter probably written in November 1481, John's wife Margery suggested conciliating the duchess. Margery reported a raid by several of William's farmers, who had "carried away from Marlingford . . . twelve of your great planks, of which they made six loads, carrying bows and swords around the cart" to prevent anyone's stopping them. At Marlingford, furthermore, the conflict between uncle and nephews had interrupted the course of tillage, which was "a great hurt and loss" to the tenants

"for lack of seeding their lands with their winter wheat; beseech-
ing you for God's sake to remember some remedy for them."
However, "My lady Calthorp has been at Ipswich on pilgrimage,
and came homeward by way of my lady of Norfolk, and there
was much communication of the matter betwixt you and my
uncle, [the duchess] saying to my lady Calthorp that you need
not have gone to London, you might have an end at home."
Uncle William "was not merry" on his parting from the duchess,
and "he intends largely to have peace with you, as she says, but
trust him not too much, for he is not good."

Sowing grain in the fifteenth century.
(British Library, MS. Add. 18850, f. 10)

Margery turned to personal news. "My mother-in-law thinks it long she heard no word from you. She is in good health, blessed be God, and all your babies also. I marvel that I hear no word from you." The letter was penned by Richard Calle, still in the Pastons' employ, but Margery signed it herself, in an awkward, unpracticed hand, "By your servant and bedeswoman, Margery Paston." She dictated a postscript: "Sir, I pray you, if you tarry long at London, that it will please you to send for me, for I think it long since I lay in your arms."[20]

In a letter apparently written a few days later, Margery offered to approach the duchess herself. Reporting another raid—three of William's men had carted off two loads of mixed grain (maslin) and wheat from the mill at Marlingford—she quoted her cousin William Gurney as advising that if she were to visit the duchess

and beseech her good grace to be your good and gracious lady, she would so be, for he said that one word of a woman should do more than the words of twenty men, if I could rule my tongue and speak no harm of my uncle. . . . And if you command me to do so, I trust I should say nothing to my lady's displeasure, but to your profit. . . . I understand by my cousin Gurney that my lady is nearly weary of her part [her support of William]; and he says my lady shall come on pilgrimage into this town [Norwich]; and if I would then get my lady Calthorp, my mother-in-law, and my mother, and myself, and come before my lady, he thinks you shall have an end.

Margery's perceptive conclusion was that the duchess had two desires: she wanted to "be rid of it, with her honor saved, but yet money she would have." Noblesse oblige, but not gratis. Once again, Margery signed the letter in her own hand, "By your servant and bedeswoman, Margery Paston."[21]

"Mine own sweet heart, in my most humble wise, I recommend me to you." Letter from Margery Brews Paston to John Paston III, 4 November, probably 1481, with closing and signature in her own hand.

(*British Library, MS. Add. 27446, f.52*)

◻

At the time that she wrote her letters, Margery had evidently been staying with her mother-in-law in Norwich. When she rejoined her husband, John wrote his mother an eloquently reproachful letter; Margaret, revising a will she had made three years earlier, had asked Margery to make sure that John carried out her wishes.

> Mother, it pleased you to have certain words to my wife at her departing, touching your remembrance of the shortness that you think your days will be, and also of the intentions that you have toward my brothers and sister [Anne], and also of your servants, in which you asked her to be a mediator to me, that I would tender and favor the same. Mother, saving your pleasure, there need no ambassadors nor mediators betwixt you and me, for there is neither wife nor other friend shall make me do what your commandment shall make me do, if I have knowledge of it. . . .
>
> You ought not to doubt me over anything that you would have me accomplish if I outlive you; for I know well no man alive has called on you as often as I to make your will and put everything in certainty that you wanted done for yourself, and your children and servants. Also, at the making of your will, and at every communication that I have had with you touching the same, I never opposed anything that you would have done but always offered myself to be bound by the same.
>
> Mother, I am right glad that my wife is in any way in your favor or trust; but I am right sorry that my wife, or any other child or servant of yours, should be in better favor or trust with you than myself; for I will and must give up and put from me everything that your other children, servants,

priests, workmen, and friends that you bequeath anything to will be given. . . . And this have I [done] and ever shall be ready to do, while I live . . . so God help me, whom I beseech to preserve you and send you such good life and long that you may do for yourself and me after my decease; and I beshrew the hearts of those that would or shall cause you to mistrust or to be unkind to me or my friends.

He signed himself "Your son, and truest servant, John Paston."[22]

Her complaints of poverty and financial losses notwithstanding, Margaret Paston's will gives unmistakable evidence of the comfortable lifestyle of the gentry. Like most such fifteenth-century documents, it was composed with meticulous attention to detail, first providing for her burial place and funeral service, then for prayers for her soul and the souls of her father, mother, husband, and their ancestors, "for a term of seven years after my decease," and for a long list of philanthropies, and finally for individual bequests to children, grandchildren, and servants.

Like Agnes, Margaret directed that she was to lie with her own family rather than with her husband. Her body was "to be buried in the aisle of the church of Mautby, before the image of Our Lady there, in which aisle rest the bodies of divers of my ancestors, whose souls God assoil." The aisle was to be "newly robed, leaded, and glazed and the walls thereof to be heightened conveniently and workmanly," and a "stone of marble to be laid aloft upon my grave within a year after my decease," the stone to bear escutcheons with her husband's arms and those of the Mautbys and the Berneys of Reedham, "and in the middle of the said stone I will have an escutcheon of Mautby arms alone, and under the same these words written: 'In God is my trust.'" On the "verges" of the stone were to be engraved the words "'Here lies Margaret Paston, late the wife of John Paston, daughter and heir

of John Mautby, Esquire,'" with "the day of the month and the year that I shall decease [and] 'on whose soul God have mercy.'"

Twelve poor men chosen from her tenants, "or others if they do not suffice," were to hold torches around her bier at the burial, with money to be distributed to them and to the priests that performed the service. Alms were to be given to "each household of my tenants" in her manors, and repairs and furnishings were to be provided for their parish churches. The churches and hospitals of Norwich and Yarmouth were also beneficiaries, as well as "each leper at the five gates of Norwich . . . and each leper without the north gates at Yarmouth." Two Norwich churches were especially rewarded: St. Michael Coslany and St. Peter Hungate. The latter, the church the Pastons had rebuilt in 1460, received money to be given to "each household of the parish . . . that receives alms."

To her children she left furnishings: feather beds, tapestries, curtains, blankets, "fine sheets," bolsters, ornaments, and plate—this last including twelve silver spoons, two silver salt cellars, six goblets of silver, and "a standing cup with a gilt cover with a flat knob." There were homelier objects: pewter basins and ewers, brass pots and pans, "a brass chaffer to set by the fire," a brass mortar with an iron pestle, and a stone mortar. Only a few items of apparel were listed: several girdles, including "a purple girdle decorated with silver and gilt," some silver beads, and "to Agnes Swan, my servant, my musterdevillers gown furred with black."

To Anne Paston Yelverton and her husband, Margaret left "the money that I shall owe them of their marriage money the day of my decease"; to her son William, still unmarried, 100 marks to buy land or to purchase a marriage. There were bequests to her grandchildren, the largest, 100 marks, to be divided equally between John III's son William and daughter Elizabeth "when they come of lawful age."

Two noteworthy gifts were those to Constance, "bastard daughter of John Paston, Knight," and to John Calle, "son of Margery, my daughter," or, if he died before he came of age, to his brothers William and Richard—10 marks to Constance, and triple that, £20, to Margery's progeny. Margaret's servants received household items, such as a feather bed, pairs of blankets and sheets, and "a down pillow." Her household was to be kept together for half a year after her death, their wages paid, plus an extra quarter's wages on the day of her death. The residue of her household goods was to be divided among Edmund, William, and Anne.

John III was her chief executor, and most of her inherited "manors, lands, and tenements, rents and services" went to him, "according to the last will of Robert Mautby, Esquire, my grand-father."

In the copy that has survived, the will is annotated in the margin by John III. Margaret's concern over the carrying out of her intentions is understandable, but she need not have worried. John meticulously checked off every item with a cross as he dealt with it.[23]

Margaret was still alive in 1483 when Edward IV died at Westminster Palace on 9 April, at the age of forty-one. The chain of events that ensued formed the last chapter in the Wars of the Roses and had a large impact on the fortunes of the Paston family.

Shortly afterward, John Paston III was sent to Calais to aid Lord Hastings's ailing brother Ralph, in command of the sub-sidiary stronghold of Guisnes. On 26 April, Lord Hastings wrote John thanking him for the tasks he had "truly and diligently acquitted . . . unto my said brother," and saying that he had written to ask Sir Ralph "to license you to come over to me again."[24]

But Hastings's days of being the Pastons' good lord were numbered. Even before the king's death, dissension had arisen between the Woodville party and that of the king's brother, Richard of Gloucester. Edward had named Richard Protector of twelve-year-old Edward V; the Woodvilles planned to have the queen named Regent. The struggle for power ended with Richard's seizing the throne and crowning himself Richard III. Hastings, long Richard's ally against the Woodvilles, opposed the move, and in June, at a meeting of the Royal Council, he was overpowered, accused of treason, and summarily beheaded. Several Woodville nobles were then executed, including Earl Rivers, formerly Lord Scales, onetime jousting partner, friend, and almost kinsman of Sir John Paston. Young Edward V and his brother, the nine-year-old duke of York, disappeared into the Tower, never to emerge.

In October 1483 the duke of Buckingham raised the banner of rebellion against Richard. The new duke of Norfolk called on the gentry of the shire to help suppress the rising. Among others he summoned John Paston to come to London, bringing "six tall fellows in harness" (arms and armor) to help.[25] The new duke was none other than John Howard, who as sheriff of Norfolk had had the election-day scuffle with John Paston's father twenty-two years earlier. He had become heir to the Mowbray lands when five-year-old Anne Mowbray died in 1481, but he had been kept from his inheritance by Edward IV's holding onto her estate for her child husband, the duke of York, now in the Tower. Richard III's accession freed estate and title for Howard, thereby winning Howard's loyalty to the new regime.

John Paston prudently evaded the duke's summons without, however, joining the rebels. Sir George Browne, husband of his Aunt Elizabeth, together with her son Edward Poynings, did join them. Sir George was captured and executed. Edward Poynings escaped, was attainted in absentia, and fled abroad to join Henry

Tudor, the Lancastrian earl of Richmond, who was in Brittany awaiting a favorable season to press his own claim to the throne.[26]

The duke of Norfolk apparently held no grudge over John III's evasion of his summons; early in 1484 he and his co-heir to the Mowbray estates, the earl of Nottingham, formally relinquished all rights to the manor of Caister "of which Sir John Paston was disseised unjustly by the late duke," putting a finishing stroke to the twenty-five-year dispute over Sir John Fastolf's estates.[27]

On 4 November 1484, Margaret Paston died.[28] With her death there passes from the scene the central figure of the Paston story, the indomitable lady who was carried bodily out of Gresham manor house, who served as "captainess" at embattled Hellesdon, who tirelessly championed her husband's interests against his enemies and, while often finding fault with her sons, loyally supported them. After Sir John's death, the affection and easy comradeship of his correspondence with John III is lost; with Margaret's death the loss is greater: one of the most attractive and sympathetic personalities, as well as one of the most prolific and vigorous writers. The focus blurs, the letters become sparser, and some of the heart goes out of the correspondence, which becomes engrossed with business to the detriment of personal matters and family intimacy.

Chapter 15

THE LAST OF
THE MEDIEVAL PASTONS

ow the wellspring of the medieval Paston letters begins to run dry. Three of the most prolific correspondents—John I, Sir John, and Margaret—are dead; few family members remain for John III to write to or hear from, and he and his wife are apparently not often apart. Much of the information that has survived is fragmentary, and marriages, births, deaths, and other family matters are made known only from legal documents and other sources outside the letters.

In the person of John Paston III were now united the Mautby inheritance of his mother, the Paston inheritance of his father and brother, and all that had been salvaged from the Fastolf estate. Debts and disputes, however, kept him short of money.

Up to this point the Pastons had gained or lost

only temporarily in the political upheavals of the Wars of the Roses. That situation was about to change. During the three-year reign of Richard III, John kept a discreetly low profile; though out of favor, he did not become entangled in the succession of conspiracies against the king, who found himself increasingly isolated and threatened.

In 1484, Richard persuaded the duke of Brittany to undertake the arrest of his Lancastrian rival Henry Tudor, who, however, escaped across the Loire into the kingdom of France. There he won from the new French king, Charles VIII, not only asylum but backing—men, money, ships—for an invasion of England.

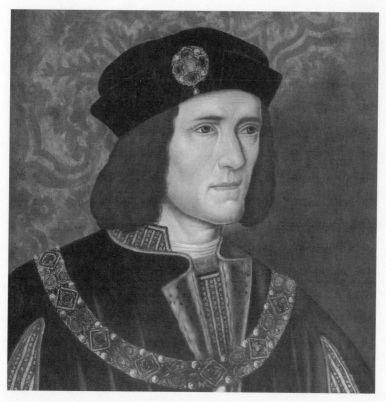

Richard III. *(National Portrait Gallery, London)*

The Pastons' old patron, the earl of Oxford, who had been held prisoner in a fort near Calais since his capture eight years earlier, now talked the commandant of the fort into joining the expedition. Captive and jailer enlisted together in the force, mainly made up of French mercenaries, that landed (7 August 1485) at Milford Haven, on the southern coast of Wales, whose inhabitants, like those of Kent, were notoriously ready for insurrection. Appealing to the Welsh more on the grounds of his family's noble Welsh ancestry than on the basis of his shaky legal claim to the throne, Henry swiftly built up his army and crossed the border into England.

Once more John Howard, duke of Norfolk, summoned the gentry of the county to rally to defense of the kingdom. He wrote John Paston, "I pray you that you meet with me at Bury [St. Edmunds, in Suffolk] . . . and that you bring with you such company of tall men as you may goodly make at my cost and charge . . . and I pray you ordain them jackets of my livery, and I shall content you at your meeting with me."[1]

John was thus presented with three options: to fight for his old patron, the earl of Oxford, on the one side; to fight for the duke of Norfolk on the other; or to sit tight. It was another precarious moment in the family's long and wary relationship with the warring nobility. John chose to sit tight.

He did not have long to sit. The two armies clashed at Bosworth Field on 22 August 1485. The duke of Norfolk commanded the vanguard of Richard III's host, and the earl of Oxford served in the same post for Henry Tudor. A strange Wars of the Roses feature of the battle was the presence of a third army: the large retinue of Lord Stanley, the dominant magnate of Lancashire, a notable fence-sitter in the wars—and incidentally Henry Tudor's stepfather. Stanley's force camped within sight of the battlefield, and when Richard III's desperate charge to try to kill Henry failed, leaving Richard himself without a horse (and,

according to Shakespeare, offering his kingdom for one), Stanley galloped up to join the winning side. Over Richard's corpse, Stanley was created earl of Derby, and soon after he carried the Sword of State at Henry's coronation.

Also among the slain was John Howard, duke of Norfolk; also surviving victoriously was the earl of Oxford, who became a pillar of the new regime, to the immense benefit of John Paston. John's prudence was rewarded when he was made sheriff of Norfolk and Suffolk,[2] and presently also steward of the earl of Oxford's large estates; John's younger brother William became one of the earl's secretaries.

John's cousin Edward Poynings fought on the winning side in the battle and survived to recover most of the lands stolen from his mother Elizabeth by the Percys. Elizabeth enjoyed the recovered estates until her death in 1488, Edward Poynings until his own in 1531. At that point, a fresh irony: since Edward died without issue, the lands went to a descendant of his cousin Eleanor Poynings—the fifth earl of Northumberland, who happened to be the surviving Percy.[3]

In January 1486, Henry of Richmond, now King Henry VII, carried out a project long planned by his supporters: marriage with Edward IV's daughter Elizabeth of York, heiress of the York dynasty, thus finally uniting the houses of York and Lancaster.

In March 1487, Henry VII paid a visit to Norfolk. John's brother William Paston III wrote giving the itinerary and, in a letter that breathed the spirit of the Pastons' happy fortune, recommending preparations:

On Monday come fortnight he will lie at the abbey of Stratford and so to Chelmsford, then to Sir Thomas Montgomery [at Faulkham], then to Hedingham [the earl of Oxford's castle] then to Colchester, then to Ipswich, then to Bury, then to

Dame Anne Wingfield's [at East Harling, Norfolk], and so to Norwich; and there will be on Palm Sunday Eve, and so tarry there all Easter, and then to Walsingham.

His hosts in Norwich must make sure that they "purvey wine enough, for every man tells me that the town shall be drunk dry, as York was when the king was there." Also, John should see that plenty of ladies were present—"my sister [Margery Brews Paston] with all other goodly folks thereabouts should accom-

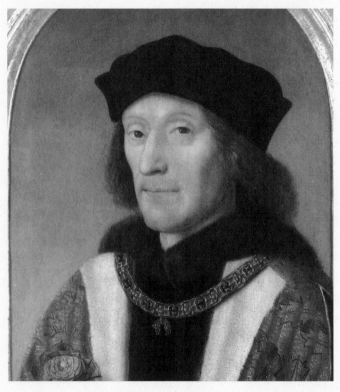

Henry VII, portrait painted in 1505.
(National Portrait Gallery, London)

pany Dame Elizabeth Calthorp, because there is no great lady thereabout for the king's coming, for my lord [of Oxford] has made great boast of the fair and good gentlewomen of the county, and so the king said he would surely see them." The earl had summoned most of the gentlemen of Essex to wait upon him at Chelmsford, where he intended to meet with the king, and had told them to be "well appointed, so that the Lancashire men may see that there are gentlemen there of such great substance that they could buy all Lancashire. Men think that you should do the same among yourselves. Your county is greatly boasted of, and also its inhabitants."[4]

In June of that year (1487), John Paston III became Sir John. An impostor named Lambert Simnel, claiming to be the earl of Warwick's son, headed a rebellion that King Henry and the earl of Oxford crushed at Stoke; John Paston, fighting in Oxford's affinity, was among those rewarded with knighthood after the battle.[5] Simnel was given a surprisingly mild punishment: he was made a turnspit in the royal kitchen.

By 1489 the new Sir John held another important post, that of deputy to the earl of Oxford in his office of Lord High Admiral. From his tenure in this role a few papers survive. One is a report of "a whale fish" captured, slain, and brought to land at Thornham, on the northwest coast of Norfolk, "by Thornham men laboring all night." The whale, along with the sturgeon, porpoise, and grampus, was a "royal fish," in which the king or his official, the Lord High Admiral, had special rights. The earl's representative arrived on the scene to claim half, and a representative of the king to claim half of the earl's half. It was "a great fish and a royal . . . eleven fathoms [66 feet] and more in length and two fathoms [12 feet] in bigness and depth in the mid-fish."[6] When John's brother William III referred the matter to the earl,

however, the latter renounced his claim; he and the king then ordered that the lower jaw of the animal be brought to the king but agreed that "the remnant of the fish be to the use of those of the country."[7]

Edmund Paston was also employed by the earl of Oxford on at least one occasion, in a role that indicated regard for his ability and trustworthiness. Lands formerly belonging to Lord Scales had descended to the earl and his cousin William Tyndale, and in 1489, until the estate could be settled, the earl asked Edmund ("having special confidence in you") to act as receiver for the revenues, delivering one half to each of the cousins.[8]

During this period, John succeeded at last in coming to an arrangement with Uncle William, at no small cost, in loss of revenues, legal expenses, and money paid directly to his uncle in settlement. The necessary borrowing left him in financial straits for several years, but it successfully ended the long feud that had originated in Judge William's maladroit will. The schism had cost much more than money, especially in the failure of the family to present a united front in the contest over Fastolf's will.

John was evidently still short of funds when his brother Edmund wrote him, in about 1490, proposing a match for John's oldest son, William IV, then ten or eleven. The prospective bride was Bridget Heydon, daughter of Sir Henry Heydon and granddaughter of the Pastons' old enemy John Heydon. The Heydons would be "gladder to bargain over this than you realize," Edmund wrote; they would offer as much as 500 marks' dowry and, unlike another candidate, who would pay the money to John's creditors, Sir Roger Townshend and Henry Colett, "which [Heydon] knew you would not want," they would give the money directly to John, so that he would "have [it] at your own disposition." Heydon would make sure that the money went "to the redeeming of your lands and paying your other debts. . . . I know well this gentleman bears you as good will as

any man alive, and my mistress his mother, and also my mistress his wife likewise, and meseems he makes not the difficulties about delivering you his money that other men do."

Edmund was aware that John was contemplating a journey to London to sound out the marriage market there for his son, but Edmund believed it would be a wasted effort. "Merchants and new gentlemen," he said, might make large offers, but "you know the continuance [ancestry] of this man, and how he is allied. . . . By my poor advice, wait three or four days, for meseems I would not have been spoken to as openly except that they intend to speak of it to you soon."[9] The Heydons' background was similar to the Pastons', and the two families, if once enemies, at least thoroughly knew each other and each other's "continuance" and alliances.

Sir Henry Heydon proved as amenable as Edmund had promised, notably assisting in the final settlement with William Paston II. Sir Henry wrote John that he had spoken to the duchess of Norfolk and to Uncle William, "and it is agreed for you to enter into Marlingford and all other manors in debate in your name, and to keep your courts, sell your woods, and do with it as with your own. Whereupon I advise you, as soon as you may, send some discreet man to keep your courts and lease your farms and sell your woods to your greatest profit. Your presence there shall be costly." John's tenants and farmers should be "warned courteously" to pay what had not been collected since the last reckoning, but Heydon advised John "not to make threats to any farmer or tenant for any dealing before this time" but only to let them know that "it is agreed by my lady [the duchess of Norfolk] that you have peaceable possession."

He concluded with a request that he might "speak to yourself in private, and to none other" on such topics as "in what silk or cloth you will have these two young innocents married, and, if it should be purveyed in London, to send me word, or else at

Norwich. . . . For it must be ordered by you in the young husband's name. Your penance from your uncle's matter I will tell you when I come home. There is no other means but to sell your woods and timber in all your manors to your best profit."[10]

In 1491, Catherine, Edmund Paston's wife, died, and he presently married Margaret Lomnor, the widow of longtime Paston agent and friend William Lomnor, who thus became another Margaret Paston.[11]

John's wife Margery had apparently become known for her medical skill. In a letter probably written in the early 1490s, John urged "Mistress Margery" to send "in all haste possible . . . by the next sure messenger that you can get, a large plaster of your *flos unguentorum* (flower of ointments) for the king's attorney, James Hobart," an old acquaintance who, like John, had been in the service of the duke of Norfolk, "for all his disease is but an ache in his knee. He is the man that brought you and me together, and I would give £40 if you could with your plaster part him from his pain. But when you send me the plaster, you must send me writing about how it should remain on his knee unremoved, and how long the plaster will be good, and whether he must wrap any more cloths about the plaster to keep it warm or not."[12]

Margery's ointment was probably a version of a popular medieval remedy made by mixing bacon fat with grease from "a neutered boar," wax, powdered incense, ground wheat, and rye grain, the result pounded in a mortar until it resembled honey and could be stored in a box. Spread on a cloth or piece of leather, it was applied to the affected area twice daily. The medical profession ridiculed the use of this "potage made of herbs and swine's grease and water and wheat flour," but unlike the more radical treatments of doctors it at least did no harm.[13] With or without its help, James Hobart survived thirty years.

John Paston probably sat in Parliament in these years, but the names of few MPs are known, and the sparse correspondence makes no reference to his election. Among the details known of the last two decades of his life is his acquisition in about 1487 of the fine stone house on King Street in Norwich. Built in the twelfth century by Isaac Jurnet, Jewish moneylender, and known today as the Music House, it was purchased by John from the Yelvertons. He refurbished the upper floor and added an elaborate braced roof.[14]

In July of 1495, the Corporation of Yarmouth notified John Paston, in his capacity as deputy to the Lord High Admiral, of a threatened invasion by a new impostor, Perkin Warbeck, who

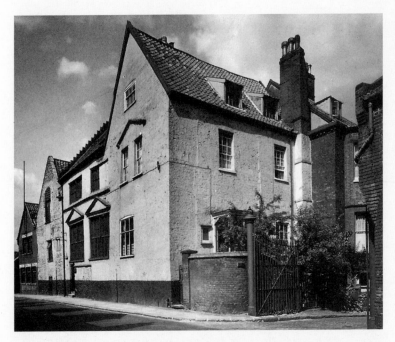

The Music House, on King Street in Norwich, acquired by John Paston III in about 1487 and refurbished by him. *(Hallam Ashley)*

claimed to be the duke of York, the younger of the two princes in the Tower. Warbeck had the backing of the princes' aunt, the dowager duchess of Burgundy, the lady whose marriage John Paston and his brother had attended in Bruges in 1468. Warbeck's fleet succeeded in alarming the Norfolk coast. When one of his ships was captured near Dover, a Yarmouth man reported that some of its officers had boasted that they "would have Yarmouth or they would die for it." The Corporation asked John for his "mighty aid and succor," and for him to "move" the mayor of Norwich to send help, "but especially that we may have your mastership among us" to reassure and counsel them.[15] However, on the following day word came that the rebel fleet had sailed away, and the threat was removed.[16] Warbeck was soon captured and eventually executed.

Margery Brews Paston, John's "Valentine" and "true love," died in 1495. John presently married Agnes Hervy, a widow with several children: the marriage had no issue.[17] At some point John and his family moved out of Caister Castle into more comfortable quarters at Oxnead, which remained the family's main residence for succeeding generations.

In March 1500, John was honored with an invitation to be present at court to welcome "the right excellent princess," fifteen-year-old Catherine of Aragon, daughter of "our dearest cousins, the king and queen of Spain," who was coming to England to marry Henry VII's eldest son, Arthur.[18] Catherine's arrival was postponed until the following October, and her marriage to Arthur was cut short by his death in 1502. Catherine then became the first wife of Arthur's brother, who ascended the throne in 1509 as Henry VIII.

William Paston III had served the earl of Oxford as secretary for sixteen years when he became afflicted with a mental illness that caused the earl to write John:

Your brother William, my servant, is so troubled with sickness and crazed in his mind that I may not have him about me, wherefore I am right sorry, and at this time send him to you; praying especially that he may be kept safely and tenderly with you to such time as God help him to be better assured of himself, and his mind more wisely disposed, which I pray God may be in short time.[19]

In 1503, probably that same year, John finally recovered East Beckham, mortgaged to Roger Townshend since 1469.[20]

John Paston III died on 28 August 1504. His uncle William (d. 1496), brother Edmund (d. c.1503), and sisters Margery (d. c.1482) and Anne (d. 1495) had all predeceased him. The date of his brother William's death is unknown.[21]

The male line of the family survived through John's oldest son, William IV, who was knighted sometime before 1520, when he was present at the royal Anglo-French diplomatic extravaganza known as the Field of the Cloth of Gold.[22] William lived into his seventies and left a posterity freely sprinkled with Sirs and Ladies. The family's prosperity lasted into the seventeenth century, when the English Civil War and Restoration brought elevation followed by ruin. Diehard Royalists in a Parliamentary county, the Pastons suffered heavy losses in fines and confiscations. The current head of the family, Sir William Paston, took refuge in Holland during the Civil War but returned to settle at Oxnead, where the old moated manor house had been replaced by a "great house" on a hill. In 1659, to help pay his debts, he sold Caister Castle, which otherwise might have made an appropriate residence for his son Sir Robert. Sir Robert's zeal for the Royalist cause brought him the title of earl of Yarmouth and the honor of seeing his eldest son married to one of Charles II's ille-

gitimate daughters. On one occasion, Sir Robert entertained the
king himself at Oxnead, to which he had added a suitable ban-
queting hall.

The honors, however, did little to increase Sir Robert's
income and instead contributed much to his expenditures. In the
tradition of many male heads of the family, starting with John
Paston II, Sir Robert enjoyed good living; his extravagance ended
by impoverishing the family.[23] His son, yet another William
Paston, lived to a ripe age but in ever-increasing straits—in 1708
he was described as being "as low as you can imagine; he hath
vast debts and suffers everything to run to extremity."[24]
William's death in 1732 brought a sale of his lands and an auc-
tion of his movable property. In 1736, Edward Paston, head of
the junior branch, sold the last Paston estate, at Barningham,
marking the final eclipse of the family.[25]

Only a few traces of the medieval Pastons survive in Norfolk or
London today: the tower and ruins of Caister Castle, the over-
grown foundations of the manor house at Gresham, the much-
altered parish churches at Oxnead, Gresham, Mautby, and
Paston, and St. Peter Hungate, the beneficiary of John and
Margaret's patronage.

Even the tombs, on which so much thought and care were lav-
ished, are gone. The Lady Chapel of Norwich Cathedral, where
Judge William was buried, has vanished. Bromholm Priory, rest-
ing place of John I, fell victim to Henry VIII's Dissolution of the
Monasteries, as did White Friars, Norwich, where Agnes, her son
Clement, her grandparents, and Margery Brews Paston all were
buried; the same fate overtook White Friars, London, where Sir
John was interred.

St. Benet's, Sir John Fastolf's place of burial, survived the
Dissolution, but the abbey was abandoned in 1545 and was sub-
sequently cannibalized for its stone and paneling; Fastolf's grave,

too, disappeared. That of his father, with its "flat figure of an armed man," met a different fate when the parish church of St. Nicholas in Yarmouth was destroyed by German bombs in World War II. Nothing marks the site of Margaret Paston's grave in her aisle in the church at Mautby, or those of Clement I and Beatrice Somerton in St. Margaret's of Paston.

Paper has proved more enduring than stone. The family that allocated so much cost and effort to prayers, masses, and monuments for their dead would be astonished to learn their true source of immortality—that readers five hundred years later would examine their private correspondence, read about their marriage negotiations, household errands, and family quarrels, and scan their love letters. What would Margaret Paston say if she knew that posterity would enjoy her reproofs to her spendthrift son; her requests for almonds, honey, and spices from London for her table; her concern over her Norfolk neighbors' gossip? Certainly she would "marvel."

Valued by scholars for their information about an important historic period and a significant social class, the letters provide a lasting memorial to the Pastons, giving this middle-class English family a nearly unique place in history.

Notes

1. The Letters

1. Horace Walpole, *Letters,* ed. Mrs. Paget Toynbee (Oxford, 1905), pp. 442–443.

2. Hannah More, *Memoirs,* ed. W. Roberts (London, 1839), vol. II, p. 50.

3. F. R. H. DuBoulay, *An Age of Ambition: English Society in the Late Middle Ages* (New York, 1970), p. 19.

4. Ibid., p. 10.

5. Norman Davis, ed., *The Paston Letters and Papers of the Fifteenth Century,* 2 vols. (Oxford, 1971, 1976; henceforth referred to as Davis), vol. I, p. 247.

6. Ibid., p. 153.

7. Alison Hanham, ed., *The Cely Letters 1472–1485* (Early English Text Society, no. 273, 1975); T. Stapleton, ed., *The Plumpton Correspondence* (Camden Society Original Series 4, 1839); Christine Carpenter, ed., *Kingsford's Stonor Letters and Papers 1290–1483* (Cambridge, 1996).

8. BL Add. MS 39848, f. 19, cited in Colin Richmond, *The Paston Family in the Fifteenth Century: The First Phase* (Cambridge, 1990; henceforth referred to as Richmond, *The Paston Family,* I), p. 228; also abstracted in James Gairdner, ed., *The Paston Letters,* A.D. *1422–1509,* 6 vols. (London, 1904; henceforth referred to as Gairdner), vol. II, p. 252.

9. Davis I, p. 333.

10. A. I. Doyle, "English Books in and out of Court from Edward III to Henry VII," in W. J. Scattergood and J. W. Sherburne, eds., *English Court Culture in the Late Middle Ages* (London, 1983), p. 164.

11. DuBoulay, *Age of Ambition,* p. 125.

12. Davis I, p. 380.

13. Colin Richmond, "The Pastons Revisited: Marriage and the Family in Fifteenth-Century England," *Bulletin of the Institute of Historical Research* 58 (1985), p. 30.

14. Davis II, p. 185.

15. Davis I, p. 364.

16. Ibid., p. 482.

17. Ibid., p. 523.

18. Ibid., p. 464.

19. Davis II, pp. 35–36.

20. Ibid., pp. 313–315.

21. Davis I, p. 364.

22. Ibid., p. 315.

23. Ibid., p. 296.

24. Ibid., p. 461.

25. Ibid., p. 590.

26. Ibid., p. 343.

27. Ibid., p. 593.

28. Davis II, p. 453.

29. Davis I, p. 370.

30. Ibid., pp. 47–49.

31. Ibid., pp. 36–37.

32. Davis II, pp. 521–522.

33. Davis I, pp. 223–225.

34. Ibid., pp. 301–302.

35. Davis II, pp. 498–500.

36. Davis I, p. 460.

37. Davis II, p. 68.

38. Ibid., p. 42.

39. Davis I, p. 293.

40. Davis II, pp. 345–346.

41. Davis I, p. 139.

42. Ibid., p. 274.

43. Ibid., p. 282.

44. Ibid., p. 276.

45. Ibid. p. 316.

46. Ibid., p. 276.

47. Ibid., p. 525.

48. Ibid., p. 449.

49. Ibid., p. 126.

50. Ibid., p. 654.

51. Ibid., p. 360.

52. Ibid., p. 262.

53. Davis II, p. 345.

54. Davis I, p. 198.

55. Ibid., p. 606.

56. Davis II, p. 262.

57. Davis I, p. 260.

58. K. B. McFarlane, *The Nobility of Later Medieval England* (Oxford, 1973), p. 151.

59. McFarlane attributes the invention of the term to Charles Plummer in the introduction to an 1885 edition of Sir John Fortescue's *Governance of England;* see K. B. McFarlane, "Bastard Feudalism," in his *England in the Fifteenth Century: Collected Essays* (London, 1981), pp. 23–43.

60. Davis II, pp. 226–227.

61. Ibid., p. 84.

62. K. B. McFarlane, "Parliament and Bastard Feudalism," in *England in the Fifteenth Century*, p. 18.

63. Davis I, p. 368.

64. Ibid., p. 282.

65. Rosemary Horrox, "Personalities and Politics," in A. J. Pollard, ed., *The Wars of the Roses* (New York, 1995), p. 90.

66. Davis I, pp. xxiv–xxviii.

67. Ibid., pp. xxviii–xxx.

2. The Family

1. Davis I, pp. xli–xlii.

2. Davis II, pp. 551–552.

3. Davis I, pp. xli–xlii.

4. Davis II, pp. 551–552.

5. Francis Worship, "Account of a MS Genealogy of the Paston Family in the Possession of His Grace the Duke of Newcastle," *Norfolk Archaeology* 4 (1855), p. 4.

6. McFarlane, *The Nobility of Later Medieval England*, p. 142.

7. Christopher Dyer, *Standards of Living in the Later Middle Ages: Social Change in England c.1200–1500* (Cambridge, 1989), p. 47.

8. Caroline Barron, "Who Were the Pastons?" *Journal of the Society of Archivists* 4 (1972), pp. 530–533; Richmond, *The Paston Family*, pp. 19–20.

9. Davis I, p. xi.

10. Gairdner VI, pp. 188–189 (abstract).

11. Richmond, *The Paston Family*, I, pp. 20–21.

12. M. M. Postan, *The Medieval Economy and Society* (Berkeley, Calif., 1972), p. 157.

13. Colin Richmond, "After McFarlane," *History* 68 (1983), pp. 59–60.

14. Davis I, p. 27.

15. J. A. F. Thomson, *The Transformation of Medieval England, 1370–1529* (London, 1983), pp. 293, 295.

16. McFarlane, *The Nobility of Later Medieval England*, pp. 68–76.

17. Davis I, p. lii.

18. DuBoulay, *Age of Ambition*, p. 52.

19. Richmond, *The Paston Family*, I, pp. 3–5.

20. Ibid., p. 8.

21. Davis I, p. 26.

3. *Judge William and His Children (1421–1444)*

1. Davis I, p. 7.

2. Davis II, pp. 509–515.

3. Davis I, p. 7.

4. Richmond, *The Paston Family*, I, pp. 35–37.

5. Davis II, pp. 4–5, 507–508; Davis I, p. xliii.

6. Davis I, pp. 7–12; Davis II, pp. 505–507; Edward Powell, "Arbitration and the Law in England in the Late Middle Ages," *Transactions of the Royal Historical Society*, 5th Series 33 (1963), pp. 49–67; J. G. Bellamy, *Bastard Feudalism and the Law* (London, 1989), p. 71.

7. Richmond, *The Paston Family*, I, pp. 70–76.

8. Christine Carpenter, "The Religion of the Gentry of Fifteenth-Century England," in Daniel Williams, ed., *England in the Fifteenth Century* (London, 1987), pp. 53–74.

9. Richmond, *The Paston Family*, I, pp. 81–103.

10. Paul Brand, "Courtroom and Schoolroom: The Education of Lawyers in England Prior to 1400," *Bulletin of the Institute of Historical Research* 60 (1987), pp. 147–165.

11. E. W. Ives, "The Common Lawyer in Pre-Reformation England," *Transactions of the Royal Historical Society,* 5th Series, 18 (1968), pp. 146–147.

12. Sir John Fortescue, *On the Laws and Governance of England,* ed. Shelley Lockwood (Cambridge, 1997), p. 69.

13. Richmond, *The Paston Family,* I, pp. 120–134.

14. Davis I, p. 26.

15. Davis I, pp. 216–217. Gairdner attributes this letter to John III's wife, Margery Brews Paston, and dates it 1477 (it is addressed to "my reverend and worshipful husband, John Paston, and signed "M.P.").

16. Davis I, pp. 217–219.

17. Barbara A. Hanawalt, *Growing Up in Medieval London: The Experience of Childhood in History* (Oxford, 1993), p. 47.

18. Davis I, pp. 260–261.

19. Ibid., pp. 21–25.

20. Ibid., pp. 44–45.

21. Ibid., p. 45.

22. Ibid., pp. 47–49.

23. Ibid., p. 46.

24. Ibid., p. 627.

25. Ibid., pp. 46–47.

26. Richmond, *The Paston Family,* I, p. 175; Davis II, pp. 608–611.

4. Land Disputes and the Siege of Gresham (1444–1450)

1. Davis I, p. 28.

2. Ibid., p. 27.

3. Ibid., p. 33.

4. Richmond, *The Paston Family,* I, p. 7; Gairdner II, p. 80 (abstract).

5. Davis I, pp. 34–35.

6. Ibid., pp. 36–37.

7. Ibid., pp. 35–36.

8. Ibid., p. 36.

9. Ibid., pp. 42–43.

10. Ibid., p. 220.

11. Richmond, *The Paston Family*, I, pp. 42–44.

12. Davis II, pp. 520–521.

13. Davis I, p. 234.

14. Davis II, pp. 30–31.

15. Ibid., pp. 521–522.

16. Davis I, p. 31.

17. Richmond, *The Paston Family*, I, pp. 103–109.

18. Ibid., pp. 47–53.

19. Davis I, p. 233.

20. Ibid., pp. 223–225.

21. Ibid., p. 51.

22. Davis II, pp. 519–520.

23. Davis I, pp. 51–52. Sir John sketched the outlines of the building in a letter of September 28, 1471 (Davis I, pp. 442–444).

24. Ibid., pp. 226–227.

25. Davis II, pp. 29–30.

26. Ibid., pp. 27–29.

27. Davis I, pp. 51–52.

28. Ibid., p. 53.

29. Ibid., pp. 52–53.

30. Ibid., pp. 227–230.

31. Ibid., pp. 230–233.

32. Davis II, p. 521.

33. Davis I, p. 236.

34. Ibid., pp. 237–238.

35. J. R. Lander, *The Wars of the Roses* (Toronto, 1986), pp. 52–53.

36. Davis II, pp. 35–36.

37. Davis I, p. 148.

38. Ibid., p. 234.

39. Ibid., p. 255.

40. Ibid., pp. 30–31.

41. Ibid., pp. 31–33.

5. *Sir John Fastolf, a Soldier in Retirement (1450–1452)*

1. K. B. McFarlane, "William Worcester: A Preliminary Survey," in his *England in the Fifteenth Century*, pp. 199–224.

2. William Worcester, *Itineraries,* ed. John H. Harvey (Oxford, 1969), pp. 352–355.

3. Ibid., p. 183.

4. McFarlane, *The Nobility of Later Medieval England,* pp. 44–45, and "The Investment of Sir John Fastolf's Profits of War," in McFarlane, *England in the Fifteenth Century,* pp. 178, 186, 195.

5. *Dictionary of National Biography* (Oxford, 1967–1968), vol. VI, p. 1099.

6. McFarlane, "Investment," p. 175.

7. Ibid., pp. 178, 179n.

8. Ibid., p. 186.

9. Ibid., pp. 177–184.

10. P. S. Lewis, "Sir John Fastolf's Lawsuit over Titchwell, 1448–55," in *Essays in Later French History* (London, 1988), p. 232.

11. McFarlane, "William Worcester," p. 253.

12. Ibid., p. 203.

13. Joseph Stevenson, ed., *Letters and Papers Illustrative of the Wars of the English in France During the Reign of Henry VI, King of England* (London, 1864), vol. II, pp. 579–591.

14. H. D. Barnes and W. Douglas Simpson, "The Building Accounts of Caister Castle, A.D. 1432–1435," *Norfolk Archaeology* 30 (1952), pp. 178–188.

15. McFarlane, "Investment," pp. 185–188.

16. Ibid., pp. 187, 195–196.

17. McFarlane, "William Worcester," p. 217.

18. Davis II, pp. 101–102.

19. Ives, "Common Lawyers," p. 149.

20. Gairdner II, pp. 55–65.

21. C. A. J. Armstrong, "Sir John Fastolf and the Law of Arms," in C. T. Allmand, ed., *War, Literature, and Politics in the Late Middle Ages* (Liverpool, 1976), pp. 46–56.

22. Gairdner II, p. 152.

23. Ibid., p. 194.

24. Richmond, *The Paston Family,* I, pp. 235–250; Anthony Smith, "Litigation and Politics: Sir John Fastolf's Defence of His English Property," in Tony Pollard, ed., *Property and Politics: Essays in Later Medieval English History* (London, 1984), pp. 59–75.

25. Lewis, "Sir John Fastolf's Lawsuit over Titchwell," pp. 215–234.

26. I. M. W. Harvey, *Jack Cade's Rebellion of 1450* (Oxford, 1991), pp. 83–88.

27. Davis II, pp. 313–315.

28. Harvey, *Jack Cade,* pp. 89–95; Robin Jeffs, "The Poynings-Percy Dispute: An Example of the Interplay of Open Strife and Legal Action in the Fifteenth Century," *Bulletin of the Institute of Historical Research* 34 (1961), p. 152.

29. Davis II, pp. 314–315.

30. Harvey, *Jack Cade,* pp. 98–100.

31. Davis II, p. 315.

32. Ibid., p. 42.

33. Harvey, *Jack Cade,* p. 133.

34. Davis I, pp. 55–56.

35. Ibid., pp. 40–41.

36. Ibid., pp. 56–58.

37. Davis II, p. 45.

38. Ibid., pp. 48–49.

39. Ibid., p. 54.

40. Ibid., pp. 54–55.

41. Ibid., pp. 50–51.

42. Gairdner II, pp. 195–200.

43. Davis I, pp. 239–240.

44. Ibid., pp. 240–241.

45. Davis II, p. 52.

46. Ibid., p. 71.

47. Ibid., p. 72.

48. Gairdner II, pp. 238–240.

49. Davis II, pp. 72–74.

50. Davis I, pp. 66–67.

51. Ibid., pp. 58–62.

52. Davis II, pp. 80–81.

53. Davis I, pp. 243–244.

54. Ibid., p. 243.

55. Carole Rawcliffe, *Medicine and Society in Later Medieval England* (Stroud, Gloucestershire, 1995), pp. 152–155.

56. Davis I, pp. 246–247.

57. Ibid., pp. 39–41.

58. Ibid., p. 249.

6. Sir John Fastolf and John Paston (1453–1459)

1. Davis I, pp. 253–254.

2. Ibid., pp. 248–252.

3. Gairdner II, pp. 295–299.

4. Davis I, p. 154.

5. Gairdner III, pp. 166–189; McFarlane, "Investment," pp. 189–190.

6. McFarlane, "Investment," pp. 190–191.

7. Davis II, pp. 574–575.

8. McFarlane, "Investment," p. 190.

9. H. S. Bennett, *The Pastons and Their England: Studies in an Age of Transition* (Cambridge, 1970; originally published in 1922), p. 111.

10. Richmond, *The Paston Family*, I, pp. 241–243; Smith, "Litigation and Politics," pp. 64, 69–70; Davis II, pp. 93–94.

11. Ibid., pp. 104–105.

12. Ibid., p. 100.

13. Davis I, pp. 247–248.

14. Ibid., pp. 31–32.

15. Davis II, pp. 89–90; Davis I, pp. 40–41.

16. Davis II, p. 96; Davis I, pp. 81, 155.

17. Davis I, pp. 155–156.

18. Davis II, p. 108.

19. R. L. Storey, *The End of the House of Lancaster* (Gloucester, England, 1986; originally published in 1966), p. 159.

20. Davis II, pp. 115–116.

21. Gairdner III, pp. 32–33.

22. Davis II, p. 117.

23. Ibid., pp. 119–120.

24. Gairdner III, p. 75.

25. McFarlane, "Investment," p. 177.

26. Davis II, pp. 132–133.

27. Ibid., pp. 109–110.

28. Ibid., pp. 156–157.

29. Ibid., pp. 133–134.

30. Ibid., pp. 140–141.

31. Ibid., pp. 128–129.

32. Ibid., pp. 144–145.

33. Ibid., pp. 159–160.
34. Ibid., pp. 162–164.
35. Ibid., pp. 170–171.
36. Ibid., pp. 171–172.
37. Ibid., pp. 129–130.
38. Ibid., pp. 168–169.
39. Davis I, pp. 41–42.
40. Jeffs, "The Poynings-Percy Dispute," pp. 151–156.
41. Davis I, pp. 206–207.
42. Ibid., pp. 41–42.
43. Davis II, pp. 184–185.
44. Richmond, *The Paston Family*, I, pp. 254–255.
45. Gairdner III, pp. 147–160.
46. Davis II, pp. 180–181.
47. Richmond, *The Paston Family*, I, p. 257.
48. Davis I, pp. 103–104.
49. Davis II, p. 186.
50. Gairdner IV, pp. 237–245.
51. Davis I, pp. 87–91; Gairdner III, pp. 160–163.
52. Davis II, pp. 534–535.
53. Gairdner IV, pp. 181–185.
54. Richmond, *The Paston Family*, I, p. 258.

7. The Fastolf Will Contested (1459–1465)

1. Davis I, pp. 157–158.
2. Ibid., p. 158.
3. Davis II, pp. 203–205.
4. Davis I, pp. 257–258. Gairdner attributes this letter to Margery Brews Paston and dates it "1484 (?)"; however, it is in the handwriting of Paston servant John Daubeney, who was killed in 1469.
5. Davis II, pp. 332–335.
6. Davis I, pp. 163–164.
7. Noel Spencer and Arnold Kent, *The Old Churches of Norwich*, revised by Alec Court (Norwich, 1990), p. 52.
8. Davis II, pp. 216–217.
9. Ibid., pp. 209–210.

10. Davis I, pp. 258–260.
11. Ibid., pp. 197–198.
12. Davis II, p. 233.
13. Davis I, pp. 165–166.
14. Davis II, p. 233.
15. Jeffs, "The Poynings-Percy Dispute," pp. 157–160.
16. Davis II, pp. 236–237.
17. Gairdner I, pp. 202–203.
18. Davis II, pp. 235–236.
19. Davis I, p. 392.
20. Davis II, pp. 240–247.
21. Davis I, pp. 390–392.
22. Ibid., pp. 199–200.
23. Ibid., pp. 200–202.
24. Ibid., p. 470.
25. Lander, *Wars of the Roses,* p. 301–302.
26. Davis I, pp. 270–272.
27. Ibid., pp. 276–278
28. Ibid., pp. 278–280.
29. Ibid., p. 281.
30. Ibid., pp. 392–393.
31. Davis II, pp. 247–249. Both Davis and Gairdner date the Cotton struggle as 1461; Roger Virgoe, in his *Illustrated Letters of the Paston Family: Private Life in the Fifteenth Century* (New York, 1989), places the episode in 1462.
32. Davis II, pp. 253–255.
33. Davis I, pp. 98–102.
34. Ibid., pp. 523–524.
35. Davis II, pp. 292–294.
36. Davis I, pp. 287–288.
37. Ibid., pp. 289–290. Davis dates this letter as 1464; Gairdner as 1459.
38. Ibid., p. 291.
39. Ibid., pp. 203–204.
40. Davis II, pp. 300–302.
41. Davis I, p. 291.
42. Ibid., pp. 126–131.

8. *The Sack of Hellesdon and the Death of John Paston I (1465–1466)*

1. Davis I, pp. 292–293.
2. Ibid., pp. 293–295.
3. Ibid., pp. 295–299.
4. Ibid., pp. 299–300.
5. Ibid., pp. 301–302.
6. Ibid., p. 303.
7. Ibid., pp. 304–306.
8. Ibid., pp. 306–308.
9. Ibid., pp. 131–134.
10. Ibid., p. 309.
11. Davis II, pp. 310–312.
12. Davis I, pp. 310–312.
13. Ibid., pp. 134–135.
14. Ibid., p. 317.
15. Ibid., pp. 311–314.
16. Ibid., pp. 314–316.
17. Gairdner IV, pp. 181–185.
18. Gairdner I, p. 339.
19. Davis I, pp. 528–529.
20. Ibid., pp. 140–145.
21. Ibid., pp. 318–322.
22. Ibid., pp. 529–531.
23. Davis II, p. 430.
24. Davis I, pp. 323–324.
25. Ibid, pp. 329–332.
26. Richmond, *The Paston Family*, I, pp. 217, 240–241.
27. Worcester, *Itineraries*, p. 189.
28. Davis II, pp. 374–375.
29. Davis I, p. 361.
30. Gairdner I, p. 233.
31. Gairdner IV, p. 230.
32. Ibid., pp. 226–231.
33. Davis II, pp. 549–551.
34. Ibid., pp. 551–552.

9. Royal Marriages and Misalliances (1466–1469)

1. Davis I, p. 334.

2. Ibid., pp. 531–533.

3. Ibid., p. 346.

4. Ibid., pp. 534–535.

5. Ibid., pp. 396–397.

6. Ibid., p. 535.

7. Ibid., pp. 334–335.

8. Gairdner IV, pp. 289, 290, 292.

9. Davis II, pp. 350–356.

10. Ibid., p. 356.

11. Davis I, pp. 397–398.

12. Davis II, pp. 385–386.

13. Davis I, pp. 535–540.

14. Richard Barber and Juliet Barker, *Tournaments: Jousts, Chivalry, and Pageants in the Middle Ages* (New York, 1989), pp. 121–124; R. Coltman Clephan, *The Tournament: Its Periods and Phases* (London, 1919), pp. 78–82.

15. Davis I, p. 540.

16. Davis II, pp. 386–387, 391–392.

17. Ibid., pp. 561–564.

18. Ibid., pp. 564–567.

19. Ibid., pp. 534–535.

20. Ibid., pp. 567–569.

21. Ibid., pp. 569–570.

22. Ibid., pp. 388–389.

23. Davis I, pp. 398–399.

24. Ibid., pp. 336–338.

25. Richard H. Helmholtz, *Marriage Litigation in Medieval England* (Cambridge, 1974), p. 29.

26. Davis I, pp. 338–339.

27. Davis II, pp. 571–572.

28. Davis I, pp. 541–543.

29. Ibid., p. 542.

30. Davis II, pp. 498–500.

10. *The Siege of Caister (1469)*

1. Davis II, pp. 395–396.
2. Davis I, pp. 543–545.
3. Worcester, *Itineraries,* p. 191.
4. Davis I, p. 543.
5. Ibid., pp. 435–436.
6. Ibid., pp. 340–341.
7. Ibid., pp. 341–344.
8. Bellamy, *Bastard Feudalism,* p. 47.
9. Davis I, pp. 344–345.
10. Ibid., pp. 405–407.
11. Ibid., p. 347.
12. Ibid., pp. 345–347.
13. Davis II, pp. 431–432.
14. Davis I, pp. 346–347.
15. Ibid., p. 546.
16. Ibid., pp. 547–548.
17. Ibid., pp. 408–410.
18. Ibid., p. 409.
19. Ibid., pp. 410–411.
20. Ibid., pp. 550–551.

11. *The Battle of Barnet (1470–1471)*

1. Davis I, pp. 412–415.
2. Ibid., pp. 554–556.
3. Ibid., pp. 559–560.
4. Ibid., p. 561.
5. Ibid., pp. 419–420.
6. Davis II, pp. 401–402.
7. Davis I, p. 349.
8. Ibid., pp. 563–564.
9. Ibid., pp. 350–351.
10. Ibid., pp. 432–434.
11. Ibid., p. 348.

12. Ibid., pp. 487–489.

13. Gairdner V, p. 95.

14. Lander, *Wars of the Roses*, pp. 175–185.

15. Charles Ross, *The Wars of the Roses: A Concise History* (New York, 1977), p. 125.

16. Davis I, pp. 437–438.

17. Ibid., pp. 565–566.

18. Ibid., pp. 566–567.

19. Ibid., pp. 567–568.

20. Ibid., p. 445; Gairdner I, p. 265.

21. Richmond, *The Paston Family*, I, p. 191; Davis I, p. lvii.

22. Davis II, pp. 591–592.

23. Davis I, p. 439.

24. Worcester, *Itineraries*, p. 253.

12. *Family Discord, Foreign War, and Other Disturbances* (1471–1475)

1. Davis I, pp. 439–441.

2. Ibid., pp. 351–355.

3. Ibid., pp. 633–645.

4. Ibid., pp. 358–360.

5. Ibid., pp. 445–446.

6. Ibid., pp. 442–444.

7. Davis II, pp. 433–434.

8. Davis I, pp. 551–554.

9. Ibid., p. 449.

10. Colin Richmond, "The Pastons Revisited: Marriage and the Family in Fifteenth-Century England," *Bulletin of the Institute of Historical Research* 58 (1985), p. 28.

11. Davis I, pp. 364–365.

12. Ibid., p. 576.

13. Ibid., pp. 635–636. Gairdner dates this letter "1475 (?)"; Davis, "probably 1472."

14. Ibid., pp. 575–577.

15. Ibid., pp. 577–580.

16. Ibid., pp. 581–582.

17. Ibid., p. 574.

18. Ibid., p. 577.

19. Ibid., pp. 449–450.

20. Ibid., pp. 453–455.

21. Ibid., pp. 585–586.

22. Ibid., pp. 369–371.

23. Ibid., p. 458.

24. Ibid., pp. 460–461. J. C. Holt, in "The Origins and Audience of the Ballads of Robin Hood," in R. H. Hilton, ed., *Peasants, Knights, and Heretics: Studies in Medieval English Social History* (Cambridge, 1981), p. 247, writes: "There is clear evidence, in a letter of 1473, that Sir John Paston retained a servant who played St. George, Robin Hood and the sheriff of Nottingham."

25. Ibid., pp. 463–464.

26. Ibid., p. 465.

27. Ibid., pp. 466–467.

28. Ibid., pp. 470–472.

29. Ibid., pp. 475–478.

30. Ibid., p. 470.

31. Ibid., pp. 467–468. Gairdner dates this letter "1466 (?)," Davis "late 1473," when John I's will was finally proved.

32. Ibid., pp. 622–625.

33. Ibid., pp. 470–472.

34. Ibid., pp. 591–592.

35. Ibid., pp. 480–481.

36. Ibid., pp. 375–376.

37. Ibid., pp. 373–374.

38. Ibid., pp. 481–482.

39. Ibid., pp. 636–638.

40. Ibid., p. 486.

41. Ibid., pp. 594–595.

42. Ibid., pp. 595–596.

13. *Caister Regained, a Marriage Negotiated (1475–1478)*

1. Davis I, pp. 487–489.

2. Ibid., pp. 489–490.

3. Ibid., p. 596.

4. Ibid., pp. 597–598.

5. Ibid., pp. 490–492.

6. Ibid., pp. 601–602.
7. Ibid., pp. 493–494.
8. Ibid., p. 603.
9. Ibid., pp. 494–495.
10. Davis II, p. 434.
11. Ibid., p. 435.
12. Ibid., pp. 435–436.
13. Davis I, p. 496.
14. Davis II, p. 435.
15. Davis I, pp. 662–663.
16. Ibid., p. 663.
17. Davis II, pp. 436–437.
18. Davis I, pp. 605–606.
19. Ibid., pp. 498–499.
20. Davis II, p. 413.
21. Davis I, p. 499.
22. Ibid., pp. 606–607.
23. Ibid., p. 607.
24. Ibid., pp. 502–503.
25. Ibid., pp. 500–501.
26. Ibid., p. 608.
27. Ibid., pp. 501–502.
28. Davis II, pp. 414–415.
29. Davis I, p. 378.
30. Ibid., pp. 608–611.
31. Ibid., pp. 504–505.
32. Ibid., pp. 374–380.
33. Davis II, pp. 420–422.
34. Davis I, pp. 611–612.
35. Davis II, p. 379.
36. Ibid., p. 425.
37. Ibid., pp. 389–390.
38. Ibid., pp. 426–427.
39. Davis II, pp. 612–614.
40. Ibid., pp. 510–511.
41. Ibid., pp. 380–381.
42. Ibid., pp. 511–512.
43. Ibid., p. 649.

14. *Deaths (1479–1484)*

1. Davis I, p. 369.
2. Davis II, pp. 365–366.
3. Ibid., pp. 366–367.
4. Davis I, pp. 645–646.
5. Ibid., pp. 646–647.
6. Ibid., p. 647.
7. Ibid., pp. 638–639.
8. Ibid., p. 515.
9. Ibid., pp. 614–616.
10. Ibid., pp. 650–651.
11. Ibid., pp. 638–640.
12. Ibid., pp. 614–616.
13. Ibid., pp. 640–641.
14. Ibid., pp. 617–618.
15. Davis II, pp. 437–438.
16. Davis I, pp. 618–619.
17. Ibid., p. 192.
18. Ibid., pp. 622–623.
19. Davis II, p. 400.
20. Davis I, pp. 664–665.
21. Ibid., pp. 665–666.
22. Ibid., pp. 621–622.
23. Ibid., pp. 382–389.
24. Davis II, pp. 440–441, 439.
25. Ibid., pp. 442–443.
26. Jeffs, "The Poynings-Percy Dispute," pp. 161–162.
27. Gairdner VI, p. 74 (abstract).
28. Ibid., p. 78n.

15. *The Last of the Medieval Pastons*

1. Davis II, pp. 443–444.
2. Ibid., p. 445.
3. Jeffs, "The Poynings-Percy Dispute," pp. 162–163.
4. Davis I, pp. 652–654.
5. Gairdner VI, pp. 101–102.

6. Davis II, pp. 457–458.

7. Davis I, pp. 667–669.

8. Davis II, p. 491.

9. Davis I, pp. 641–643.

10. Davis II, pp. 469–470.

11. Davis I, p. lxii.

12. Ibid., p. 628.

13. Rawcliffe, *Medicine and Society*, p. 185.

14. Brenda Davis, *The Story of a House, Wensum Lodge* (Norwich, n.d.); R. W. Ketton-Cremer, *The Story of the Pastons,* guide to Paston exhibition at the Castle Museum (Norwich, 1953), p. 19.

15. Davis II, pp. 472–473.

16. Ibid., pp. 473–474.

17. Davis I, p. lxi.

18. Davis II, p. 478.

19. Ibid., p. 486.

20. Ibid., pp. 612–613.

21. Davis I, pp. l–li.

22. Ibid., p. li.

23. Ketton-Cremer, *The Story of the Pastons*, pp. 6–10.

24. Davis I, p. xxv.

25. Ketton-Cremer, *The Story of the Pastons*, p. 10.

Bibliography

Archer, Rowena. "Rich Old Ladies: The Problem of Late Medieval Dowagers." In *Property and Politics,* edited by Tony Pollard, 15–35. London, 1954.

Armstrong, C. A. J. "Sir John Fastolf and the Law of Arms." In *War, Literature, and Politics in the Late Middle Ages,* edited by C. T. Allmand, 46–56. Liverpool, 1976.

Ashley, Maurice. *Great Britain to 1688.* Ann Arbor, 1961.

Aston, T. H. "Oxford's Medieval Alumni." *Past and Present* 74 (1977): 3–40.

Aston, T. H., G. D. Duncan, and T. A. R. Evans. "The Medieval Alumni of the University of Cambridge." *Past and Present* 86 (1980): 19–27.

Barber, Richard, and Juliet Barker. *Tournaments: Jousts, Chivalry, and Pageants in the Middle Ages.* New York, 1989.

Barron, Caroline. "Who Were the Pastons?" (Review of Norman Davis edition of the Paston Letters.) *Journal of the Society of Archivists* 4 (1972): 530–535.

Bean, J. M. W. *From Lord to Patron: Lordship in Late Medieval England.* Philadelphia, 1989.

Bellamy, J. G. *Bastard Feudalism and the Law.* London, 1989.

Bennett, H. S. *The Pastons and Their England: Studies in an Age of Transition.* Cambridge, 1970 (originally published in 1922).

Brand, Paul. "Courtroom and Schoolroom: The Education of Lawyers in England Prior to 1400." *Bulletin of the Institute of Historical Research* 60 (1987): 147–165.

Carpenter, Christine, ed. *Kingsford's Stonor Letters and Papers, 1290–1483.* Cambridge, 1996.

Clephan, R. Coltman. *The Tournament: Its Periods and Phases.* London, 1919.

Cobhan, A. B. "The Medieval Cambridge Colleges: A Quantitative Study of Higher Degrees to c.1500." *History of Education* 9 (1980): 1–12.

Contamine, Philippe. *War in the Middle Ages.* Translated by Michael Jones. Oxford, 1984 (first published in French in 1980).

Crowder, C. M. D. "Peace and Justice Around 1400: A Sketch." In *Aspects of Late Medieval Government and Society: Essays Presented to J. R. Lander,* edited by J. G. Rowe, 53–81. Toronto, 1986.

Davis, Norman, ed. *The Paston Letters and Papers of the Fifteenth Century.* 2 vols. Oxford, 1971, 1976.

DuBoulay, F. R. H. *An Age of Ambition: English Society in the Late Middle Ages.* New York, 1970.

Dyer, Christopher. "A Redistribution of Incomes in Fifteenth-Century England." *Past and Present* 39 (1968): 11–33.

———. *Standards of Living in the Later Middle Ages: Social Change in England c.1200–1500.* Cambridge, 1989.

Fleming, F. W. "The Hautes and Their Circle: Culture and the English Gentry." In *England in the Fifteenth Century,* edited by Daniel Williams, 85–102. London, 1987.

Fortescue, Sir John. *On the Laws and Governance of England,* edited by Shelley Lockwood. Cambridge, 1997.

Gairdner, James, ed. *The Paston Letters,* A.D. 1422–1509. 6 vols. London, 1904.

Gies, Frances. *The Knight in History.* New York, 1984.

Gies, Frances and Joseph. *Marriage and the Family in the Middle Ages.* New York, 1987.

———. *Women in the Middle Ages.* New York, 1978.

Hanawalt, Barbara A. *Growing Up in Medieval London: The Experience of Childhood in History.* Oxford, 1993.

Hanham, Alison. *The Celys and Their World.* Cambridge, 1985.

———, ed. *The Cely Letters, 1472–1485.* Early English Text Society 273 (1975).

Harvey, I. M. W. *Jack Cade's Rebellion of 1450.* Oxford, 1991.

Haskell, Ann S. "The Paston Women on Marriage in Fifteenth-Century England." *Viator* 8 (1973): 459–471.

Haward, W. J. "Gilbert Debenham, a Medieval Rascal in Real Life." *History* 13 (1928–29): 300–314.

Helmholtz, R. H. *Marriage Litigation in Medieval England.* Cambridge, 1974.

Hicks, M. A. "The Last Days of Elizabeth Countess of Oxford." *English History Review* 103 (1988): 76–95.

Holmes, George. *The Later Middle Ages, 1272–1485.* New York, 1966.

Horrox, Rosemary. "Personalities and Politics." In *The Wars of the Roses,* edited by A. J. Pollard, 89–109. New York, 1995.

Ives, E. W. "The Common Lawyer in Pre-Reformation England." *Transactions of the Royal Historical Society,* 5th Series 18 (1968): 145–173.

Jacob, E. F. *The Fifteenth Century, 1399–1485.* Oxford, 1993 (first published in 1961).

Jeffs, Robin. "The Poynings–Percy Dispute: An Example of the Interplay of Open Strife and Legal Action in the Fifteenth Century." *Bulletin of the Institute of Historical Research* 34 (1961): 148–164.

Ketton-Cremer, R. W. *The Story of the Pastons,* guide to Paston exhibition at the Castle Museum. Norwich, 1953.

Lander, J. R. *Crown and Nobility, 1450–1509.* Montreal, 1976.

———. *The Wars of the Roses.* Toronto, 1986.

McFarlane, K. B. "Bastard Feudalism." In K. B. McFarlane, *England in the Fifteenth Century: Collected Essays,* 23–43. London, 1981.

———. "The Investment of Sir John Fastolf's Profits of War." In K. B. McFarlane, *England in the Fifteenth Century: Collected Essays,* 175–198. London, 1981.

———. *The Nobility of Later Medieval England.* Oxford, 1973.

———. "Parliament and Bastard Feudalism." In K. B. McFarlane, *England in the Fifteenth Century: Collected Essays,* 1–21. London, 1981.

———. "William Worcester: A Preliminary Survey." In K. B. McFarlane, *England in the Fifteenth Century: Collected Essays,* 199–224. London, 1981.

Morgan, D. A. L. "The House of Policy: The Political Role of the Late Plantagenet Household 1422–1485." In *The English Court from the Wars of the Roses to the Civil War,* edited by Davis Starkey, 25–70. London, 1987.

Myers, A. R., ed. *The Household of Edward IV: The Black Book and the Ordinance of 1478.* Manchester, 1959.

Neillands, Robin. *The Wars of the Roses.* London, 1992.

Postan, M. M. *The Medieval Economy and Society*. Berkeley, Calif., 1972.

Powell, Edward. "Arbitration and the Law in England in the Late Middle Ages." *Transactions of the Royal Historical Society,* 5th Series 33 (1963): 49–67.

Rawcliffe, Carole. *Medicine and Society in Later Medieval England.* Phoenix Mill, Far Thrupp, Stroud, Gloucestershire, 1995.

Richmond, Colin. "After McFarlane" (review article). *History* 68 (1983): 46–60.

———. *The Paston Family in the Fifteenth Century: The First Phase.* Cambridge, 1990.

———. *The Paston Family in the Fifteenth Century: Fastolf's Will.* Cambridge, 1996.

———. "The Pastons Revisited: Marriage and the Family in Fifteenth-Century England." *Bulletin of the Institute of Historical Research* 58 (1985): 26–36.

Ridder-Symoens, Hilde de, ed. *A History of the Universities in Europe,* vol. I. *Universities in the Middle Ages.* Cambridge, 1991.

Robertson, D. W. *Chaucer's London.* London, 1968.

Roskell, J. S. *Parliament and Politics in Late Medieval England.* London, 1983.

Ross, Charles. *The Wars of the Roses: A Concise History.* New York, 1977.

Sayer, M. J. "Norfolk Visitation Families: A Short Social Structure." *Norfolk Archaeology* 36 (1975): 176–182.

Smith, Anthony. "Litigation and Politics: Sir John Fastolf's Defence of His English Property." In *Property and Politics: Essays in Later Medieval English History,* edited by Tony Pollard, 59–75. London, 1984.

Southern, R. W. "The Changing Role of Universities in Medieval Europe." *Bulletin of the Institute of Historical Research* 60 (1987): 134–140.

Stapleton, T., ed. *The Plumpton Correspondence.* Camden Society Original Series 4 (1839).

Storey, R. L. *The End of the House of Lancaster.* Gloucester, England, 1986 (originally published in 1966).

———. "The Universities During the Wars of the Roses." In *England in the Fifteenth Century,* edited by Daniel Williams, 315–327. London, 1987.

Thomson, J. A. F. *The Transformation of Medieval England, 1370–1529.* London, 1983.

Virgoe, Roger. "An Election Dispute of 1483." *Bulletin of the Institute of Historical Research* 60 (1987): 24–44.

————, ed. *Illustrated Letters of the Paston Family: Private Life in the Fifteenth Century.* New York, 1989.

Worcester, William. *Itineraries,* edited by John H. Harvey. Oxford, 1969.

Worship, Francis. "Account of a MS Genealogy of the Paston Family in the Possession of His Grace the Duke of Newcastle." *Norfolk Archaeology* 4 (1855): 1–55.

Cast of Characters

The Paston Family

William Paston I (1378–1444), son of Clement Paston (d. 1419), a
substantial yeoman, and Beatrice Somerton, sister and heir of
Geoffrey Somerton, Justice of the Common Bench.

Agnes (Berry) Paston (c.1405–1479), daughter of Sir Edmund Berry,
married William Paston I in 1420.

CHILDREN OF WILLIAM I AND AGNES PASTON

John Paston I (1421–1466), lawyer, legal adviser to Sir John Fastolf
and chief heir of his large estate, married *Margaret Mautby*
(d. 1484), heir to the Mautby estates, c.1440.

Edmund Paston I (1425–1449), lawyer.

Elizabeth Paston (1429–1488), married Robert Poynings in 1458, Sir
George Browne in 1471.

William Paston II (1436–1496), lawyer, married Lady Anne Beaufort
(c.1470), two daughters.

Clement Paston (1442–c.1468), lawyer.

CHILDREN OF JOHN I AND MARGARET MAUTBY PASTON

John Paston II (Sir John) (1442–1479), courtier, died unmarried,
leaving an illegitimate daughter, Constance.

John Paston III (1444–1503), in the service of the duke of Norfolk and
later of his brother, Sir John, married Margery Brews (d. 1495), in
1477.

Margery Paston (before 1450–c.1482), married Paston bailiff Richard
Calle in 1469.

Edmund Paston II (c.1450–c.1503), lawyer, twice married, no
surviving issue.

Anne Paston (1455–c.1495), married William Yelverton in 1477.

Walter Paston (c.1456–1479), died two months after his graduation from Oxford.

William Paston III (1459–after 1503), educated at Eton; in the service of the earl of Oxford until 1503, when he became mentally ill.

CHILDREN OF JOHN III AND MARGERY BREWS PASTON

Christopher Paston (b. 1478), died in infancy.

William Paston IV (c. 1479–1554), married Bridget, daughter of Sir Henry Heydon (c.1490); ancestor of all the later Pastons.

Friends, Servants, and Associates of the Family

Richard Calle, Paston bailiff, son of Framlingham shopkeepers, married Margery Paston in 1469.

John Damme, friend at whose house Margaret Paston took refuge after being ousted from Gresham in 1450.

John Daubeney, trusted agent, killed at the siege of Caister Castle in 1469.

Sir John Fastolf, wealthy veteran of the Hundred Years War.

Friar John Brackley, Fastolf's confessor.

Thomas Howes, Fastolf's chaplain.

William Worcester, Fastolf's secretary; antiquarian and genealogist, married to Thomas Howes's niece.

James Gloys, Paston chaplain from c.1448 to his death in 1473.

James Gresham, one of William Paston I's clerks and for many years a Paston agent.

John Pampyng, longtime Paston servant who took part in the siege of Caister in 1469.

William Pecock, Paston servant.

William Lomnor, close associate apparently related to the Pastons.

Elizabeth Clere, Margaret Paston's cousin and close friend; Fastolf's niece.

Lady Elizabeth Calthorp, wife of Margaret Paston's kinsman Sir William Calthorp.

Anne Haute, cousin of Elizabeth Woodville, engaged to Sir John Paston.

Other Characters

John Heydon, lawyer, agent of the duke of Suffolk in the 1440s, longtime enemy of the Pastons, whose granddaughter, however, married the son of John Paston III.

William Yelverton, member of Fastolf's legal staff, justice of the King's Bench, adversary of the Pastons over Fastolf's will.

William Jenney, another of Fastolf's lawyers, who joined forces with Yelverton after Fastolf's death.

Robert Hungerford, Lord Moleyns, Paston enemy who seized the manor of Gresham in 1450.

Official Personages

King Henry VI (reigned 1422–1461)

King Edward IV (reigned 1461–1483)

King Richard III (reigned 1483–1485)

King Henry VII (reigned 1485–1509)

Margaret of Anjou, Henry VI's queen

Elizabeth Woodville (or Wydeville), Edward IV's queen

Anthony Woodville, Lord Scales, later Earl Rivers, Queen Elizabeth's brother

William, Lord Hastings, Paston patron

William Waynflete, bishop of Winchester, Paston patron

Richard Neville, earl of Warwick, "the Kingmaker"

George Neville, archbishop of York, Warwick's brother

John de Vere, earl of Oxford, Paston patron

Dukes of Norfolk: John Mowbray III (d. 1461), John Mowbray IV (d. 1476), John Howard (d. 1485)

Dukes of Suffolk: William de la Pole (d. 1450), m Alice Chaucer, granddaughter of the poet; John de la Pole (d. 1491/1492)

Calendar of Events,
Paston and Political, 1415–1504

	1415	Battle of Agincourt
Clement Paston dies	1419	
William Paston I marries Agnes Berry	1420	Treaty of Troyes, high point of English success in Hundred Years War
Birth of John Paston I	1421	
	1422	Accession of Henry VI
William Paston appointed judge of Court of Common Pleas	1429	Joan of Arc at Orléans; battle of Patay
Marriage of John Paston I and Margaret Mautby	c.1440	
Birth of John Paston II	1442	
Birth of John Paston III; death of William Paston I	1444	
Gresham dispute	1448–51	
	1450	Battle of Formigny; disgrace and murder of duke of Suffolk; Jack Cade's rebellion; return of duke of York from Ireland

Queen Margaret visits Norwich en route to Walsingham	1453	Battle of Castillon; madness of Henry VI; birth of Prince Edward; Yorkist and Lancastrian parties form
Sir John Fastolf moves into Caister Castle	1454	Duke of York appointed Protector; king recovers and Protectorate ends
	1455	Wars of the Roses begin, with first battle of St. Albans; duke of York again becomes Protector
Elizabeth Paston marries Robert Poynings	1458	
Death of Fastolf and start of litigation over his will	1459	"Rout of Ludlow," Yorkist reverse
John Paston I elected to Parliament	1460	Battle of Northampton; duke of York claims throne; battle of Wakefield, York killed
Robert Poynings killed at St. Albans; duke of Norfolk claims Caister, John Paston successfully defends it; John reelected to Parliament despite fracas with Sheriff Howard in shire house; John II placed at royal court; John I briefly in Fleet Prison	1461	Second battle of St. Albans; Edward IV proclaimed king; death of third duke of Norfolk, accession of fourth duke

Yelverton and Jenney seize manor of Cotton for duke of Suffolk; John III in service of duke of Norfolk	1462	
John Paston II knighted	1463	
John Paston I again imprisoned	1464	Edward IV marries Elizabeth Woodville, causing break with earl of Warwick and renewal of Wars of the Roses
Hellesdon and Drayton seized by duke of Suffolk; John I imprisoned for third time	1465	
Death of John Paston I; certification of Paston genealogy	1466	
Sir John Paston elected to Parliament; tentative settlement of Fastolf estate	1467	
Thomas Howes makes declaration contradicting Paston claim to Fastolf estate; Sir John and John III attend Princess Margaret's wedding in Bruges; Sir John betrothed to Anne Haute	1468	Marriage of Margaret of York to Charles the Rash of Burgundy
Siege of Caister; Richard Calle–Margery Paston affair revealed; their marriage	1469	Edward IV visits Norfolk; battle of Edgecote Field, Warwick triumphant; recovery of Edward IV, Warwick flees

Bishop Waynflete appointed to administer Fastolf estate; new settlement made; Sir John recovers Caister	1470	Warwick again invades England; battle of Losecoat Field; Lancastrian army lands in western England; Edward IV flees abroad
John III wounded at Barnet; duke of Norfolk reoccupies Caister; Paston brothers obtain pardons	1471	Battle of Barnet, Warwick killed; battle of Tewkesbury, defeat of Queen Margaret; Henry VI put to death
Five Paston brothers go to Calais to join army	1475	Edward IV takes expeditionary force to Calais; Treaty of Picquigny averts war
Death of duke of Norfolk; Caister regained by Pastons	1476	
Marriages of John Paston III with Margery Brews and Anne Paston with William Yelverton	1477	Defeat and death of Charles the Rash
Deaths of Agnes Paston, Walter Paston, and Sir John Paston; birth of William Paston IV	1479	
	1483	Death of Edward IV; Richard III seizes power
Death of Margaret Paston	1484	

	1485	Battle of Bosworth; death of Richard III; accession of Henry VII
John Paston III made sheriff of Norfolk and Suffolk	1485–86	
John Paston III knighted	1487	Battle of Stoke
Death of Margery Brews Paston	1495	
Death of John Paston III	1504	

Glossary

Technical Terms

Advowson: right to present a benefice or church office
Affinity: total following of a lord
Almoner: officer who bestows alms
Assize: trial held in each county twice a year to try civil and criminal cases
Attaint: formally condemn
Bailiff: lord's chief official
Banneret: superior grade of knight
Bondman: serf or villein, a peasant subject to special obligations and fines
Chantry: establishment endowed to provide prayers for the souls of the dead
Disseize: expel from a property
Distraint or distress: seizure of goods to enforce obligation, or the goods seized
Dower: gift of the groom to the bride to support her in widowhood
Dowry: money or property given the groom by the bride's family
Enfeoffment: grant of legal title of property to trustees ("feoffees") to hold for the donor while he or she continues its "use"
Entail: limit of the inheritance of an estate to a specific line of heirs, precluding sale or other disposal
Escheator: royal officer charged with overseeing the king's feudal rights in inheritances
Farmer: one who collects rents and pays a fixed sum to the owner
Indenture: written contract for service, often military
Jointure: settlement of land at marriage on a couple, for their lifetime and that of the survivor
Manor: estate consisting of lord's demesne and tenants' holdings
Manorial court: court held by the lord of an estate dealing with a

range of civil and criminal cases and providing him with fines, fees, and confiscations

Messuage: house and yard

Nuncupative will: oral will

Oyer and terminer: royal commission appointed to try a specific offense

Pinfold: lord's pound for stray animals

Replevin: legal action for recovery of goods unlawfully seized

Seisin: right of possession

Sheriff: royal county official

Wardship: right of guardianship exercised by a lord over a minor

Yeoman: substantial peasant

Archaic Terms

Assoil: pardon

Bedesman, bedeswoman: one who prays for another

Brethel: good-for-nothing

Camlet: fine wool cloth

Charge: importance

Cursing: excommunication

Ensured: engaged

Evidence: legal papers

Fellowship: company of men

Good: property

Heavy: sad

Jack: padded or armored leather jacket

Labor: attempt to influence, lobby

Lewd: foolish, ignorant, bad

Livelode: income or property yielding income

Lordship, especially good lordship: patronage

Move: urge, try to influence

Murrey: purple cloth

Musterdevillers: gray woolen cloth (from the place-name *Mouster de Villers* in Normandy)

Plunket: gray-blue

Points: laces for attaching hose

Sad: sensible, wise, serious

Scarlet: a kind of expensive cloth

Shrew: villain

Stew: fishpond

Stomacher: padded waistcoat

Thrifty: worthy, respectable

Treaty: negotiation, agreement

Well-willer: well-wisher

Worship: respect, honor, good name, as opposed to **disworship:** disgrace, loss of face

Index

Index

Chamberlain, Sir Roger, 112
Chamberlain, Sir William, 91
chantries, 35, 45–48, 115
Chapman, John, 204, 227
Charles VIII, king of France, 221
Charles the Rash, duke of Burgundy, *196*, 243, 278, 280, 288; marriage to Margaret of York, 195–199, 238; death, 294
Chaucer, Thomas, 57
Clarence, George, duke of, 136, 149, 217, 222, 223, 226, 228, 233, 238, 244, 305
Clere, Edmund, 108
Clere, Elizabeth, 72–73, 101–102, 175, 258, 260, 305
Clere, Robert, 242, 309
Clere family, 166, 173
Clippesby, Catherine, 316–317, 338
Clopton, John, 107–108
clothing, 40–42, 60, 119, 176, 240, 251, 259–260, 282, 310, 326
Colett, Henry, 275, 336
Costessey (Norfolk), 82, 162, 164, 167, 169, 171, 173, 174, 180, 181
Cotton (Suffolk), 79, 82, 150–151, 178–179, 181
courts of law, 29, 36–37; assizes, 173–174; Chancery, 36, *37*; Court of Common Pleas, 29, 36; ecclesiastical, 157–158, 175; Exchequer, 36; King's Bench, 36, 37, 234; manorial, 26, 152, 173, 178, 262
Crane, John, 111

Cromer (Norfolk), 35, 44, 314, 318
Crop, John, 83
Crowmer, William, 88

Dale, Edward, 151, 153
Damme, John, 42, 46, 47, 61, 63, 64, 65, 67, 71
Daubeney, John, 159, 164, 169, 188, 204, 214, 222, 223, 225, 227, 232
Davis, Norman, 21
Dawne, Cecily, 306–307
Debenham, Gilbert, 152–153, 178–179, 289
Debenham, Sir Gilbert, 289
Dedham (Essex), 79, 81–82, 144
distraint, 151, 163–164, 167–168, 204
dower, 42, 313
dowry, 30–31, 39, 44, 277, 289, 291, 293, 295, 298, 301, 308, 313, 315
Drayton (Norfolk), 82, 162, 163, 164, *165–166*, 167–168, 170, 173, 174, 181, 235–236, 306, 307
DuBoulay, F. R. H., 9, 29–30
Dudley, Katherine, 231

East Beckham, 35, 57, 61, 209, 229, 268, 341
Eberton, Elizabeth, 277
Ebesham, William, 199–200
Edgecote Field, battle of (16 July 1469), 217, 252
education, 35–36, 45, 118–119, *120*, 250, 272, 311–312